VISUAL MERCHANDISING

Situated at the crossroads of visual culture and consumerism, this essay collection examines visual merchandising as both a business and an art. It seeks to challenge that scholarly ambivalence that often celebrates the spectacle but denies the agenda of consumerism. The volume considers strategies in the imaging of selling from the mid nineteenth century to the present, in terms of the visual interaction that occurs between the commodity and the consumer and between body and space.

Under the categories of Promotion, Product and Place, contributors to the volume examine the strategies in the presentation of retail goods and environments that range from print advertising to product design to store display and architecture. *Visual Merchandising: The Image of Selling* is located directly at the nexus of business practice and cultural myth, where the spectator never loses sight of their status as buyer and the object of desire is always still a commodity.

Louisa Iarocci is Assistant Professor in the Department of Architecture at the University of Washington, Seattle, USA.

T0300150

Visual Merchandising

The Image of Selling

Edited by Louisa Iarocci
University of Washington, Seattle, USA

Routledge
Taylor & Francis Group

LONDON AND NEW YORK

First published 2013 by Ashgate Publisher

2 Park Square, Milton Park, Abingdon, Oxon OX14 4RN
711 Third Avenue, New York, NY 10017, USA

Routledge is an imprint of the Taylor & Francis Group, an informa business

First issued in paperback 2016

British Library Cataloguing in Publication Data
Visual merchandising : the image of selling.
 1. Display of merchandise--History--20th century. 2. Show
 windows--History--20th century. 3. Showrooms--History--
 20th century. 4. Consumers--Psychology.
 I. Iarocci, Louisa.
 659.1'57-dc23

The Library of Congress has cataloged the printed edition as follows:
Visual merchandising : the image of selling / edited by Louisa Iarocci.
 pages cm
 Includes bibliographical references and index.
 ISBN 978-1-4094-2697-4 (hardcover) 1. Display of merchandise. I. Iarocci,
 Louisa, editor of compilation.
 HF5845.V56 2013
 659.1'57--dc23

 2012039664

ISBN: 978-1-4094-2697-4 (hbk)
ISBN: 978-1-138-24716-1 (pbk)

Contents

List of illustrations

List of tables

Notes on Contributors

[faded text at top of page, largely illegible]

Emily Bills received her Ph.D. in the History of Architecture and Urban Planning from the Institute of Fine Arts at New York University. Her dissertation examines how telephone infrastructure shaped the development of Los Angeles in the first half of the twentieth century. She completed a Smithsonian Postdoctoral Fellowship to work on selected writings of the Los Angeles architectural historian and critic Esther McCoy. She currently teaches Architectural and Urban History at Woodbury University, San Diego, where she is also Coordinator of the Urban Studies Program and Director of the Julius Shulman Institute.

Robert Buerglener is a Visiting Scholar in the Department of History at Northwestern University. He also teaches in the Department of History at DePaul University. He received his Ph.D. in US History from the University of Chicago in 2006 with a dissertation entitled "Creating the American Automobile Driver, 1898–1918." His research deals with the meanings of technology, the built and natural environment, and material culture in US history.

Kathleen Chapman is Assistant Professor of Modern Art and Architecture in the Department of Art History in the School of the Arts at Virginia Commonwealth University. She has a Ph.D. in German Literature and in Art History from the University of Southern California. She worked at the Getty Institute and the Rifkind Center for German Expressionist Studies at the Los Angeles County Museum of Art. Her research focuses on early twentieth-century German art and culture.

Sarah Cheang is Senior Tutor in the History of Design program at the Royal College of Art, London. Her work focuses on the history of cultural exchange between East and West with a special interest in femininity, modernity, the body, and things Chinese. Her journal articles embrace topics such as Chinese

embroideries in Western homes, and the history of the Pekingese dog in Britain. She co-edited the book *Hair: Style, Culture and Fashion* with Geraldine Biddle-Perry (2009), and is currently working on a monograph on fashion and ethnicity.

Jeffrey A. Cohen is Senior Lecturer and Chair of the Growth and Structure of Cities Department at Bryn Mawr College, near Philadelphia. His teaching ranges from the history of urban form and architecture to more specific foci on nineteenth-century downtowns, the emerging suburb, the row house, representations of the built environment, and research approaches to Philadelphia's architecture. Among his publications are studies of the work of Benjamin Latrobe, of Frank Furness, early architectural education, and early architectural drawings.

Ethel Goodstein-Murphree is Professor of Architecture at the University of Arkansas where she specializes in North American and British architecture. She has worked in historic preservation and is a partner in studio m2, an alternative design firm. She has given talks and published widely on a wide range of subjects from the architecture of Edward Durell Stone to the image and representation of New Orleans. Her paper is based on her scholarly and field research into the truck, the cultural landscapes it occupies, and the modes of representation it inspires.

Mona Hadler is Professor of Twentieth-century European and American Painting and Sculpture at Brooklyn College and The Graduate Center at CUNY. Since receiving her Ph.D. from Columbia University, she has given numerous talks and published widely on various Abstract Expressionist painters, Lee Bontecou, postwar sculpture, and jazz in the visual arts. Her other interests include postwar visual culture and most recently the relationship between Surrealism, David Hare, and the comics.

Louisa Iarocci is Assistant Professor of Architecture at the University of Washington in Seattle. She received her Ph.D. from Boston University in 2003 and has taught at Harvard University, University of British Columbia and Western Washington University. Her research focuses on commercial and utilitarian architecture with a focus on issues of modernity, consumerism and cultural identity. She is a registered architect and is currently working on the monograph, *The Urban Department Store in America*, to be published by Ashgate.

Dean Lampros is a native of New England and a doctoral student in Boston University's American and New England Studies Program. He received his BA in History from the University of Pennsylvania. For several years he

worked in the field of institutional advancement for the Boston University School of Theology and later for the New England Foundation for the Arts, a regional arts organization working in partnership with the NEA. His current research is in the field of vernacular architecture, material culture, and historic preservation.

John Potvin is Associate Professor of Art History at the University of Guelph, Canada. He is the author of *Material and Visual Cultures Beyond Male Bonding, 1880–1914* (2008) and *Giorgio Armani: Empire of the Senses* (2012). He is also the editor of *The Places and Spaces of Fashion, 1800–2007* (2009), and co-editor of both *Material Cultures, 1740–1920: The Meanings and Pleasures of Collecting* (2009) and *Fashion, Interior Design and the Contours of Modern Identity* (2010).

Gayle Strege is Curator of The Ohio State University's Historic Costume and Textiles Collection where she has created over 20 exhibitions. She holds a BA in Fashion Design from Mount Mary College, Milwaukee, WI, and an MA in Museum Studies from the Fashion Institute of Technology in New York City. She has worked for the Chicago History Museum, American Textile History Museum, and the Wexner Center for the Arts, and began her career as a theatrical costumer in Milwaukee, St Louis and Buffalo.

Introduction: The Image of Visual Merchandising

Louisa Iarocci

In the field of retailing, merchandising is typically defined as the diverse array of business practices involved in selling goods directly to the final user—ranging from the selection and acquisition of products, to the planning and promotion of sales, and to the conduct of salesmanship and service. Where these methods involve appearance, as in the promotion and presentation of goods in window and store displays and in the planning and design of the store environment, merchandising has been more specifically identified as "visual." In retailing practice, visual merchandising has come to describe not simply the means by which information about the product is communicated but how the message is received by the customer in a way that stimulates their senses and motivates them to buy.[1] Considered in terms of its perceptual and psychological impact, the goal of visual merchandising has been not simply to promote and display commodities, but ultimately to engage and persuade the potential possessor of those goods.

The critical role played by the appearance of goods and the sales environment is so embedded in our contemporary culture that it is hard to understand how the image of selling has been so overlooked in the field of visual studies. In studies of consumerism and urbanism, the rise of store display, in particular the store window, in the late nineteenth century has often been evoked as material evidence for the onset of modernity. The physical spaces of consumption have been used as a tangible entry point into discussions of the desiring subject and the spectacle of capitalism.[2] In visual studies, instances where celebrity artists and architects have experimented in commercial work have been considered relatively safe scholarly territory where commerce has only marginally infiltrated the realm of fine art. But the images and installations made explicitly for the purposes of selling seem to have fallen into the cracks between studies of the aesthetic and commercial realms. The study of visual merchandising as an art continues to

be characterized by that scholarly ambivalence that celebrates the spectacle but often denies the agenda of consumerism.

Is it possible then to study the history of visual merchandising as a significant aesthetic practice without neglecting its primary purpose in the realm of business? The sales image, in the form of the show window, has been described by Jean Baudrillard as "both magical and frustrating," at once the mirror/looking glass that absorbs the spectator into the contemplative realm of consumption and at the same time, denies them access to the physical means to attain it.[3] The cover photograph, "A Living Sign on 5th Avenue," provides such an example, vividly capturing a street view of the retail scene in turn-of-the-century New York. The seemingly fortuitous location of dentists' offices above a candy store has resulted in the need to communicate the physical location and identity of multiple establishments and their wares. Proudly bearing a sign advertising a dental parlor, the cordial doorman serves as mobile billboard and outdoor salesman, engaging the pedestrian on the street and directing them towards the shops. Living bodies and goods for sale, outdoor display cases and building storefront all interact in this lively scene which serves as a promotional portrait of these turn-of-the-century businesses while providing glimpses of potential exchanges within.

As the "Living Sign" demonstrates, the practice of selling has always been a human activity that involves the coming together of objects and people. The central role played by "the human agents" or the sales staff is the focus of the earliest discussions of selling in trade literature and popular magazines in the United States in the early nineteenth century. The article, "The Art of Selling," that appeared in the *Philadelphia Album and Ladies' Literary Portfolio* in 1831 devotes most of its attention to describing the role of salesmanship in successful selling.[4] This emphasis on sales practice reflects the scale and nature of retail operations in the early nineteenth century where goods would often be stored in back of shops and brought out selectively to be presented to interested buyers. The anonymous author describes the various methods by which a sales clerk might convince a reluctant customer to buy, in humorous scenes intended both to instruct and to entertain. But the author also observes that selling extends beyond the skills of the clever merchant, arguing for the importance of the "(judicious) display of the wares and merchandise to the best advantage." The tasteful exhibition in visible locations in the store like its windows, glass cases, and even doors is noted to have the potential to create a "silent appeal" for the "desired object." Display is already perceived to go beyond simply providing information about the type and quantity of stock a store might carry, by conveying a general impression of wealth and abundance.[5] The author even argues that these "shining articles" can literally come to life, to actively participate in the art of persuasion, and "say to every beholder, Buy! Buy!"

In the second half of the century the emphasis on personalized, time-consuming human sales service diminishes with the expanded scale and complexity of retail trade. With increased production and expanded markets, a more varied array of urban businesses emerges, expanding the scale of facilities and services and the complexity of distribution networks.[6] The impact is felt on an urban scale as commercial districts expand to accommodate increased numbers and varieties of import, wholesale, and retail businesses. As Claire Walsh observes in relation to eighteenth-century London, less individual time could be spent with customers who also had less time to browse, resulting in greater emphasis being placed on the appearance of the shop.[7] In his 1882 manual, *How to Keep a Store*, Samuel H. Terry argues that successful retailing involves not only the "art of selling," referring to salesmanship, but also to the visual character of the store and its products.[8] His advice to the storekeeper includes subjects from the larger urban scale of choosing a profitable location to minute details about the spacing of stockroom shelves. The orderly arrangement of goods is noted to not only facilitate efficient retrieval for sales presentations but to help protect valuable stock from damage. The author further stresses the connection of the store environment to the perception of products by describing how to adjust the quality of light to "enhance the beauty of the articles on a retailer's counter" while concealing their "imperfections of manufacture."

Instructional literature on store display begins to appear in earnest around the 1880s when existing journals for the dry goods and textiles industries like *Dry Goods Chronicle and Fancy Review* and the *Dry Goods Economist* began including regular features devoted to the design of "store attractions." The earliest known trade journal dedicated to store display in the United States was *Harman's Journal of Window Dressing* of Chicago of 1893, often overshadowed by its more famous successor, *The Show Window: A Monthly Journal of Practical Window Trimming* which was begun by L. Frank Baum in 1897.[9] The following year, Baum established the National Association of Window Trimmers that held an annual national convention in Chicago and awarded prizes for display excellence — providing evidence of organized efforts to legitimize the display profession.[10] Baum's often cited book of 1900, *The Art of Decorating Dry Goods Windows and Interiors*, was not the first of numerous lavishly illustrated display manuals to emerge on the subject in the late nineteenth century. Earlier author/practitioners like Frank L. Carr and J. H. Wilson Marriott also sought to set out a systematic approach to display that was both scientific and artistic.[11] Serving as both textbooks and treatises, their books provide technical information on subjects like lighting and mechanical devices alongside chapters in color harmony and composition. The store window took on special significance for storekeepers as a highly visible, on-site marketing tool, acting as a kind of three-dimensional catalogue in "stocky" type displays. These exhibits were often composed of a single type of small-scale household or apparel item,

assembled into an eye-catching arrangement that emphasized abundance and variety. In more "artistic" displays, more selective arrangements of objects were used to create narrative scenes that ranged from more formal pictorial compositions to animated novelty sideshows. While focusing on window displays, the manuals also addressed the decoration of the larger store interior and even extended their coverage into the city streets, including parades and street carnivals.

The 15-year gap between the fourth and final edition of the *Art of Decorating Show Windows and Displaying Merchandise* of 1924, reflects a general waning of these kinds of publications as the display field seems to become too large and diverse to survey in a single volume. Baum's trade journal undergoes numerous name and owner changes, becoming *The Merchants Trade Record and Show Window* in 1903 and then *Display World* in 1938, reflecting the continual repositioning of the publication to keep up with the changing profession. Greater specialization in the display industry is evident in the production of pamphlets and smaller books dealing with detailed subjects like show card writing and window backgrounds and specific lines of merchandise like men's wear and textiles.[12] Often produced by manufacturers, these publications reflect the rise of industries producing store equipment that sought to sell their expertise along with their products. The National Cash Register Company, for example, published its first edition of *Better Retailing: A Handbook for Merchants* in 1919 that covered a comprehensive range of topics from store organization to interior display. Advances in the mass production of store equipment and display fixtures provided store owners with new ways to simplify and systematize the constant challenges of handling sales merchandise.[13] Yet at the same time even these industry publications acknowledged the need for displays to be responsive to seasonal changes in the market and developments in product lines. Display manuals for stores selling specialty items like groceries and hardware perpetuated the notion that retail design still required an individualized and specialized approach.[14]

At the other end of the scale the rise of the urban department store fueled the potential to make goods accessible and alluring to a mass consuming crowd who were free to browse their continually expanding open sales floors. Taking over entire city blocks in dense commercial zones, these large stores often used closed back-store windows, presenting merchandise on a small-scale theatrical stage, while smaller stores were more apt to use backless windows that opened up their interiors to the street. Along with their greater variety of lines of goods and services, department stores also had the resources to manage the appearance of their entire premises. They began to take control of the education of their display personnel, providing in-house training in window trimming alongside salesmanship and accounting.[15] Heading up large teams of trimmers, carpenters, and electricians, display directors of major stores in New York and Chicago began to gain notoriety for their

signature work. Arthur V. Fraser's work for Marshall Fields, for example, was featured in almost every issue of the *Show Window* between 1910 and 1930.[16] Fraser is often credited for leading the trend towards less clutter and more museum-like fashion displays that made use of increasingly naturalistic human forms. The participation of professional designers like Raymond Loewy, who worked for Macy's in 1919 and then Saks Fifth Avenue, and Normal Bel Geddes, who began working for Franklin Simon in the late 1920s, similarly raised the profile of retail design, making it a legitimate venue for experiments in the emerging modern style.[17]

Developments in manufacturing, transportation, and distribution in the early decades of the twentieth century fueled the further expansion of markets providing more opportunities to sell a wider range of products. While existing print media like newspapers and magazines continued to increase in circulation, new communication technologies provided more venues for advertisers to create brand recognition of their consumer products. National advertising campaigns took advantage of new forms of media like radio, film, and eventually television in order to reach a wider audience. Stressing the link between print advertising and store display, trade authors argued that the physical premises were still essential, "the last and final link in the great advertising chain."[18] But as noted by Carl Percy in his *Window Display Advertising* of 1928 the point of sale in the store is no longer singled out as the critical moment of decision to buy, the message having "been through every other medium ... before being impressed on the brain" of the consumer. Window display becomes "window advertising," one of a series of media venues that can serve as an ever-changing "screen, on which you present to the customer the merchandise you have for sale."[19] Percy's book contains numerous examples of lithographed display cards and other advertising trims produced by manufacturers, reflecting the rise of the product itself as a nationally recognizable brand.

The centralization of retailing in department stores in city centers makes them more vulnerable, and the economic collapse in the 1930s has the expected impact on retailing, and the display profession.[20] But as Gary Cross points out, despite the financial and political upheaval, this period also provided opportunities for new and aggressive types of marketing at both the high end and budget ends of the spectrum.[21] Trade authors argue even more strongly for the link between successful display and retailing profits, advocating for the use of inexpensive and reused materials.[22] But a recently arrived group of European designers articulate a different approach, embracing high-end retailing as a vehicle for Modernism as an aesthetic practice. In his *New Dimensions: The Decorative Arts of Today of 1928*, Paul Frankl presents a manifesto for the arrival of modern art in the realm of interior design, where he proclaims the radical "strict and severe" aesthetic is most essential in business. He argues that the retail designer must consider all the "various mediums at

[his] disposal," including business letterhead, show window backgrounds, store plans, and furnishings.[23] In 1930 his fellow Austrian-American, theater designer, artist, and architect Frederick Kiesler even more emphatically positions the store as the link between everyday life and the fine arts, and the leading instrument for the introduction of the modern aesthetic to the United States. In *Contemporary Art Applied to the Store and Its Display*, Kiesler links recent developments in modern painting, sculpture and architecture with the display of high fashion. The show window is presented as a dreamlike space that provides unlimited possibilities for avant garde experiments such as kinetic windows dispensing merchandise through a push-button system and a "tele-museum" with a retractable "screen-curtain," broadcasting the latest fashion news.[24]

In the postwar period, reality returns as the term "Visual Merchandising" comes into common usage to usher in an era of scientific research conducted by newly formed associations of manufacturers, retailers, and educators. The National Association of Display Industries in New York reported the results of their first efforts to determine the selling potential of store windows in *The Pilot Study of Display* of 1949. Their data collection methods went beyond simply counting pedestrian traffic and conducting in-store interviews to quantifying human behaviors. Through careful visual observation, the "passers" walking by could be distinguished from the "looker" (who might become a buyer), revealing the connection between the "attraction of display to the circulation it receives."[25] The results of this experiment seeking to link spatial movement to social behavior was presented in a matrix that traced a path from storefront location to window display, and finally to statistical data on the circulation of male and female "lookers." The 1955 *Display Manual* by the Visual Merchandising Group of the National Retail Dry Goods Association offers an even more comprehensive approach in a collection of essays by an impressive line-up of display experts, many from major department stores. The volume seems as concerned with making a case for the prestige of the profession, as with dispensing practical advice. Each article includes a photographic portrait of its author conveying a vivid picture of this army of professional display men, described as both "artistic showmen and realistic, hard-selling merchants."[26] The campaign of visual merchandising is at one point directly compared to warfare, the windows noted as "a store's first line of offense, cash register-wise," with the secondary support being the interior merchandise presentation. These author practitioners, several noted to be just back from military service, are portrayed as leaders in this aggressive campaign of selling from the first arrival of merchandise in the store "to its removal" by the customers.

The arrival of visual merchandising was not only in the business of retail management, but also as a legitimate field of academic study. The 1955 *Display Manual* lists over 50 institutions in the United States offering some

kind of instruction in display practices, some exclusively retailing schools but others degree-granting colleges and universities. The participation of not just professionals in business but also in design becomes more evident with the increased visibility of architects in retail design. Richard Longstreth has documented the transformation of commercial architecture in the postwar period as the center of retailing shifted from downtown main streets to the periphery of the city. Auto-oriented suburban retailing centers produced free-standing structures with few ground floor windows surrounded by parking.[27] The extension of store architecture from a predominately planar storefront on a narrow lot to a three-dimensional monolith set within a generous site drew the attention of architects. In his 1948 book, *Planning Stores That Pay*, Louis Parnes describes the department store as a "machine for selling ... which will efficiently take the merchandise and customers (the raw material), apply the sales force (motive power) in a well-designed selling procedure, and produce the desired end—profitable sales."[28] The engineering of the store covers urban planning considerations, store operations and layout, and even the arrangement and selection of store equipment and furnishings. The author directs architects to seek a more "organic approach" to successful store design that employs traffic and motion studies alongside psychological profiles to study customers as physical bodies and thinking beings.

In 1946, architects Gene Burke and Edgar Kober observe that that are few acknowledged practitioners of retail design, like themselves, and even fewer up-to-date design treatises, like their newly published book, *Modern Store Design*. They present the modern store as "an efficient merchandising plant" that must be comprehensively designed from the appearance of the exterior shell to interior treatments with color, lighting and furnishings, and even budgeting and construction management.[29] Store design is again seen as the ideal vehicle for the perpetuation of modernity in its streamlined aesthetic, functional simplicity, and technological advancement. Illustrated with freehand architectural perspectives and detail specification sheets, the book dissects the retail environment into a collection of discrete vignettes, providing the client with a more flexible catalogue of modernization options. The image of "the machine for selling" is supplanted with the image of the more humanly scaled environment of the small store, where a customer can be "considered as a welcome and honored guest."[30] In his forward to the 1948 *Contemporary Shops in the United States*, George Nelson observes that design is "a weapon in the arsenal" in the campaign to return to the early nineteenth century, pre-industrial revolution, when the shop was "one element in a small-scale, integrated system of production, merchandising and living."[31] The resurgence of the specialty shop as boutique brought the heightened sense that the retail environment could be domesticated, presented as the link between the factory and home and as part of a national project of recovery.[32] The extension of display practices into the design of the showrooms in offices,

travel agencies, and hairdressing salons provided further opportunities to demonstrate how visual merchandising could be validated as a valuable field of design, and an integral part of everyday life.[33]

With the rise of suburban shopping, the small store now subsumed within the interior of the mall logically gains more attention in visual merchandising efforts. But even as it seems to dematerialize in space, the store window continues to play a major role in merchandising efforts. In *The Art of Window Display* of 1952, Robert Leydenfrost claims to have rediscovered the window display as "a new art form," emphasizing its physicality as "the first direct and personal contact between shopper and merchandise."[34] In stark black-and-white photographs, the author provides numerous examples of the revival of surrealism in display, recalling the iconic work of Salvador Dali for Bonwit Teller in the late 1930s.[35] Jim Buckley's *The Drama of Display* of 1955 similarly reflects the trend towards the theatrical in window display, where familiar objects for sale were arranged in increasingly abstract and fantastical compositions, typically focused on fashion. Characterizing the display profession as "too often submissive" Buckley presents a compelling argument for a more expressive and intuitive approach derived from other types of performance media. The show window can thus serve as "show business," providing space for tie-ins with other popular forms of entertainment that include "plays, movies, art exhibits, opera, ballet, concerts and [the] circus." In his exploration of the "language of the object," Buckley considers "the physical arrangement of objects in relation to each other and to the environment (the surroundings beyond the window itself)."[36] He observes that in this "plastic space of the window" the power of objects can go beyond their commodity function, to serve as "symbols, signs and allegories ... [that are] often more potent than the thing itself."

Despite difficult economic times for urban retailing, the idea persisted that the window display could exist as an independent art, providing a realm of possibilities distinct from the increasingly standardized arrangements of the interior. Michael Emory's *Windows* of 1977 reflects the continuing allure of store windows as artistic works generated by star designers and their high-profile clients.[37] Large-scale art photographs, many in color, represent the work of the profiled designers all employed by major urban stores, including Gene Moore of Tiffany and Company, Robert Currie of Henri Bendel, and Colin Burch of Bonwit Teller. Andy Warhol, whose early display work is mentioned but not shown, is quoted as declaring that the store has supplanted the gallery as the training ground for the best new wave artists. The trend towards seeking to "shock, amuse and seduce" is strongly evident in the work of Candy Pratt, display director at Bloomingdales. In these more minimal and austere windows, spare fashion figures and props were set cleanly against blank backgrounds in fantastical scenes that could even veer into the taboo territory of violence and sex. In 1978 Leonard Marcus commented that this

"theatre of the street" employed a style of "mock realism" that mirrored the urban context in a way that "could at times have greater visual immediacy than television."[38] His book, *The American Store Window*, provides another illustrated compilation of the work of individual designers as evidence of the status of window display as an applied art. His opening essay, however, provides a remarkably comprehensive survey of modern display in the United States up until the 1970s. By interweaving its commercial functions with concurrent stylistic developments in art, Marcus argues that the store window continues to serve as a bridge from the "seriousness of the museums to the paper and string of everyday life."

Reflecting the tentative nature of the economic recovery of downtown shopping, Martin Pegler declares the return of the field in his *Visual Merchandising and Display* in 1983, noting that even if the days of unlimited budgets are long gone, "display did not die!"[39] Covering familiar terrain from the exterior of the store to the interior layout and furnishings, as well as instruction in composition and color,, the author reasserts the essential role of an effectively designed retail environment. The numerous editions of Pegler's textbook, up to the latest one in 2011, attest to to the continuing relevancy of the field for the display student and sales professional, despite significant challenges from other forms of advertising. But the inspired belief in the power of display to go beyond just "maintaining the store's image" and communicating brand awareness of its goods seems to have waned, as it is no longer imbued with the potential to achieve the status of avant garde art. In an eerily prescient moment, in 1983 Pegler predicts a future where "all of retailing will be display," describing merchandise enshrined in "square glass bowls," with no visible stock, and computers replacing salespeople in the ordering and delivery of goods directly to the customer. His vision of a technologically automated and aesthetically minimalist retailing environment includes robots serving lunch and delivering packages to waiting customers watching "sensoramic" fashion shows. But in the 2011 edition of Pegler's book, this technological utopia of selling has been replaced by the latest buzzword, "greening," or sustainable uses of recycled and repurposed materials, reflecting current concerns with environmental and economical approaches.[40]

In the last 20 years the electronic marketplace has become the ultimate go-between, "the universal middleman," refocusing attention on the buyer and seller as the primary human agents in the retailing exchange.[41] The journal *Visual Merchandising and Store Design* that absorbed *Display World* in 1983 now provides industry and product news through its website but still publishes monthly issues in print. Daily galleries of store displays are classified according to product type (apparel, home goods, specialty items, and so on), by type of sale with seasonal and/or specialty themes, and/or by location from store windows to dressing rooms. *VMSD*'s product section now includes digital media, but continues to provide extensive coverage of the

physical props of the store environment from architectural façades to fixtures, lighting, and signage. The persistent belief in the design field that retail architecture constitutes a lesser endeavor has been increasingly challenged by the involvement of celebrity architects in high-profile retail projects.[42] Recent authors in visual merchandising continue to articulate basic design principles while providing a catalogue of examples in publications that seek to be both educational and entertaining manuals.[43] In his 2003 book, *Retail Desire: Design, Display and Visual Merchandising*, Johnny Tucker reiterates the idea that visual merchandising requires a holistic approach in order to create an environment, "whether it is a whole store interior, a store promotion scheme, or a window display, [that] evoke(s) as strong an empathetic response from the customer as possible."[44] The interior displays presented in glossy color photographs emphasize the integration of the product, its display system, and the larger space it occupies, in order to produce a kind of sensory assault on the shopper at multiple "scales of impact."[45]

The Image of Selling

Inspired by these past and present efforts by authors and practitioners, this edited volume, *Visual Merchandising: The Image of Selling*, seeks to recover the spaces of display as a historical phenomenon and artistic practice. The collective effort is to broaden the study of visual culture by including display imagery and to enrich the understanding of consumer culture by more closely studying its visual artifacts. Borrowing the categories succinctly articulated by Robert Colbourne in his *Visual Merchandising: The Business of Merchandise Presentations* of 1996, the images of selling are studied as a holistic environment that unfolds across the realms of promotion, product, and place.[46] The idea for this collection began at sessions at the annual conferences of the College Art Association and the Society of Architectural Historians. From its inception the project has thus been interdisciplinary in its effort to study the presentation of retail goods in terms of the transformation that happens across the page, the street, and the shop counter. These chapters address subjects that range from print advertising to product design to store and showroom interiors in the United States and Europe beginning in the late nineteenth century. While dealing with a wide range of topics, these authors draw on similar themes in their consideration of the modern practices of selling. Rather than focusing on traditional art historical categories of style and biography, the collective effort is to understand how the presentation of retail goods produces its own distinctive visual language that can be both "credible" and "astonishing," existing in the realm where art and commerce intersect.[47]

Promotion

While often treated as a separate field, print advertising was considered as an integral part of visual merchandising as their industries developed in tandem in the early nineteenth century.[48] The earliest advertisements in eighteenth-century newspapers consisted of inventories of goods recently arrived at ports for sale. But merchants quickly came to recognize the power of the print ad to efficiently reach a wider audience as it developed into a more elaborate combination of image and text. Selling in print was even noted to conform to higher standards of honesty—over the "less than scrupulous practices of the drummers,"[49] or of travelling salesmen. Print ads were found not only in newspapers and magazines but stood alone as broadsides and handbills, trade cards and postcards, and posters and storefront signage. The chapters comprising Part 1 consider strategies in print advertising where the two-dimensional surface of the page is considered in relation to the larger geographical context in which it emerged. In "Corridors of Consumption: Mid-Nineteenth Century Commercial Space and the Reinvention of Downtown," Jeffrey A. Cohen examines the serial character of the American streetscape as a succession of small-scale retail buildings captured in the little discussed genre of the long street view. In the early twentieth century the German object poster promoted name-brand identity of new consumer products in the streets of the city and provided a new way of seeing as analyzed by Kathleen Chapman in "Hieroglyphs of Commerce: The Visual Rhetoric of the German *Sachplakat*." Strategies in selling a new technological product are discussed by Emily Bills in "Selling Perceptions of Space: AT&T Print Ads, 1908–1930," where the telephone was depicted as the means to connect users across the territorial space of the nation through invisible networks of communication.

Product

While advertising sought to initiate a "desire for things" through their representation,[50] the products themselves also had to physically participate in the act of selling to complete the transaction. The chapters in Part 2 explore the ways in which the commodity and its props shaped the retailing environment as a place of capitalist order and of social interaction. In "Pontiac Hood Ornaments: Marketing the Chief," Mona Hadler argues that these decorative car elements fused the Native American body and the jet plane, reflecting technological and social stereotypes in postwar America. The way that the commodity and its display system could stand in as a kind of surrogate body for the American consumer, in this case for the idealized fashion figure, is discussed by Gail Strege in "The Store Mannequin: An Evolving Ideal of Beauty." The complex, layered meanings of the material objects offered for

sale is further explored by Sarah Cheang in "Selling China: Class, Gender and Orientalism at the Department Store." Cheang examines the representation of these exotic goods in London department store catalogues to show how they simultaneously offered women access to ideas of empire and of femininity. The particular strategies involved in the representation and presentation of goods in the shop window in the United States are discussed by Louisa Iarocci in "'The Art of Draping': Window Dressing." In its unique position between the street and the interior, the store window framed the transformation of the sales product from tangible article of use to immaterial object of desire.

Place

The commodity itself must therefore be understood as the focal point of a holistic retail space that was both physically and perceptually constructed. While studies of retailing often focus on the department store, the final chapters in Part 3 seek to consider the practice of selling as it took place in more overlooked sites in the built environment. In "Selling Automobility: Architecture as Sales Strategy in US Car Dealerships before 1920," Robert Buerglener examines the automobile showroom around the particular nature of the car itself—as both luxury object and functional machine. The way that retailing has infiltrated even what seems to be the most common and yet sacred of modern sites is further evident in "Mansions as Marketing: The Residential Funeral Home and American Consumer Culture, 1915–1965," by Dean Lampros. The places of selling are here seen as both domestic and monumental, forming a kind of temporary refuge and public stage for the rituals of death. The inherent tensions between service and shelter, and utility and myth in roadside architecture are explored by Ethel Goodstein-Murphree in her chapter, "The Common Place of the Common Carrier: The American Truck Stop." The fluid and flexible character of retail space becomes evident as it shifts between system conduit and display prism depending on the character of the goods and the stage of the transaction. In his examination of luxury Armani boutiques, John Potvin examines the relationship between the design and perception of the designer garment, the minimalist interior, and the city. His chapter, "A Tale of Two Cities: Image, Space and the Balancing Act of Luxury Merchandising," reiterates how the character of the environment and the brand of the product are woven together to create a space that is both exclusive and timeless, and accessible and transient, embodying the cyclical nature of high fashion.

 Writing about the psychology of shopping, Harvey Ferguson has observed that: "the mechanism of wanting or desiring depended on the maintenance of a psychological distance between 'ego' and 'object', and the creation of an inner tension which was felt as a want."[51] Returning to the cover photograph of the

Living Sign, we can perhaps see it now as capturing the multiple dimensions of visual merchandising that construct these spaces of desire between the object and the self.[52] The photograph itself constitutes the first layer of separation, framing a portrait of the retail scene that records a recognizable urban place but restricts access to its spatial and social boundaries. In resistance to the racial prejudices that seek to consign him to the role of fixture, the dignified African American salesman elevates and animates the scene, engaging the viewer with his direct gaze while blocking their physical entry. The products, from the sweets in the store window to the dental appliances in the showcase, are exposed to view and yet remain inaccessible, protected in their transparent enclosures. From the sidewalk to the storefront, the images of selling unfold as a series of transactions between viewer and object, conducted through the surfaces of living and fixed signs and glazed and shadowy openings.[53] Across text, image, and space, these shifting exchanges tell a story of selling in which goods for sale are transformed into objects of desire and bodies become both consumer and consumed.

Notes

1 Shona Kerfoot, Barry Davies and Philippa Ward, "Visual Merchandising and the Creation of Discernible Retail Brands," *International Journal of Retail & Distribution Management* 31, 3 (2003): p. 143.

2 Walter Benjamin, *The Arcades Project*, trans. Howard Eiland and Kevin McLauchlin, Cambridge, Mass. and London: Belknap Press of Harvard University, 1999.

3 Jean Baudrillard, *The Consumer Society: Myths and Structures*, trans. Chris Turner, London: Sage, 1998, p. 192.

4 "Art of Selling," *The Philadelphia Album and Ladies' Literary Portfolio* 5, 31 (July 30, 1851): p. 247.

5 Leonard S. Marcus, *The American Store Window*, New York and London: Architectural Press Ltd, 1978, pp. 14–15.

6 Charles H. Patti and Edwina M. Luck, "Marketplace Forces and the History of Retailing: The Cycle of Control," in *The European Institute of Retailing and Services Studies (EIRASS) Conference on Recent Advances in Retailing and Services Science Conference*, July 2004, Prague. (Unpublished), pp. 2–4. Web.

7 Claire Walsh, "Shop Design and the Display of Goods in Eighteenth-Century London," *Journal of Design History* 8, 3, (1995): p. 171.

8 Samuel H. Terry, *How to Keep a Store. Embodying the Conclusions of more than Thirty Years' Experience in Merchandizing*, New York: Fowler &Wells, 1882, pp. 112–14. See *Advertisement in Manufacturer and Builder* 14, 12 (1882): pp. 112–14, 286.

9 *Harman's Journal of Window Dressing and Decorating* was published in Chicago from 1893 to 1899. See Leigh Eric Schmidt, "The Commercialization of the Calendar: American Holidays and the Culture of Consumption, 1870–1930," *Journal of American History* 78, 3 (December 1991): pp. 894–5.

10 "Window Trimmers in Session," *New York Times*, 2 August 1899, p. 1.

11 J.H. Wilson Marriott, *Nearly Three Hundred Ways to Dress Show Windows: Also Suggestions for Store Decoration*, Baltimore: Show Window Publishing, 1889 and Frank L. Carr, *The Wide-Awake Window Dresser*, New York, Dry Goods Economist, 1894.

12 See for example, *Store Windows Design as Suggestions by the Sherwin Williams Co.*, Cleveland: [The Company], 1907 and George J. Cohen, *Window Backgrounds: A Collection of Drawings and Descriptions of Store Window Backgrounds*, Chicago: Dry Goods Reporter, 1912.

13 The National Cash Register Company's *Better Retailing: A Handbook for Merchants*, Dayton Ohio: Merchants Service Bureau was published 12 times between 1919 to 1949.

14 Harry Mason, *Window Displays for Druggists*, Detroit: E.G. Smith, [1915], Calvin Franklin Brown, *The Grocer's Window Book*, Chicago: The Modern Grocer Publishing Company, 1923. John T. Hotchkiss, *Bookstore Advertising Publicity and Window Display*, New York; National Association of Book Publishers, 1926.

15 Paul Nystrom, Education and Training for Marketing, *Annals of the American Academy of Political and Social Science*, 209, (May 1940): pp. 160–1.

16 Gayle Strege, "Influences of Two Midwestern American Department Stores on Retailing," *Business and Economic History Online* Vol. 7 (2009): pp. 4–6.

17 Norman Bel Geddes, "The Store Window a Stage: Merchandise the Actors," WWD (November 19, 1927): p. 1. Normal Bel Geddes *Horizons*, Boston: Little, Brown, 1932, pp. 259–71.

18 *Better Windows and Hardware Advertising*, Philadelphia: Philadelphia Made Hardware, 1928, p. 30. Carl Percy, *Window Display Advertising*, New York: John Day Co, 1928. See Joseph Siry, *Carson Pirie Scott: Louis Sullivan and the Chicago Department Store*, Chicago: University of Chicago Press, 1988, pp. 130–134 on the link between print advertising and window display. See also Leonard Marcus, p. 18.

19 Reyburn Manufacturing Company, *Colorful Window Trims*, Philadelphia: The Company, c.1930, p. 3.

20 Books on window display were produced in the 1930s but largely emphasized economy and efficiency over art. See William Harrall Leahy, *Window Display for Profit*, New York and London, Harper and Bros, 1931.

21 Gary Cross, *An All-Consuming Century*, New York: Columbia University Press, 2000, pp. 77–82.

22 G. Henry Richert, *Retailing: Principles and Practices of Retail Buying, Advertising, Selling, and Management*, New York: Gregg Publishing Company, 1938, p.175.

23 Paul T. Frankl, *New Dimensions: The Decorative Arts of Today in Words and Pictures*, New York: Brewer & Warren, 1928, pp. 62–3.

24 Frederick Kiesler, *Contemporary Art Applied to the Store and its Display*, New York: Brentanos, 1930, np.

25 Howard M. Cowee et al., *The Pilot Study of Display*, New York: National Association of Display Industries, Prentice Hall, 1949, pp.25–36.

26 Robert L. McCorkle, "Store-Wide Promotions- Coordinating Window and Interior Displays," in Visual Merchandising Group, *Display Manual*, New York: National Retail Dry Goods Association, 1955, p. 87.

27 Richard Longstreth, *The American Department Store Transformed 1920–1960*, New Haven: Yale University Press, 2009.

28 Louis Parnes, *Planning Stores That Pay*, New York: F.W. Dodge, 1948, pp. 293–4.

29 Gene Burke and Edgar Kober, *Modern Store Design*, Los Angeles: Institute of Product Research, 1945, pp. 64.

30 Burke and Kober, p. 64.

31 George Nelson, "Foreword," in Emrich Nicholson, *Contemporary Shops in the United States*, New York: Architectural Book Publishing, 1948, pp. 6–8.

32 See Leontine de Wit and David Vernet, eds *Boutiques and Other Retail Spaces: The Architecture of Seduction*, London: Routledge, 2007.

33 Karl Kaspar, *Shops and Showrooms: An International Survey*, New York and Washington: Frederick A. Praeger, 1967, pp. 6, 8.

34 Robert Leydenfrost, *The Art of Window Display*, New York: Architectural Book Publishing, 1952, p. 9.

35 Robert Kretschmer, *Window and Interior Display: The Principles of Visual Merchandising*, Scranton: Laurel Publishers, 1952.

36 Jim Buckley, *The Drama of Display: Visual Merchandising and its Techniques*, New York: Pellegrini & Cudahy, 1953, pp. 19—23, 210. See also Walter Herdeg, *International Window Display*, New York: Pellegrini and Cudahy, 1951.

37 Michael Emory, *Windows*, Chicago: Contemporary Books, 1977, np.

38 Marcus, pp. 52–4.

39 Martin Pegler, *Visual Merchandising and Display*, New York, Fairchilds Publications, 1983, pp. vi, 229.

40 Martin Pegler, *Visual Merchandising and Display*, New York, Fairchilds Publications, 2011, pp. 5–7.

41 Bill Gates, *The Road Ahead*, New York: Viking, 1995 quoted after *Trade: Commodities, Communication and Consciousness*, eds Thomas Seelig, Urs Stahel and Martin Jaeggi, Zurich: Scalo, 2001, p. 187.

42 High-profile international firms headed by Rem Koolhaas, Zaha Hadid, Renzo Piano and Herzog and de Meuron have designed high-end retail projects for Prada, Hermes and Chanel in the last 15 years.

43 Recent examples of textbook types are Lynn Mescher, *Basics Interior Design: Retail Design*, Lausanne, Switzerland: Ava, 2010. Recent picture book publications are often from European publishers such as Philip Jodidio, *Shopping Architecture Now!* Cologne: Taschen, 2010. From the United States are Sara Manuelli, *Design for Shopping: New Retail Interiors*, New York: Abbeville Press, 2006 and *Stores and Retail Spaces* 11, ST Media Group International, 2010, the latter part of a series consisting of winning entries compiled from *VMSD*.

44 Johnny Tucker, *Retail Desire: Design, Display and Visual Merchandising*, East Sussex, UK: Rotovision, 2003, p. 8.

45 Christoph Gruenberg and Max Hollein eds, *Shopping, A Century of Art and Consumer Culture*, Ostfildern-Ruit: Hatje Canz, 2003. Jane Pavitt, ed., *Brand New*, London: V&A Publications, 2000.

46 Robert Colbourne, *Visual Merchandising: The Business of Merchandise Presentation*, New York: Delmar Publishers, 1996.

47 "A.T. Stewart's Grand Expositions," *The Independent*, 23, 1159 (Feb 16, 1871): p. 5

48 "Dry Goods," *The Independent*, 22, 1103 (January 20, 1870): p. 8.

49 "Mercantile Miscellanies," *The Merchants' Magazine and Commercial Review*; xxxiv, 1 (Jan. 1, 1856): p. 131.

50 "The Development of the Retail Store," *Bankers Magazine*, 90, 4 (April 1915): p. 443.

51 Harvey Ferguson, "Watching the World Go Round: Atrium Culture and the Psychology of Shopping," *Lifestyle Shopping: The Subject of Consumption*, ed. Rob Shields, London and New York: Routledge, 1992, p. 29.

52 Laura Oswald, "The Space and Place of Consumption in a Material World," *Design Issues* 12, 1 (Spring 1996), p. 3.

53 Joseph Weishar, *The Aesthetics of Merchandise Presentation*, Cincinnati: ST Books, 2005, p. 163.

PART I

Promotion

Corridors of Consumption: Mid-Nineteenth Century Commercial Space and the Reinvention of Downtown

Jeffrey A. Cohen

Long pictured by images of factories and smokestacks, the new landscapes of industrialized production of the late eighteenth and early nineteenth centuries quickly found counterparts in dramatically transformed urban landscapes of consumption.[1] The nineteenth-century city, unlike any previous urban form, was brimming with goods manufactured in quantity or processed in part though the new productive technologies, and often brought, via canal or by steam propulsion over seas and rails, from well beyond the local settings where they were offered. This new urban environment was bursting with workers drawn to a new urban economy, and its population often doubled and doubled again over the succeeding decades. A landscape of consumption had not only to accommodate such activities, but also to announce them, to identify its offerings and its invitation to customers by a range of means, from signboards to architectural individualization, proffered on the street as well as through surrogates on paper (Figure 1.1).

In piecemeal ways reflecting small-scale agency, businesses adapted directly to their place in this changing city and its shifted spectrum of functions, creating a dense yet heterogeneous streetscape. New patterns and typologies of building became dominant in a markedly expanded realm of commerce that in larger cities constituted thousands of narrow-fronted stores shouldering each other for a foothold of frontage on solidly built-up streets.

As different business functions sorted themselves amid that dynamic realm, high-end or high-volume retail and recreational venues would vie for the most visible locations. They often claimed areas that had had an earlier visibility as sites of elite residence, creating new arrays of fashionable shops, theaters, and hotels in continuously bounded linear corridors along thoroughfares leading across or outward from the old urban core. Retailers recognized the need for their stores to invite entry, to be visibly distinct from private homes or

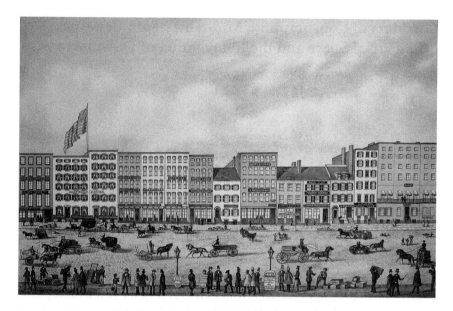

1.1 Detail of Wm. Boell, "View of Park Place, New York, from Broadway to Church Street, North Side," published by W. Stephenson & Co., 1855[2]

workplaces. Their identification also needed to be more specific, assertively declaring a line of business, and even distinguishing individual stores in the same line from one another. This part of the city quickly became a dense and visually competitive matrix. Space here was valuable and voids were short-lived, both in terms of ground and on façades, which were crowded with insistent signboards, painted promotional messages, and display windows beckoning the eyes and then the feet of passersby.

Architecturally, this was a changeful place, with structures at first adapted and then rebuilt for business. Once strikingly new, this commercial landscape of the mid-nineteenth century city soon proved remarkably ephemeral, with buildings often replaced within a generation or two, despite their solid construction. At the heart of this emerging central business district, many structures were consumed by the sharply accelerating land values and the growing ability to build tall using iron, and then taller using steel in the last decades of the century.

This chapter will explore the physical form of that earlier, now largely lost city of commerce, a district of many small pieces as compared with its successor, a place of larger ones that is much better known from survivals and turn-of-the-century photographs focused upon preening office towers and block-long department stores. The character of that earlier city persists, though, in occasional remaining clusters of survival and scatterings of

relatively obscure visual documents, ranging from early photographs and advertising materials to detailed ward atlases and fire insurance surveys. These and other contextualizing images document not just the most elaborated, architect-designed commercial buildings, but also the more typical ones that formed the far greater part of this new urban landscape. Especially valuable are records pertaining to a key component type, the individual business building of the mid-century, tall, narrow, and deep, that served retailers, wholesalers, importers, and small-scale manufacturers. In these elements of the mid-nineteenth-century streetscape—as built, as projected in signage, and as represented in advertising—one discerns the enacted motives of businesses serving their interests in shaping their individual presence; in their aggregation those decisions formed patterns that collectively defined some of the most visible and characteristic aspects of this early version of the modern city.

Newly Big Cities

Perhaps the most concise and concretely measurable indication of the scope of this change lies in population statistics for cities tied to the industrializing economy. Manchester, England, one of the first cities to experience this transformation, offers a pattern that would be revisited again and again in other cities. The city's population ascended at an astounding pace:

Table 1.1 Population Growth—Manchester

Manchester	1750	1801	1831	1851	1861	1881
(given roughly for the city itself, in thousands)	18k	90k	182k	303k	338k	342k

This leap occurred early in Manchester, leveling off close to mid-century, when many other cities were just starting to show similarly explosive rates of growth. Approximate numbers for other cities track comparable changes in population:

Table 1.2 Population Growth—Various Cities

London	1750	1801	1861	1881		
	675k	959k	2,804k	3815k		
Birmingham	1750	1801	1831	1851	1871	1891
	24k	74k	147k	223k	344k	478k
Berlin	1775	1800	1825	1840	1875	1900
	136k	173k	220k	329k	969k	1,889k
Hamburg/Altona	1800	1850	1890			
	120k	205k	712k			
Vienna	1800	1857	1890			
	232k	476k	1,342k			
Paris	1750	1801	1851	1890		
	565k	548k	1,053k	2,537k		
Lyon	1800	1850	1890			
	110k	177k	429k[3]			

The key issue here is not the comparison between cities so much as the precipitous growth within each. Of course, legal city boundaries and successive annexations varied in their inclusion of associated industrial landscapes, especially when mills were water-powered or dependent on peripheral canal and then rail networks. And the population growth of many cities in the nineteenth century was less directly connected to their own manufacturing prowess than to their expanding role as major transportation, administrative, or financial centers. But the pattern was unmistakable. The new economies of mechanized production in Western Europe and North America meant cities were drawing workers from farms to factories and to stores and offices at an unprecedented rate. The local circumstances of urban immigration due to push or pull from agricultural, political, or other factors could critically condition this movement of people, but the basic fact remains that city employment was able to absorb newcomers, and at some fundamental level, population growth was a measure of the much enlarged capacity of these urban economies.

Many of the new city residents, especially in European cities, may have come to industrializing workplaces from rural agricultural settings, and from tenancy or displacement, and some may have been entering the money economy in a more substantial way than before, purchasing food, clothing, shelter, and anything else they could not produce for themselves—becoming consumers in a city of strangers brought into contact by such transactions. But others belonged to expanding middling and newly wealthy classes who prospered substantially in connection with this new environment, and who propelled an economy of elite consumption that would itself reshape parts of the city's center.

US cities experienced the same explosion in population, attracting domestic immigrants from the countryside along with foreign immigrants. This too was a precipitous shift, most revealingly expressed in the percentage of urban residents in the population at large.

Table 1.3 Population Growth—New York and Philadelphia

New York City	1800	1820	1840	1860	1880	1900
	61k	124k	313k	814k	1,217k	3,437k
Philadelphia	1800	1820	1840	1860	1880	1900
(county, then city)	81k	137k	258k	566k	847k	1,293k

Urban areas accounted for well under 4 percent of the US population in 1790—attesting to the primarily agricultural work of most Americans. Living in the city, very visible in our imaginations and in representations of the past, had been statistically exceptional. But by 1850, the city was home to more than 15 percent of the US population, and by the end of the century, by 1890, to nearly 40 percent. That proportion would continue to ascend steeply through the twentieth century, reaching into the high 70s.[4]

Differentiated Geographies

With such an influx of new city dwellers, the most obvious visible change in nineteenth-century cities was a massive expansion of their densely settled area, often seen as a hatched amoebic shape, hungrily advancing within (and often beyond) the larger legal boundary of the city. As one sees by comparing successive maps of those cities, the growing built-up area after the mid-nineteenth century could easily dwarf that from earlier on. The homogeneity

of that hatching, however, belies areas of increasingly pronounced differentiation within the built-up area. The outer edges sometimes marked the reach of densely built working-class housing on the cheapest, most accessible, hitherto-undeveloped land nearest the center. Just within or just beyond that, especially in Anglo-American cities, one might find an airier zone of detached villas and cottages in a suburbanizing fringe reached by rail, whether via horse-drawn streetcars or commuter railroads. Depending on when they were built, industrial districts might have located either nearer to or further from the old urban core than these workers' and suburbanizing zones, easily crossing concentric patterns of development by hugging lines of waterways or rails that could bring them raw materials, provide power or fuel, and permit their products to reach markets. The irregular perimeter of the more densely built urban area would usually distend outward into "pseudopodia" along the older radial roads leaving the city.

Less visible on large maps, but more relevant to the present study were the changes occurring within the urban core. Businesses, multiplying enormously in number, sought these central locations, outbidding nearly every other use of the land there that had not been claimed by immovable civic institutions. A new "downtown" devoted almost exclusively to commerce displaced sites of housing, especially of townhouses and mansions whose elite residents moved successively "uptown" into new residential corridors, into adjoining neighborhoods, or out to those new suburban peripheries. Adjacent to the old downtowns, sometimes in realms extending perpendicularly from the base of the downtown/uptown axis, were districts where many of the urban poor crowded into aging houses adapted as multiple residences, into newly built tenements that took their place, or along the narrow interior alleys and courts within large blocks.

The showplace of this reconfigured city, though, was the new downtown, recast by the desires of a dramatically expanding cohort who had disposable means and an avid hunger to consume. They bought goods, services, and even experiences through which they performed the prerogatives of their newly achieved economic standing, patronizing venues from jewelers' and haberdashers' shops to photography studios, theaters, and restaurants. Such venues for the rising bourgeoisie to equip, entertain, and display itself were often aligned along thoroughfares that were well-traveled and highly visible where they extended through and out from the older urban core. These central business streets were the subjects of many prints of the period, especially some long, nearly elevational view-series that captured their assertive presence, density, and well-trafficked setting.

Such elite retail corridors often shared the center of the modernizing, mid-nineteenth-century city with a network of intersecting streets that made up a more varied district of business just off the key avenues. There, wholesale and small-scale manufacturing mixed with retail, accommodating jobbers who

provided materials, intermediate products, and services to other merchants and manufacturers, and quartering activities that ranged from selling highly specialized but less "fancy" goods, to providing office space for the growing number of workers in finance, insurance, transportation, newspapers, and various other white-collar business activities. Images from 1849 of the initial blocks of Maiden Lane near Broadway (Figure 1.2), for example, identified importers of watches, perfume, and "fancy goods," jewelers, sellers of gas fixtures, hats, guns, cutlery, makers of watch cases, gold pens, and pocket books, alongside sellers of cloth, linen, clothing, hosiery, shirts, and generic dry goods, some identified as serving both "wholesale and retail" customers. As one moved further down the block, away from Broadway and toward the East River docks, the goods grew less elite—varnishes, drugs, oil cloths, boots, combs, trunks, paper hangings, and trimmings, window glass, printers, oils, paints—and words such as "wholesale" and "warehouse" appeared more frequently.

Further south, Wall Street, already a financial center when it was recorded in a similar set of street views from 1850, showed an interdependency in the clustering of insurers, brokers, commission merchants, printers and stationers, express companies and auctioneers near the banks that were the street's iconic presences. These constituted a special linear precinct within a much larger matrix of intersecting streets that mediated between the fashionable consumer

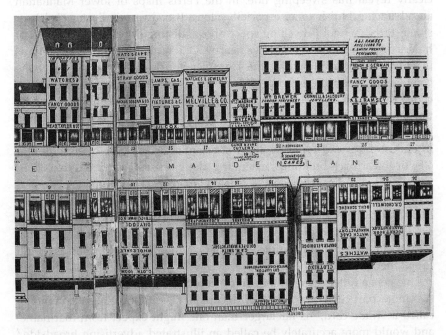

1.2 Detail of Edward Jones, *New York Pictorial Business Directory of Maiden Lane*, New York: E. Jones, 1849, plate 1

on Broadway and the port at river's edge, with much of this landscape devoted to business-to-business trade of varied types.

Such districts were often the destination of visiting businessmen, intent on acquiring goods or equipment that could be inspected, ordered, and shipped out to their distant stores or factories. A rare artifact serving their navigation within this active realm is a special type of commercial map, such as E. Whitefield's "Map of the Business Portion of Chicago," 1862; other examples record analogous portions of Boston (1869), and New Orleans (1883).[5] The constrained scope and selective identifications on such maps reflect their purposeful focus on a functional geography that was inscribed within a more heterogeneous one, with unmarked sites and peripheries that were less pertinent to businessmen than to others.

Early Commercial Building Types

This expanding claim of business upon downtown territory is perhaps best demonstrated by the color-coding of some of the earliest highly detailed maps of such areas, in large-scale atlases that are often generically referenced as "Sanborns"—real estate or fire insurance atlases of unprecedented scale and coverage that began to appear in some large cities in the 1850s. These clearly reveal this sweeping tide: in the Perris maps of lower Manhattan an advancing bluish tone, especially along Broadway, indicates "brick or stone stores" without dwelling space above, distinguished from the pink of homes or combined-use buildings nearby. One recognizes the same patterns in Philadelphia, as shown in the Hexamer and Locher atlas plates of the commercial sector there from 1858 to 1860, with business buildings color-coded in a green tone.[6] In both cases, these fully commercial buildings show the same distinctive footprint of nearly full-lot coverage, whereas neighboring houses (or former houses summarily adapted to commerce) were rendered in pinkish hues and typically show substantial back yards, often with rear ells, or linear back buildings, extending along one side. In these two cities, such detailed and comprehensive cadastral maps date back only to near mid-century, denying us comparable counterpart images from the prior decades. But later iterations show the same process playing out as the commercial core expanded, with open space to the rear and sides of lots, along with residential setbacks in front, being consumed by enlarged footprints as businesses rebuilt to suit their expanding needs.

One gets a fuller sense of the typical component of such districts through two more particularizing kinds of document. The first of these, commonly called a "trade card," is far larger than one might expect from that name, and would more accurately be called an illustrated advertising broadside.[7] These prints varied greatly in character and number from city to city, perhaps

partly reflecting the entrepreneurial bent of individual lithographers in each who pursued this line and, critically, of the merchants there who engaged them. Philadelphia seems to have a tradition of both, and experienced an extraordinary flurry of hundreds of these images produced during the decades before and after mid-century (or perhaps of preservation of these usually ephemeral images, as many known examples seem now to be unique survivals). They were typically large sheets with a detailed lithographed image of a business, sometimes of its factory, sometimes of its showroom, sometimes of its products, but quite often of the exterior of its downtown quarters. Scores of these survive to show isolated glimpses within the new central business districts of the mid-nineteenth century, usually as frontal views animated by signage, wares, and street-side life (see Figures 1.3a, 1.3b and 1.3c).[8]

The key building type found on these early trade cards was already rather fully developed by the 1830s, with its ground story opened up between vertical stone piers, typically marble or granite, and tall windows within heightened floors usually rising above the older residential double-pitched and dormered roofs, often to a full-height third, fourth, or even fifth story. Building fronts might be two to four windows across on their upper stories, but where an individual store in Philadelphia had a 17- to 22-foot front, as most did, the central ground-story opening would often be a window over a bulkhead, flanked by wide doorways to each side. Much of the upper floor space might be dedicated to storage, breaking up of bulk quantities, or

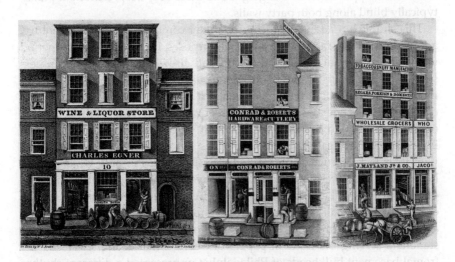

1.3a W.L. Breton, [Charles Egner store, 10 North Third Street,], c.1837
1.3b W.H. Rease, [Conrad & Roberts hardware & cutlery, 123 N. Third Street], 1846
1.3c [J. Mayland, Jr. & Co. tobacco & snuff manufactory. Segars, foreign & domestic. Wholesale grocers, N.W. corner of Third and Race Streets], 1846

processing of goods. The hoist for hauling such materials to upper levels was usually located in one of the end bays, sometimes betrayed by a loop of rope or a rising barrel in one doorway in these prints.

Such trade cards can almost always be combined with evidence from the early real-estate-atlas plates to connect the building face with its built context and footprint. But one can also get inside these buildings as they were configured when they were new through detailed plans and written descriptions made when the properties were surveyed by fire insurance companies. Tens of thousands of these surveys dating from the 1820s to the 1890s are held in Philadelphia archives, and scores of plans of this specific sort of building survive in these collections. In what appears to be their mature form as a commercial building type, these tall narrow façades usually fronted very deep, clear-span spaces meant to flexibly accommodate a range of activities. Often different firms on different floors were served by a closed staircase that ran longitudinally along one blind party wall—with successively more distant landings for each floor. The rope hoist and the hatchway opened through each floor, sometimes right in front of the start of the staircase. The large front space could go back as much as 80 or 100 feet, and sometimes even more on Philadelphia's unusually deep blocks. At the rear was a "counting room" that connected to a much smaller "fireproof" for critical records and valuables, both of these opening onto a shallow rear court or "area" that would bring some daylight to these office functions. Frequently there were skylights over the counting rooms and above the taller main volume, along with additional setbacks on upper floors to bring light into these very deep, dark floor plates, typically blind along both party walls.

This simple but adaptable form was rather common around mid-century, adopted for a wide range of commercial purposes. It is found in many period views of commercial districts in the US and elsewhere, and one encounters some surviving instances of it along early commercial streets. With modifications, this building type was also a staple of the early financial and office district, as one sees in the Wall Street views from 1850,[9] although there, elevated stoops and half-sunken basement offices reflected the diminished importance of eye-catching shop windows for this type of business, along with their lack of a need to deal with physical goods in bulk which would have favored direct connections at the level of the pavement. Firms that offered services to the financial sector were avid for a presence on such blocks, even for spaces a half-story below grade, and one would find these buildings accommodating express offices, exchange brokers, auctioneers, and especially stationers serving the trade in paperwork here. Other examples lacked the frontal basement bulkheads of Philadelphia or presented a different rhythm of front doors and windows. From about mid-century, cast iron might replace the large marble or granite blocks that opened the ground story—often pieces

produced as standard, commodified elements that could be shipped out for integration into commercial buildings in various cities and towns.

This rather generic building type may well represent an international commercial vernacular, at least in Anglo-American contexts. Its functional form was of course hardly unselfconscious; it was, in fact, extremely witting, and easily adaptable for what would often turn out to be a fairly frequent succession of varied businesses, some taking only a floor while others broke through party walls to neighboring spaces. Some accommodated manufacturing on site or simply storage of goods that were bought and sold, while others brought customers in to inspect items on display, for direct purchase or for items that could be ordered and shipped to distant locations.

These buildings were critical equipment in a landscape of shifting opportunities often only modestly capitalized, where tenancy seems to have been the more common situation for businesses. When period real estate atlases indicated ownership, the names on the map were rarely coincident with the ones on the signboards. In Boston's downtown in the late 1880s, for example, many of the landowners were identified as trusts of venerable old families and institutional corporations vested beneath the changing retailers, even owning the sites of many of the best-known stores.[10] Such key venues in various cities seem to have been held by long-standing interests that recognized their present and future value. As long as rents were stable, this arrangement may have suited many merchants, who could then dedicate nearly all their working capital for goods to resell, for raw materials, personnel, or promotion rather than tying it up longer term in real estate.

This could have a decided effect on built form. Where many merchants did not own the premises and might move within a decade, their investment in an individualized architecture was understandably rare. Instead, their place within a dense commercial matrix of similarly generic buildings depended critically on applied signage, and on placing their address repeatedly before their potential customers by other means. Their numerical address was an insistent feature of signs and of early advertising. In period photographs, an almost implausibly feverish multiplication of signboards crowded the long horizontal registers between windows, sometimes rising in great shaped crestings crowning a façade to prominently display a number, name, or even an icon like a hat or umbrella that cued passersby to the offerings within.

One might expect this rather prosaic building form in the secondary commercial network of streets where wholesale, specialized retail, and small-scale manufacturing thrived, but it was also a key component of the early form of the elite retail corridor, although it survives less often there, for those more visible streetscapes were much more susceptible to decades of incremental but unceasing and ultimately sweeping change. The more fashionable retail

streets were also, however, frequent subjects of period images of many sorts that help document the form of this commercial corridor in its earlier form.

Long Views

Isolated period glimpses and oblique vistas are offered in old photographs, in early forms of illustrated advertising, and in occasional survivals that, alongside detailed period maps, allow us to assemble and reconstruct a sense of that once new city. The most effective period portrait, however, lies in a particular, if rather scarce species of print that offered long views of successive block faces in near elevation. (see Figures 1.1, 1.2, and 1.4) These extended street views, usually produced as lithographs or wood engravings, serve as rich records of the changeful business corridors, capturing their period appearance and continuities like no other. In strips that were sometimes just a few inches high but that could amount to several feet in length, they tracked multiple blocks along major routes, offering virtual eye-level surrogates for movement along such streets.

These street view series were created for a range of reasons, and in a range of forms. Some of the earlier continental European examples from the 1820s to 1840s—showing the Grand Boulevards of Paris, Unter den Linden in Berlin, and the Nevsky Prospekt in St. Petersburg—appear to have been undertaken by entrepreneurial artists for sale as touristic keepsakes of vaunted destinations. The shops, theaters, or cafés in these broadly indicated forms of consumption promised more than just visual experiences—they added a sense of transactional permeability and social verisimilitude to the images, reflecting on the desirability of these sites.

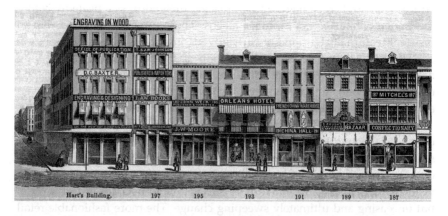

1.4 Detail of 500 block of Chestnut Street, north side, in 1857, from Baxter & Neff, prospectus for "Baxter's Panorama and Business Directory of Philadelphia," 1857

Most of the Anglo-American examples, though, were made primarily and quite specifically to promote the businesses depicted and identified, as a matter of paid advertising. Sometimes called "pictorial" or "panoramic" business directories, these were vehicles for disseminating an awareness of commercial buildings, prominently displaying addresses, identifying offerings, and capturing distinctions embodied in their architecture and their signage. They also set these buildings into context, situating them relative to landmarks, intersections, and immediate neighbors.

These long street-view sets effectively served as did the façades crested with the big number or the occasional individualized stone façade—with stores primping for identifiability within the ensemble, if in microcosm, on paper. In the best documented cases, an enterprising artist would draw a promising block and then canvass the businesses depicted there for paying subscribers, who would have their buildings identified in the published street view and sometimes also in a grid of business-card replicas or a letterset directory. The façades of non-subscribers would lack these identifying elements.

This specific scheme seems to have been first exploited on a large scale in London in the street views issued by John Tallis from 1838 to 1847, and the form soon found its way to Bristol, Bath, Manchester, and Dublin. Tallis intended to bring this to New York City, sending his nephew Alfred, only to learn that the short-lived firm of Jones, Newman, and Ewbank had already published their *Illuminated Pictorial Directory* of Broadway in 1848 on much the same scheme.[11] Other New York streets, such as William Street, Fulton Street, Maiden Lane, and Wall Street, followed in 1849 and 1850, with Chestnut Street in Philadelphia in 1851, and two key Boston streets in 1853. The Bostonian set adopted a different operative model, identifying stores more comprehensively in double-page spreads as an added attraction for subscribers to *Gleason's Pictorial Drawing-Room Companion*—a publication venue *par excellence* for the bourgeois consumers of precisely this high-end retail territory in several American downtowns; illustrated articles in *Gleason's* would cover subjects such as the opening of a new silverware and jewelry store, a carpet warehouse, or a lace and bonnet shop.[12]

The long street view series on paper vividly captured a seriality of experience, of these places revealing themselves frontally in turn to the pedestrian moving past one store to the next. In a way that was similar but more persistent in form than their assembly in memory, they stored that frontal appearance of successive buildings within an armature of intersections and landmarks. Over time, these long views also recorded the successive typologies that defined these corridors of commerce. The preeminence of certain elite corridors over nearby business streets was often borrowed from fashionable residential venues that preceded their functional reassignment, and vestiges of that prior history were often visibly inscribed in the appearance of repurposed buildings seen in these long views from near mid-century.

Even as ground-story portions of façades were almost universally removed and replaced by maximized glazing and multiplied doorways, many stores preserved their old dormered, double-pitched roof, residentially scaled upper windows, and limited extent in height—rarely more than three-and-a-half stories—although fewer long retained the sizable rear yard that had characterized most residential properties. But these changes also required removing the front steps that had led to an elaborated doorway in most middle- and upper-class townhouses, and dropping the whole first floor to street level. Some older residences had also been set back a few feet or more from the sidewalk; conversion to stores could leave their façades recessed relative to newly built or extended commercial buildings next door that almost always toed the building line, pushing right up to the pedestrian traffic.

This pattern of commercial adaptation is especially notable in an early set of continuous views of eight blocks of Chestnut Street in Philadelphia from 1851. Toward the older city center, near Third Street, were some purpose-built high-end shops from decades earlier, marked by large yet geometrically simplified arched window arrangements beyond the first floor that reflected multiple story commercial spaces. Further west from there, one mainly observes the vestiges of older elite residences—some of them wide individual mansions and some narrower townhouses built in repetitive rows—that were altered for business uses in a tide that successively swept outward from the old commercial core nearer the Delaware River waterfront.

Within a decade, though, there was evidence of two other tides: first, replacement of some adapted residences by those taller, purpose-built commercial buildings, prosaic façades of repeated oblong windows fronting deep, open floor spaces; and second, greater investment in distinctive façade designs and materials, meant by some owners to call their buildings out amid these long, repetitive blocks. The first to do the latter were larger structures—theaters, grand hotels, and banks—often embellished with enriched carved stone or cast iron elements to more assertively invoke the cultural benediction of recognized languages of historical style.

Some early store buildings built in repetitive series were also sometimes collectively elaborated in this way. Built speculatively for leasing to individual merchants, they would proffer a degree of shared visual distinction. These could range from paired stores with repeated arched or pilastered forms or tinted stucco surfaces—in designs that would embrace their essential verticality and mark them in an otherwise planar and rectilinear brick streetscape—to much longer fronts that reiterated characterizing elements, such as repeated window heads treated as Gothic labels, long series of engaged piers or columns joining upper stories, or embracing cornices and identical doorway designs, establishing impressive horizontal unities.

In these large structures, component two- or three-bay wide stores could bear a group identification as part of the "Washington Stores," "Park Row

Stores," or "Grigg Block." Large period lithographs of such blocks sometimes celebrated their extent and form and identified their initial tenants, apparently touting that mutually beneficial connection for landlord and tenant alike, in what might be thought of as a collective trade card.[13] Ambitions on the part of landowners must have been expected to reward their investment in this degree of architectural distinction because of an anticipated appeal to individual merchants, for such arrangements would memorably situate the tenant within a larger, recognized piece of the city rather than leave them to the relative anonymity of address coordinates within the grid.

Such unifying treatment often relied on polite architectural language, employing stone and stylistic detail to identify the whole broadly with a character of bourgeois gentility as set off from more prosaic and expedient usages. Difference, however, was soon increasingly inscribed in individualized architectural form. Images of American streetscapes from about the mid-1850s on suggest that a sense of visual competition on the principal streets drove many high-end retailers to more frequently engage architects to design single buildings meant to stand out on these streets, just as each would in their paper surrogates. For these businesses, elaborated, singular façades could be more assertive essays in place-marking, in class-connoting elaboration, and in fashionable currency played out against the foil of their neighbors—with stone against brick, light tones against darker ones, rounded openings against rectilinear ones, wall relief against planarity, taller against shorter.

Businesses in buildings individualized in stone also implicitly made a promise of solidity and persistence, having invested beyond a signboard, letterhead, and a steady rent to mark themselves amid what otherwise might have seemed a treacherous landscape of shifting opportunities and opportunists. Proprietors of such businesses would have seen the advantage of owning their property outright (or on longer term leases) in order to control their location and distinguish their quarters as they rarely had earlier, as tenants. And images of that façade would appear wherever they could disseminate visual recognition on paper, from their correspondence and bill-heads to other still rare venues for such illustrated self-promotion, such as these trade cards and street view series (Figures 1.5a and 1.5b).

Even as the operative rules of full-lot coverage, blind party walls, and frontal self-identification still pertained, there was also an architectural transformation inside, something portrayed in later trade cards, in magazines like *Gleason's Pictorial*, in occasional photographs, and in fire insurance surveys. They show lavish interiors opened to large skylights and surrounded by balustraded balconies beckoning customers to upper levels.[14] Wall and ceiling surfaces were elaborated far beyond the old prosaic standard with what might best be described as baroque plasterwork and rich materials that matched the finest domestic parlors of their clientele, identifying with the same haute-bourgeois material aspirations and anxieties.

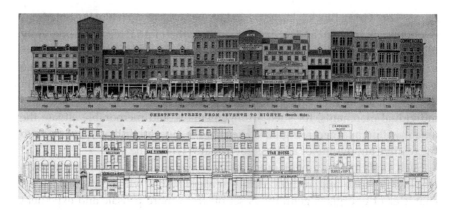

1.5a "700-block Chestnut Street, south side," 1851, from Julio H. Rae, *Rae's Philadelphia Pictorial Directory and Panoramic Advertiser*, Philadelphia, 1851
1.5b "Chestnut Street from Seventh to Eighth. (South Side)," 1861, from Dewitt C. Baxter, "Baxter's Panoramic Business Directory of Philadelphia," first series, 1857–61

Few touted their understanding of this visually competitive environment more strongly than Henry Shaw, the entrepreneur behind Dublin's *New City Pictorial Directory* of 1850, which included a set of 76 street views. Writing promotionally when he first issued his directory, Shaw explained that:

> the merchant or trader will now ... have the opportunity of ... bringing his establishment prominently before the public eye. The improvements in Shop Architecture recently effected can here be introduced with advantage, while the superiority of this [visual] mode of publicity to a mere literary [textual] advertisement needs no comment.[15]

Those improvements in shop architecture were not so dramatic in Shaw's views of Dublin's streets, but in the succeeding decades they would become far more noticeable, at least in images of commercial streets in Philadelphia and New York, Boston and New Orleans. In those cities, the 1850s seem to have brought a marked increase in a more insistently particularized and elaborated commercial architecture seen in many of the street view sets of that and the subsequent decades. Leading architects of those decades rose to the challenge to individualize, even in the limited scope of 20 or 30 feet of frontage (Figure 1.6).

But therein lies another chapter, one that climaxed in the 1870s and 1880s, and yet a third quickly followed, this operating at new scales that ushered in a far more sweeping transformation beginning in the late 1880s. Vertically, this new scale was made possible by new building technologies, but it was often propelled by a growing hunger for downtown office space, a demand frequently served though real estate investment by financial companies—

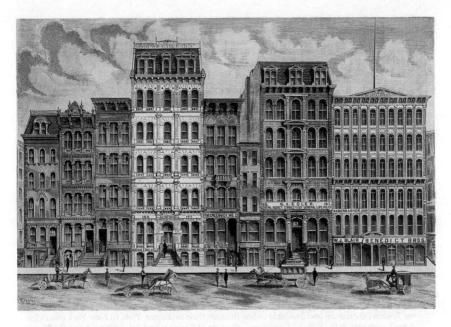

1.6 "Broadway, West Side, Liberty to Cortlandt," from John R. Asher & Co., *Asher's New Pictorial Directory and Atlas of the City of New York*, New York, 1879–80

whose own identifying architectural imagery usually overshadowed that of the shops below. Meanwhile, department stores claimed extended horizontal footprints within the central business district, claiming the sites of many smaller, older shops. Ever larger business buildings and then the automobile would continue to devour much of the remaining mid-nineteenth-century streetscape, but visual evidence such as that broached here offers a rare window onto an earlier downtown streetscape largely lost to subsequent development. And that once new downtown embodied a formative prologue that helped shape the commercial landscapes that would follow.

Notes

1 This paper began as part of a session titled "Architecture of the Roadside" convened at the April 2009 annual meeting of the Society of Architectural Historians, held in Pasadena. The author thanks Louisa Iarocci for organizing that session and for her editorial suggestions on the present version.

2 Note the surviving formerly residential stoops and doorways at no 13., at center, and no. 3, four buildings to the right, interspersed alongside newly built loft buildings.

3 Adna Ferrin Weber, The Growth of Cities in the Nineteenth Century, New York: Macmillian, 1899, reprint Ithaca: Cornell University Press, 1962, esp. p. 450; "List of towns and cities in England by historical population," Wikipedia, Web, revision *of 14 May 2011; and other statistical sources.*

4 Weber, pp. 20–40, 144–229; Kingsley Davis, "The Urbanization of the Human Population," *Scientific American* 213, no. 3 (September 1965), pp.40–53; Eric H. Monkkonen, *America Becomes Urban: The Development of US Cities and Towns, 1780–1980*, Berkeley: University of California Press, 1988, pp. 69–73; Russell F. Weigley, ed., *Philadelphia, A 300-Year History*, New York: Norton, 1982, pp. 134, 280–281, 309; James H. Kunstler, *The Geography of Nowhere*, New York: Simon & Schuster, 1993, esp. p. 94; Joel Garreau, *Edge City*, New York: Doubleday, 1991, esp. p. 30.

5 E. Whitefield's "Map of the Business Portion of Chicago," 1862, is at the Chicago Historical Society, and is posted on the Encyclopedia of Chicago website, Web. Other examples of what may have been a more widespread but rarely preserved graphic species include: B.B. Russell publisher, "Nanitz' Great Mercantile Map of Boston" (Boston, 1869), Norman B. Leventhal Map Center, Boston Public Library, Web. J. Popper, publisher, "Map of Central Business District and Mouth of Mississippi River" (New Orleans, 1883), Historic New Orleans Collection. Julio Popper Ferry, "Plano del perimetro central, directorio comerical de la Ciudad de Mexico" (Mexico City, 1883), David Rumsey Historical Map Collection. Popper and Popper Ferry seem to be one and the same character, better known for his slightly later adventures in Argentina in pursuit of gold.

6 William Perris, *Maps of the City of New York*, surveyed under directions of insurance companies of said city, vol. 1, New York: Perris & Browne, 1852, fully digitized as part of the NYPL Digital Gallery, Web. Ernest Hexamer and William Locher, *Maps of the City of Philadelphia*, 7 vols., Philadelphia: E. Hexamer & W. Locher, 1858–60, fully digitized as part of the Greater Philadelphia GeoHistory Network, Web.

7 Robert Jay, *The Trade Card in Nineteenth-Century America*, Columbia, MO: University of Missouri Press, 1987, pp. 20–21; Nicholas B. Wainwright, *Philadelphia in the Romantic Age of Lithography*, Philadelphia: Historical Society of Pennsylvania, 1958, pp. 2, 78.

8 Wainwright, *Philadelphia in the Romantic Age of Lithography*; Library Company of Philadelphia, "Philadelphia on Stone Digital Catalog," Web. Many examples of Boston's trade cards are held by the Boston Athenaeum and available online through their catalogue, Web. In New York one of the richest resources is the Bella C. Landauer Collection of Business and Advertising Art at the New-York Historical Society.

9 Francis Michelin, *New-York Pictorial Business Directory of Wall St.*, New York: C. Lowenstrom, 1850.

10 This can be seen by comparing names of stores on signboards in 1880s streetscape images with their footprints in ward atlases such as George W. Bromley, *Atlas of the City of Boston and Vicinity*, Volume 1, Philadelphia: G.W. and W.S. Bromley, 1889, which inscribed the names of many landowners.

11 See Peter Jackson, *John Tallis's London Street Views, 1838–1840*, London: Nattali & Maurice, 1969, which reproduces the plates and also provides valuable research on the publisher and the series in two introductory articles.

12 These three views of Washington and Tremont streets appeared in *Gleason's Pictorial Drawing-Room Companion* 4, no. 20 (14 May 1853), pp. 312–13; 4, no. 21 (21 May 1853), pp. 328–9; and 5, no. 5 (30 July 1853), pp. 72–3.

13 G. and W. Endicott, "Washington Stores," William Street, New York, c.1845–49, from Sigfried Giedion, *Space, Time and Architecture: The Growth of a New Tradition*, Cambridge: Harvard University Press, 1941, p. 171; Doty & Bergen, "Park Row Stores," New York, c.1854, in John A. Kouwenhoven, *The Columbia Historical Portrait of New York*, New York: Harper & Row, 1972, p. 276; William H. Rease, "Grigg Block, North Fourth Street, Philadelphia," 1848, (Library Company of Philadelphia), Philadelphia on Stone, no. 331 [W162], Web.

14 See for example, Max Rosenthal, "Interior View L. J. Levy & Co's Dry Goods Store, Chestnut St. Phila." [809–11 Chestnut Street], c.1857 (Historical Society of Pennsylvania [W186]) Philadelphia on Stone, no. 387, Web.

15 *Commercial Journal & Family Herald* (Dublin), 17 March 1850.

Hieroglyphs of Commerce: The Visual Rhetoric of the German *Sachplakat*

Kathleen Chapman

In 1904, the early twentieth-century advertising and printing professional Ernst Growald summarized his views of what constituted an effective poster, declaring, "Good posters should not be read—they should be seen."[1] Growald's insistence on this particular mode of apprehension—the seemingly simple, instantaneous act of seeing rather than the more complex and extended process of reading—promoted what was, for the time, a fairly radical understanding of successful poster design in Germany. The usual early twentieth-century German poster was an amalgamation of formal, often florid text and a fairly conventionally rendered image of something that may or may not have had anything directly to do with the product being promoted. Words and pictures were treated as separate elements, leaving the task of piecing together the connections between them to the viewer. Posters for exhibitions and other cultural events were often designed in this way, as in, for example, Alexander Frenz's 1899 poster for a festival celebrating the writer Johann Wolfgang von Goethe (Figure 2.1). In this design, text is clearly separated from image, while the picture evokes allegorically the event being advertised.[2]

In other instances, where text and image were unified effectively into a single design, as in typical *Jugendstil* posters, the ornamental qualities often seem to obscure the message that the poster was meant to communicate. In one of the most widely circulated designs featuring such *Jugendstil* stylization, a 1898 poster for Tropon powdered egg protein, designer and architect Henry van de Velde synthesized semi-abstract forms, patterning, and innovative lettering (Figure 2.2).[3]

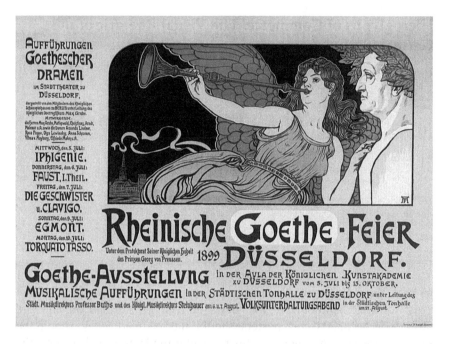

2.1 Poster for Rheinische Goethe Festival, Alexander Frenz, 1899

Here, the patterns and forms are rendered in so stylized a fashion that they require a period of focused looking to decode what they represent— separating eggs. The text, *"Tropon ist die concentrierste Nahrung"* ("Tropon is the most concentrated nutrition"), while presented using a clear script, nevertheless necessitates a bit of study. The final "t" of "ist" vanishes into the egg pattern, and the hyphenation of "concentrierste" forces the viewer to pause and reassemble the word in order to understand its meaning.

Distancing himself from such contemporary designs, Growald called for a technique of poster-making that acknowledged the fast pace and the overly saturated visual environment of the modern city. His ideal of good poster design was manifested in the type of poster that has constituted one of Germany's most important contributions to the history of poster-making: the *Sachplakat*, or object poster.[4] Unlike traditional design approaches that encouraged viewers to linger over an advertisement, the *Sachplakat* is constructed to enable instant comprehension; it unites words and pictures in a single, forceful image that communicates its sales message immediately. The object poster functions like a hieroglyph, a word-picture that can be apprehended instantly, a type of image that requires no lengthy exposition and no process of "reading" or decoding of discrete signs in a particular sequence in order for its meaning to become clear.[5] The object poster thus

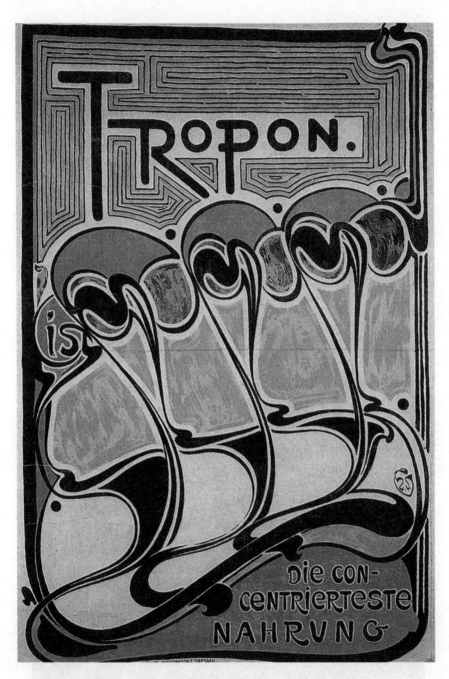

2.2 Poster for Tropon, Henry van de Velde, 1898

worked to train urban viewers to adopt a new, non-contemplative way of perceiving images, teaching them to make consumer choices instantly and predictably in response to those images.

Consisting of nothing more than a simplified, brightly colored depiction of a mass-produced product alongside the clearly legible name of the manufacturer, the early twentieth-century *Sachplakat* prioritizes seeing over reading.[6] For example, in Lucian Bernhard's poster for Priester matches (Figure 2.3), the conventional relationship between text and image is realigned so that pictorial elements no longer depend on words to justify their presence in each poster's design.

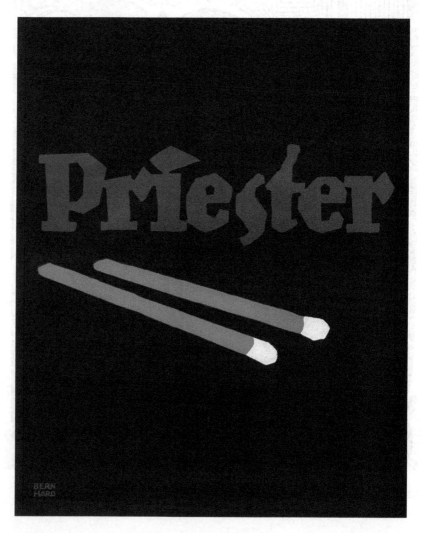

2.3 Poster for Priester Matches, Lucien Bernhard, 1905

Text and image are equal, collaborating to create a single, focused message that is insistently eye-catching in its bold simplicity and utterly unambiguous in its rhetorical appeal. The documentary rendering of a generic product alongside a manufacturer's name works to blend product and name seamlessly in viewers' minds, urging them to think "Priester," for example, when thinking of matches. In this reduction of informational elements to consumer product and producer name only, the *Sachplakat* functioned as a very modern hieroglyph—a pictographic expression of the industrial capitalist dynamics, specifically the circulation of commodities—that structured the urban public sphere: it delivered a clear and concentrated message that promoted brand recognition without excessive text and without the ornamental or allegorical flourishes that all too often made early twentieth-century posters visually intriguing but communicatively confusing.

These posters, along with the majority of advertisements printed around the *fin-de-siècle*, were conceived of and executed with the expectation that the viewer would be sufficiently intrigued by the overall visual impact of the designs to take the time to decipher them. Such a model of viewership presupposed a visual environment conditioned by the culture of the book, which was particularly strong in Germany—widely regarded as the "Land of Poets and Thinkers"—and the enduring centrality of the printed word.[7] For those who commissioned and executed such posters, if the design caught a viewer's attention, the poster had accomplished its goal. They assumed that, once engaged, the viewer would continue to read for the sales message. Such ads were designed by artists who thought of themselves as fine artists, not as specialists in designing advertisements.[8] However, as advertising developed into a professional specialty in rapidly industrializing Germany, a realm of expertise with its own distinct set of academic, economic, and aesthetic rules, such indirect approaches to delivering sales messages became the targets of withering criticism.

The critic Fritz Hellwag, for example, dismissed the efforts of early poster artists and the businessmen who employed them as hopelessly misdirected:

> Most of the earlier posters simply attempted in various ways to excite attention and only later trotted out their true, that is, economic message. After the viewer had enjoyed a joke, a clever drawing, a colorful flourish, or a decorative picture, he was either shamed into disillusionment or surprised with brutality.[9]

In the case of Van de Velde's Tropon poster (Figure 2.2), viewers, drawn initially to the intriguing imagery and tasteful balance of shapes and patterns, realize that they are studying nothing more than a stylized depiction of egg yolks and whites while being instructed that Tropon is nothing less than "the most concentrated nutrition." The design and message are incongruous—the forms and colors that seemed so intriguing are exposed in their full banality

by the hyperbolic yet demystifying text, leaving viewers perhaps amused or even disappointed, but not necessarily primed to purchase.

The *Sachplakat* thus appeared as a remarkable innovation, simultaneously communicating its sales message and its essence as advertising. There is no mistaking the *Sachplakat* for a painting or even an illustration; it prominently displays its purpose as advertisement for a specific manufacturer's product, and its concentrated focus ensures that viewers run no risk of misunderstanding what it is selling. The visual clarity of the object poster helped it to stand out from the other posters that crowded the *Litfaßsäule*, the columns stationed at various locations throughout a city, where, since the mid-nineteenth century, posters were permitted to be displayed.[10] Such precision of design and directness of message distinguished the object poster as one of the first types of advertising specifically adapted to the demands of the perpetually changing, increasingly dense and chaotic German city space. While the energetic compositions and vivid colors of early color lithographic commercial posters—for example, those designed by the nineteenth-century French "masters of the poster" Jules Chéret and Henri de Toulouse-Lautrec, or by the English Beggarstaff Brothers—produced a visual impact that enabled them to seize urban viewers' attention, such posters still relied on the process of reading, or the gradual piecing together of meaning from the various elements in the ad in order to communicate their messages. The key distinction between the *Sachplakat* and these earlier posters was its appeal to instantaneous comprehension.

When the object poster emerged, just after the turn of the nineteenth into the twentieth century, most poster designers were taking their cues from the visual codes of high art. They focused more centrally on creating pictures that could somehow attract a viewer's attention than on communicating a sales message. Accordingly, the majority of German posters seemed to address a viewer who was able to spend time decoding the ads' messages. The critic Hellwag decried the inefficiency of such an approach, denouncing not only the distracting ineffectiveness of using imagery that did not overtly support the product, but also the senseless waste of the viewer's time that such extended engagement encouraged. Early advertising professionals found that this leisurely approach simply did not acknowledge the realities of the outdoor environment of poster display or the hurried, harried, overly stimulated mobile state of the urban consumer-viewer. The typical pre-1914 German city view would have included trams, carts, and buses covered in signs; sides of buildings plastered with signs both painted and posted; shop windows filled with carefully arranged wares; sandwich men walking the streets with their signboards draped over their shoulders; *Litfaßsäule* that displayed numerous different posters simultaneously; and increasingly, electronically illuminated signs that flashed or glowed steadily.[11] Urban viewers would have moved through an environment fully saturated with insistent, competing advertising

messages. Given the conditions of this environment and the pace at which viewers traveled through it, the advertising expert Growald advises, "Don't write any novels on the poster–no one wants to get cold feet while standing on the street."[12]

Instead, what was needed, according to Hellwag, Growald, and others, was a mode of address more suited to the modern urban environment than the usual appeals to traditional modes of apprehension that presumed calm surroundings and the leisurely pace of contemplation. They advocated design attuned to the acceleration of all aspects of life that numerous observers have concluded characterizes the modern age. The sociologist Georg Simmel, for example, noted in 1902 that the psychological foundation of the modern urban dweller had changed dramatically in comparison with that of rural inhabitants and urbanites from earlier times. Assaulted by a constant barrage of sensations, the modern city resident adapted to the faster pace of life by developing a careful indifference, a "blasé metropolitan attitude" that enabled him or her to withstand and successfully navigate the ever-changing rush of stimuli of modern urban life.[13] More recently, the critic Paul Virilio declared that this constantly destabilized and destabilizing urban environment is nothing more than a site of *"habitable circulation."*[14] In this view, the city is no longer a reliably static set of landmarks and pathways, but an unstable locus of perpetual flux. Nothing seems secure, and even the most permanent, solid-seeming of structures and routes change constantly under the shifting layers of advertisements, resurfacings, and reorientations for new commercial purposes. The city has become less of a physical location than a configuration of signs whose meanings slide and change under the relentless pressures of the circulation of commodities.[15] In fact, under these conditions, the city, too, becomes a more or less "habitable" commodity.

Communication in such an environment required streamlining and acceleration if any message was to reach distracted, mobile individuals (and most early twentieth-century advertising professionals continued to think of individuals rather than masses when it came to theorizing address).[16] The solution called for by advertising experts like Hellwag and Growald was the simplification of form and content—the concentration of their message into pure promotion of sales. For them, the *Sachplakat* embodied this new approach to addressing the urban viewer-consumer. However, while the concentrated design of the object poster enabled rapid comprehension, its easy equation of maker's name with product elided the process whereby a standard mass-produced object becomes a commodity, thereby training viewers to regard the brand as the ideal form of the object that the poster depicted. Such elision of the commodifying process produced the alienation that had been disturbing critics since the rise of capitalism.

Karl Marx, for example, had been troubled already in the mid-nineteenth century by the way in which the object-turned-commodity is able to encode

and conceal the process of labor and the creation of value that constructed it. He thus argued for a mode of critical reading that would reveal the process by which value was created, a mode of reading that could decode the commodified object that operates hieroglyphically to mask the workings of capitalism.

> Value ... does not stalk about with a label describing what it is. It is value, rather, that converts every product into a social hieroglyphic. Later on, we try to decipher the hieroglyphic, to get behind the secret of our own social products: for to stamp an object of utility as a value, is just as much a social product as language.[17]

Despite such protestations, these mystifying "hieroglyphics" proliferated. Subsequent critics found them in a variety of visual forms ranging from shop windows to silent film to advertisements, including the object poster, not to mention the products themselves.[18]

In fact, the *Sachplakat* functions as one of the most efficient instances of these mystifying hieroglyphics. It emerged at a crucial early point in the development of German advertising, when practitioners began to organize themselves as experts performing the specialized duties of a distinct profession. Arguing that advertising had a vital role to play in the contemporary economy, these experts attempted to draw attention to the specificity of advertising as a mode of representation and as a form of address. They sought to differentiate posters clearly from art, thereby distancing themselves from proponents of so-called *Reklamekunst* (advertising art) and *Reklamekultur* (advertising culture), advocates who had tried to legitimate advertising by highlighting its aesthetic properties and its affinities with high culture. The early advertising professionals dismissed these nineteenth-century attempts to formulate guidelines for creating advertising imagery based on the compositional and color theories of fine art, and instead generated rules that embraced the functional nature of advertising and status as a rhetorical strategy. They hoped to invent a new visual vocabulary, one focused exclusively on the primary purpose of advertising—the generation of sales. This new vocabulary would no longer be premised upon appeals to the disinterested, contemplative gaze of traditional aesthetic experience; instead it was to address the distracted, hurried glance of the sensation-saturated urban dweller. The reduced visual language of the *Sachplakat* seemed to be a perfect example of this new type of vocabulary. For many critics, this new type of poster provided welcome relief from the historicist allegorical figures and the *Jugendstil*-derived excesses that comprised most of the posters of the time, and it presented viewers with what seemed to be a definitive break with past attempts to design advertisements based on the standards of high art. One of the most widely circulated examples of this type of poster is a 1908 advertisement for Stiller shoes (Figure 2.4).

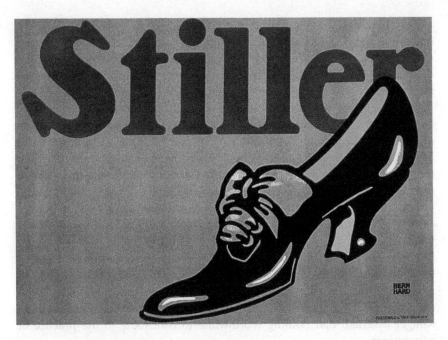

2.4 Poster for Stiller Shoes, Lucian Bernhard, 1908

Here, a sturdy yet elegant women's shoe is positioned in three-quarters profile in front of the name of the manufacturer, Stiller. Thoroughly decontextualized, presented without any illusionistic depiction of support such as a floor or even a sales counter, the shoe nevertheless stands rather jauntily, turned slightly toward the viewer, and, in a mild concession to realistic modeling, it sports a black bit of shadow, where the sole shades the heel, and white patches that indicate the gleam from some unknown light source. Shoe and lettering occupy roughly the same amount of space on the printed sheet, yet there are ultimately three major elements working together in the composition—text, image of the product, and uninterrupted, colored, background space. The open space in the lower left forms the base of a tilted triangle that leads the eye from lower left to upper right, where manufacturer name and product intersect. The light-brown background unites shoe and "Stiller," creating a neutral zone that is notable for the unadorned simplicity that distinguishes it from the bustle of the street. Thus, the *Sachplakat* inserts itself into the flow of modern urban traffic, even as it seemingly detaches itself from the frenzy of urban clamor. Within this quiet realm, "Stiller" and shoe are joined as symbol, a hieroglyph or pictogram where text and image inter-define one another, encouraging viewers automatically to think "shoe" when they see "Stiller," and to think "Stiller" when they see a shoe.

The "inventor" of this type of poster was Lucian Bernhard, who became one of the most widely recognized—nationally and internationally—poster designers in Germany. While what Bernhard produced was advertising, critics celebrated his work in ways reminiscent of the usual adulatory treatment of fine artists as geniuses, and the story of how he arrived at his "ingenious" design circulates in several versions. The *Sachplakat* is meant to have emerged variously as the result of modernist streamlining and elimination of extraneous ornament, as the savvy reaction to the professionalization and institutionalization of the advertising industry, or as the inspired synthesis of the many visual influences imported into Germany due to the increasingly international circulation of mass-produced products. Yet, more importantly, Bernhard was also understood as a new type of artist,[19] and his admirers were eager to distinguish what they identified as his particular genius from that of fine artists.

For example, writing in 1913, the poster designer Julius Klinger asserted that Bernhard was the first visual artist to understand fully that the field of advertising demanded entirely different skills than those associated with the fine artist. The fine artists who wished to create artistic advertisements, Klinger asserted, had nothing worthwhile to contribute to the practice of advertising:

> Today, since we have become very level-headed, we know that advertising demands trained experts and artisans, and that the "artist with ideals" has no say in these matters. The first man to understand this state of affairs was Lucian Bernhard. Bernhard brought only his instinct for reality, without the influence of any artistic direction from an arts academy or applied arts school. He seemed to create out of nothing; in reality, he shaped matter, and he did so very decisively, coolly, and commercially. There are surely other ways to go about solving the problem [of designing posters], but since nature had given him a strong sense of form and color, his way was the boldest, the simplest and, therefore, the most striking. Bernhard's influence on advertising was decisive. He changed its entire direction.[20]

According to Klinger, Bernhard is distinguished not only by his sensitivity to the present, but also by the fact that he had not attended any arts academy that would have shaped his work. While the attention to Bernhard's singularity, not to mention his innate "sense of form and color," presents him as a traditional artistic genius, Klinger is also careful not to elevate him to an overly idealized level. Bernhard thus does not create "from nothing" or from his own inspiration; rather, he works with what is given, the materials of the contemporary world, and his simple, effective designs are the result of his logical and—very importantly—his commercial approach to those materials. Klinger acknowledges that there are many other ways to address the problem of how to design an effective poster, but he finds that Bernhard's solutions are

the simplest and cleverest, and they therefore exercised the greatest influence over the direction that advertising took in Germany.

Another admirer of Bernhard was the left-leaning critic and art historian Adolf Behne, who celebrated the hieroglyphic character of the *Sachplakat* and valued Bernhard specifically for his ability to design a poster that conformed to the conditions of the modern urban environment. In a discussion of the history of German posters, Behne imagines what Bernhard may have thought of the object poster and the effects it is meant to produce:

> He said to himself: "The poster should charm the eye with an astonishing overall appearance, and the passerby should be able to take in the poster in an instant: Aha! A boot-, chocolate-, wicker furniture-, or book cover-maker! This can be achieved with a catchy picture of a typical object from a particular branch of business. And already the passerby should also have read the name of the firm—one-two-three—without having to stop: Schultze, Müller, Lehmann—These two hieroglyphs, object and name of firm, suffice completely. If a poster of this type is made well and with refinement, the name Tom or Dick or Harry will bind with the term "pomade" with every repeated encounter, and then it will be seated firmly in the brain of the passerby. And with that, the goal of the advertisement has been reached."[21]

For Behne, the object poster is so clearly legible that he can actually reconstruct Bernhard's own ideas about the design. Assuming the perspective of Bernhard, Behne emphasizes the strength of the *Sachplakat*, its ability simultaneously to captivate the eye of the viewer and deliver a clear sales message. Its composition is unified—and unifying. Its condensed composition strikes the eye as a single unit, and this visual impact helps the viewer synthesize the two individual "hieroglyphic" pieces—image of product and name of maker—into a unified, hieroglyphic whole.

However, Behne's Bernhard does not rely solely on the hieroglyphic instantaneity of the *Sachplakat* to ensure that viewers equate Stiller, for example, with shoe. He knows that, in order for this equation to become imprinted in their memories, viewers must be exposed to the poster repeatedly. The *Sachplakat* thus functions not only as a hieroglyph, but a modern, mass-produced and widely-circulated hieroglyph. In stripping away any high art trappings from his poster design, Bernhard embraces the poster as poster—an image that is meant to circulate widely, to be reproduced multiple times, and to be displayed prominently, frequently, in the midst of urban chaos, decidedly in the mainstream of life, unlike a painting, a unique, precious image most often displayed in a space specifically devoted to it. For Behne, Bernhard truly seemed to understand how modern urban conditions had begun to change viewers' relationships to images. He understood the need for a condensed composition that was visually compelling enough to seize viewers' attention even after multiple viewings.

Among the viewers whose attention was riveted by the object poster were members of the German Werkbund. This association of manufacturers, artists, designers, architects, and critics formed in 1907 to address what members saw as the troubled state of German manufacturing and its relationship to German culture in an era of industrial capitalism.[22] They believed that well-designed advertising could help to educate Germans, who were overwhelmed by the rapidly rising flood of mass-produced commodities, to recognize high-quality goods that merited purchase. The Werkbund regarded the *Sachplakat* as an exemplary instance of such well-crafted advertising, and their admiration for it helped to establish it as one of the most significant forms of advertising in pre-World War I Germany.

The Werkbund claimed to seek, above everything, to maintain the integrity of German culture in an industrial-capitalist age by promoting the integration of art into the design of industrially made goods and by making high quality in both design and production their priority. Werkbund members believed that such efforts would ensure that mass-produced goods would strengthen, rather than undermine, German culture, and they believed that these goods would ultimately result in a new, unified German style. They therefore made it their mission to teach Germans how to identify and purchase only those goods that supported this notion of style, and they focused on advertising as a key component of their educational program. The *Sachplakat*, with its ability to promote brand recognition instantly, seemed to be ideally suited to the Werkbund purposes.

The ideas of the Werkbund, particularly their concerns about the fallen state of German culture, were symptomatic of early twentieth-century anxieties about the effects of capitalism in Germany.[23] Unlike followers of Marx, who focused on matters of labor, property, class division, and the means of production, members of Werkbund focused more centrally on the gap between producers and consumers, a rift that had arisen as the result of mass production and distribution. For Werkbund member Hermann Muthesius, for example, the fact that producers and consumers no longer communicated directly with each other meant that production had become "estranged" from consumption. Large-scale producers no longer knew precisely what consumers wanted, and consumers no longer had the means to articulate their needs to producers.[24] Facing the impersonal marketplace awash in a flood of mass-produced goods, consumers were left confused and adrift, easily swayed by unscrupulous manipulators who convinced them that they needed what were ultimately worthless and meaningless objects.[25]

In order to circumvent the growing influence of mercantile enterprises that mediated between producers and consumers and in order to sidestep the forced obsolescence built in to the dynamics of fashion, the Werkbund looked to improving advertising as one possible way to bridge the gap between sellers and buyers, and it sought a new type of artist who was able to create

such unifying advertising.[26] The group also celebrated the trademark and the brand-name product as important means of helping German consumers instantly identify first-rate products, commodities that had been made according to high aesthetic and manufacturing standards, goods that could resist the whims of fashion and historicism, and contribute to a thoroughly modern, German style. The Werkbund found its new type of artist in the designer Bernhard, and it recognized in the *Sachplakat* the new form of advertising that could reinforce the impact of the trademark and the brand name, helping consumers to identify reliable goods whose appearance and level of quality they could recognize and trust over time.

Bernhard's 1910 poster for Manoli cigarettes demonstrates how the trademark and the advertisement can combine forces to underscore the sales message and reinforce brand recognition (Figure 2.5). Here, Bernhard again employs his basic idea of setting product and producer name in uninterrupted, colored space. As with the Stiller poster, the viewer's eye is drawn into the poster from lower left to upper right, but in this case, it is not a cone of empty space but a single cigarette directed outward, tilting downward toward the viewer, that pulls the eye in. The cigarette, however, is not presented in isolation, as the Stiller shoe or the Priester matches were. Instead, the cigarette appears with its packaging, which bears the trademark for the company on the inside of the open box. The Manoli trademark, a sleek, sans-serif M set in

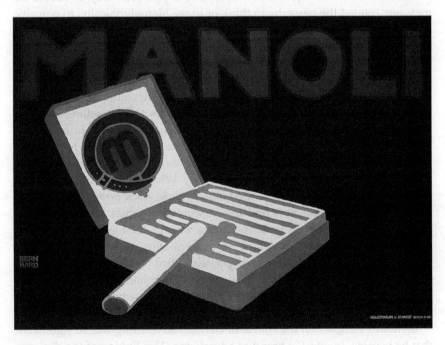

2.5 Poster for Manoli Cigarettes, Lucien Bernhard, 1910

a circular field, takes on the appearance of a cigarette as it is seen from the front. The viewer's encounter with the hieroglyphic message is, thus, doubled in this design. In its equation of "Manoli" and cigarette, the poster heightens the memorable impact of the trademark that also seeks to unite producer—Manoli—and product—cigarette—into a single, unchanging, reliable sign.[27] In the *Sachplakat*, the process by which text and image inter-define each other is repeated in the trademark. In both object poster and trademark, the selling strategy consists of establishing a relation between verbal sign, visual sign, and the implied referent so that each of these signs appears as the motivation of the others. The trademark, however, conveys a message that exceeds the simple linkage of product and manufacturer name. It communicates the Manoli corporate identity, history, and product line, and it is simultaneously more specific and more "portable," that is, transferrable to a range of surfaces and contexts, than any specific form of advertising can be. As such, the trademark can appear as an integral part of an advertisement such as a *Sachplakat* even as it floats free of the printed page, acquiring value and meaning as it circulates in the marketplace alongside countless other commodity-signs.

It is in Bernhard's Manoli poster that the purpose of the object poster—along with his strategy for encouraging the distracted, hurried urban viewer to adopt a new mode of perceiving the city and the commodities that are available and on display there—becomes most immediately apparent. The *Sachplakat*, in its rejection of reading as a preferred way to absorb its message, trained the passerby to think or to see hieroglyphically, to perceive in trademarks, to learn to join manufacturer and product automatically into a single, recognizable, and reliable commodity. In other words, the object poster worked to counteract any sort of engagement that would recognize the mystifications of capitalism or to decode its hieroglyphics as Marx and others who opposed the machinations of commodity culture would have preferred.

Indeed, the object poster was so efficient at its task of selling—and its task of selling selling—that it helped early twentieth-century businessmen understand the importance of advertising for the success of their enterprises. The wide acclaim that greeted Bernhard and his object poster thus heralded a turning point in German advertising history. While, in the years leading up to World War I, businessmen tended either to use stock poster templates or to invent the ads themselves and then commission artists to execute them, they gradually learned to trust specialists who understood how to design effective sales messages and how to conceptualize an entire advertising campaign.[28] Many early advertising specialists attributed this growing trust to the revolutionary impact of the visual appeal of Bernhard's innovative poster design, and they applauded him for helping businessmen understand the importance of the professional advertiser in the capitalist economy.

Bernhard's impact on the course of German advertising was so significant that he became, in effect, a brand of advertising. This linking of the designer

Bernhard with the specific design approach of the object poster led to critics' use of turns of phrase such as "the Bernhard type" (*der Bernhard-Typ*) or "Bernhard-hieroglyphs" (*Bernhardhieroglyphen*) when referring to the *Sachplakat*. In some ways, the designer as brand seemed an ideal answer to the Werkbund's call for ways to negate the transitory pleasures of fashion by directing consumers toward specific makers of stable, high-quality goods and services. However, this figure also contains the makings of its own undoing. The success of a brand, an advertisement, or even a designer is determined by commercial criteria, and in order to succeed commercially, all of these phenomena must follow the logic of the commodity. In short, they must follow fashion, whose essence as a transitory phenomenon and whose dependence on novelty doom it to obsolescence.

Accordingly, Bernhard as brand and the *Sachplakat* itself also were caught up in the mechanisms of fashion. Unavoidably, as the object poster became increasingly popular among businessmen, its effectiveness began to wane. The *Sachplakat* was used to advertise an endless variety of products, Bernhard imitators proliferated, and very quickly, the object poster became a design cliché—ubiquitous, predictable, and, therefore, increasingly easy to ignore. By the start of World War I, the *Sachplakat* had become obsolete. However, as a mechanism that trained urban dwellers in a new way of perceiving visual imagery, the object poster had succeeded. The *Sachplakat*—and the trademark—with their purpose of guiding consumers to equate a given object with a specific manufacturer, trained viewers to look exclusively at the immediate appearance of an object, at only the name, outline, and surface of objects in their world, to steer them toward identifying only specific brand-named commodities as desirable. The decline of the object poster occurred only after it had helped to teach capitalism to German viewers—the universal equivalence and exchangeability among goods, that is, images, commodities, values, and money. Later, silent cinema continued the work of the *Sachplakat*, training viewers to perceive immediately, to see, but not to read, to recall Growald's phrase, everything in the cinematic frame as a magical iconic sign/object, a hyper-commodity which, despite product tie-ins and an early star system, was not selling anything really except itself. The process by which early twentieth-century Germans came to "see" rather than "read" in capitalism necessitated learning. The *Sachplakat* was a potent instrument for selling them seeing and for teaching them to buy into seeing as buying.

Notes

1 Ernst Growald, "Der Plakat-Spiegel. Einige Beispiele," in *Die Reklame*, ed. Paul Ruben, Berlin: H. Paetel, 1914, p. 117. This text is an excerpt from Growald's *Der Plakat-Spiegel. Erfahrungssätze für Plakat-Künstler und Besteller*, Berlin: O.L. Salomon, 1904. All translations from German are mine unless otherwise noted.

2 The design approach that keeps words and pictures separate is perhaps a hold-over from the early nineteenth century, when most posters were produced using letterpress printing, often in combination with woodcut pictures.

3 The Belgian Van de Velde designed this widely distributed poster for Tropon, a Cologne-based food processing company, to circulate internationally.

4 For the context and development of the *Sachplakat*, see Hanna Gagel, "Studien zur Motivgeschichte des deutschen Plakats, 1900–14," PhD thesis, Freie Universität Berlin, 1971, esp. pp. 130–173.

5 Commentators have often understood manifestations of mass culture as hieroglyphics, for example, in the German context, Theodor Adorno, Max Horkheimer, and Siegfried Kracauer. See Miriam Hansen, "Mass Culture as Hieroglyphic Writing: Adorno, Kracauer, Derrida," *New German Critique* 56 (Spring–Summer, 1992), pp. 43–73. For a more general overview, see Hilmar Frank, "Arabesque, Cipher, Hieroglyph: Between Unending Interpretation and Loss of Meaning," trans. David Britt, in *The Romantic Spirit in German Art, 1790–1990*, ed. Keith Hartley, Henry Meyric Hughes, Peter-Klaus Schuster, and William Vaughan, Stuttgart: Oktagon Verlag, 1994, pp. 146–54; and Frances Connelly, *The Sleep of Reason: Primitivism in Modern European Art and Aesthetics, 1725–1907*, University Park, PA: The University of Pennsylvania Press, 1995.

6 The object poster was used to advertise a wide range of industrially produced products, from pianos to spark plugs, from cigarettes to shoes.

7 For reading habits in early twentieth-century Germany, see Gideon Reuveni, *Reading Germany: Literature and Consumer Culture in Germany before 1933*, trans. Ruth R. Morris, Oxford and New York: Berghahn Books, 2006. For a discussion of the impact of new media on reading and print culture, see Friedrich Kittler, *Discourse Networks 1800/190*, trans. Michael Metteer, with Chris Cullens, Stanford: Stanford University Press, 1990; also Stefanie Harris, *Mediating Modernity: German Literature and the "New" Media, 1895–1930*, University Park: Pennsylvania State University Press, 2009, pp. 1–20. Significantly, in their praise of the object poster, Werkbund members and other advertising experts still thought in terms of attracting viewers rather than reaching consumers.

8 At this point, most commercial advertisements were commissioned by businessmen who either requested posters from printers that combined stock imagery with the specific details provided by the business commissioning the ad or they commissioned artists to create pictures to accompany advertising text. For the development of the advertising poster and the changing understandings of its potential by German businessmen and artists, see Christiane Lamberty, *Reklame in Deutschland 1890–1914. Wahrnehmung, Professionalisierung und Kritik der Wirtschaftswerbung*, Beiträge zur Verhaltensforschung, vol. 38, Berlin: Duncker & Humblot, 2000, pp. 185–98.

9 Fritz Hellwag, "Bernhard," *Das Plakat* 7, no. 1 (Special Issue 1916), p. 4.

10 For the emergence of the poster column in the nineteenth century, see Werner Faultisch, *Medienwandel in Industrie- und Massenzeitalter (1830–1900)*, Göttingen: Vandenhoeck & Ruprecht, 2004, pp. 145–9.

11 Dirk Reinhart, *Von der Reklame zum Marketing. Geschichte der Wirtschaftswerbung in Deutschland*, Berlin: Akademie Verlag, 1993, pp. 289–329, and Lamberty, pp. 205–11.

12 Growald, p. 117.

13 Georg Simmel, "Die Großstädte und das Geistesleben," *Jahrbuch der Gehe-Stiftung zu Dresden 9. Die Großstadt. Vorträge und Aufsätze zur Städteausstellung, Winter 1902–1903*. (1903), pp. 187–206.

14 Virilio connects this restless version of the city to the logic of speed that results from the acceleration of modern life; he terms this logic of speed "dromology," *Speed and Politics: An Essay on Dromology*, trans. Mark Polizzotti, New York: Semiotext(e), 1986, p. 6.

15 The shifting face of the city and the increasing number of advertisements that covered it were cause of considerable concern among the so-called *Heimatschutzbewegung* (homeland protection movement). While advocating for the protection of historical monuments and for city beautification, the movement was also fueled by ultra-conservative, nationalist sentiments. See Reinhart, pp. 378–87.

16 For a discussion of the intersections between psychology and early advertising theories, see Reinhart, pp. 87–99.

17 Karl Marx, *Capital*, vol. 1, 1867, trans. Samuel Moore and Edward Aveling, Moscow: Foreign Languages Publishing House, 1958, p. 74.

KATHLEEN CHAPMAN 53

18 Max Horkheimer and Theodor Adorno later referred to such mystifying mechanisms as "priestly hieroglyphics" that flourished in mass culture, Horkheimer and Adorno. "Das Schema der Massenkultur," 1942, in Adorno, *Gesammelte Schriften* III, Frankfurt am Main: Suhrkamp, 1981: pp. 332–5. For the hieroglyphic as historical reality and emblem in modern and modernist culture, see Miriam Hansen, *Babel & Babylon: Spectatorship in American Silent Film*, Cambridge, Mass.: Harvard University Press, 1991, pp. 190–194.

19 Today, Bernhard and other poster designers are known as graphic artists but the term *"Gebrauchsgraphiker"* only came into common circulation during the 1920s, Reinhart, pp. 77–80. For details about the full range of Bernhard's work, see Hubert Riedel, ed., *Lucian Bernhard. Werbung und Design im Aufbruch des 20. Jahrhunderts*, Berlin: Institut für Auslandsbeziehungen, 1999.

20 Julius Klinger, "Plakate und Inserate," *Jahrbuch des Deutschen Werkbundes. Die Kunst in Industrie und Handel*, Jena: E. Diederichs, 1913, pp. 110–111.

21 Adolf Behne, "Alte und neue Plakate," in *Das politische Plakat*, Charlottenburg: Verlag "Das Plakat," 1919, pp. 6–7.

22 For the founding and growth of the Werkbund, see Joan Campbell, *The German Werkbund: The Politics of Reform in the Applied Arts*, Princeton: Princeton University Press, 1978, pp. 9–32.

23 Frederic J. Schwartz, *The Werkbund: Design Theory and Mass Culture before the First World War*, New Haven and London: Yale University Press, 1996, p. 14

24 Schwartz., p. 50.

25 As Jean Baudrillard later pointed out in his analysis of "consumer society," given the fact that authentic needs (tied to the use value of commodities) are no longer at play in the capitalist economy, desire for goods has to be manufactured so that consumers have reasons and motivation to purchase items that they, ultimately, do not need, *The Consumer Society: Myths and Structures*, trans. Chris Turner, London, Thousand Oaks, New Delhi: Sage Publications, 1998, pp. 69–86.

26 Werkbund attacks on the role of mercantile function in the capitalist economy often took the form of overt anti-Semitism. The writings of the sociologist Werner Sombert, for example, stand as particularly egregious examples of this tendency. See Schwartz, *The Werkbund*, pp. 82–91.

27 Here, both trademark and object poster fulfill the definition of what *fin-de-siècle* philosopher and semiotician Charles Sanders Peirce terms the icon, "Of Reasoning in General," 1894, in *The Essential Peirce: Selected Philosophical Writings* vol. 2, 1893—1913, ed. The Peirce Edition Project, Bloomington: University of Indiana Press, 1998, p. 13.

28 For an overview of the rise of the advertising professional in Germany and the increasing acceptance of advertising among businessmen, see Lamberty, pp. 134–40.

Selling Perceptions of Space: AT&T Print Ads, 1908–1930

Emily Bills

On March 10, 1876 Alexander Graham Bell picked up the receiver of his latest telephone device in his Boston laboratory and successfully transmitted what would become one of the most famous lines in modern history: "Mr. Watson— come here—I want to see you." In retrospect this statement may initially seem to be counterintuitive. Why would Bell ask to see Watson when he had just succeeded in speaking to him over the phone? The inventor most likely sought his assistant's presence to verify that his words had been successfully communicated. But his request suggests the kind of complications this new device created by transmitting sound but not bodies through time and space. The American Telephone and Telegraph Company (AT&T) faced similar issues when it set out to adjust new telephone users to the "miracle" of modern telecommunication. The telephone made it possible for people to talk to one another in real time, without going anywhere and without seeing anyone. This experience was unprecedented. As a result, when AT&T set out to help potential subscribers adjust to this new form of social interaction, there was little in the way of imagery or language they could look to for ideas.

For this they hired N.W. Ayer & Sons, an up-and-coming advertising agency in New York that would remain AT&T's primary image-maker from 1908 through the 1980s, eventually introducing such well-known mottos as "Reach Out and Touch Someone" into American popular culture. When they were first hired, Ayer & Sons' primary responsibility was to create print ads that would help subscribers make a conceptual disconnect between social interaction and physical space and between verbal conversation and visibility. In other words, AT&T's advertisers were given the substantial task of changing the way people thought about space and vision itself.

Creating consumer comfort with the telephone, however, was only part of AT&T's long-term objectives. As a survey of the print ads produced for the company by Ayer & Sons between 1908 and 1930 reveals, AT&T's definitive

goal was to gain public support for private monopoly control over the country's entire telephone system—a goal that was ultimately fulfilled and which shapes the debate surrounding telecommunications regulatory practices to this day. So, as Ayer & Sons set out to encourage subscribers to adjust all they knew about interaction in physical space to the expanded imperceptible space of the telephone system, AT&T set out to connect the entire country under a single telephone monopoly. This chapter traces how Ayer & Sons gradually connected those two goals in their print ads for the Bell Company. Through the careful pairing of imagery and words, ads that were initially used to mold perceptions of telephonic processes were gradually used to also promote the Bell System as a key means of facilitating the nation's economic growth and solidifying national identity. In each of these manifestations, space— the virtual space of communication, the territorial space of the nation—is presented as an entity that needs to be both explained and overcome.

Everyday Magic: A Spatial Problem

In the early twentieth century, emerging telephone concerns were faced with two major challenges: one, developing a cost-effective way to erect and run a telephone system, and two, educating potential users on how to navigate that system. To achieve the second of these goals, telephone companies launched instructional campaigns meant to inform the populace about how the telephone system could improve daily life and how users could best contribute to its efficiency. They provided information that helped the consumer understand such new technological issues as establishing quick, clear connections and running a telephone switchboard, as well as the factors governing appropriate subscription rates.

Due to the extent of this educational program, the marketing of the telephone required much more than the association of a trademark with a product or service, as with the Bell Company's "bell" logo with telephony or the telephone device; it required a multifaceted promotional crusade that would shape potential consumers into loyal lifetime subscribers. The thrust of this type of marketing was explanation based—meaning less the promotion of a material good than the potential functioning of that good. In 1905 Philadelphia Bell advertising manager George Steel emphasized the suitability of this approach when he estimated that it took the average consumer five to ten years after being introduced to the telephone device to subscribe for service.[1] Even after customers acquired a telephone and became familiar with all of its potential uses, marketers still found that most people were confused about how the system worked. As a result, the slightest dissatisfaction in service was frequently expressed as suspicion or anger

toward the company. As AT&T marketing agent N.C. Kingsbury stated in a 1915 issue of the advertising journal *Printer's Ink*:

> We spend large sums of money every year in our national advertising, and yet we do not advertise for the purpose of inducing people to install telephones or to talk over our long-distance lines. Not at all; we advertise because we became convinced some years ago that the public at large knew very little about our business…and we have been trying to educate the people of this country along those lines.[2]

Although most Americans had used a telephone by the time Kingsbury wrote his article, many did not understand the process by which voice was transmitted. Thus, the device continued to be perceived as a curious and even alien apparatus, either embraced with a kind of blind acceptance or rejected as a dangerous trend. As with the telegraph before it, the most positive futurologists lauded the telephone as the great benefactor of humanity, a technological marvel that through the electrical transmission of ideas could become the motive force of desired social change and the key to the creation of a humane utopian society.[3] Conversely, the telephone was the subject of a variety of superstitious myths that warned of its devilish influence on society — including the dubious assertion that it was possessed by the supernatural.[4]

Most citizens, however, simply accepted telephony as another timesaving product among a thousand other new inventions that were shaping modern society. As Roland Marchand explains: "Americans had traditionally welcomed modernization. They had celebrated the contributions of new technologies to prosperity, convenience, comfort, and a faster pace of life."[5] But in spite of this positive outlook, Marchand continues, those devices that directly challenged traditional interpretations of time and space were particularly difficult to disseminate: "… many had accommodated uneasily to the new scale of social and economic life occasioned by technological advances. People had responded with both excitement and suspicion as new forms of transportation and communication invaded local communities."[6] The introduction of the telephone, for example, drastically increased the number and reach of people one could contact in a section of space and a segment of time. These new space-time factors altered the way modern Americans had to conceptualize the conventions governing interaction as they struggled to adjust to the seemingly immeasurable, imperceptible space of their town, city, or region's new circulatory system, one occupied solely by the disembodied voice.

The attempt by telephone educators to shape user behavior, it might be reasoned, was tied to this general confusion surrounding how to navigate the workings of a system whose space was basically intangible. At the heart of this problem was the almost universal incomprehension of the processes of electricity and the associated need to find an easy method of explaining

such processes to potential consumers. This was no easy task, in part because it required the consumer to overcome any misgivings surrounding close interaction with an entity or process that cannot be observed—an arena traditionally experienced only in the context of spiritual worship. For the average user, the method by which a battery sends an electrical impulse over a wire, as in the case of the telegraph, or a current is shot up a cord into a light bulb, as triggered by the flip of a light switch, was exceedingly difficult to comprehend. But the means by which the telephone transforms human voice into electric impulses, carries them over a wire, and then receives and translates them into understandable spoken language, was often utterly baffling.

When AT&T hired Ayer & Sons in 1908, the firm's first task was to help people obtain a basic understanding of how the telephone works. Greater understanding, it was reasoned, would attract subscribers and help them to use the device properly. At first, the advertisers risked embracing the public's perception of telephony's mysterious processes. One 1910 ad, entitled "Everyday Magic," compared the very real yet disembodied transportation of the human voice to the mythical transportation of a corporeal Aladdin by means of his genie lamp.[7] In the image, the Aladdin figure, rendered in a soft gray and located just behind the lamp, raises his hands and widens his eyes as if to conjure a spirit. The lamp and the telephone, in contrast, are both rendered in deep black-and-white chiascuro. The two are positioned next to each other at the same, oversized scale in the foreground, thereby assigning them a prominence and an equivalency in the image's iconography, while also identifying the telephone as a modern equivalent of the magical lamp.

At the time, AT&T's target market was the male, business subscriber, but the ads were published in nationally circulated journals with a broad readership, like the *Saturday Evening Post, Collier's* and the *Literary Digest*. There is no documentation of the journal in which "Everyday Magic" originally appeared, but it was likely a full-page spread repeated in subsequent issues for about a year, as was typical with other AT&T ads at the time.[8] Although the Aladdin mascot would be replaced within the same year, the "informational" format the firm developed for AT&T's print ads stayed virtually unchanged for the next 50 years. The basic layout includes an image at the top, such as the genie and his lamp, underlined by a catchy slogan like "Everyday Magic" and followed with a few paragraphs of explanatory and promotional information.

While the layout of the ads remained standard, a wide range of imagery, ranging from the fantastical to the utilitarian, features the telephone as either a mystical device or a technological object capturing human voice and conveying sound. These changes to the visual imagery reveal the struggle Ayer & Sons faced in trying to promote this new device and communications service. The obstacle for the telephone talker was that outside of the physical traces of telephone infrastructure, identifiable in the poles and wires

that mark the paths of communication, the actual processes by which this spatial convergence occurred were difficult to envision. In effect, the rapid dissemination of telephone technology completely revolutionized, or at the very least intensified, a separation between two separate means or categories of transmitting information: the experiential, physical commutation of things and people via modes of transportation like road and rail, and the virtual communication of thought by means of intangible electrical impulses. For this reason, the problem of visual representation went beyond the usual perceptual challenges that face any advertiser seeking to capture the "roving eye." In order to ease potential subscribers into this virtual, exaggerated "time-space convergence" process, telephone companies needed to find a means of extolling the telephone's ability to conquer distance while making its "space adjusting" technique comprehendible.

A Telephone Highway

The solution, it turns out, was located within the nature of the problem itself. Ayer & Sons found that the best way to comprehend the invisible transmission of a disembodied voice was to apply the vocabulary and images of transportation technology to the inner workings of the telephone system. In other words, they decided to align the way consumers perceive traversing space virtually with the principal means of traversing space physically. This created a visual image the subscriber could comprehend—such as the invisible voice transmitted over a wire being analogous to a steam train traveling on a track—and established a language that matched the physical experience of the image—like using the term "telephone traffic" to describe calling congestion on telephone lines.

Ayer & Son's transportation-themed advertisements were produced mainly between 1909 and 1913. At their most elementary level, the ads created simple visual associations between the transference of information by means of an intangible electrical impulse and physical movement over an observable path laid for transportation, like a highway or train track. For example, in the ad "A Highway of Communication," (Figure 3.1) released in 1909, two rows of standardized, black lacquered telephones are lined in regimented precision along the sidewalk of what appears to be a quaint, cobblestone thoroughfare.

The AT&T "bell" logo is also represented at the center of the cobblestone street, but it is rendered to resemble a manhole cover and almost blends into the patterning of the paving stones. This is a rare, more nuanced representation of the bell logo. From their earliest ads, Ayer & Sons used a graphically simple representation of a bell inscribed with the words "local and long distance telephone" and circled by the company name. They experiment with the placement of the logo for several years and by the 1920s it is reduced in size and placed almost exclusively at the bottom of the ads.

A Highway of Communication

It goes by your door. Every home, every office, every factory, and every farm in the land is on that great highway or within reach of it. It is a highway of communication, and every Bell Telephone is a gateway by which it can be reached.

Millions of messages travel over this highway every day. In the great cities they follow one another like the bullets from a machine gun, and over the wide reaches of the country they fly with the speed of shooting stars.

The Bell service carries the thoughts and wishes of the people from room to room, from house to house, from community to community, and from state to state.

This service adds to the efficiency of each citizen, and multiplies the power of the whole nation.

The Bell system brings eighty million men, women and children into one telephone commonwealth, so that they may know one another and live together in harmonious understanding.

A hundred thousand Bell employees are working all the time on this highway of communication. Every year it is made longer and broader, and its numerous branches are more widely extended. Every year it is furnished with a larger number of telephone gateways and becomes the means of greater usefulness.

The Bell Long Distance Telephone will meet your new needs and serve your new purposes. It means — one policy, one system, universal service. Every Bell Telephone is the center of the System.

The American Telephone and Telegraph Company and Associated Companies

For Rates and Other Information Regarding Service, Call the District Manager

The Central District and Printing Telegraph Company
BELL SYSTEM

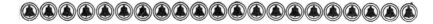

3.1 "A Highway of Communication" advertisement, AT&T, 1909

Despite the bell logo's placement in the center of "A Highway of Communication," the representation of the device itself is the ad's clear focus. The bell logo blends into the street patterning but the early candlestick models' upright bodies and raised earpieces stand at attention as they recede toward the street's vanishing point. They are rendered at an exaggerated scale and are placed at exact intervals from each other, thereby mimicking the street lamps, electric poles, or even telephone poles that by 1909 would have lined many city streets. Combined with the juxtaposition of the telephone device with the road as it disappears into the horizon, this pictorial organization aligns the product with the idea of distance or movement through space and, more specifically, with the march of technological progress across the country. The accompanying text is used to emphasize this association: "Millions of messages travel over this highway every day. In the great cities they follow one another like the bullets from a machine gun, and over the wide reaches of the country they fly with the speed of shooting stars."[9] The message persuades the reader to perceive telephonic communication as something material that operates inside real space by describing journeys along "highways" in the same manner that a Model-T races down a road.

In this earliest attempt to associate telephone "travel" with transportation travel, the written message is clear but the graphic execution remains clumsy and in some ways counter effective. There is no sense of rapid movement in the static positioning of telephones along the sleepy road, and thus the picture does not match the energy of the text. At a fundamental, visual level the ad succeeds only in posing the street and telephone as mutual icons, serving as as an associative exercise in the alignment of two objects in the consumer imagination.

This associative approach was likely deemed inadequate, as Ayer & Sons quickly developed a more direct means of utilizing the transportation analogy to characterize the telephone system. The first change came when the company began emphasizing the functioning and ultimate benefit of the service over the physical device or product itself. As described in "A Highway of Communication," the telephone as object was often featured in early ads, even those that experimented with creating associations between the device and movement. But as AT&T Vice Chairman Morris Tanenbaum explained in 1993, the decision to sell service rather than hardware was a key element in the technological development of telephony.[10] Indeed, as early as 1910, Ayer & Sons went so far as to completely remove the image of the telephone device from many of their advertisements. In "The Clear Track," a lone railroad spur, which disappears in unilateral perspective into the background of the picture plane, is the only image represented. The written message compares "scores of trains carrying thousands of passengers" to the "ten million miles of wire" that make possible "twenty million 'clear tracks' a day for the local and long distance communication of the American people."[11] The message asks the

viewers to place him or herself in the invisible vehicle being transported into the space beyond and actively engaging with a massive, interconnected communications community.

During the first few years as AT&T's advertisers, Ayer & Sons were clearly experimenting with multiple means of expressing this idea visually. A final ad that appeared in 1910, however, successfully reinserts the telephone back into the visual material while maintaining a focus on process as product. Entitled "The Efficient Minute," (Figure 3.2) the telephone's sleek body is positioned as a vertical counterpart to the great, horizontal streamlined markers of efficient transportation design.[12]

THE
EFFICIENT MINUTE

We have speeded up our ships and railways; we have made rapid transit more and more rapid; we have developed a mile a minute in the air and much faster in an automobile.

But the Bell Telephone is quickest of all. It is *instantaneous*. No weeks or days or minutes wasted in waiting for somebody to go and come; no waiting for an answer.

It is the most effective agency for making minutes more useful, more efficient.

In almost every field of work men are accomplishing more in less time with the Bell Telephone than they could without it. They can talk with more people, near and far; they can keep the run of more details; they can buy or sell more goods, and to better advantage; they can be active in more affairs.

The Bell Telephone has placed a new and higher value upon the minute—for everybody. It has done this by means of One Policy, One System, and Universal Service.

Bell Long Distance Telephone service not only gives an added value to a man's minutes—it accomplishes business results which would be absolutely impossible without it. Every Bell Telephone is the Center of the System.

AMERICAN TELEPHONE AND TELEGRAPH COMPANY
AND ASSOCIATED COMPANIES

3.2 "The Efficient Minute" advertisement, AT&T, 1910

In its exaggerated height and streamlined form, the device assumes a position among the great signposts of modern transport: the automobile, the railroad, the steamship, and the airplane. The ad goes one step further, however. The telephone does not simply stand head to head with these technological conveniences that shatter the relationship between time and space but takes a step in front of, and is thereby rendered to be in advance of, those icons of modernity. It is thus boldly postulated as the supreme deity in a pantheon of space-time saving conveniences.

The physical dominance of the telephone device over the technological scene is reflected in the message. According to the ad, telephony is not only faster and more efficient than these earlier forms of physical transportation, but also provides the subscriber with a direct, literally "instantaneous" connection on an unencumbered line to every other subscriber in the system. If not connected to a party line, the speaker was promised the experience of having their very own railroad car on their very own railroad track. This form of personalized efficiency was supposed to entice the harried businessman, who relied on AT&T's ability to provide a direct and instantaneous means of contact with his fellow capitalists.

In this way, the transportation association became more than a means of creating consumer comfort. It tried to convince the subscriber that the telephone system's "clear tracks" could make the connections that would help a business be successful. The telephone is depicted as the leading player in the hastening of what David Harvey calls the "turnover time of capital." As such, its value lies in being the most effective means of speeding up, in economic terms, the "time of production together with the time of circulation of exchange." In this process, the telephone is utilized by businesses to annihilate the barriers of space and time by helping to rapidly distribute products and information. It is touted, in other words, as the ultimate gateway to economic efficiency.

Calling as Capital

The idea of telephonic communication as a tool for facilitating business was solidified in a new series of print ads produced by Ayer & Sons between 1916 and 1930. Headed by such titles as a "Bee-Line to Everyone" and "The Kingdom of the Subscriber," the ads emphasize the telephone as a powerful tool that, when wielded by the businessman, gives him instant access to a world of commerce.[13] As such, it is often pictured grasped firmly in the hand of the powerbroker, industrialist, and farmer, the active male participants in the country's economic advancement. Whether pictured staring over the peaks of the skyscraper metropolis or proudly gazing across a meadow toward their smoke-belching factories, these men tightly grasp their telephone devices,

wielding them forth like a royal scepter. The telephone is now shown in use, an instrument of power for the gigantic figure of its possessor.

What these ads suggest is that telephony, like transportation, not only possesses a geography that is navigated by the user, but also helps generate a geography of business whereby the processes of capitalism are manifested in the circulation networks of the telephone system. This association is essential to understanding AT&T's larger, monopolistic preoccupation. Ayer & Sons' use of transportation as an analogy for communication first helped the subscriber adapt traditional, physical modes of interaction to the new virtual space of the telephone system. In the process, it persuaded the public to perceive telephonic space as one highly productive, interconnected system, run by AT&T to benefit the advancement of capitalism. Any roadblocks to that system, the ads insinuated, could impede commerce and wound businesses where it hurts most—their pocketbooks.

With a monopoly on their mind, AT&T identified the biggest roadblock to be independent telephone companies whose lines were not connected to the Bell System. By 1902, these independent companies existed in many communities across the country and usually provided short-range connections in areas that local Bell subsidiaries had overlooked or under serviced. AT&T was primarily focused on its long-distance "Long Lines" division, but also wanted control over local service to make sure all telephones connected to their long-distance lines. If the systems remained separate, subscribers to an independent company could only call those within their own "network" and not make use of AT&T's services.

In response to these competing telephone concerns, Ayer & Sons introduced a new AT&T motto: "One Policy, One System, Universal Service." The theme "universal service" emphasized the consolidation of the nation's telephone system under the jurisdiction of a single company. The local independent companies, AT&T insinuated, were roadblocks that impeded the flow of commerce and the "march toward modernization" that was the perpetual catchphrase of progressive, corporate rhetoric. The use of the transportation analogy in telephone education was thus more broadly a lesson in capitalist economics, one predicated on the paternalistic assertion that big business knows best how to organize and direct "movement" around the space of the nation. The most philosophical telephone advocates even purported the superiority of communications over transportation as a means of consolidating and traversing land because "it involved not the mere modification of matter but the transmission of thought."[14] In effect, the telephone embodied the ultimate degree of efficiency in transmitting information through time and space: subscribe to service, the consumer is told, and become freed from physical movement itself.

Relieved from the shackles of the corporeal body, intangible ideas are conveyed fluidly along these new circuits of communication. The magazine ads

reinforced the notion that this disembodied telephone user had been granted a right to travel in a manner that surpassed all other modern conveniences. In their quest to gain a monopoly over the nation's telephone business, AT&T used transportation analogies to promote their ability to provide, as one 1912 ad states, the "Right of All the Way." In the ad, poles and wires are depicted running parallel to railroad tracks, matching the pace of a racing locomotive. While the imagery purports a mutuality of transmission types, the accompanying narrative places them in stark contrast. Unlike the railroad, where the movement of individual passengers is limited by the necessities of others, the telephone carries messages over wires "devoted exclusively for the time being to the individual use of the subscriber."[15]

The telephone is thereby heralded as the pinnacle in the personalization of information transmission, a luxury of "the right of way" now available to all subscribers that even the richest multimillionaire could not acquire in the form of rail transport. But to achieve such miracles of information transmission, the ad copy states, the telephone system must "build more tracks—string more wires" to cover the nation.[16] In order to reach its ultimate potential, the system's physical infrastructure was shown to be in a constant state of expansion while its supervision would be consolidated under AT&T's prudent authority.

The magazine ads reflect this move towards promoting not only the telephone as a spatial device that could link the nation, but also the company itself as an instrument of consolidation. This became particularly evident after the completion of the transcontinental telephone line on January 25, 1915, that linked New York City to San Francisco. The "Universal Service" motto now appeared at the bottom of ads that focused on the potential of AT&T connecting businesses across the country. For example, in "As if Across a Desk" (Figure 3.3) a businessman from the East grips a telephone that forms part of a New York City skyline in order to talk trade with his colleague in the West. The desktop between them forms a representation of the vast landscape of the country across which their conversation is carried by miniature telephone poles. The telephone is back to a more realistic scale but it is physically connected to this larger infrastructure.

The text repeats all the rhetoric familiar by this point:

> "New York is calling!" Says the operator in San Francisco. And across the nation business is transacted as if across a desk ... Without moving from his chair, without loss of time from his affairs, [the businessman] may travel an open track to any of those places at any time of day or night ... Without telephone service as Americans know it, industry and commerce could not operate on their present scale.[17]

Efficient communication without physical or visual interaction, wide-open telephone "tracks," and AT&T as the custodian of American commerce—the

ad links them all. But the ad does not stop there. This image of the desk-map is more than a clever visual device; it also acts as a patriotic symbol. In the early twentieth century, any commercial ambition towards "consolidation" was often seen as related to the nation's efforts to link the entire country into one, cohesive commonwealth. In the past, transportation developments

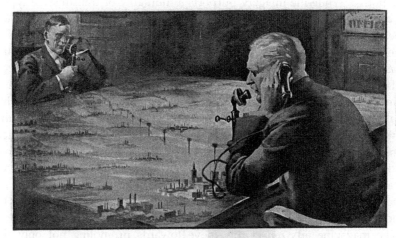

As if across a desk

"New York is calling!" says the operator in San Francisco. And across the continent business is transacted as if across a desk.

Within arm's length of the man with a telephone are seventy thousand cities, towns and villages connected by a single system. Without moving from his chair, without loss of time from his affairs, he may travel an open track to any of those places at any time of day or night.

In the private life of the individual the urgent need of instant and personal long distance communication is an emergency that comes infrequently— but it is imperative when it does come. In the business life of the nation it is a constant necessity. Without telephone service as Americans know it, industry and commerce could not operate on

their present scale. Fifty per cent more communications are transmitted by telephone than by mail. This is in spite of the fact that each telephone communication may do the work of several letters.

The pioneers who planned the telephone system realized that the value of a telephone would depend upon the number of other telephones with which it could be connected. They realized that to reach the greatest number of people in the most efficient way a single system and a universal service would be essential.

By enabling a hundred million people to speak to each other at any time and across any distance, the Bell System has added significance to the motto of the nation's founders: "In union there is strength."

" BELL SYSTEM "

AMERICAN TELEPHONE AND TELEGRAPH COMPANY

AND ASSOCIATED COMPANIES

One Policy, One System, Universal Service, and all directed toward Better Service

3.3 "As if Across a Desk" advertisement, AT&T, 1922

like the transcontinental railroad had earned special recognition for literally "binding" the populace across the vast spatial terrain of the nation or, as more dramatically expressed, effectively expunging the problem of space itself by means of technological advance. Even a commercial bid for spatial fusion could therefore be linked to efforts towards political unity.

In this way, the "One Policy, One System, Universal Service" promotion sought to link the idea of the privatization of service with the provision of a public service. Ayer & Sons presented the notion that the monopolization of the system under the authority of a single corporation had the goal of furthering in cooperative spirit the advancement of American business. The contradictions are familiar as a fundamental feature of the founding goals of American society in the problematic effort to "cement the union" by spatially and socially unifying a vast landscape and large population. AT&T's objective was to encourage the public to recognize electronic communications as the most advanced means of promoting this project, and its advertisements can be read as an exercise in claiming for telephony a central role in the historical struggle to bind the country, both in ambition and in space.

AT&T's Codification of the West

AT&T inserted its aspirations for monopoly control directly into the doctrine governing this incorporation mentality. In a new round of print ads in popular magazines like *Saturday Evening Post*, Ayer & Sons argued that the unification of the United States demanded the spatial unification of all of its vast territory. The best way to connect people across that territory, they asserted, was to centralize the telephone system under a single commander. Purportedly, AT&T could then more efficiently and effectively serve America's economic growth.

The completion of the transcontinental telephone line in 1915 proved the perfect vehicle for marketing this idea of "patriotic advancement through monopolization." In the ads that accompanied the massive project, subscribers were encouraged to associate virtual telephonic access for consumers across the country with the appropriation of the "Wild West" in physical actuality. As illustrated in "Highways of Speech," the workers installing telephone lines were portrayed as heroic pioneers navigating the untamed wilds of the American West in the name of progress.

Every harrowing experience of these Lewis-and-Clark-type trailblazers was chronicled in the ads as they erected poles and lines across the Rocky Mountains and the Sierra Nevada. Each sacrifice by foot was celebrated in the name of the common businessman who would ostensibly be able to more easily navigate that same treacherous terrain from the comfort of his office telephone. In "Highways of Speech," (Figure 3.4) the workers are shown on

The Bell System's transcontinental telephone line crossing Nevada.

Highways of Speech

Necessity made the United States a nation of pioneers. Development came to us only by conquering the wilderness. For a hundred and fifty years we have been clearing farms and rearing communities where desolation was—bridging rivers and making roads—reaching out, step by step, to civilize three million square miles of country. One of the results has been the scattering of families in many places—the separation of parents and children, of brother and brother, by great distances.

To-day, millions of us live and make our success in places far from those where we were born, and even those of us who have remained in one place have relatives and friends who are scattered in other parts.

Again, business and industry have done what families have done—they have spread to many places and made connections in still other places.

Obviously, this has promoted a national community of every-day interest which characterizes no other nation in the world. It has given the people of the whole country the same kind, if not the same degree, of interest in one another as the people of a single city have. It has made necessary facilities of national communication which keep us in touch with the whole country and not just our own part of it.

The only telephone service which can fully serve the needs of the nation is one which brings all of the people within sound of one another's voices.

" BELL SYSTEM "

AMERICAN TELEPHONE AND TELEGRAPH COMPANY

AND ASSOCIATED COMPANIES

One Policy, One System, Universal Service, and all directed toward Better Service

3.4 "Highways of Speech" advertisement, AT&T, 1923

horseback, dressed in Western gear, and installing the Nevada portion of the line, while the ad's text repeats all the clichés of traditional frontier rhetoric:

> Necessity made the United States a nation of pioneers. Development came to us only by conquering the wilderness. For a hundred and fifty years we have been clearing farms and rearing communities where desolation was ... reaching out, step by step, to civilize three million square miles of country ... [This] has made necessary facilities of national communication which keep us in touch with the whole country and not just our own part of it.[18]

The bottom of the ad continues to reiterate AT&T's corporate motto: "One Policy, One System, Universal Service."

Universal service, the advertisement suggests, is not only economical and patriotic but it is also the nations destiny. The tone of this advertising campaign can be interpreted as part of a broader exercise in the invention of a cultural myth that linked the conquering of the West to the idea of progress. Perhaps more than any other text, Theodore Roosevelt's *The Winning of the West*, first published between 1889 and 1896, advanced the idea of "pioneer spirit" as an innate drive toward progress, realized in the conquering and settlement of the untamed lands of the country. "In obedience to the instinct working half blindly within their breasts," Roosevelt writes, "spurred ever onward by the fierce desires of their eager hearts, they made in the wilderness homes for their children, and by so doing wrought out the destinies of a continental nation."[19] Alan Trachtenberg begins his study of the "era of incorporation" with a chapter entitled "The Westward Route" in which he aligns the invention of the concept of "Americanness" or "Americanization" with what was characterized as an innate drive to perpetuate the "race" through the conquering of the West. He identifies in Roosevelt's assertions "a half-mystical imperative of the 'race-history,' a culminating moment in the drive of the 'English speaking peoples' for dominance in the world."[20] As Trachtenberg summarizes:

> And so history seemed for [Theodore] Roosevelt, for [William Jackson] Turner, for countless others contemplating the westward experience, a foreclosed event, an inevitable advance from low to high, from simple to complex, and in more senses than one, from "Indian" to "American." For Turner, "West" offered a transparent text in which "line by line...we read this continental page from West to East," deciphering a "record of social evolution."[21]

This sentiment finds a direct interpretation in a Western-themed ad released by AT&T in 1911 entitled "Civilization—from Signal Fire to Telephone."[22] Adopting a vaguely Darwinian tone, the ad presents indigenous societies as a necessary step on the evolutionary ladder that is also a ladder of technological improvement. Jagged mountains, a vast horizon, and the vaguely anthropological exhibitionism of the Indian figure in his natural

setting: it is into this recognizable Western panorama that Ayer & Sons asks the consumer to imagine the introduction of a whole new system of modern communication. The telephone is thereby presented as that which distinguishes modern society from its "uncivilized" past.

The ad mirrors Roosevelt's vision of the conquest of the West as the territorial concept of progress but aligns it now with a corporate ambition for a universal system linking all parts of the country. In arguing for commercialization as a civilizing force, AT&T's promotional campaign follows the earlier lineage of visual material that pictured the telegraph as a key player in the settlement of the country. A familiar example is American artist John Gast's 1873 landscape painting *American Progress* (Figure 3.5), which was distributed widely at the end of the nineteenth century.

A description engraved along the bottom edge of the print describes the large, female figure in the foreground as a "diaphanously and precarious clad America" who "floats Westward through the air with the 'Star of Empire' on her forehead." She bears in one hand a book representing "Common Schools" or knowledge, and with the other "she trails the slender wires of the telegraph that will bind the nation." The figure leaves behind her a great metropolis and an advancing railroad line (the East), while ushering ahead of her the brave pioneers who press forward across an uncivilized terrain of the West.

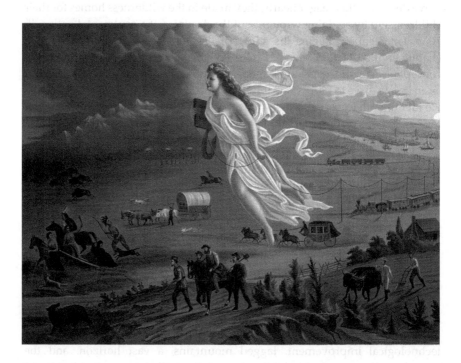

3.5 *American Progress*, John Gast, 1873

These symbols of progress chase away with unhurried confidence a band of "savage others," the feathered and half-naked figures that signified to the agents of incorporation a roadblock to what the explanatory text states is the "grand drama of progress in the civilization, settlement, and future history of the country."[23] The Native American is thereby rendered as an artifact of the past and, in recognition of its impending doom, the tribe glances back with a grimace of horror at the celestial being as she unravels the lines of telegraphy.

"Civilization—from Signal Fire to Telephone" (Figure 3.6) does not marginalize the Native American in the same blatant manner as Gast's painting. It did not have to. By the time the ad was released it was no longer necessary. Most Native Americans had surrendered to the larger firepower

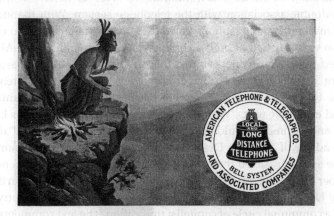

Civilization—from
Signal Fire to Telephone

THE telephone gives the widest range to personal communication. Civilization has been extended by means of communication.

The measure of the progress of mankind is the difference between the signal fire of the Indian and the telephone service of to-day.

Each telephone user has a personal interest in the growth of the whole telephone system.

He is directly benefited by every extension of his own possibilities. He is indirectly benefited by the extension of the same possibilities to others, just as he is benefited by the extension of the use of his own language.

Any increase in the number of telephones increases the usefulness of each telephone connected with this system.

The Bell System is designed to provide Universal service.

AMERICAN TELEPHONE AND TELEGRAPH COMPANY
AND ASSOCIATED COMPANIES

One Policy *One System* *Universal Service*

3.6 "Civilization—from Signal Fire to Telephone" ad, AT&T, 1911

wielded by the American government and its "free agents," the pioneers that usurped the lands of indigenous societies and, in the words of nineteenth-century journalist William Gilpin, "subdued the continent."[24] Free to relegate such tensions to the past, Ayer & Sons embraces a docile characterization of a former foe in its historical romanticization of the telephone's ancestry. As in the "Highways of Speech" ad and "The Clear Track" one before it, the telephone device itself is not pictured, the assumption being that consumers no longer need the manual object to connect telephone service with the country's continued history of technological progress. While making this dubious claim about its Native American lineage, the company at the same time distinguishes itself as the true signal fire of civilization.

By aligning progress to AT&T's commercial ambitions, as filtered through the idealization of modern communication, Ayer & Sons constructed a complex double association with the telephone system. With the increased use of transcontinental telephone calls, the company's ambition to conquer the nation was satisfied at both a commercial and symbolic level. Although the United States census determined that the frontier line (as measured by settlement westward) was all but eradicated by 1890, this comprehensive, pervasive telephone system assured the incorporation of the country as a social and economic unit. "Without telephone service as Americans know it, industry and commerce could not operate on their present scale ...," declares the 1922 ad "As if Across a Desk," noting: "The pioneers who planned the telephone system realized that the value of a telephone would depend upon the number of other telephones with which it could be connected."[25] In the 1923 ad "Cave Life or Civilization," industrialists from around the country grasp hands in a communal circle of capitalist unification. The text comments on the evolution of society through the cooperation of citizens for the common cause of the advancement of production. Civilized man, is said to: "require a market for his surplus products, and the means of transportation and exchange." "Interdependence," the ad concludes, "means civilized existence."[26]

By aligning the idea of "civilizing the west" to their commercial ambitions, AT&T's marketers rounded out their monopolistic advertising campaign that had started in 1908, when Ayer & Sons successfully applied transportation terminology to the language of telephony. At its simplest, the association would have encouraged subscriptions because it helped users adjust their accepted behaviors in order to navigate the new virtual space of telephonic communication. However, the more grandiose goal was to create an association in the consumer imagination between effective connections across space and the need for a telecommunications monopoly to oversee those connections.

The ads succeeded in promoting telephone subscriptions and in making AT&T a success. People embraced telephone use and AT&T obtained public support for a private monopoly until deregulation in the 1980s. As for Ayer & Sons, they soon found themselves in high demand. After all, through their

partnership with AT&T, the advertisers had proved that they were capable of constructing simple visual analogies that did no less than create popular sentiment for a corporate takeover of an entire competitive industry. But while their ads were ultimately about this economic dominance, their more significant success was selling new perceptions of space. The intangible, invisible domain of the telephone connection, they announced, is where commerce would increasingly happen, and in this calculation they were strikingly prescient.

Notes

1 George G. Steel, "Advertising the Telephone," *Printers' Ink* 51 (April 1905), p. 14.

2 N.C. Kingsbury, "Advertising Viewed as an Investment," *Printers' Ink* 93 (December 1915), p. 39.

3 James W. Carey, *Communication as Culture: Essays on Media and Society*, Boston: Unwin Hyman, 1989, p. 114.

4 The more scientifically minded also found cause to be skeptical as they experimented with the *unheimlich* qualities of electricity. As Thomas Watson recalled about the telephone: "The apparatus sometimes seemed to me to be possessed by something supernatural, but I never thought the supernatural being was strictly angelic when it operated so perversely." In Robert Cheatham, "The Post Human(ism) Factor," Lecture, June 1999, Nexus Contemporary Arts Center, Atlanta, GA.

5 Roland Marchand, *Advertising and the American Dream: Making Way for Modernity, 1920–1940*, Berkeley: University of California Press, 1985, p. 12.

6 Marchand, p. 12.

7 "Everyday Magic," AT&T, 1910, N.W. Ayer Advertising Agency Records, Archives Center, National Museum of American History, Smithsonian Institution (AC).

8 There is little documentation in the N.W. Ayer Advertising Agency Records of the journals in which specific advertisements were placed or the number of issues in which the ads ran. A review of several journals that printed AT&T ads at the time suggests the company ran one ad per issue in a particular journal for approximately a year before changing to a new ad. There might be different ads run in different journals at the same time.

9 "A Highway of Communication," AT&T, 1909, AC.

10 Morris Tanenbaum, "The Historical Evolution of U.S. Telecommunications," *Technology in Society* 15 (1993), pp. 264–5.

11 "The Clear Track," AT&T, 1910, AC.

12 "The Efficient Minute," AT&T, 1910, AC.

13 "A Bee-Line to Everyone," 1916 and "The Kingdom of the Subscriber," 1916, AT&T, AC.

14 Carey, p. 23.

15 "Right of All the Way," AT&T, 1912, AC.

16 "Right of All the Way."

17 "As if Across a Desk," AT&T, 1922, AC.

18 "Highways of Speech," AT&T, 1923, AC.

19 Theodore Roosevelt, *The Winning of the West*, New York: Putnam, 1903, p. 46.

20 Alan Trachtenberg, *The Incorporation of America: Culture and Society in the Gilded Age*, New York: Hill and Wang, 1982, p. 13.

21 Trachtenberg, p. 26. Turner's "Frontier Thesis," officially titled "Significance of the Frontier in American History," was read on July 12, 1893, before a session of the American Historical Association at the World's Columbian Exposition.

22 "Civilization—from Signal Fire to Telephone," AT&T, 1911, AC.

23 Trachtenberg notes that this section of the inscription is from an explanatory text on the reverse side of the image. Trachtenberg, p. 26.

24 William Gilpin, Report March 2, 1846 to the United States Senate, reprinted in Gilpin, *Mission of the North American People; Geographical, Social, and Political*, Philadelphia: J.B. Lippincott & Co., 1873, p. 124.

25 "As if Across a Desk," AT&T ad, 1922, AC.

26 "Cave Life or Civilization," AT&T ad, 1916, AC.

PART II

Products

PART II

Prelude

4

Pontiac Hood Ornaments: Marketing the Chief

Mona Hadler

Pontiac hood ornaments are striking examples of automotive mascots that matured in the flamboyant era of the 1950's.[1] These chrome emblems originated for a utilitarian purpose as decorative radiator caps on the outside of the hood. By the mid-1930s, however, they had become elaborate sculptures that functioned as a primary form of branding for the car manufacturer. The Pontiac mascot took a particularly distinctive form. First appearing as a Native American head adorned with feathered headdress (Figure 4.1), by the 1950s the ornament had morphed into the memorable configuration of jet plane with the head of Chief Pontiac at the helm (Figure 4.2).

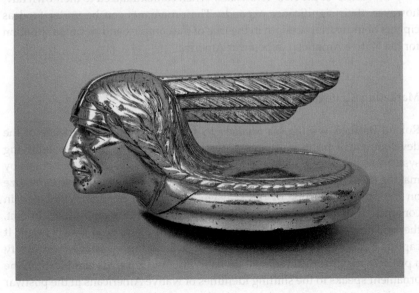

4.1 Pontiac radiator cap, General Motors, 1930

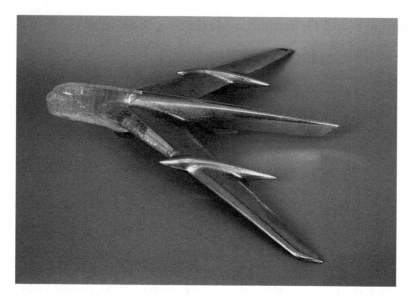

4.2 Pontiac hood ornament, General Motors, 1955

These beautiful and iconic designs continue to capture the public imagination today as they did when first produced. In fact, when General Motors announced the closing of its historic Pontiac division in 2009, it was the amber-headed chieftain that took center stage on the front page of the May 4th edition of the *New York Times*. When contextualized to their own day, however, their significance expands. The ornaments can be understood as ciphers of industrial strength in the face of the complex and troubled situation for the Native American in postwar America.

Marketing Strategies

Roland Barthes, writing his *Mythologies* from 1954–56, at the apogee of the development of the hood ornament, described advertising and other signifying systems as practices that served to artificially resolve social contradictions by making them appear natural.[2] General Motors may have wanted to capitalize on the primitivist trope of raw, savage energy and freedom, embodied in conjunction of Indian body and jet plane, for its automobiles, but, in fact, the car, branded by its iconic emblem, signified and sold much more. It captured and made "natural," tensions in society during what was in reality a problematic historical moment. In its hybrid and complex signification, the ornament speaks to the shifting identities of Native Americans in the postwar era when veterans returned from the front and hobbyists played Indian. At

the same time termination of federal responsibility of Native American tribes became the official US government policy and the red power movement of the 1960s was soon to be a reality. By allowing a difficult situation to seemingly be resolved within an elegant design, General Motors created a paradigm in this ornament of dissonant and new cultural formations, being magically subsumed under the wings of corporate patronage. As Charlie Wilson, then the firm's president, put it in 1953 when he accepted the position of Secretary of Defense: "I always thought that what was good for the country was good for General Motors, and vice versa."[3]

Since production of the car began in Pontiac, Michigan, the wily and strong leader became an apt symbol for General Motors. Chief Pontiac's name was first aligned with the car in 1926 when the new six-cylinder version went on the market and the company copyrighted a coin depicting the Chief and inscribed with the words, "Chief of the Sixes."[4] Chief Pontiac was the inspiration for over 40 different mascots from 1926 to 1955, the longest use of the same symbol each year by any carmaker in the United States.[5] The head of the chief, in fact, lingered on as a branding element until 1970 when it was used for the high beam indicator of the large models.[6] Pontiac, the son of an Ottawa father and Ojibway mother, lived from about 1720 to 1769. As the chief of the Ottawa Tribe, he united six tribes to assist the French against the British during the Seven Years' War.[7] His legendary reputation derives from his fierce, but ultimately unsuccessful, six-month siege of Fort Detroit, and his dream of building a united Native American front against the European colonizers. Native Americans, as is well known, became intertwined with consumer capitalism in America through the mass circulation of their imprint on coins, advertisements, and products from the late nineteenth century onward.

The use of Chief Pontiac, a strong but defeated warrior, as the trademark for the Pontiac for decades to follow, exemplifies the ubiquity of mascots and other forms of "playing Indian" in what has aptly been called a "celebration of the Indian sacrifice in the name of imperial progress according to the divine plan of Manifest Destiny."[8] To be sure, American cultural identity and fate of the Indian have always been interconnected and mascots, like masks, allowed for the endless replay of the dynamics of imperial power—in other words, the fiercer the enemy, the stronger the aggressor. When Avon Corporation, for example, marketed Chief Pontiac for its aftershave lotion, "Deep Woods," in 1940, it specifically cited the "determination, intelligence and courage of the famous Indian Chief" on its packaging. As product signifiers, such mascots attested to the triumph of America's consumer culture, so identified with megalithic corporations such as General Motors. Indeed, advertising images of the conquest of the Indian serve as an implied affirmation of the civilized status of consumers.[9]

Prime exemplars of this broader critique, Pontiac hood ornaments also existed at a specific historical moment that shaped its particular attributes. While different names appear on the patents for these ornaments, they were the products of the now famous Art and Colour division led by Harley Earl at General Motors which expanded in 1938 into the styling section. It was this group that was to create the 1948 Cadillac Coupe, the first car to sprout rudimentary tail fins. Even though the designers, working together in a guild like tradition[10] with Earl at the helm, had the final say in the overall look of the new vehicles, they avoided discussing specific design issues with the press. In the numerous interviews compiled by the Benson Ford Research Center, General Motors and Ford designers skirted the issues of style, imagery, or trademark branding. Art historian Edsen Armi notes their surprise at his own questions in 1983 as they were used to expounding on the subject of "firsts," such as when the first fin appeared, but rarely discussed artistic process or design issues.[11]

Nonetheless, the hood ornaments were carefully designed with attention to design and signification. They were part of a total design concept, credited to Earl, where all elements reinforce each other aesthetically. As designer Virgil Exner Jr remembers it, no detail was too small for consideration:

> You may attribute it to Harley Earl, but it was the idea of having a continuity of design where each detail, be it a bumper, and that was considered a detail at that time, or a radiator ornament, or a door handle, or any type of a molding, that every piece of ornamentation would look like it was designed to go with the basic body itself as well as every other detail.[12]

Designer Audrey Moore Hodges, one of the few women in the field, is unusual in taking credit for a specific design of a hood ornament. She remembers with pride winning a 1947 contest for the design of the Studebaker ornament.[13] Moore Hodges recalls that she was pleased since, in this collaborative brainstorming environment, few designs ever found their way onto an actual car.[14]

The Art and Color section became known for introducing a new model annually in the spirit of "dynamic obsolescence." Alfred Sloan, the chief executive officer of General Motors, promoted this policy—a reflection of the company's realization during World War II that consumers ranked styling as their primary consideration in purchasing cars.[15] David Gartman has outlined the steady usurpation of power by the designers over market researchers and even engineers. By 1932 the GM sales division had surveyed over a million motorists and concluded that primarily practical concerns led to their buying preferences. In deference to these results the company designed a tailored car with little chrome embellishment. It failed financially, thereby supporting Earl's growing fantastical aspirations[16] which lead ultimately to the lavish

1950s automobiles with enough brightwork, or metal ornamentation, for designer Raymond Loewy to deem them "jukeboxes on wheels."[17]

Hood Ornaments: Evolution of Style

The head of Chief Pontiac first appeared on radiator caps in the 1920's for Pontiac's new six-cylinder car. After 1935, when the radiator was buried under the hood of the car, designers continued to use the motif on ornaments bolted to the hood which grew to be called "hood ornaments" in common parlance. The initial mascots sported a realistically rendered if exaggerated zinc die-cast head of a Native American colored red by copper plating or chrome plated as in Figure 4.1, and marked by three feathers tailing behind. In the early 1930s General Motors had released the first of five versions of the Indian head in a ring which remained the prototype for Pontiac's advertising logo. In keeping with prevailing design aesthetics of the time, by the late 1930s the head had grown into a stylized long, low profile with streamlined feathers trailing behind, resembling the elegant locomotives of the period (Figure 4.3). The ornaments sat perched on the car's distinctive "silver-streak" trim of parallel chrome lines that adorned the hood from 1935 to 1956 and subtly evoked a metaphorical railroad or runway.

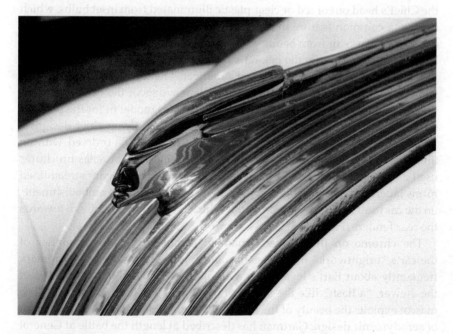

4.3 Pontiac hood ornament, General Motors, 1937

The silver streak, designed during Frank Hersey's tenure as head of the Pontiac studio,[18] marked the onset of the employment of recognizable branding devices for marketing automobiles. Since by 1935 General Motors had instituted the use of body interchangeability among their various models, the adoption of distinguishing motifs became crucial to individualizing a particular make. The Pontiac mascot then, as an integral element of the successful silver streak design theme, formed a major factor in the car's branding. The sleek streamlined forms of the "Indian/train/runway" emblem mirrored the growing use of decorative streamlining that marked the design of both cars and trains of the late 1930s. The streamlined shells of these vehicles acted in part to obscure the workings of the actual machinery with glossy exteriors that denoted speed and progress. In this sense, the ornament was a model for the car as a whole, and a harbinger for the future, with a design that evoked speed but had parted ways with concerns for function.

World War II had a pivotal effect on General Motors car design as the company became a leading military contractor making its mark with torpedoes launched from aircraft. Hence their 1940's torpedo series with an elongated hood ornament that shot out from the front of a car whose body terminated gracefully in sloping, rear fender panels, as seen in the 1942 streamliner torpedo sedan coupe. At this time the company also experimented with plastic, a material of choice for war equipment, and it began producing the Chief's head out of red or clear plastic illuminated from inset bulbs, which became a common feature in the hood ornaments. Red or amber plastic (or sometimes glass), lit from behind, replaced the red copper of earlier decades, but continued to conjure the pejorative epithet "redman" or "redskin."

In 1949 the feathers of the Native American's headdress began to sprout stubby wings that grew into the wide airplane wings of the 1950 mascot for the Chieftain Catalina Hardtop, a luxurious Pontiac model fit for the postwar spending spree (Figure 4.4). This was the first of six flying chief designs.[19] The ornament, zinc die cast and chrome plated, could be ordered with an illuminated amber plastic face insert, a feature that Pontiac sales brochures used as a prime marketing strategy. The sleek mascot's elegant streamlined forms tapering off at the edges of the wings echo the chrome embellishments on the car itself which sweep across the vehicle's body tapering down towards the rear fenders (Figure 4.5).

The chrome on the Pontiac ornament complements the remainder of the car's "brightwork" in its linearity and luminescence. Designers remark frequently about Earl's love of the material that would shine in the eyes of the viewer, "a flash" like the ascent of a plane or the flash of money.[20] The mascot exploits the beauty of the metal as its rounded edges capture the grace of aerodynamic design. Gartman has described at length the battle at General Motors between functional streamlining advocated by the engineers and aesthetic streamlining, the brainchild of the designers.[21] The purely decorative

and semantic elements of the ornament place it in the latter and "winning" camp and underscore its use as a distinctive symbol for a car that emphasizes the sense of movement and speed that asserts the power of technology. In this regard the ornament falls heir to the beauty of the industrial aesthetic from the 1920s and 1930s at work in the tapered forms of Brancusi's 1926 *Bird in Space* or the shape of the outboard propeller featured in the Museum of Modern

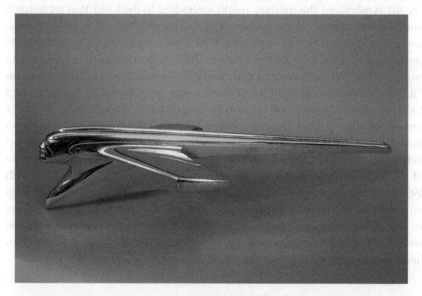

4.4 Pontiac hood ornament, General Motors, 1950

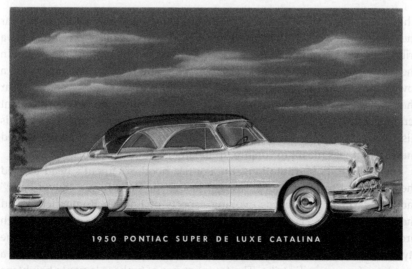

4.5 Pontiac advertisement, General Motors, 1950. Photograph by Alden Jewell

Art's 1934 exhibition "Machine Art." At the same time its kitschy amalgam of machine and man nods back to art deco—as in the Chrysler radiator cap as machine/eagle gargoyle in the 1930 building—and forward to the Populuxe designs of the 1950s.

The flying mascot's sleek body, trailing behind the bold, simplified features of Chief Pontiac, is replete with glistening surfaces and tapering forms. Its swept wings were modeled after the jet planes of the period and in that regard symbolized the military might embodied in the Cold War jet fighters and bomber planes. In the words of one designer, "We liked jet airplanes, we liked flashiness, we liked power."[22] At work was a language of corporate power and machismo linked as much to the technical imagery of planes as to tropes of the Native American male body.[23] General Motors did produce an "Indian Maiden" mascot for a few years in the mid-1930s, but the male chief took precedence. As the Indian converts into its technological other, Pontiac's ornament appropriates the raw power of the myth of the savage body so associated with the Indian warrior, and transforms it into a streamlined extension of the car's force as moving energy. Indeed, the cultural stereotype of the Native American living freely in wide open spaces was in sync with 1950s notions of jet-age freedom. A comparable mascot with other ethnicities no doubt would have been untenable. Many hood ornaments by carmakers in the 1950s were modeled wholly after jet planes, but Pontiac retained recognizable features in its mascots, specifically that of the canonical Indian head, making its pairing with the jet all the more suggestive.

Primitivist Discourse and Historical Context

The era of these mascots had ended by 1956—significantly the same year the US government decided to terminate its responsibility for the Ottawa tribe[24]—when Chief Pontiac's face was replaced by the nose of the plane. In the late 1950s, with the extension of the tail fin and the movement towards a lower, more simplified end, automobile designers focused more on the rear than the front of the car with the exception of rounded bumps on the front fenders called "dagmars" after the buxom actress.[25] For the purposes of this discussion, it was the Pontiac car then, in its entirety, more than the retired mascot, that was meant to conjure up the image of the jet plane.

Through all its permutations, the Pontiac hood ornament's head evoked the primitivist trope of "noble savage" just as the Rolls Royce "Silver Lady" radiator cap can be seen as evoking aspects of English Romanticism and the grill Palladium classicism as argued by Erwin Panofsky in 1937.[26] With prominent brow and long nose, the Pontiac hood ornament resembles the stylized face on the Indian nickel more than a particular individual or a member of any specific tribe. The frequent use of amber elements heightens

this association and puts it in line with the primitivist discourse of the mythic Abstract Expressionist art of the 1940s. Writers such as John Graham and Carl Jung [27] classified Indians with other "primitives" as evolutionary children in spite of new ideas of cultural pluralism put forth by the Franz Boaz school of anthropology associated with Columbia University. Some writings, however, were more subtle such as the text for the Museum of Modern Art's popular exhibition, "Indian Art of the United States" held shortly before the attacks at Pearl Harbor.

Rene D'Harnoncourt's essay for the exhibition veers away from adopting a primitivizing myth by pointing out the Native Americans' ability to renew themselves by exploiting resources and new technologies. He cites Navajo silversmithing and Plains horsemanship as examples.[28] Co-author Frederic Douglas initiated the first Indian fashion show in 1941 with a similar agenda. Women were encouraged to adopt Indian clothing as contemporary fashion, rather than as atavistic or folkloric attire.[29] Native Americans, according to D'Harnoncourt, could become an important factor in building an America of the future, because they both preserved tradition and used the resources of the present—a tantalizing construct when applied to the Pontiac mascot, an amalgam of the "primitive" and the modern.

During the war itself, the status of the Native American became complicated. It was no accident that Johnny Cloud or Navaho Ace, the 1960s comic hero who inspired Roy Lichtenstein's 1963 painting *Whaam!* (Figure 4.6), was based on a fictionalized World War II pilot. [30] Native Americans had played an important role in the war and were touted as fierce fighters. Notwithstanding some resistance based on religious beliefs, they enlisted en masse. Authors Alison Bernstein and Kenneth Townsend[31] have recorded the contributions of Native American soldiers in great detail. Navajo Code Talkers and Ira Hamilton Hayes's involvement at Iwo Jima have become legendary. Perhaps less well known is the number of Native Americans who served in the Air

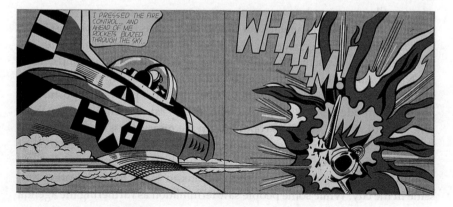

4.6 Roy Lichtenstein, *Whaam!*, 1963

Force. The most prominent, General Clarence Tinker, an Osage, served as commander of the army Air Corps based in Hawaii. Killed at Midway, he was awarded the Distinguished Service Medal. Others whose photographs appear in Townsend's book include Ensign Thomas Oxendine, a Cherokee, and Sergeant Gilbert Eaglefeather, a Sioux, who flew in the Eighth Air Force Division. By the end of the war Indians had received 71 air medals and 34 distinguished flying crosses, the highest aviation honor.

Native Americans were trained in aviation, commanded ships, earned commissions, and rose to high-level ranks. Unlike African Americans, they were considered white and were integrated into the armed forces. The media emphasized their bravery in battle, but this became a double-edged sword because it reinforced the stereotype of American Indians as blood thirsty savages that dominated movies and popular media. Native Americans were characterized as having innate fighting abilities—better coordination, eyesight, and survival skills honed from a putative closeness to nature. One magazine described Indians performing a war dance prior to battle, with a "fury of drums and savage rhythm." The article ends with the warning, "watch out Hitler—the Indians are after your scalp."[32] Even the *New York Times* got into the act by comparing a 1945 Sioux Sun Dance to one performed in 1876 before General Custer's Cavalry was wiped out.[33] As early as 1944, prominent Indian activist and writer, Ella Deloria, decried this stereotyping of Indian fighters as savages[34] that was nevertheless ubiquitous.

Major Red Hawk, for example, was a 1940s comic character who, even as a Native American aviation hero, sported a headband, wore buckskin pants, and remained virtually naked to the waist.[35] Indeed, like our Pontiac mascot, Indian soldiers during the war were generally referred to as "chief" by their white comrades[36]—a recalcitrant epithet. In 1960s comics, for example, Johnny Cloud is called "chief" and praised for his keen Navajo eyesight. The name garnered even more visibility from Ken Kesey's famous character "Chief" in his 1960 book *One Flew Over the Cuckoo's Nest*, and its 1975 Academy Award-winning film.

The period from 1945, when John Collier resigned as Indian Commissioner, to 1953, when the US government's policy of termination began with the passage of House Concurrent Resolution 108, was a time of ferment and change for Native Americans. Veterans who had received fair pay in the war and fought as equals with whites did not garner the same postwar opportunities as their comrades. By 1950 the unemployment rate for Indians was three times that of whites[37] and dire conditions in the reservations were exposed in the press.[38] The situation became more complex with the implementation of the termination policy that took an assimilationist stance with the Voluntary Relocation Program that encouraged Indians to leave the reservation and settle in the city. While some people saw termination as furthering the agenda

of land-hungry whites, others saw it as a positive step toward freeing Indians from paternalistic governmental policies.[39]

As early as 1944, Ella Deloria advocated a hybrid position, arguing for the rejection of both forced assimilation and cultural separatism; instead, she argued, Native Americans should retain their own culture while also learning new skills.[40] American Indian Veterans, however, who were accustomed to being called "Chief" during the war, returned to school under the GI Bill, became activists, and joined new Indian-led groups such as the National Congress of American Indians. They maintained that the government had a one-sided approach to casting off its responsibilities to the Indian population. By 1958 the NCAI position that no tribe should be terminated without its permission became official government policy. The decades from the end of the war to the 1960s, with the rise of the Red Power Movement, clearly were stormy interim years during which debates on self-determination and assimilation abounded.

Hybridity and the Postwar Native American

This history, so eloquently put forth in Bernstein's book, underscores the ambiguous position of the Indians in postwar America—independent or protected, self-determining or assimilated, rural or urban, traditional or modern, "primitive" or advanced, savage or educated. It was in this hybrid context that the development of the Indian/pilot hood ornaments occurred. The amalgam that conjoined the stereotypical "redman's" face to the sleek, modern, technologically advanced jet planes captured, among other things, the dilemma of the postwar Native American in the quandary over tradition and assimilation. It could be argued, however, that the graceful design dulls the tension and in that way furthers General Motors' positive marketing agenda.

As a hybrid image the Pontiac mascot of the 1950s engaged in various discourses central to the era and anticipated a more contemporary discourse on the blending of cultures. For example, in its mixture of the industrial and the preindustrial, it touched on issues of commodification central to the tourist production of the day, one dimension of which eschewed the industrial in a quest for the authentic. As one critic wrote, essentialist discourses hate hybridity, but mixed items were legion.[41] The 1952 Indian fashion show is a case in point. James Clifford further problematizes the issue of precolonial authenticity in his well-known critique of the Museum of Modern Art's 1984 primitivism exhibition when he asks why there were "relatively few 'impure' objects constructed from the debris of colonial culture contacts?" or why no Samoan men wear wristwatches in the Hall of Pacific Peoples at the Museum of Natural History?[42] He includes a photograph of a New Guinean girl adorned

with photographers' flash bulbs in his section on affinities not included in the show. Like the Pontiac hood ornament, it forms a binary in which each part problematizes the other and questions the entrenched authority of the modern. Yet in the last analysis, images such as the one used by Clifford exploit the element of disjunction as a critical tool, whereas the elegance of the corporate design of General Motors naturalizes and neutralizes its content.

With the explosion of the mass culture in the 1950s the public developed an almost insatiable appetite for kitsch objects, providing authors with an equal desire to lambast what they saw as this pernicious and frivolous production of capitalism.[43] Since a kitsch sensibility flourished in the kind of hybrid borrowing and combinations found in hood ornaments, it is not surprising that Umberto Eco, writing on kitsch in the 1960s, used the Rolls Royce as a quintessential example: "Kitsch is the winged figure that adorns the hood of a Rolls Royce, a Hellenistic touch meant to evoke the prestige of an object that should instead obey more honest aerodynamic and utilitarian criteria. Kitsch is the Volkswagen beetle that flaunts the hood of a Roll Royce or the stripes of a swanky sports car."[44] While Eco argues that in this regard kitsch denudes the object of its interpretative tension, more recent studies, such as the writings of Celeste Olalquiaga, argue for its hybrid power. For her, kitsch is postmodern. By selecting motifs at random and mixing them together, it transgresses boundaries and destabilizes hierarchies.[45] Kitsch markets nostalgia just as iron leaves and glass flowers naturalize machine made objects, or save what it has destroyed.[46] In the kitschy Pontiac amalgam then, the new—the jet plane— conjoins nostalgically with the old—the old West. The new industrial power, by this reasoning, saves what it has destroyed.

The discourse of hybridity relates as well to the American love of playing Indian which reached new heights in the hobbyist culture of the 1950s. In his book, *Playing Indian*, Philip Deloria aligns the practice with personal liberation in the carnivalesque tradition. He traces the phenomenon from the Boston Tea Party, through the growth of the Boy Scouts and Camp Fire Girls, to the Cold War era. Playing at "going native" allowed white Americans the freedom to partake in the "authentic primitive" in the face of growing industrialization. In the postwar decades, Deloria argues, during the period of termination, the notion of identity became increasingly unstable. Relocation helped to create inter-Indian communities in urban centers that held powwows on the weekends that were also open to white hobbyists.[47] The Native Americans who sang at these gatherings changed clothes to work at the factory alongside the whites who donned the headdress to impersonate the chief on the weekend. Along these lines we might ask who, in the Pontiac mascot, is "playing Indian"? Who has removed his worker's garb to don the headdress and play Indian by conquering the "wide open spaces" in the new frontiers of the jet age? And we might further question whether the driver/consumer of the powerful Pontiac performs the role of the chief himself, ready, in 1956,

to command a sleek jet/car 40,000 miles across the country's newly mandated interstate highway system.

Conclusion

The symbolism of the 1950s automobile, as encouraged by Madison Avenue marketing strategies, was a subject of much speculation even in its own day. Freudian associations, not surprisingly, were particularly newsworthy. The ubiquitous sexual symbolism in the advertisements fed the imagination of visual artists from Richard Hamilton to James Rosenquist. According to the well-known adage of the 1950s, put forth by Ernst Dichter, president of the Institute for Motivational Research, the car was a "she." Men saw the convertibles as their mistress and the hardtop as their wife.[48] For Marshall McLuhan, the car was more androgynous, functioning as both a "womb symbol and paradoxically enough, as a phallic power symbol."[49] This subject could be controversial as is evident in the case of designer, Roy Brown, who reportedly lost his job for outraging censors by overtly discussing the sexual symbolism of cars on public television.[50] In a chapter called "The Ad and the Id" from a popular 1958 book, *The Insolent Chariot*, author, John Keats, lambasted the "penile" ornaments of the period and concludes by asking:

> How much of this is appreciated by the average conscious mind is open to serious question. What is not open to question is the fact that Detroit believes, and operates on the theory that Americans don't buy automobiles, but instead buy dreams of sex, speed, power and wealth.[51]

Consumers, as we have seen, answered questions practically, but bought cars emotionally.

Madison Avenue was adept at catering to these emotional needs through their controversial use of motivational research or MR. Vance Packard, who exposed this practice in his 1957 book, *The Hidden Persuaders*, cites General Motors as one of the large corporations to use MR by 1954.[52] MR proponents argued that advertisement worked by indirection, using symbolism and associational language. Followers of "creative" advertising, such as Bernbach, shared this attitude as well.[53] The point here is not to linger on well-known tropes of the phallic automobile or to argue for the effectiveness of covert advertising symbolism as put forth by MR. In fact, few authors today espouse MR's notion of advertising's effect on the naive viewer and rather tend to stress the complicated relationship between the ad and consumers. But what is clear is that 1950s designers attended to their symbolism, a point emphasized by the characters in the current award-winning American television series, *Mad Men*, set just a few years after the demise of the ornaments. Clearly 1950s advertisers realized the need to associate their messages with the mindset of

their audiences. Just as the complex signification regarding Native Americans would not have gone unnoticed, so too would the mandate of corporate optimism have informed their design strategy.

General Motors wanted to sell and Pontiac sales soared in the postwar era. The car with the Indian plane mascot at the helm was a marketing success story similar to the popular Indian motorcycle whose production ended in 1953. The Pontiac was a lower-to-middle priced vehicle designed to appeal to a general public. Pontiac advertisements stressed the lower-priced car's mass appeal,[54] reiterating the slogan "Dollar for dollar you can't beat a Pontiac" or characterizing their clientele as populist: "From the North, East, South and West they came and from people in every walk of life." Writing in 1961 about this era, Raymond Williams called advertising the "official art of the capitalist society."[55] General Motors was a sophisticated marketing entity and its designers were commercially and psychologically savvy. The Indian/ airplane mascot topped a highly successful product and the company chose to continue its use until 1956 when it, like the Ottawa tribe, was terminated and notions of Red Power were waiting in the wings. As Dick Hebdige argues, dominant classes frame the discourse in a hegemonic way, "so that subordinate groups are, if not controlled; then at least contained within an ideological space which does not seem to be at all 'ideological': which appears instead to be permanent and natural ..."[56]

General Motors captured and made "natural" a complexity of signification concerning Native Americans in the postwar era for consumers who watched "savages" on television, donned Native American regalia on the weekend, and played Indian in a carnivalesque mode. In the Pontiac hood ornaments they renewed myths of authenticity and replayed superiority over a conquered people, while at the same time accepting the language of termination which was soon to spawn a language of revolt.

Notes

1 This chapter expands on my earlier article, "Pontiac Hood Ornaments: Chief of the Sixes," which appeared in the *Journal of the Society for Commercial Archeology* 28, 1 (Spring, 2010), pp. 6–15. I would like to thank Louisa Iarocci for her excellent suggestions and close reading of the different versions of this chapter.

2 Roland Barthes, *Mythologies*, trans. Annette Lavers, New York: Farrar, Straus and Giroux, 1972.

3 Charlie Wilson, quoted in Susan Buck-Morss, "Envisioning Capital: Political Economy on Display," in Lynne Cooke and Peter Wollen, eds, *Visual Display, Culture Beyond Appearances*, New York: Dia Center for the Arts, 1995, p. 113.

4 Walter W. Harris, *Pontiac Mascots, Hood Ornaments, Trademarks*, Toledo, Ohio: Walter R. Harris, 2000, 2nd ed. 2005, p. 2. This self-published book by the collector and engineer has a wealth of information. Pontiac's ornaments were first cast by Ternstedt Manufacturing Company and from 1940 on, by the BLC Company. See Harris, p. 5, for casting numbers and logos.

5 Harris, p. 2.

6 According to John Sawruk, General Motors Pontiac historian, "After that, we had to use the international symbol per the MVSS regulations. The current Pontiac red crest is in the form of an arrowhead; the star in the center is from the 1954 Pontiac Star Chief." Email communication to the author, July 17, 2007.

7 Two books from the time chronicle the story: Howard L. Peckham, *Pontiac and the Indian Uprising*, Princeton: Princeton University Press, 1947, and Francis Parkman's nineteenth-century book, *The Conspiracy of Pontiac*, 1851, reprint, Toronto: Crowell-Collier Publishing Company, 1962.

8 C. Richard King and Charles Fruehling Springwood, *Team Spirits: the Native American Mascots Controversy*, Lincoln: University of Nebraska Press, 2003, p. 9.

9 Ellen J. Staurowsky, "Sockalexis and the Making of the Myth of the Core of Cleveland's 'Indian' Image," in *Team Spirits*, p. 91.

10 See also Barthes on the Citroen, p. 88.

11 C. Edson Armi, *The Art of American Car Design: The Profession and Personalities, "Not Simple Like Simon,"* University Park: The Pennsylvania State University Press, 1988, p. 170.

12 *Reminiscences from the 1989 Interview with Virgil Max Exner, Jr Automotive Design Oral History, Accession 1673, Benson Ford Research Center*. Henry Ford Museum and Greenfield Village, Dearborn Michigan. Web. p. 18. Ford's interviews have been helpful for this chapter. General Motors' design historian, Julie Long, in a telephone conversation on April 9, 2009, maintains that General Motors has had an ambivalent attitude towards their own history and for a variety of reasons material has been destroyed, while the Ford company, being originally a family business, has kept better records.

13 *"Reminiscences from the 1985 Interview with Audrey Moore Hodges. Automotive Design Oral History, Accession 1673, Benson Ford Research Center*, Henry Ford Museum and Greenfield Village, Dearborn Michigan. "It was like a torpedo. I had worked at Willow Run … so I had some ideas of what streamlining should really look like … It probably wasn't very original in those days, but, at least, it was selected by the sales staff that made all the selections." Web.

14 Reminiscences with Audrey Moore Hodges, "It sounds so ridiculous to make such a big deal about a hood ornament, but if one considers that out of the entire styling sections, how many people in that styling section ever get anything on a car. They work for years … I, at least, in my first attempt, got something on a car."

15 Alfred P. Sloan Jr, *My Years with General Motors*, Garden City, New York: Doubleday and Company, Inc., 1964, p. 277.

16 David Gartman, *Auto Opium, A Social History of American Automotive Design*, New York: Routledge, 1994, p. 108.

17 Raymond Loewy, "Jukeboxes on Wheels," *Atlantic Monthly* (April, 1955), p. 36.

18 Reminiscences of Virgil Max Exner Jr, See also, Michael Lamm, "The Beginning of Modern Auto Design," *The Journal of Decorative and Propaganda Arts* 15 (Winter-Spring, 1990), pp. 76–7.

19 Harris, p. 93

20 Gartman, pp. 110, 129

21 Gartman, p. 127

22 *Reminiscences from the 1984 Interviews with John Najjar, Automotive Design Oral History Accession 1673, Benson Ford Research Center*, Henry Ford Museum and Greenfield Village, Dearborn Michigan. Web.

23 Erika Doss has convincingly shown that the Indian was the male worker most often shown in the nude in the 1930s and 1940s, "Toward an Iconography of American Labor: Work, Workers, and the Work Ethic in American Art, 1930–1945," *Design Issues* 13/1 (Spring, 1997), p. 64

24 The 84th congress (1956) passed legislation releasing federal control of the Ottawa. See Arthur W. Watkins, "Termination of Federal Supervision: The Removal of Restrictions over Indian Property and Person," *Annals of the American Academy of Political and Social Science* vol. 311, American Indians and American Life (May, 1957), p. 51. There was, of course, a lag between the design of the car and its appearance on the market.

25 Thomas Hine, *Populuxe*, New York: Alfred A. Knopf, 1986, p. 96. There were forces other than aesthetic contributing to the change. By the late 1950s some hood ornaments were considered a safety hazard. Chrysler, in reaction, developed an ornament that would flip down in a collision.

26 Erwin Panofsky's 1937 essay is reprinted in, "The Ideological Antecedents for the Rolls-Royce Radiator," Irving Lavin, ed., *Three Essays on Style*, Cambridge, Mass: MIT Press, 1997.

27 For Jung's views see, for example, Carl J. Jung, "Your Negroid and Indian Behavior: The Primitive Elements in the American Mind," *Forum* (April, 1930), pp. 193–9.

28 W. Jackson Rushing, *Native American Art and the New York Avant-Garde, A History of Cultural Primitivism*, Austin: University of Texas Press, 1995, p. 115. See his subtle discussion of the Museum of Modern Art exhibition, pp. 104–20.

29 Nancy J. Parezo, "The Indian Fashion Show," in Ruth B. Philips and Christopher B Steiner, eds, *Unpacking Culture, Art and Commodity in Colonial and Postcolonial Worlds*, Berkeley: University of California Press, 1999, pp. 243–63. The fashion show was initiated by Dr Frederic H. Douglas, curator of the Department of Native Art in the Denver Art Museum. It was held over 180 times between 1947 and 1956, when he died.

30 Kirk Varnedoe and Adam Gopnik, *High and Low: Modern Art and Popular Culture*, exh. cat., New York: The Museum of Modern Art, 1990, pp. 200–201 For Lichtenstein's long-standing interest in Native American culture, see Gail Stavitsky and Twig Johnson, *Roy Lichtenstein: American Indian Encounters*, exh. cat., Montclair, NJ: Montclair Art Museum, 2006, pp. 7–36.

31 Alison R. Bernstein, *American Indians and World War II: Toward a New Era in Indian Affairs*, Norman: University of Oklahoma Press, 1991 and Kenneth William Townsend, *World War II and the American Indian*, Albuquerque: University of New Mexico Press, 2000.

32 Townsend, pp. 133–4, *Indians at Work*, 10 (July-August 1942), p. 17.

33 "Sioux Begin Sun Dance Today," *New York Times*, 6 August 1945, p. 17.

34 Ella Deloria, *Speaking of Indians*, New York: Friendship Press, Inc, 1944, p. 141.

35 Major Red Hawk first appeared in Blazing Comics #1, Enwill Publishing, but his tribe is not named. Johnny Cloud first appeared in DC Comics in 1960 as part of the *All American Men of War* series, with Robert Kanigher as the writer and Irv Novik the artist.

36 Townsend, p. 140 and Bernstein, p. 40.

37 Bernstein, p. 150

38 Howard A. Rusk, M.D., "Death and Disease Reflect Neglect of American Indian," *New York Times*, 8 April 1951, p. 43.

39 Bernstein, p. 175

40 Ibid., p. 128 and Deloria, *Speaking of Indians*, pp. 144–63

41 Philips and Steiner, *Unpacking Culture*, p. 10 and Philips, "Nuns, Ladies, and the Queen of the Huron, Appropriating the Savage in Nineteenth-Century Huron Tourist Art," *Unpacking Culture*, p. 35

42 James Clifford, *The Predicament of Culture: Twentieth-Century Ethnography, Literature, and Art*, Cambridge, Mass: Harvard University Press, 1988, pp. 192, 202.

43 See, for example, Gillo Dorfles, *Kitsch, The World of Bad Taste*, New York: Universe Books, 1969.

44 Umberto Eco, "The Structure of Bad Taste," in *The Open Work*, trans. Anna Cancogni, Cambridge, Mass: Harvard University Press, 1989, p. 205.

45 Celeste Olalquiaga, *Megalopolus, Contemporary Cultural Sensibilities*, Minneapolis: University of Minnesota Press, 1992, p. 41.

46 Celeste Olalquiaga, *The Artificial Kingdom, On the Kitsch Experience*, Minneapolis: University of Minnesota Press, 1998, pp. 38–9

47 Philip J. Deloria, *Playing Indian*, New Haven: Yale University Press, 1998, p. 142. See also his discussion of the carnivalesque tradition, p. 7.

48 John Keats, *The Insolent Chariot*, Philadelphia: Lippincott, 1958, pp. 72–5 discusses this idea and relates it to the writings of Ernest Dichter, the President of the Institute for Motivational Research.

See also Karal Ann Marling, *As Seen on TV: The Visual Culture of Everyday Life in the 1950s*, Cambridge, Mass: Harvard University Press, 1994, p. 356.

49 Marshall McLuhan, *The Mechanical Bride, Folklore of Industrial Man*, Boston: Beacon Press, 1951, p. 84.

50 Reminiscences with John Najjar, *1673*.

51 Keats, p. 71.

52 Vance Packard *The Hidden Persuaders*, New York: Ig Publishing, 1957, reprint 2007, p. 64.

53 *High and Low*, p. 317.

54 See Adrian Room, *Dictionary of Trade Name Origins*, New York: Routledge, 1982, p. 140.

55 Raymond Williams, "Advertising the Magical System," in Simon During (ed.), *The Cultural Studies Reader*, New York: Routledge, 1993, p. 334.

56 Dick Hebdige, *Subculture and the Meaning of Style*, London: Routledge, 1979, p. 16.

The Store Mannequin: An Evolving Ideal of Beauty

Gayle Strege

Department stores in America developed concurrently with museums in the late nineteenth century, and in their early years shared similar methods of displaying their "merchandise." Following the "cabinet of curiosities" approach, department stores and museums both crowded their wares onto shelves or in display cases, and in the case of stores, into the store's windows. While elaborate means were not required to present various forms of store merchandise in a way that could evoke desire in passing customers, the display of clothing did require some type of three-dimensional figure to give it "life" and make it appealing to the customer.

Dressmaker's dummies were the first figures to perform the role of store customer in window displays; however they were quickly replaced by mannequins with more "human" characteristics. The mannequin was created solely for the purpose of being a human surrogate, and an idealized one at that. It performs a complex role in the practice of selling merchandise since it must act both as a functional store fixture while also representing the customer. These figures are meant not only to represent us as consumers, but also to create in us a desire for the merchandise they are selling by also being the contemporary aesthetic ideal in face and figure that society deems desirable. As the desired "us," they need to evolve aesthetically to reflect our image of ourselves, and our fashionable ideals of beauty as they shift over time. Only in so doing could mannequins continue to be successful sales "people."

Ideals of feminine beauty and body type shift over time in the same way as styles in fashion and architecture evolve. They are influenced by developments in art, medicine and technology and shifts in politics and social expectations. What is considered attractive in one time, or one culture for that matter, is not necessarily thought of as such in another time or place. "Beautiful" women of the late nineteenth century had ample rounded hourglass figures with small waists, heads, hands and feet. If one were not so

blessed naturally, busts and hips were padded to create that shape. Numerous images of these ideal women are depicted in the illustrations and fashion plates of various women's magazines of the time, or in the studio postcards of famous actresses. At the turn of the century a different feminine ideal appears, reflecting an emerging interest in athletic pursuits. She is a tall, slender and more athletic looking figure as depicted by Charles Dana Gibson's famous illustrations and personified by Princess Alexandra, wife of Edward Prince of Wales. This tall and more active ideal was herself replaced in the 1910s by a young girlish model with very little curves, represented by actress Mary Pickford or Clara Bow's 1920s "It" girl flapper.[1] Feminine ideals of beauty and fashion continued to evolve throughout the remainder of the twentieth century into more mature figures that were again replaced by youthful ones. Economic hardship, followed by war and subsequent population boom, technological advancement, and economic prosperity all worked together to influence changes in humankind as well as the environments and material culture we created around us, including our retail venues and products of visual merchandising.

Shifting ideals of beauty and body type affect changes in clothing fashions, which in turn have an impact on mannequin design. The former must inevitably affect the following in order to be a viable product to meet consumer demand, and mannequin design must logically follow body type and fashion change to be an effective visual merchandising tool. Therefore, this chapter will take a chronological approach to studying the evolution of changing beauty ideals, fashion history, and mannequin design.

Early Mannequins

A painted wooden torso form with an attached head was found near a clothing chest in King Tutankhamen's tomb when it was discovered in 1922. It may have been used to support or display garments, but while some consider this to be the earliest known mannequin, the form is without arms or legs.[2] By definition, "mannequin," alternately spelled "manikin," derives from the Dutch word "maneken" and translates as little men.[3] Currently, a true mannequin may or may not have a head, but it should have arms and legs covered with some semblance of a human skin. While this skin can be any color, historically it was painted to mimic the variations of human flesh, predominantly European Caucasian, and the heads were painted, either realistically or abstractly, to resemble faces.

The ancestors of today's store mannequins were dolls dressed in French fashions that traveled to the royal courts of Europe as early as the late fourteenth century to communicate the latest fashions in clothing and hairstyles throughout the continent.[4] The earliest mannequins were

constructed exactly like these dolls, with realistic looking heads and arms made of wax, eyes of glass, and fabric bodies filled with sawdust, however they were life-size. Over the intervening years, mannequin faces and bodies evolved as they became a mainstay of retail and display practices. While continuing to communicate fashionable trends in styles of dress, they also reflected advances in technology, societal shifts in ideals of feminine beauty, and changing practices in visual merchandising.

The establishment and growth of the great retail department stores in Europe and America in the mid- to late nineteenth century, in conjunction with the development and introduction of ready-made clothing sold in those stores, created a demand for a means by which to display and sell that merchandise. Headless and armless dressmaker's dummies and tailor's draping forms were the first "human" figures effectively used for this task. They were quickly repurposed from having a sole function as a manufacturing tool to being a successful device for display as well.

These dress forms were a good beginning as human stand-ins, but they were incomplete. They lacked the arms and heads deemed necessary to create a desired realistic display of a human figure that could adequately showcase a fashionable costume's necessary accessories of gloves and hats. While they also did not have realistic legs, these were not yet mandatory. During the Victorian and Edwardian periods, long skirts were the clothing fashion and women's legs were rarely seen—especially in public displays —so legs on display forms were not required. Many forms were perched on three-footed stands, having an expandable wire or metal "skirt" attached to the bottom of the torso form to fully support and display the skirts of fashionable dresses (Figure 5.1). Fred Stockman, a Belgian mannequin manufacturer, was one of the first to add heads and limbs to simple torso forms in the 1870s, producing more lifelike and animated mannequins. These appendages were made of wax or papier maché. He also installed joints in the fingers, arms, and legs to provide more articulation[5] and the appearance of movement.

The availability of large pieces of plate glass helped drive the demand for mannequins during the decades of the second half of the nineteenth century. Relatively inexpensive pieces of plate glass began to appear in the 1860s as prices for flat glass fell and it became affordable for all types of building construction. The center of plate glass manufacturing moved from Europe to the United States at the beginning of the 1880s, making this glass even more affordable for use in American department stores.[6] Large windows were installed in commercial emporiums as they shifted their focus from wholesale to retail. The purpose of these windows was no longer simply to let light into these establishments in order to see display cases, tables, and shelves stacked with merchandise, but to display that merchandise artistically in the window and entice the customer into the store for its purchase. This was the beginning of a new profession, that of the "window trimmer" or display artist, and

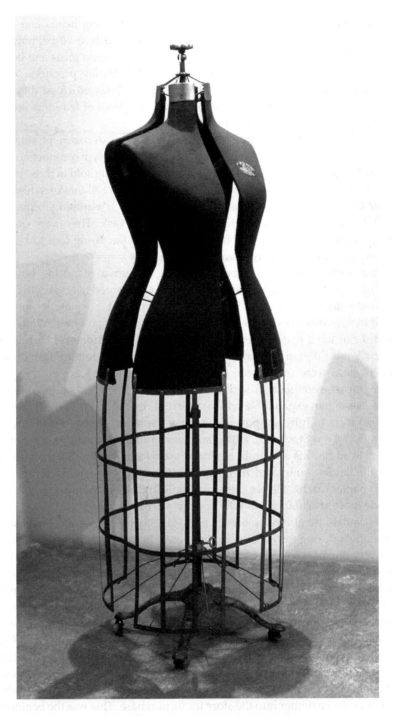

5.1 Expandable dressmaker's form with metal cage skirt, 1908–12

mannequins became one of his (because they were all men at this time) most important tools. Mannequins were expensive merchandising tools, and as such were used in the premiere advertising locations—store windows.

By the turn of the century, market demand for realistic mannequins to put in store window displays in both Europe and the United States led to the establishment of professional workshops in Brussels, Rome, Berlin, London, and Paris. Dutch artist Pierre Imans established his studio at this time when mannequin design rivaled the artistic qualities of sculpture. Imans was regarded as the most famous mannequin designer/manufacturer of his day due to his skills and techniques with manipulating wax to create extremely lifelike mannequins. He not only created lifelike figures but gave them gestures that made them appear to interact with one another—delicately sculpted raised hands and heads slightly turned to create a hint of movement. His creations were made similarly to wax figures found in the popular wax museums of the day, and, like those in wax museums, were figures with recognizable faces of well-known politicians and actresses,[7] capitalizing on their popularity. Imans's mannequins were made in the style of the fashionable ideal body of the time—full bosom, small waist, and full hips—following the shape of the dressmaker's form used to manufacture current fashionable dress. After all, the clothing to be sold was made to fit this figure ideal, so the mannequin in turn had to fit the clothes it was selling, reflecting a co-dependence of art and commerce.

Those body parts of the mannequin hidden by clothing, and not visible to the public eye, did not need to be beautiful. They were made out of papier maché and covered with canvas. However, the visible portions—face, hands, and neck—required a realistic appearance and were produced in wax (Figure 5.2).[8] The head was the most important part of the mannequin, requiring a true artisan in its manufacture. Its features were often sculpted from live models and then transferred to clay molds. Similar to the production of figures in waxworks museums, the hot wax was poured into molds, and when the wax was set but still warm and soft, the hair and glass eyes were added, followed by the teeth, which were the same teeth dentists made to replace lost human ones. The most painstaking process of creating the head was the addition of the hair. Each strand was individually inserted into the head with a needle. The process for eyebrows was the same. Each head took one working day to make.[9]

In 1897 *The Show Window, A Monthly Journal of Professional Window Trimming* began publication in the United States. Its editor, L. Frank Baum, was a former "displayman" of Macy's (and future author of the *Wizard of Oz* books). The journal regularly offered advice on window trimming techniques and featured photographs of creative window displays from around the country.[10] Although realistic wax mannequins were available and desirable, they were not widely featured in the photos of the early years of publication. Few American retail stores were using them in their window displays because

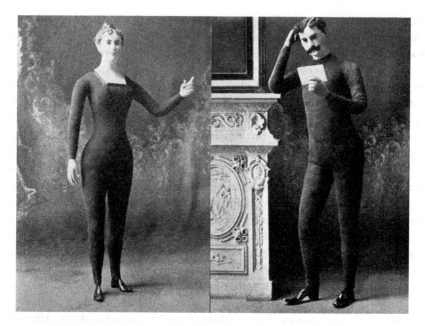

5.2 Flexible form mannequins with jointed fingers and wax heads manufactured by Hugh Lyons & Co., Chicago, 1897–98

at this time mannequins were manufactured primarily in Europe and as such were too expensive for all but the major stores. However, even Arthur Fraser, display director for Marshall Fields in Chicago and, according to the journal, "America's foremost artist in window display,"[11] did not use wax mannequins in his theatrical museum quality window displays until 1912.[12] Rather he used headless dressmakers' dummies.

Although remarkably realistic looking, the wax figures were ultimately impractical for window display use. In addition to being expensive, they weighed approximately 250 pounds and were difficult to move. The figures also required too much specialized handling to keep clean and looking fresh.[13] Their biggest disadvantage, however, was that the wax used to create them had a low melting point. While this made it possible to create realistic-looking scenarios by softening and molding a mannequin's fingers to grasp a fan, handbag,[14] or parasol, a mannequin in a store window that received too much direct exposure to the sun or had a spotlight shining on it too directly could suffer drastic consequences.

Marshall Field would not allow the use of wax mannequins in his store while he was alive because he did not want to leave his namesake store open for ridicule or an embarrassing moment such as one he had witnessed on a trip to New York. While passing a store with wax mannequins in the windows, Field noticed that one of the mannequin's heads had fallen onto its bosom

because the sun had melted its neck.[15] In a 1946 feature for the *Saturday Evening Post*, Anne O'Brien and Warner Olivier also recount a story from earlier in the century about this very same problem happening in Macy's windows—when display director Irving Eldredge left for a weekend after putting up a display, he returned to find the heads of his mannequins resting on their chests.[16]

In spite of their problems, wax mannequins were used into the 1920s precisely because they appeared so lifelike and thus appealed to consumers. Many display artists wanted their customers to identify with the figures in the windows so they would be inspired to purchase the products shown. Therefore, the more naturalistic and human the mannequins looked, the easier it was for customers to relate to them. By 1926, in his *Handbook of Window Display*, William Nelson Taft writes that the "displaying of merchandise in the proper way has come to be recognized as the most valuable advertising, the greatest sales-producing medium." He also states that, "… the customer is influenced to look upon the model [mannequin] as a replica of herself." It is no wonder then that he also notes that realistic wax mannequins were preferred to dressmakers "dummies" at this time because they were "beautiful and lifelike," while the dummies made the merchandise "appear ridiculous to the critical customer."[17]

In addition to wax figures, realistic looking mannequins made of papier mâché were developed following World War I and used in the 1920s. These were preferred by Arthur Fraser and other display men over the wax models because they were equally lifelike but lighter in weight and did not have the melting problem. In an interview after working 49 years for Field's, Fraser stated that he "always aimed to be realistic" in his displays and "tried to get the mannequins so real the woman would feel it was she wearing it."[18] This creation of desire in the consumer was a collaboration between the mannequin makers who made the figures and the display artists who brought them to life. Later in the twentieth century, American mannequin manufacturers would employ noted display artists as consultants in mannequin design.

A New Art Form

Throughout the teens and early 1920s, realistic-looking mannequins reigned supreme in store windows, often in *tableaux vivants* settings in front of elaborate *trompe l'oeil* backdrops reminiscent of museum dioramas. They were the best of mannequin royalty, displaying only the finest of merchandise. With them, the window display trade arose to the realms of art,[19] ably assisted by the likes of Arthur Fraser. By 1925, however, their reign came to an end.

The years following World War I saw many changes in the worlds of art and fashion. The ostentatious Victorian and Edwardian aesthetic of clutter was being cast aside in favor of the cleaner and more streamlined look of art

deco and the abstraction of three-dimensional forms into the flatter geometric planes of Cubism. Fashionable styles of dress and beauty ideals also changed. A more athletic and straight boyish figure dressed in simpler clothes began to take precedence over the decorative and embellished curvy female forms of the late nineteenth and early twentieth centuries. Changes in clothing styles reflected this straighter aesthetic as well. Loose, untailored dresses reflected the flat planes of Cubism and gradually shortened to the position of the knee — the length of a young girl's dress — revealing more of this new feminine form's lower regions. Clara Bow's youthful "It Girl" gradually replaced the aging "Gibson Girl" as the feminine ideal.

In order to stay current with the changes in art, fashion, and feminine body ideals, mannequins had to change as well. The new clothing styles did not go well with the full-bosomed realistic figures who now looked too matronly and out of place wearing youthful fashions. A new figure that reflected this younger, post-World War I customer was required, and one that now needed legs, as hemlines rose.

The 1925 Exposition des Arts Decoratifs in Paris and its US tour to New York, Chicago, and Boston in 1926 was a turning point for mannequin design. Canadian businessman Victor-Napoleon Siègel, director of a mannequin factory, had merged with Fred Stockman to form Siègel & Stockman. They introduced a stylized mannequin at the exposition that presented the clothing creations of the top Paris fashion designers, including Chanel, Paquin, Lelong, Lanvin, and Vionnet. This Art Moderne mannequin had more in common with a sculpted statue, having face and molded "hair" of the same material as the rest of the body, unlike the wigs of past wax figures. Her face was long and angular and her small eyes were no longer glass, but also of the same material as the rest of the mannequin.[20] Lester Gaba, an American designer of mannequins a decade later, described this 1920s aesthetic as "pointy." According to him, mannequins had "pointed lips, coiffures, eyebrows, and elbows" as well as pointed toes, and carried "gloves from pointed fingers."[21] The Art Moderne figure soon replaced realistic mannequins in the windows of the major department stores.

Siègel argued that the old realistic wax figures did not fit in with new architectural and decorative styles, and could no longer adequately reflect the luxury of goods often displayed in department store windows. They would be seen as too old fashioned and out of place, so something "modern" was needed instead.[22] Realism's strict imitations of nature were abandoned in favor of artistic stylization. The mannequin as "art form" and representation of the modern female customer was summed up by a writer for *Vogue* magazine:

> The art of the mannequin, which did not previously exist, has now been perfected ... By means of the simplest techniques, the artist has succeeded in evoking the complex personality of the modern well-dressed woman, who is a creature of luxury but at the same time full of life ... A new art form has been born.[23]

For Siègel & Stockman the process to create these art forms began in 1922. Jérôme Le Maréchal, director of Galeries Lafayette in Paris, asked for mannequins to be created from contemporary fashion drawings instead of live models.[24] Fashion illustrations were the primary means of communicating current clothing fashions, and the graphic designs appearing on the covers of fashion magazines such as *Vogue* and the *Gazette du Bon Ton* by artists such as Georges Barbier, Erté, Paul Iribe, and Georges Lepape captured the new and desired aesthetic.

These new mannequins had bodies and legs cast in one piece with arms cast separately. They were molded from head to foot in papier maché, with a hollow interior that made them light but solid.[25] Less weight made them relatively easy to move, but their one-piece length was still unwieldy. Poses of these mannequins were more varied than the standard three options of the wax figures—right foot forward, left foot forward or both feet together[26]—and they were more action oriented, bringing life and youthful movement to the clothes and the displays themselves.[27]

Ironically, the trend for this stylized mannequin was relatively short-lived. By 1929, her popularity, along with that of the flapper, was already waning. The crash of the stock market toward the end of that year brought with it a sobering return to realism and the Great Depression took its toll on American stores' ability to purchase from the great European mannequin houses. In addition to Siègel & Stockman and Pierre Imans in Paris, Gottwald in Vienna and Paul Bashowitz in Berlin had been the reigning kings of mannequin production.[28] Although stylized mannequins would continue to be used into the 1930s, they would do so alongside newer mannequins who were returning in appearance to a more realistic look[29] in a number of American-produced cousins.

Americans, Movement, and Personality

The aesthetic pendulum regarding mannequin design swung back toward realism in the 1930s, but now with a new emphasis on personality. The abstract, cold statue-like qualities of the "Art Moderne" style mannequin gave way to a variety of body types that could be seen for a short time in European store windows representing all social classes, from old to young and fat to thin.[30] This was not the same realism of the stiff wax figures of previous decades, however, but a hybrid of the super-realistic wax figure plus abstract stylization. The result was figures with faces having a type of stylized realism with a quality that was almost cartoon-like or mask-like. This overall style of mannequin continued into the 1960s with minor variations (Figure 5.3).

Since the beginning of the century, a growing cultural interest and participation by women in leisure and sports activities such as swimming,

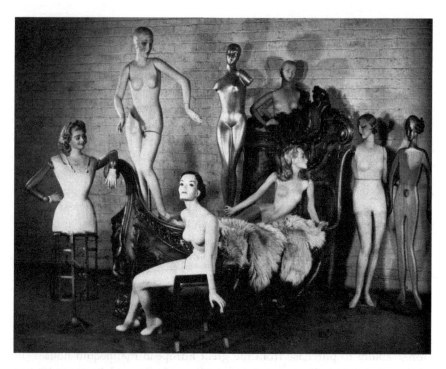

5.3 Mannequin styles including wax, abstract and stylized realism from 1900–50 showing changing technology and ideals of beauty, arranged by James David Buckley for *The Drama of Display*, 1953[31]

skiing, golf, and tennis affected ideals in body type, clothing fashion, and mannequin design that coalesced in the 1930s. Body-hugging clothing styles revealed the slim, long, and lean athletic ideal female form much more than the 1920s loose-fitting, rectangular-shaped dresses. Evening gowns of the period even reflected the popularity of sports activities with skin-revealing low-cut backs similar to those found on bathing suits. Hollywood films, a great popular escape from economic woes during the 1930s, featured movie stars who reflected this new ideal of athletic beauty—a bit more mature than the 1920s flapper, but still boyishly slim—a sort of hybrid of Gibson Girl and flapper.

Mannequins reflected this changing societal attitude toward women and sports and the popularity of Hollywood. Mannequin artists and manufacturers during this decade made their creations appear more active and lifelike by giving them the appearance of motion through use of lighter weight materials and innovations such as interchangeable limbs with removable hands that made action poses possible.[32] They also gave their designs distinct personalities; some based on Hollywood film stars or high-society celebrities.

American department stores and Fifth Avenue boutiques used European-made mannequins during the 1920s, but there was some criticism that those

mannequins looked too Germanic and not enough like their American women customers. Lester Gaba, in an article on display mannequins for *Advertising Arts* magazine in 1929 suggested using American movie stars as a solution. Mary Lewis, then Vice President of the store Best & Co., read the article and asked Gaba to design that store's new mannequins. Working in tandem with Richard Terhune, Best's Display Director, they introduced the "Gaba Girls" in 1930. Modeled after "typical" American girls, these mannequins were youthful, slight caricatures with cute contemporary molded plaster hairstyles and perky upturned noses. One even had freckles and was pigeon-toed. They were cheerful looking and came in action poses, standing on tip-toe or running,[33] in contrast to the stoic and static realism of their wax grandmothers whose foot positions were limited.

Following the Gaba Girls success, the store B. Altman asked Lester Gaba for an exclusive set of mannequins inspired by society's most fashionable and popular women, and Saks Fifth Avenue wanted yet another group to personify the typical Saks customer. These were described by Leonard Marcus as having a "thirties type of beauty and worldliness" with "bold glances ... snub noses and heavily rouged lips." One of the Saks mannequins was based on Cynthia Wells who modeled clothes in Saks custom salon. Gaba liked it so much he ordered one for himself, naming her Cynthia. She became quite the celebrity in her own right, receiving invitations to society events, escorted by Gaba, and had stories written about her in the popular press.[34] Cynthia came to an unfortunate demise, however, when she fell off a chair and her plaster body shattered to pieces.

Lester Gaba eventually got around to creating mannequins based on Hollywood film stars like Greta Garbo, Marlene Dietrich, and Carole Lombard in 1937. However, Cora Scovil, another renowned American mannequin designer/manufacturer of the decade, had already done so two years previously with a series based on Garbo, Joan Crawford, and Joan Bennett.[35] Before retiring in 1935, Scovil mentored two other American women innovators in the mannequin business, Lillian Greneker and Mary Brosnan. Greneker had a great interest in creating mannequins that had more flexibility and greater mobility than the 1920s figures that stiffly combined legs and torso in one piece. She developed a figure with a flexible waist in 1933 and later formed the Greneker Corporation in 1937 with Edgar Rosenthal to manufacture mannequins. The action-oriented Greneker golfer, tennis player, and diver mannequins all modeled sportswear in the windows of Lord & Taylor.[36] Mary Brosnan went on to become the most important American mannequin designer of the 1940s.

By the end of the decade, this mature flapper girl had evolved into a "broad-shouldered, big busted Amazon of a mannequin with over long legs"[37] who appeared on the scene as the new body ideal. Reflecting a shift to the Joan Crawford look created for the Hollywood actress by MGM designer

Gilbert Adrian, this silhouette remained the standard beauty ideal until after World War II when Christian Dior's 1947 "New Look" set the new standard of beauty and fashion.

War and Recovery

During the World War II years, America no longer had access to European mannequins so American manufacturers D.G. Williams, with designers Mary Brosnan and Lilian Greneker, increased domestic production to fill the void.[38] Subject to shortages of raw materials, mannequins had faces that reflected the seriousness of their time, with downcast eyes and grave expressions (Figure 5.4). Depending on where they were made, the materials were either plaster or papier maché. Plaster mannequins had molded plaster hair while papier maché mannequins wore wigs of horsehair.[39] Wartime era L-85 regulations in the US regarding lengths of skirts, along with the broad-shouldered and slim-hipped beauty ideal, helped to create a decidedly masculine and utilitarian look in women's fashions during the first half of the decade. Mannequin design reflected these regulations as well since their legs needed to be shortened[40] to accommodate the shorter skirts.

After wartime austerity, visual display in general entered a period of "elaborate extravagance." Increased budgets resulted in veritable armies of mannequins both in the interiors of stores and their windows. The newest and best mannequins were always reserved for the windows, since this was the first point of contact with potential customers, while older mannequins were retired to a store's interior. Department stores also began to have branch locations in addition to those located in a city's downtown center, and those needed mannequins too. Once again produced exclusively out of papier maché, displayman and author William Herdeg referred to them as "featherweight" in comparison to the more fragile earlier plaster figures. Body poses, surface finishes, and hair became less serious and more natural and lifelike. Wigs were made of human hair or a recently developed nylon fiber, makeup was brighter and more colorful, and fingertips had bright red nail polish.[41]

Instead of the unsmiling faces prevalent during the war years, mannequins during the late 1940s postwar years looked "happy and prosperous." Some of them even wore a radiant smile. They appeared happy to have their men back on the home front and ready to start living again. The realistic mannequins Mary Brosnan created at D.G. Williams were modeled after real individuals, but rather than exact copies, they represented a broad spectrum of society, from young college girls to suburban matrons.[42] Contrary to Lester Gaba, Brosnan believed that a "mannequin shouldn't force its own personality on customers."[43]

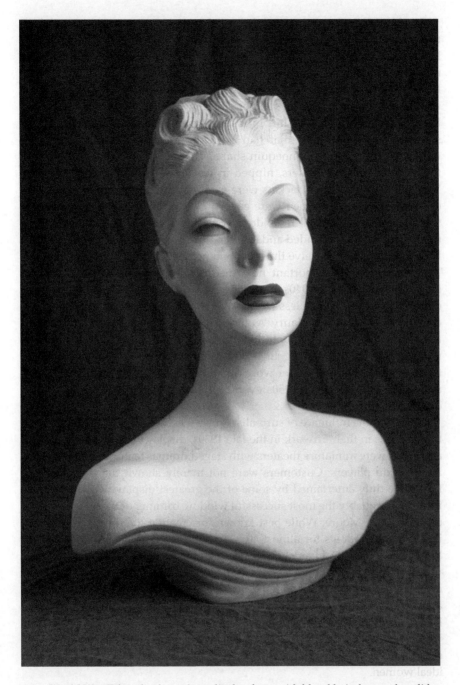

5.4 World War II female plaster bust display form with blond hair, lowered eyelids
and unsmiling lips

In 1948 Mary Brosnan created the "New Look" mannequin just when the postwar fashions created by Christian Dior were hitting the stores. Harry Callahan, display director of Lord & Taylor remarked that, "These mannequins sold more dresses than any other mannequin in display history."[44] But it is not entirely certain whether it was the mannequin that sold the dresses, or the style of clothing itself (Figure 5.5). The "New Look" was such a drastic shift in fashion from the broad-shouldered and slim-hipped female form that had been the ideal during the war years that it required a new mannequin shape. This new feminine aesthetic had the softer sloping shoulders, nipped-in waist, and full-rounded hips of a Victorian woman. Dior's jackets were even padded at the hip to create the desired fuller look. Women were eager to leave behind the old utilitarian wartime fashions and all their dour connotations for the decidedly more feminine look. This rounded and more mature figure fit the image of a fertile Madonna ready to conceive the baby boomer generation.

Plastics were an important new medium implemented in mannequin design throughout the 1940s and 1950s, making it possible to create greater detail in features, to have less weight overall, and to use nylon wigs in place of molded plaster hair. Maury Wolf and David Vine perfected a fiberglass figure in 1950 that was revolutionary for mannequin design. Now even more lightweight and strong, fiberglass mannequins could easily be moved, taken apart and stored, never wore out and rarely needed repairing. Many mannequins of the early 1950s even took on a "plastic doll" quality that dominated the decade.[45]

Following the influence of surrealist artists who were fond of using display mannequins in their artwork in the late 1930s, display windows of the 1940s and 1950s were miniature theaters with staged dramas featuring mannequins as the main players. Customers were not merely shown the merchandise; they were duly entertained by some of the greatest displaymen of the time, including arguably the most successful window trimmer of the late twentieth century, Gene Moore. While best known for creating the miniature dramas in Tiffany's windows for almost 40 years, he served as display director for Bonwit Teller and Delman shoes prior to that in the 1940s and 1950s. Moore was also the chief idea man for Greneker Corporation in the 1950s. Like those of Lester Gaba, Moore's mannequin designs were based on popular models and movie stars of the era such as Suzy Parker, Audrey Hepburn, Vivien Leigh, and Rosalind Russell. However, they, like Mary Brosnan's figures, were not line for line copies. They were more perfect than the mere human, exaggeratedly feminine and intimidatingly beautiful[46]—idealized versions of ideal women.

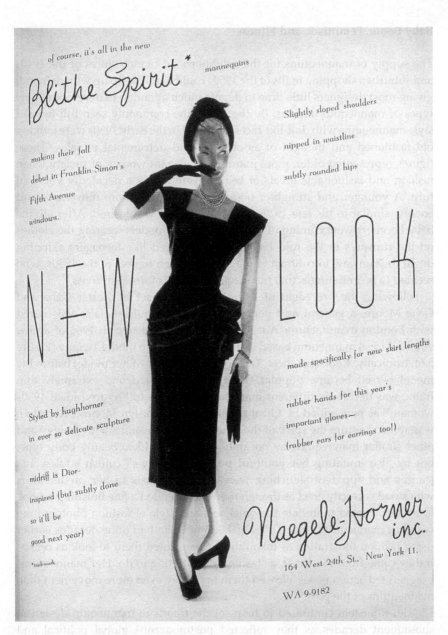

5.5 New Look Mannequin c.1949

Baby Boom, Feminism, and Fitness

The supply of mannequins for the neighborhood branch stores of the 1940s and suburban shopping malls of the 1950s could barely keep up with demand, giving most designers little time to devote much attention to developing new types of mannequin designs. By the 1960s, the commonly seen full-figured style mannequins with doll-like faces launched in the early 1950s were looking old fashioned and thought of as obsolete and detrimental to sales. These figures represented older, more mature and elegant women of society when fashion and fashionable ideals of beauty were taking a decidedly youthful turn. A younger and straighter body type, depicting more movement and energy, similar to the late 1920s and 1930s trend, was desired. After all, the baby boomers were coming of age and were the models wearing the clothes on the runways in the mid-1960s. They appeared like teenagers skipping down the runway, in contrast to the stately poised figures of the 1950s, who seemed to be imitating actual mannequins by their formal stiffness.[47]

Following the precedent of using top models set by Lester Gaba and Gene Moore, a general and pervasive anti-mannequin malaise was cured with London manufacturer Adel Rootstein's introduction in 1966 of a new youthful ideal mannequin based on the popular British model Twiggy (Figure 5.6). Ironically, Rootstein chose Twiggy for the figure of her model before the model herself became popular. Twiggy's flat-chested and extremely thin frame was decidedly different than the voluptuous full-figured ideal 1950s woman,[48] as personified by Elizabeth Taylor and Marilyn Monroe. Rootstein was able to capture the spirit of the time in her mannequins with Twiggy and other similar mannequins by not only creating the ideal beauty body type, but by also imitating her youthful posture. Twiggy's "coltish adolescent" stances and apparent slouching were direct contrasts to her predecessors who stood correctly erect as though they had attended a fine finishing school. Rootstein wanted to imitate the quickness and style of fashion photography with her mannequins, much as Siègel & Stockman had done decades earlier using fashion illustration as inspiration. She wanted them to look as real as if they came from the street, as fashion was starting to do. Her mannequins' exaggerated action poses allowed them to convey even more movement than mannequins of the past.[49]

Adel Rootstein continued to help set the trends in mannequin design in subsequent decades as they reflected postmodernist global political and societal changes. Mannequins with facial features of Asia and the African diaspora[50] reflected a greater acceptance of those races and their civil rights within European and American populations. Mannequins with loose breasts and prominent nipples in the 1970s reflected women's liberation from more than the brassiere as did those with clenching fists.[51] Saks Fifth Avenue's decidedly older-than-teenage customers could see themselves reflected

in a mannequin designed by Henry Callahan in 1972. The "Contessa" represented a woman in her mid-thirties.[52] Increased interest in health and fitness beginning in the 1980s and continuing into the 1990s and beyond also affected mannequin designs: the thin bodies of the Twiggy-era mannequins started looking like they had been exercising and developed muscle mass and definition.[53]

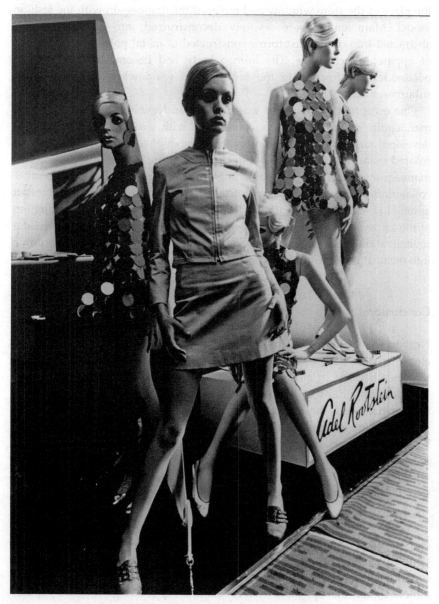

5.6 Twiggy and her likeness, launched in 1966 by Adel Rootstein

Interest in more abstract versus figural display forms returned with the advent of increasingly abstract developments in art and as downtown department stores with their large display windows declined throughout the 1970s, 1980s, and 1990s in favor of the popularity of windowless suburban malls. Mannequins in store windows were no longer the first contact with potential customers as television and print media advertising had usurped the place of the store window and replaced the mannequin with the fashion model. Mannequins were severely deconstructed into body parts and abstracted into minimalist forms constructed of metal poles for the display of apparel merchandise. The human body had become a deconstructed postmodern abstraction in the soulless and windowless environs of the suburban mall.

One exception to this trend was Barney's in New York, who hired Pucci mannequin manufacturers to collaborate with artist Andre Putman to develop a signature mannequin for their flagship store in 1985. This ivory-colored mannequin with a stone finish and built-in "shoes" inspired further mannequin design that was sometimes semi-abstract. It also led to further collaborations between Pucci and artists Ruben Toledo and Lowell Nesbitt among others in the 1990s. Ralph Pucci saw this work as "an intermingling of the art world, design world and visual merchandising."[54] It represented a revitalization of the mannequin manufacturing industry that would continue into the next millennium fueled by a new and burgeoning consumer culture.

Conclusion

Next to the merchandise in a store or store window, the most important elements in creating a sale are the visual merchandising tools used to present that merchandise in an attractive and appealing manner. Mannequins are the most important of these tools because they represent us, the human consumers, using the commodities on display that merchants want us to purchase. Changing ideals of beauty, fashion, and body type brought about by social, aesthetic, and political shifts have altered our perception of our ideal self-image over time. So too have mannequins, as mirrors of how we wish to look, evolved to accurately reflect our image of ourselves and create that desire within us to purchase not only what we see, but who or what we want to be.

As society ideals of stately Victorian and Edwardian matrons, who were responsible for doing the majority of shopping in a household, gave way to youthful flappers in a prosperous decade of seemingly unlimited credit, so too did hourglass-shaped wax mannequins with no legs give way to trim athletic figures that appeared to run or stand on tip-toed legs. Idolized popular Hollywood actresses and society celebrities were personified in plaster to

raise the nation out of Depression and wartime utility, and create a collective desire to emulate their appearance and their luxurious lifestyle. After World War II, a romantic return to femininity helped soften the hardships of the past and look eagerly to a more hopeful future. And as that future arrived in a maelstrom of teenage angst and energy, newly enfranchised adolescents laid the romantic dowager to rest.

Changing forms of mannequins relate directly to changing ideals of body type that are also reflected in changing fashions in clothing, because clothing is the commodity that mannequins sell. They must also reflect the cultural and social aesthetic prevalent during any given time period in order to appear attractive and create desire in the consumer they represent. More than merely a display armature, mannequins are a complex mechanism in the visual merchandising toolbox and play a special role in the art and practices of selling.

Notes

1 Lois W. Banner, *American Beauty*, New York: Alfred A. Knopf, 1983, p. 5.

2 Emily and Per Ola d'Aulaire, "Mannequins: Our Fantasy Figures of Fashion," *Smithsonian Magazine*, vol. 22 (1) (April 1991), pp. 66–77 and Catherine Gewertz, "The Mannequin as a Form of History: Collector Hopes to Display Collection, Archives in a Museum," *Los Angeles Times*, 17 March 1988.

3 Mari Davis, "The Mannequin Defined," *Fashionwindows.com*, 1 May 2002. Web.

4 d'Aulaire and d'Aulaire, pp. 69–71.

5 Nicole Parrot, *Mannequins*, New York: St. Martin's Press, 1982, pp. 42–3.

6 PPG Industries, Inc., "A Historical Look at Glass: The History, Its Nature and its Recipe, 1996–1999," Web. Sara K. Schneider, *Vital Mummies: Performance Design for the Show-window Mannequin*, New Haven & London: 1995, p. 10.

7 Marsha Bentley Hale, "Wax Mannequins Body Attitudes: Body Attitudes of Mannequins Part III," *Fashionwindows.com*, 8 August 1999. Web. Parrot, p. 44.

8 Parrot, p. 46.

9 Parrot, p. 47 and "Life History of the Lady and Gentleman in Wax," *New York Times*, 16 March 1902.

10 Gayle Strege, "Influences of Two Midwestern American Department Stores on Retailing Practices, 1883–1941," *Business and Economic History Online* vol. 7, (2009).

11 According to *The Merchant's Record and Show Window* (formerly *The Show Window*) in 1922, ST Publications Archives.

12 Marshall Fields Archives, Arthur Fraser Papers.

13 William Nelson Taft, *Handbook of Window Display*, New York: McGraw Hill, 1926, pp. 221–4.

14 Henry F. Callahan, "Fashion Display," in National Retail Dry Goods Association, *Display Manual*, New York: National Retail Dry Goods Association, 1951, p. 18.

15 Marshall Fields Archives, Arthur Fraser Papers.

16 Anne O'Brien and Warner Olivier, "The Lady in the Window," *Saturday Evening Post*, (20 July 1946), p. 27. The incident happened prior to 1925.

17 Taft, pp. 1, 220 and 222.

18 Marshall Fields Archives, Arthur Fraser Papers.

19 Taft, p. 220.

20 Callahan, p. 18, Parrot, p. 83 and 86, and Schneider, pp. 11 and 127.

21 Lester Gaba, *The Art of Window Display*, New York: Studio Publications, 1952, p. 18.

22 Schneider, p. 127.

23 *Vogue*, 1 August 1925 in Parrot, p. 90.

24 Parrot, p. 70.

25 Parrot, p. 86.

26 "Who Created the First Mannequin?" *Fashionwindows.com*, 24 April 1999. Web.

27 Walter Herdeg, *International Window Display*, New York: Pelligrini and Cudahy, 1951, p. 139.

28 O'Brien and Olivier, p. 27

29 Parrot, p. 121.

30 Parrot, p. 114.

31 James David Buckley, *The Drama of Display: Visual Merchandising and its Techniques*, New York: Pelligrini & Cudahy, 1953.

32 Leonard S. Marcus, *The American Store Window*, New York: Whitney Library of Design, 1978, p. 37, Schneider, p. 71, and Callahan, p. 19.

33 Parrot, pp. 139–40, Gaba, pp. 10–11, Callahan, p. 19, and O'Brien and Olivier, p. 26.

34 Gaba, p. 11–12, and Marcus, p. 36.

35 Parrot, p. 140, Schneider, p. 72, and Eric Feigenbaum, "The 1930s: Fashion, Art and Hollywood," *VMSD*, 3 May 2001.

36 Marcus, pp. 36–7, and O'Brien and Olivier, p. 85.

37 Callahan, p. 19.

38 Eric Feigenbaum, "The 1940s: Guadalcanal to Levittown," *VMSD*, 11 July 2001.

39 See Callahan, p. 19 and Parrot, p. 159–60. Parrot refers to WWII mannequins made of plaster during this time while Callahan recalls papier maché mannequins.

40 O'Brien and Olivier, p. 26.

41 Herdeg, p. 140 and Parrot, pp. 181, 199, 203.

42 Mari Davis, "Mannequins During the 1940s," *Fashionwindows.com*, 8 May 1999, Web. Schneider, p. 73.

43 Elizabeth M. Fowler, "Mannequins Limn Mores; Mannequins a Reflection of Mores," *New York Times*, (22 Feb 1970), p. 11.

44 Callahan, p. 19.

45 Callahan, p. 19. Marsha Bentley Hale, "From Plaster to Fiberglass, Body Attitudes of Mannequins Part VIII," *Fashionwindows.com*, 8 August 1999. Web. Parrot, pp. 184 and 199.

46 Schneider, pp. 18 and 74.

47 Schneider, pp. 121–2.

48 Schneider, pp. 75 and 122, and Mari Davis, "How Mannequins Are Conceptualized," *Fashionwindows.com*, 6 October 2000. Web.

49 Schneider, pp. 75 and 80.

50 See Schneider, p. 78 for a discussion on "first" mannequins with "negroid" features. A 1935 picture of a Detroit store window in Marsha Bentley Hales's Mannequin Museum Archives shows a "premiere showing of first all-colored mannequin."

51 d'Aulaire and d'Aulaire, pp. 73–4.

52 Eric Feigenbaum, "The 1970s: Street Theater and Anti-Fashion," *VMSD*, 20 September 2001.

53 d'Aulaire and d'Aulaire, pp. 74–5 and Schneider, p. 80.

54 Eric Feigenbaum, "The 1980s: Search for Identity," *VMSD*, 24 October 2001.

Selling China: Class, Gender, and Orientalism at the Department Store

Sarah Cheang

The London department store Liberty is perhaps the best known nineteenth-century retailer of Chinese ornamental goods in Britain.[1] Originating as a specialist in Eastern goods in 1875, Liberty's reputation was founded on the Aestheticist association of Sino-Japanese art with beautiful interiors, so that their Oriental collections were promoted as expressions of artistic taste.[2] Chinese decorative objects were also available in a wide variety of shops across the country. Large drapers and ladies' outfitters sold Canton shawls and embroidered work, while fancy goods shops, gift shops, and antique dealers supplied carvings, fans, ceramics, and other curiosities. However, department stores are distinguished from many other retail outlets by the creation and promotion of a particular image for the products they sold through catalogues, pamphlets, books, and posters, in addition to special exhibitions and lavish display techniques. With their rapid expansion in the 1880s and 1890s, department stores became culturally important sites for the staging of class and gender, where modernity was experienced through new modes of shopping and new retail environments.[3] Moreover, intense competition between the London stores stimulated the production of distinct retail and social identities through consumption. It was within this context that department stores created China as spectacle and as commodity through their marketing strategies.

The visions of China that were formed through the selling of its decorative arts must also be seen in relation to a highly dynamic set of changes in Chinese society as well as in China's relationship with the West. The association of China with fashionable ceramics, lacquer, and silks began in the late seventeenth and eighteenth centuries, when direct sea trade between Europe and China created a vogue for Chinese things in the West. A series of mid-nineteenth-century colonial wars with China, the suppression of the

Boxer Rebellion in 1900, and the founding of the Chinese Republic in 1911 produced new Sino-Western relationships that were material as much as they were political and martial. An interesting double nostalgia can also be associated with the selling of Chinese things in twentieth-century Britain—nostalgia for both the eighteenth-century European Chinamania, and for the old China of Mandarins and pagodas fast receding before an inexorable tide of Westernization.

This interplay between British national and imperial identities, and British and Chinese histories, calls attention to the incredibly problematic nature of binary constructions of home and empire, where the department store can act as a kind of buffer between metropolis and colony as well as a meeting place. Both the home and the department store have also been considered as conceptually feminine spaces, where the actions of women have been scrutinized, criticized, and, more lately, celebrated.[4] Studies of consumption since the late 1980s have placed increasing cultural significance on practices of shopping, assigning an important social agency to this historically trivialized area.[5] However, in opposition to this revalorization of shopping, the use of Oriental themes in selling has been theorized as the introduction of a sensual element that was entirely compatible with, or even the embodiment of, notions of shopping as a wasteful and self-indulgent pursuit involving self-gratification, impulse, luxury, and desire.[6] However, the retailing of non-Western goods at a point of convergence between ideologies of Orientalism and of shopping also suggests a potential contact zone between metropolis and empire, and the opportunity for active forms of feminine imperialism through shopping. In order to understand how social identities were forged through the transacting of Chinese art and design, this chapter is concerned not only with the ideological space of the department store, but also with the precise nature of its contents in relation to theories of Orientalism and the exotic.

Exoticism, Orientalism, and Nostalgia

The term 'exotic' has often been read in conjunction with the "primitive" in the selling of goods and in the representation of non-Western "ethnic" cultures. This concept of "primitive exotic" invokes non-Western, pre-industrial places beyond the reach of civilization, and the allure of spiritual or vital qualities as yet uncontaminated by Western modernity.[7] Yet the elaborately embroidered silks, fine porcelains, intricate carvings, and motifs that typified Chinese goods are a far cry from the "primitive." Thus, other readings of the exotic must be pursued, where China may be more ambivalently positioned as both sophisticated and degenerate. Approaches derived directly from Edward Said's theory of Orientalism can result in a lack of differentiation between

non-Western cultures in favor of a monolithic vision of East and West that also renders considerations of class and gender problematic, and leaves little or no room for positions of ambiguity with regard to the Imperial Project.[8] A detailed discussion of the Western retailing of Chinese goods may illuminate some processes by which the specificities of Sino-British relations, as well as a plurality of British social identities, were negotiated within the overarching and highly structural dichotomy of Orient and Occident.

Erika Rappaport has noted the way in which femininity, shopping, and the Orient were constructed as inter-articulated terms, enabling tropes of Eastern self-indulgence and extravagance to powerfully express anxiety over shopping as an intoxicating activity.[9] The Other often appears as a fetish of lavish sexuality, a "mark of excess [that] could be exploited to eroticize the commodity and make consumption the equivalence of pleasure."[10] Concerns about modern feminine desires were thus transferred onto the Other, raising questions of power and agency and unsettling the binary constructions of Orient and Occident, metropolis/empire. As Mica Nava has pointed out in her study of Oriental influences at Selfridges, the conflation of women, eroticism, and the East requires some reassessment when particular attention is paid to what was actually occurring within the department store.[11] Studies of the role of women as active agents in the representation of empire have been able to uncover the rich potential of domestic spaces as important contact zones between colonizer and colonized.[12] Similarly, department store selling of Oriental knick-knacks reveals a feminine, domestic presence in the structuring narratives of empire.

A further key concept in considering the marketing of non-Western goods is the notion of a colonial form of nostalgia, an important component in the creation and attraction of the exotic in the late nineteenth and early twentieth centuries. Cultural practices of nostalgia have been identified as a naturalization of both sexual and cultural difference, and as an ideological condition of modernity.[13] Chris Bongie has defined European exoticism as a practice that positioned the Other beyond the confines of Western "civilization" which "by virtue of its *modernity*, was perceived as being incompatible with certain essential values—or, indeed, the realm of value itself."[14] Exoticism was one of the oppositional terms crucial to the structuring of modernity; a modern condition necessitated nostalgia and cultural heterogeneity in order to produce the mystery and novelty that was destroyed in the process of modernity's own becoming. In discussing the impossibility of the exotic under such conditions, Bongie positions the New Imperialism of the late nineteenth century at centre stage. The rapid expansion of European colonialism aimed to achieve a global hegemony of Western civilization while simultaneously privileging non-Western territories as the last refuge of the exotic; colonialism, like modernity, produced exoticism by threatening to erase the exotic.

In order for China to satisfy Western desires for the exotic, a sense of mystery needed to be preserved. In this self-defeating and self-perpetuating quest for the unexplored, Chinese Imperial Palaces—places generally inaccessible to Westerners—seemed to be the last bastions of the unknown until forcibly opened up by military intervention. Western penetration of the Summer Palace [Yuanmingyuan] in 1860 during the closing stages of the Opium Wars, and of the Forbidden City in Beijing in 1900, following the relief of the legations from siege, symbolized penetration into the heart of China and the loss of its exotic appeal.[15] Yet this lost exotic was recoverable through the practice of nostalgia—a nostalgia for impenetrable mystery and for Chinese Imperial rule predating Western and also Japanese colonial conquest, and revolution in China. This nostalgia was also a defining factor in the market differentiation of London department stores.

Whiteley's, Liberty, and Debenham and Freebody

The department stores of the West End of London formed part of the nineteenth-century development of Oxford Street and Regent Street as a distinct and modern shopping area. Liberty and Debenham and Freebody were both located within this very fashionable and accessible district, whereas William Whiteley's was further west in Bayswater. Whiteley's original customer base lived in the upper-middle-class suburb of Westbourne Grove, but this area had already declined in social status and popularity by the late nineteenth century. Whiteley's developed a more mass-market appeal and a clientele that varied in social class, whereas the stores of the West End were more "synonymous for Society."[16] Liberty, positioned on prestigious Regent Street, had a reputation for art, elitism and anti-commercialism, and a correspondingly awkward relationship to the idea of mass-production and mass-consumption.[17]

In 1885, the following statement appeared in Whiteley's general catalogue:

> The high favour in which the Manufactures of Eastern Nations are now regarded by people of cultivated taste, has induced William Whiteley, Limited, to open a Department specially for the sale of such goods, for the supply of which they have established Agencies at the principal Ports and Markets in India, China, Japan, Persia, Turkey, Egypt, Syria, Morocco, &c., thus affording the Public an opportunity of purchasing these beautiful, original, and withal serviceable wares at even less cost than they are ordinarily obtainable in the countries in which they are manufactured.[18]

Whiteley's began as a trimmings and fancy goods shop in 1863, and had expanded into a department store by 1875, with an Oriental Department that stocked cheaply priced fancy goods from Japan and elsewhere, in response to the new fashion for Oriental Warehouses.[19] The Oriental Department sold

Chinese sleeve bands (essentially strips of embroidery) at 1 shilling 11 pence, and squares of Chinese embroidery for around 1 shilling more. At the eve of World War I, catalogues were also offering Chinese blackwood stools and stands and blue-and-white Chinese ceramics such as plant pots, vases, and ginger jars.[20]

In the department store paradox, "the goods offered to the aspirant consumer market were often mass-produced and aggressively priced, yet the culture being sold with it was one of luxury, indulgence and good taste."[21] As in the imperial displays of the international exhibitions, Oriental Departments presented a cornucopia of luxury goods that celebrated empire through a showcase of riches while masking the political, economic and social injustices inherent in imperialistic relationships.[22] However, it appears that the higher the social status of the department store, the greater the attention paid to the exact conditions of commodity exchange with China, the cultural history of the items for sale and their possible uses in the home. In their catalogues, the social distinction between West End and West London stores is apparent, not only in pricing, but also in selling techniques, perhaps reflecting the need for more "immediately grasped" forms of retailing at middle- and lower-middle-class establishments.[23] For example, the Chinese blackwood stands advertised in Whiteley's catalogues were cheap and plain with a minimal amount of carving, accompanied by descriptions such as "strongly made" that stressed practical concerns.[24] By contrast, Liberty promoted Chinese stands with heavier carving and marble tops that were also correspondingly more expensive. Liberty's catalogue descriptions were supplemented by much cultural information as well, so that the stands were not only strong, but also, "Admirably adapted for the display of important specimens of Bronze and antique Chinese Blue-and-White Porcelain." [25] Here, an entire page was devoted to Chinese stands (Figure 6.1), whereas Whiteley's showed a mixed page of Japanese, Chinese and Damascan products, united under the general category of Oriental furniture (Figure 6.2).

This heavier investment in cultural capital formed the bedrock of Liberty's reputation as a purveyor of good taste and refined sensibilities.[26] Knowledge about Chinese products—both of their origins in China and their uses in Britain—was playing an important part in the maintenance of an artistic elite identity, and was also seen in the catalogues of Debenham and Freebody, a distinctly high-class store situated on Wigmore Street and Welbeck Street, just off Oxford Street. Debenham and Freebody were in direct competition with other up-market Regent Street and Oxford Street establishments such as Marshall and Snelgrove, as well as Selfridges, which opened in 1909. In seeking a socially exclusive clientele, Debenham and Freebody did not initially identify with the modern department store image, but remained much closer to their origins as a drapers and fashionable outfitters.[27] However, by the late nineteenth century the store had diversified into jewelry,

stationery, embroideries, and tapestries, and also had a gallery for furniture. When a collection of blue-and-white Chinese porcelain was sold in 1895, it was displayed as a special exhibition, in a manner that oscillates between a domestic interior, a museum, and a specialist dealer. Vases, plates, and ginger jars were described as in the "Large Front Room," on the "high shelf," in the "corner cabinet."[28] The collection was said to have mostly arrived from

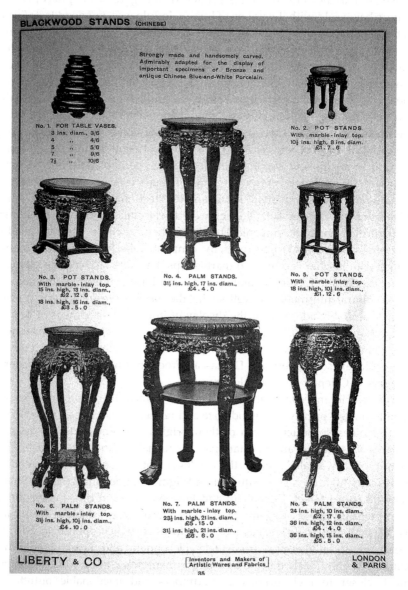

6.1 Liberty Chinese blackwood stands. Liberty & Co., 1908

China a few weeks before, giving the impression that these were rare and, above all, genuine pieces. Some were labeled as being from the Kangxi reign (1662–1722), and a list of Chinese reigns and dynasties was also provided. By mimicking the selling techniques and terminology of dealers and auction houses, and by emphasizing the old and the unique rather than the mass-produced, Debenham and Freebody were defining themselves as distinct from more mass-market establishments like Whiteley's.[29]

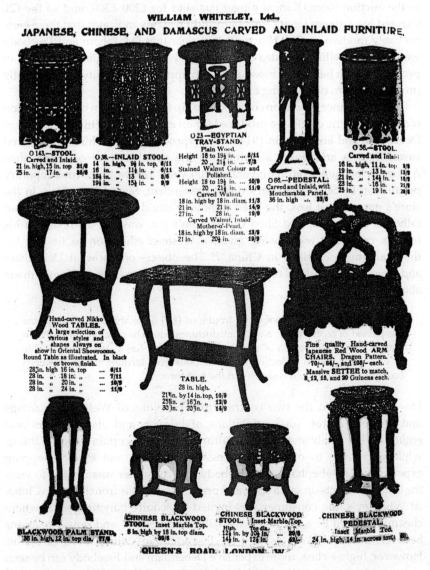

6.2 Whiteley's Chinese blackwood stands, and other Oriental carved furniture.
William Whiteley Ltd, 1914

British domestic ownership of late seventeenth-century Chinese ceramics could also be symbolic of upper-class wealth and status through the possession of family treasures handed down through the generations. At the end of the nineteenth century, Kangxi vases, and ginger jars were also considered by most collectors to be the acme of Chinese porcelain production, well represented in well-known collections such as the Salting collection displayed at the Victoria and Albert Museum, and commanding high prices in the auction room. Kangxi ginger jars sold for £200–£300, and so the £20 charged for a ginger jar at Debenham and Freebody indicates that these were probably modern copies. However, it is clear that Debenham and Freebody were not just selling the idea of China. They were also selling facsimiles of precious British heirlooms associated with upper-class identity, and a socially prestigious form of shopping expertise.

The importance placed on connoisseurship as an elite form of consumption is also seen in the catalogue produced for an exhibition of Chinese lacquer at Debenham and Freebody in 1914. Color reproductions of Chinese lacquered vases, figures, and boxes accompanied the detailed story of "Shen Shao An" gold lacquer, from its invention 300 years before to its contemporary production by Shen Shao An's direct descendent, Shen Cheng Hao. In the store's narrative of loss, the Shen technique could only be passed on from father to eldest son, and Shen Cheng Hao's son was not interested in his father's craft and was "being given a Western education to fit him for the changing conditions in China."[30] The objects on show at Debenham and Freebody therefore represented a lost China, as the catalogue made abundantly clear:

> In consequence of the serious and troublous [sic] times through which China has passed of recent years, and the misfortunes which have unhappily befallen many Chinese gentlemen of wealth and position, it has at last been possible to gather together a collection of this famous gold lacquer, which has been brought to London and is shown for the first time.[31]

Hovering between the two contradictory positions of Western advantage and Western regret, such exhibitions of lacquer, and also ceramics and embroideries, established a high cultural status for certain Chinese things while appearing to offer easy access to a unique and exotic shopping experience. At Debenham and Freebody, the consumer was invited to view the Chinese objects on sale as rare and precious survivals from long ago China. At Whiteley's, the consumer was invited to acquire bargain goods, where cheapness could be a marker of the cultural difference and power relations between East and West, as well as class identities within the metropolis. However, higher-class, more expensive Debenham and Freebody can be seen as having a correspondingly higher investment in imperial guilt, a critical point that requires elaboration.

Colonial Nostalgia/Imperial Gain/Chinese Embroideries

Narrative practices involving the evocation of religious, social and court rituals of the Qing dynasty were significant colonial processes that invested great meaning in certain things and places. James Hevia has discussed how Western humiliation of the Chinese during and after the Boxer Uprising made use of talismanic Chinese Imperial spaces such as the Forbidden City.[32] Western ownership of objects obtained from these kinds of places formed a relationship between "the act of defeating China and the constitution of colonialist subjects."[33] Thus, a fascination with lost China framed the selling of particular Chinese goods, especially after the fall of the Qing Dynasty, when China's social and economic turmoil enabled increasing amounts of Chinese antiques to enter an eager Western market. These items were presented in Britain within the context of a *past* Chinese greatness as well as present Western access to imperial booty, in which any connection to the Chinese Imperial court was particularly significant. Thus in a sale of Chinese embroideries in 1894, Liberty invoked notions of Qing dynasty court etiquette at every opportunity, no matter how tenuous, describing a hanging as "produced, in all probability, as a present to a Mandarin of high rank by his colleagues on his appointment to office." Any article showing a five-clawed dragon, "only found on pieces made for use in the Imperial household," was of especial interest.[34] As Verity Wilson emphasizes in her exploration of the dragon robe, there was a need to construct stories of acquisition that elided any quotidian buying and selling and that foregrounded any connection with the court. She writes:

> At the very time that Chinese society was going through a series of disastrous dislocations, dragon robes were held up as symbols of an ordered empire, static and wisely ruled. This picture, as we know and as many knew at the time, was far from the truth ... they took these robes as tangible evidence of a myth.[35]

Such details took on a special significance after 1911, for mandarin robes were falling out of use in the new Chinese Republic, and an emperor no longer sat on the throne. In 1915, a Debenham and Freebody embroidery catalogue was given the flamboyantly erudite title of: *Chinese Embroideries: A Unique Collection of Rare Mandarin or Court Robes, Sleeves, Etc., Worn by the Manchu Aristocracy During Empire Period, Lama Robes Worn by Tibetan Abbots in Ceremonial Observances, Etc., Etc., Collected in Western China.* The very special nature of the goods on sale was stressed from the outset, with a description of the exact location in China where the textiles had been acquired. Whereas Whiteley's had been content with the simple phrase "antique Chinese" to sell their embroidered table mats at sixpence each, Debenham and Freebody used detailed assertions of age, provenance, and social significance in their catalogue. Further references to mandarins, the "Manchu aristocracy" and religious ceremony reinforced the authenticity, rarity, and high cultural status

of the goods on offer, and confirmed notions of China as a place of exotic and traditional ceremony.[36] In alluding to the recently fallen Qing dynasty as "the period of Empire," Debenham and Freebody acknowledged the conditions of modern China while simultaneously invoking nostalgia for a past China. In fact, in the production of this imperial nostalgia, any references to consumption jolt the reader out of the exotic reverie and back into cold, retailing reality. Following the lengthy details of courtly and religious dress, there comes this sudden statement: "This Catalogue only enumerates a few of the many interesting articles now on view, which are being offered for sale at unusually low prices. They are suitable for making up as bags, blotters, and numerous articles for domestic purposes."[37]

Sold in order to be cut up and reconstituted into what was, essentially, a range of bric-a-brac, the integrity of these souvenirs of the Chinese empire was threatened by a physical and conceptual dismemberment, causing a discomfort which seems to fall along gendered lines. The most domestic common use for Chinese embroidered garments in Britain between the 1890s and the 1920s was as a decoration for upholstered furnishings.[38] However, the practice of adapting old Chinese clothing into cushions, footstools, mantelpiece covers, and antimacassars was sometimes condemned because the robes were second hand and thus perceived to be tainted by Chinese bodies.[39] The custom was also criticized on artistic merit, the "problem" seen to be feminine practices of integrating embroidery pieces into interior decor schemes instead of admiring them as works of art. Here, paradigms of femininity were being played out through the discourses of design, gender, and collecting, in which the perceived irrationality of women was being pitted against the genius of male artists and architects in a battle of the bric-a-brac.[40] Women were seen to be reducing art to the level of knick-knacks, so that "good taste" was compromised by the presence of small, feminine Oriental objects.

A separation of "artistic and rarified" and "feminine and commercial" was therefore practiced at Liberty, enabling a discreet yet definite distinction to be made between the didacticism of the museum and art gallery, and the commoditization, and modishness of the retail trade. Chinese embroideries that had been cut up and incorporated into glove boxes, card cases, and writing pads were sold under the heading of "gifts" rather than "antiques" and "curios," as their authenticity and cultural integrity had been compromised by their transformation into a far more feminine product (Figure 6.3). Entitled "Rare Old Chinese Embroidery Made-Up into Useful Bric-A-Brac," these decorative yet serviceable knick-knacks were also responsive to fashion and to changes in notions of what constituted feminine respectability. In 1909, Liberty's gift catalogues showed Chinese embroideries incorporated into objects such as bookstands, book covers, glove boxes, and photograph albums.[41] By 1926, cigarette cases, vanity cases, and playing card cases had

replaced some of these items, and in 1928, bridge sets were also introduced.[42] Thus, by the late 1920s, smoking cigarettes, wearing makeup, and playing bridge took precedence over the more solitary and time-consuming pursuits of writing letters and creating photograph albums. The selling of

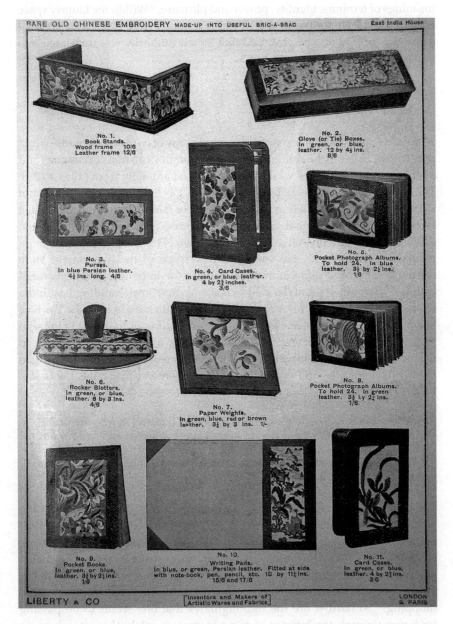

6.3 Liberty Chinese embroideries, made up into domestic objects. Liberty & Co., 1909

these "Chinese" objects related directly to fashionable, modern, feminine lifestyles.

As studies of feminine identity and department stores have argued, the shopping activities of women transformed the space of the West End, socially, architecturally and economically, and, in this process, invested it with meanings of feminine identity, power and pleasure.[43] Within the fantasy space of the Oriental Department, where Chinese goods were framed by colonial nostalgia, it could also be proposed that female authority was translated into imperial agency.

West-End Imperialism

As we have seen, Liberty certainly presented many of its Oriental goods within the "trivial" sphere of feminine novelties, through Christmas catalogues and additional gift catalogues which were produced annually from at least 1888. The claim that there was not a "lovely thing" on Earth that Liberty did not stock, combined gift retailing with an intensely feminine panopticism.[44] Just as Bennett has argued that "museums, galleries, and, more intermittently, exhibitions played a pivotal role in the formation of the modern state" through regimes of surveillance, the spectacle, and space of the department store offered a feminized and commercial context for imperialism and material culture.[45] That Liberty had decided to name his first small building East India House seems a telling reference to a history of British trade with the Far East which spawned an empire. However, the remodeling of East India House in 1927, with a frieze depicting Britannia, receiving tribute from her empire in the form of goods, links Liberty's trading with an undisguised imperialism. In the words of middle- and upper-middle-class women's magazine, the *Ladies' Field*:

> We have but to make a tour round the wonderful [Liberty] showrooms at East India House and Chesham House, Regent Street, where from North, South, East, and West, is gathered the most extensive and representative show of Christmas gifts in the world, and we shall have skimmed the cream, so to speak, off a considerable portion of our little planet.[46]

The Chinese goods sold at Liberty were also entirely representative of the goods that were available to sightseers in China. The advertisements in a 1904 guide to Guangdong, listing dealers in silks, old embroideries, lacquerware, ceramics, blackwood furniture, ornaments, and novelties, read almost as a précis of a Liberty's gift catalogue.[47] Furthermore, the experience of shopping in the streets of Guangdong was conveyed by referring to department store shopping: "So narrow are the thoroughfares that one seems to be passing for hours through the interior of some mammoth establishment, where, in

endless succession, wares of all varieties are exposed for sale …"[48] At Liberty, the reverse was also held to be true, and women were offered the opportunity to roam the world in search of "lovely things" without ever leaving the safety of the department store. As Liberty's Eastern Bazaar catalogue explained:

> Wandering amidst the labyrinth of stalls, each with its own particular class of wares, the atmosphere redolent with Eastern Perfumes, one can hardly imagine that we are in a Regent Street establishment, but that we have been suddenly transported on the wings of a genii to far distant Eastern Climes. All the Nations of the Orient seem to be represented in this wondrous place, vying with each other in offering to the Occident artistic examples of their handicraft.[49]

Thus shopping for Chinese things at Liberty offered women access to the idea of empire as well as its fruits. A further example, very directly connected with imperial ventures, can be found in the selling of jades. Carved stone pendants were a Chinese product for women that fulfilled post-Edwardian fashions for large and heavy costume jewelry, and were part of the chinoiserie revival of the 1920s (Figure 6.4).

Liberty's pendants were carved with Chinese designs and images, from fruits and flowers to tiny landscapes complete with figures.[50] From 1925 to the 1940s, smaller jade pieces were also sold, set in gold or platinum, with diamonds and pearls.[51] Liberty published a small, illustrated book to accompany these collections in 1919 and 1925, explaining that their jades had "been collected in remote localities of China."[52] In the 1925 edition, the story of Chinese jade working spanning 3,000 years, and an eight-page dictionary of motifs, was combined with a section on present-day jade carving and photographs of a contemporary craftsman at work. The inclusion of modern, historical and mythical details was typical of the store. However, the content of the book may also have been influenced by a financial interest in jade mining, as in 1923 Liberty had invested in a jade mine at Tawmaw in Burma [Myanmar]. However, a profit could not be made as the jade market fell into depression during the 1920s and 1930s, and World War II finally put an end to the venture.[53] The jades mined and carved in Myanmar were not necessarily the same ones that were sold at Liberty in London, but it is clear that the carved pendants were used to make very direct connections between Chinese people, their labor and customs, and fashionable, metropolitan feminine identities in Britain.

Mandarins and Memories

The picturing of jade workers appears to have been the only occasion when Liberty represented a Chinese person in their publicity. However, Chinese bodies, and in particular Chinese mandarins, were implicitly present

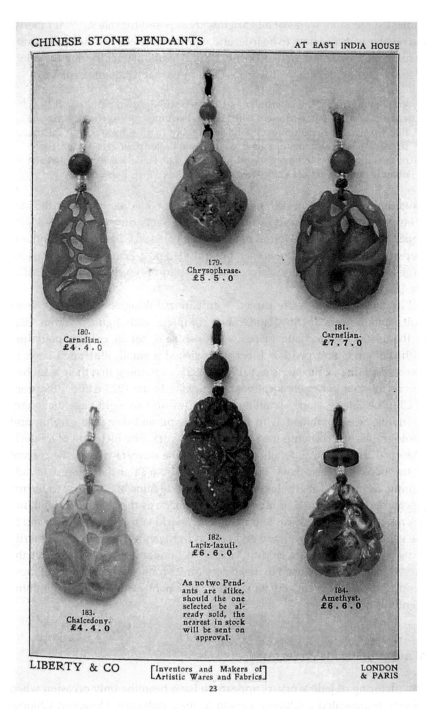

6.4 Liberty Chinese stone pendants. Liberty & Co., Liberty's Yule-Tide Gifts, London, 1923, p. 23

whenever Chinese robes were advertised, and this may have caused certain problems in their appropriation as fashionable garments in Britain. As we have seen, anxieties around the secondhand nature of Chinese embroidered garments on one hand, and the colonial narratives woven around Chinese ceremonial garments on the other hand ensured that memories of the former wearers were kept alive. It is true that, as early as the 1880s, Liberty held annual exhibitions of embroideries in which Chinese coats were modeled, but here the women were acting as walking samplers.[54] Perhaps because it was intended for a variety of uses that did not necessarily involve actual wearing, the "mandarin's robe" was always depicted without the wearer, thus leaving the costume hollow. However, the reluctance to place Chinese robes on British women's bodies may also relate to the significance placed on imagined former wearers.[55] Maintaining a hollow robe sustained the memory of the mandarin by making his absence obvious. The void in the costume was not to be filled by the living body of a Western appropriator, because this was not an empty vessel but a potent carrier of colonial nostalgia.

There is however a discrepancy between the way in which the robes were advertised by Liberty and the way in which they were used by British women in the interwar period. In fact, Chinese robes were being worn by Western women as evening wear from the 1920s. However, it was not until 1937 that Liberty finally depicted them as fashion, in an advertisement for the Embroidery Department which shows three Caucasian women sporting Eastern evening coats against a sparse modernist background (Figure 6.5).[56] The model in a jacket from India strikes a fashion pose, but two women in Chinese coats stand with their hands clasped together before them, seeming to mimic a stereotypical posture of Chinese greeting. This suggestion of masquerade perhaps bridges the gap between Chinese robes as the property of a Mandarin, and Chinese robes as Western fashion objects. Significantly, the coats were no longer described as "Mandarin's robes," but merely as "old" coats "handsomely embroidered in Pekin," and prices had almost halved in comparison to the early 1900s. The coats shown were in fact late nineteenth-century Chinese women's robes. They were still sold through the embroidery and antique departments, alongside old European embroideries and tapestries, and "ceremonial robes of historic grandeur from China, India and Persia."

By the end of the 1930s, a new China had emerged, formed by civil war between Communist and Republican forces, Japanese invasion, and modernization and Westernization. However, in the selling of bolts of silk, Liberty were still giving prominence to Qing dynasty court stories, for example offering "Hand-made Imperial Chinese Tribute Silks ... woven by the Mandarins for the Imperial Court of China about 1800."[57] (Figure 6.6). Ascribed to the early nineteenth century, these silks were sold as predating both the Boxer Uprising and the Western conquest of the Opium Wars. In a

moment of retailing fantasy, an advertisement showed the colorful tribute silks laid out in homage to an absent but all powerful emperor, and also to the twentieth-century consumer, circumventing 100 years of troubled history and allowing British women to take the place of the long-departed emperor. Similarly, the reproduction "antique" Chinese porcelains that Liberty sold evoked late seventeenth and early eighteenth-century British fascinations

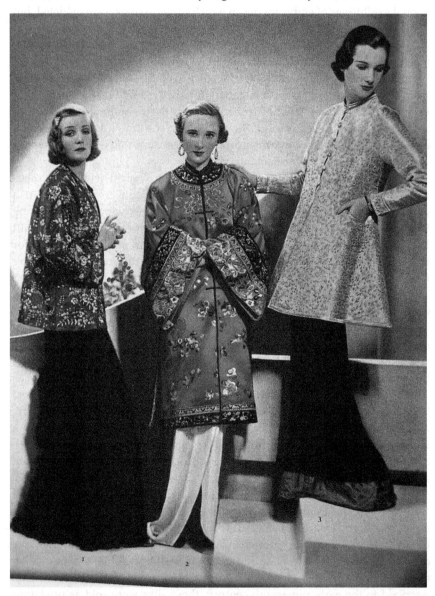

6.5 Liberty Oriental evening coats. Liberty & Co., 1937

with Chinese ceramics—fascinations which were apparently uncomplicated by issues of empire. Thus this range of contemporary Chinese retail objects still signified the exotic, whilst being valued for their exquisiteness rather than for any "primitive" cultural rawness or innate spirituality. They derived their exotic value from qualities that seemed lost to modern British

6.6 Liberty Chinese "Tribute Silks," Liberty & Co., c.1940

society, belonging to both British and Chinese pasts, in response to the moral burdening of a colonial present.

Conclusion

The embroideries, ceramics, and carved woods sold by Liberty were highly representative of the full spectrum of Chinese goods sold in Britain, but their sale was framed by a heightened sense of nostalgia. Hence, a closer analysis of the representation of Chinese ornamental goods at Liberty, examined in relation to the Chinese selling of other department stores, has enabled the phenomenon of nostalgia and the exotic to emerge as a crucial concept in the articulation of class, gender, race, and nation through the cross-cultural appropriation of luxuries.

It is perhaps not the spirit of Orientalism that needs to be reassessed, so much as the ways in which certain kinds of Chinese objects were selected and made to fulfill the criteria of the desirable exotic. Specific narratives of loss and nostalgia produced a set of issues around cultural authenticity and social status that helped to distinguish some Chinese goods from a generalized notion of Oriental production. This may have been especially pertinent at stores such as Liberty and Debenham and Freebody, which were themselves seeking for socially exclusive identities of different kinds. Here, the multivalent nature of material culture enables multiple subject positions (and implies a variety of different uses and meanings of Chinese goods for Western consumers), whilst the department store catalogue frames, fixes, and preserves these positions within the dominant ideologies of imperialism.

Notes

1 The author would like to thank Louise Purbrick, Craig Clunas, and the anonymous reviewers of the *Journal of Design History* for their help in the development of this essay. First published by Oxford University Press on behalf of The Design History Society in *Journal of Design History* 20, 1 (2007), pp. 1–16.

2 Alison Adburgham, *Liberty's: A Biography of a Shop*, London: Allen, 1975, p. 65.

3 Geoffrey Crossick and Serge Jaumain, "The World of the Department Store: Distribution, Culture, Social Change," in Geoffrey Crossick and Serge Jaumain, eds, *Cathedrals of Consumption: The European Department Story, 1850–1939*, Aldershot: Ashgate, 1999, pp. 1–45.

4 Erica Rappaport, *Shopping for Pleasure: Women in the Making of London's West End*, New Haven and London: Princeton University Press, 2000.

5 Daniel Miller, "Consumption as the Vanguard of History," in D. Miller, ed., *Acknowledging Consumption: A Review of New Studies*, London: Routledge, 1995, pp. 1–57.

6 William Leach, *Land of Desire: Merchants, Power and the Rise of a New American Culture*, New York: Vintage, 1993, p. 107.

7 James Clifford, *The Predicament of Culture: Twentieth-Century Ethnography, Literature and Art*, Cambridge, Mass: Harvard University Press, 1988, pp. 189–246.

8 Edward Said, *Orientalism: Western Conceptions of the Orient*, London: Vintage, 1978; Reina Lewis, *Gendering Orientalism: Race, Femininity and Representation*, London: Routledge, 1996.

9 Rappaport, pp. 21, 32.

10 Suren Lalvani, "Consuming the Exotic Other," *Critical Studies in Mass Communications* 12 (1995): p. 271.

11 Mica Nava, *Visceral Cosmopolitanism: Gender, Culture and Normalisation of Difference*, Oxford: Berg, 2007, pp. 19–40.

12 Anne McClintock, *Imperial Leather: Race, Gender and Sexuality in the Colonial Conquest*, London: Routledge, 1995.

13 Susan Stewart, *On Longing: Narratives of the Miniature, the Gigantic, the Souvenir, the Collection*, Durham NC: Duke University Press, 1993, pp. 22–4.

14 Chris Bongie, *Exotic Memories: Literature, Colonialism, and the Fin de Siècle*, Stanford: Stanford University Press, 1991, pp. 4–5, and see also pp. 3–9.

15 Bongie, pp. 120–126.

16 Rappaport, p. 9 and pp. 17–39; Bill Lancaster, *The Department Store: A Social History*, Leicester: Leicester University Press, 1995, pp. 23–4; Crossick and Jaumain, pp. 24–5.

17 Sonia Ashmore, "Liberty's Orient: Taste and Trade in the Decorative Arts in Late Victorian and Edwardian Britain: 1875–1914," Ph.D thesis, Open University, 2001, pp. 109–13.

18 William Whiteley Ltd, *Whiteley's General Catalogue*, London: Whiteley, 1885, p. 458.

19 Richard Lambert, *The Universal Provider: A Study of William Whiteley and the Rise of the London Department Store*, London: G.G. Harrap & Co., 1938, pp. 73, 179–80, 232–33, 242.

20 William Whiteley Ltd, *Whiteley's General Catalogue*, London, Whiteley, 1914, pp. 1000, 1002, 1004; William Whiteley Ltd, *Whiteley's Illustrated Catalogue of Furniture, Bedding, Carpets and Every Requisite for the Home*, London: Whitely, 1915, p. 147.

21 Crossick and Jaumain, p. 27.

22 Lara Kriegel, "Narrating the Subcontinent in 1851: India at the Crystal Palace," in Louise Purbrick, ed., *The Great Exhibition of 1851: New Interdisciplinary Essays*, Manchester: Manchester University Press, 2001, pp. 146–78.

23 Janice Winship, "Culture of Restraint: The British Chain Store 1920–39," in Peter Jackson, Michelle Lowe, Daniel Miller and Frank Mort, eds, *Commercial Cultures: Economics, Practices, Spaces*, Oxford and New York: Berg, 2000), pp. 29–30.

24 Whiteley, *General Catalogue*, 1914, p.1000; William Whiteley Ltd, *Whiteley's Summer Sale 28th June and July*, London: Whitely, 1915, p. 23.

25 Liberty and Co, *Bric a Brac*, London: Whitely, c.1908, p. 35.

26 Pierre Bourdieu, *Distinction: A Social Critique of the Judgment of Taste*, London: Routledge, 1984.

27 Alison Adburgham, *Shops and Shopping*, London: Allen, 1964, pp. 272–4.

28 Debenham and Freebody, *Collection of Old Nankin Porcelain. Blue And White, Powder Blue, Etc.*, London: Debenham and Freebody, 1895.

29 Rappaport, pp. 16–47.

30 Debenham and Freebody, *The Famous "Shen Shao An" Gold Lacquer of Foochow China. An Account of Its Origins and Curious Characteristic*, London: Debenham and Freebody, 1914, p. 10.

31 Debenham, p. 8.

32 James Hevia, *English Lessons: The Pedagogy of Imperialism in Nineteenth-Century China*, Durham NC: Duke University Press, 2003, pp. 203–8.

33 J. Hevia, "Loot's Fate: The Economy of Plunder and the Moral Life of Objects 'From the Summer Palace of the Emperor of China,'" *History and Anthropology* 6, 4 (1994), p. 333.

34 Liberty and Co., *Descriptive Details of the Collection of Ancient and Modern, Eastern and Western Art Embroideries, Exhibited by Messrs. Liberty, April 1894*, London: Liberty, 1894, pp. 19–20.

35 Verity Wilson, "Studio and Soirée: Chinese Textiles in Europe and America, 1850 to the Present," in Ruth Phillips and Christopher Steiner, eds, *Unpacking Culture: Art and Commodity in Colonial and Postcolonial Worlds*, Berkeley CA: University of California Press, 1999, p. 235, and see also pp. 234–9.

36 Debenham and Freebody, *Chinese Embroideries: A Unique Collection of Rare Mandarin or Court Robes, Sleeves, Etc., Worn by the Manchu Aristocracy during Empire Period, Lama Robes Worn by Tibetan Abbots in Ceremonial Observances, Etc., Etc., Collected in Western China*, London: Debenham and Freebody, 1915, inside front cover.

37 Debenham, *Chinese,* inside front cover.

38 Sarah Cheang, "Dragons in the Drawing Room: Chinese Embroideries in British Homes, 1860–1949," *Textile History* 39, 2 (November 2008), pp. 223–49.

39 "Some Curiosities of the Trade of Canton," *Times*, 17 Sept. 1890, p .3.

40 Juliet Kinchin, "Interiors: Nineteenth-Century Essays on the 'Masculine' and the 'Feminine' Room," in Pat Kirkham, ed., *The Gendered Object*, Manchester: Manchester University Press, 1996, pp. 12–29.

41 Liberty, *Liberty's Yule-Tide Gifts 1909*, pp. 28–9.

42 Liberty and Co., *Liberty Yule-Tide Gifts 1926–1927*, London: Liberty, 1926, p.30. Liberty and Co., *Liberty Yule-Tide Gifts 1928–1929*, London: Liberty, 1928, pp. 34–5.

43 Rappaport, *Shopping*; Lynn Walker, "Vistas of Pleasure: Women Consumers and Urban Space in the West End of London, 1850–1900," *Women in the Victorian Art World*, ed., Clarissa Campbell Orr, Manchester: Manchester University Press, 1995, pp.119–45; Mica Nava, "Modernity's Disavowal: Women, the City and the Department Store," in Pasi Falk and Colin Campbell, eds, *The Shopping Experience*, London: Sage, 1997.

44 Liberty and Co., *Some Lovely Things Are at Liberty's*, London: Liberty, 1937, p. 1.

45 Tony Bennett, "The Exhibitionary Complex," *New Formations*, 4 (1988), p. 79.

46 "Artistic Yuletide Gifts at Liberty and Co.'s, Ltd," *Ladies' Field*, (14 December 1901), p. 14.

47 Dr Kerr, *Guide to the City and Suburbs of Canton*, Hong Kong: Kelly, 1904, pp. vii–viii.

48 Kerr, p. 6.

49 Liberty and Co., *The Bazaar: A Catalogue of Quaint, Artistic and Inexpensive Eastern and Western Wares for Sale in the Basement Galleries of Chesham House*, London, Liberty, 1898, p. 57.

50 Liberty and Co., *Yule-Tide Gifts*, London: Liberty, 1922, p. 23.

51 See Liberty, *Liberty Yule-Tide Gifts 1926–1927*; Liberty and Co., *Liberty Gifts 1929–1930*, Liberty, 1929, pp. 18–19; Liberty and Co., *Liberty's Gifts*, London, c.1935, p. 5; Liberty, *Liberty Yule-Tide Gifts 1928–1929*, p. 21; Liberty and Co., [Christmas Catalogue, 1939–1940], Liberty, 1939, p. 3.

52 Liberty & Co., *Jade Amulets: Historical Notes with Coloured Illustrations and Interpretations of the Most Characteristic Forms*, London: Liberty, 1919; Liberty & Co., *Jade Amulets: Historical Notes with Coloured Illustrations and Interpretations of the Most Characteristic Forms*, London: Liberty, 1925.

53 Notes on jade mining interests of Liberty & Co. with Burchin Syndicate concession at Tawmaw, Burma 1923–1933, Westminster City Archives 788/65 (c).

54 Adburgham, pp. 51–2.

55 Sarah Cheang, "Chinese Robes in Western Interiors: Transitionality and Transformation," in Alla Myzelev and John Potvin, eds, *Fashion, Interior Design and the Contours of Modern Identity*, Farnham: Ashgate, 2010, pp. 134–6.

56 Liberty, *Some Lovely Things*, p. 16.

57 Liberty & Co. Album of colour posters of antique and modern eastern embroideries (clothes and furnishing) c.1940, Westminster City Archives 788/39/4. Imperial silk workshops had existed in China from the eighteenth century to at least the late nineteenth century, providing high-quality textiles for court use, so it is possible that the silks sold at Liberty's had come from old Imperial stores. See Wilson, pp. 97–9.

7

"The Art of Draping": Window Dressing

Louisa Iarocci

The shop window has often been evoked as an iconic symbol of modern spectatorship, serving as a billboard for the rise of urban consumerism and as a frame to capture the mobilized spectator. Scholars of visual and consumer culture alike have been persistently lured by the illusionistic properties of this window wall, seen as the symbol of modern visuality that captures the transformation of object to commodity, and of the spectator to consumer.[1] Following on Walter Benjamin's seminal study of the arcade, the shop window has been used as tangible evidence of the rise of a modern way of seeing, revealing the complex interplay between the commodity and the consumer as desired and desiring object and subject. The various names that have been used to identify the front façade of a store reflect its status as both material artifact and visual icon, from its most prosaic context of the "shop" or "store" to its more lofty aims to "show" or "dress." But while evocatively compared to a Cubist painting and the cinematic screen,[2] the shop window was in fact an inhabitable physical space located between the public realm of the street and the proprietary domain of the store. As both building façade and display case, it provided a tangible identity for urban retailing while providing visual access to sale goods. Through the study of architectural and retailing trade manuals, this chapter seeks to more fully understand the shop window as a built artifact and retail interior. Occupying an ambiguous realm between outside and in, the store window acted as a boundary and interface between buyer and seller that defined the domain of urban consumption in the late nineteenth century United States.

Street Architecture

The story of the rise of the modern American city has focused on its still most visible architectural landmark, the commercial building, which would rise to dominate the twentieth-century skyline. But the urban footprint from which the skyscraper arose was defined by real estate practices and building technologies that were established in the second half of the nineteenth century. While the retail storefront provided the foundation for the towering landmarks of the commercial city, it has garnered little interest as an architectural innovation, beyond a select group of historic preservationists and building science specialists.[3] The implementation of the grid plan in major urban centers in the early nineteenth century produced a regular pattern of geometrical uniformity. While the dimension of a city block varied widely in major urban centers in the United States, the street grid typically produced a standard lot size, which was typically long and narrow in shape. Most main commercial streets were platted with a regular succession of lots on a module that was between 20 to 25 feet wide and of a depth that was at least equal, and most often times much deeper.[4] New York, for example, typically consisted of street lots 20 feet wide and 100 feet deep, providing an oblong shape that provided the coveted street presence while taking advantage of the deep city block. The typical dimensions of a commercial storefront were reinforced by the efficient span of a wood joist that supported a wood floor system and rested on one-foot-thick masonry bearing walls that helped to prevent spread of fire.[5] The structural system thus helped to reinforce the uniformity of the grid to produce a regular rhythm of plots that would standardize and facilitate the growth of commerce. The central business streets of the nineteenth-century city took shape as a succession of units of trade that were readable as a series of distinctive properties and yet coalesced to form a compact and orderly whole.[6]

The distinctive aesthetic and material character of these building blocks of commerce were recognized in the earliest architectural pattern books published in the nineteenth century. While dominated by designs for dwelling houses, M. Field's City Architecture of 1853 includes several designs for public and commercial buildings.[7] The author notes that "the economy of ground plot" of retail stores creates an unusually long and constricted footprint that results in a challenging front elevation that is "necessarily too narrow for a good proportion." His designs seek to deal with the problem of the visual stability in these storefronts that "would likely appear to fall unless propped up from their neighbours [sic]." Field noted the solution was to be found in ornamental features like string courses and cornices that could help establish harmonious proportions and visually stabilize the uninterrupted plane of the street façade. Other commentators at the time concurred that the commercial shopfront posed a unique design challenge in being perceived as a mere

front, "a flat mass of building," rather than the three-dimensional volume presented by other building types.[8] The need for large windows at ground floor to illuminate the narrow interior is observed to further exacerbate the problem, the loss of visible structural supports compromising the aim of "honesty of expression." Retail buildings are observed to be a rare exception to the otherwise important principle of "real as well as apparent solidity" in architectural design. In his *Specimen Book of 100 Architectural Designs* of 1880, A.J. Bicknell advocates for thoughtful detailing that will not only give "the beholder a comfortable sense of substantial security," but also help to raise commercial architecture "to its proper position in the arts." He describes basements of plate glass that appear to be unable to visually support the weight of massive brick façades above, reinforcing the concern for visual and structural soundness in storefront design.[9] In popular commentary as well, the recurring theme was that the commercial building posed a unique challenge in achieving the appearance of structural stability while at the same time gaining acceptance aesthetically as "architecture."

The task for the designer and the merchant was thus to distinguish the individual storefront from its surrounding urban neighbors in a manner that was still sympathetic to them. As many of the earliest stores were converted houses, the scale and proportions continued to be residential, although now a greater need for accessibility called for a more open and direct connection to the street. The tendency towards classical influences in the earliest storefronts in the first half of the century reflects the reliance both on stylistic trends in architecture and on developments in building construction. The early storefront was typically divided into bays of three or four, containing single- or double-paneled doors flanked by large windows, subdividing and repeating the larger division of retail lots. The structural system again reinforced the subdividing of the storefront into a system of even smaller standardized units. The simple post-and-beam system consisted of square columns of wood or brick supporting wood or stone beams, with a substantial entablature framing bays that contained various combinations of wood and glass doors and windows.[10] This solid classical frontage reinforced the expression of the commercial building as both public—part of the street-level façade with generous openings—but at the same time private—demarcated as the identifiable property of an independent owner. The storefront façade marked a separation between exterior and interior that served as a clear boundary defining the extent of the business and the protection of the property contained within. The sense that this was a storehouse of valuable goods was reinforced by the use of shutters, first wood and then metal, that allowed windows to be covered after hours.[11] Frequent newspaper reports of vandalism, robberies and accidents indicate the large plate glass windows were a source of concern as vulnerable to breaches of store security. This language of enclosure was further reinforced in the use of signs—which

could be independent structures of wood attached to the building or even painted directly on the façade. Signage provided the necessary marker to identify the owner and the business but also reinforced the solid mass of the building wall. However, design manuals only occasionally incorporated signage into their examples, cautioning against an excess of signboards and overly decorative shutters, that, too often, "disfigure and obliterated [the] architectural features."[12] The implication was that the language of trade had to be suppressed in the design of the retail building; the structure emptied of its commercial content and turned into a more abstract exercise in planar composition in order to foreground the integrity of the built form.

Developments in iron and glass construction in the second half of the nineteenth century opened up a realm of new forms for building designers and new opportunities for building manufacturers. First used as a material for major structural components in bridges in the late eighteenth century in England, cast iron gained popularity initially for the slenderness of profile and strength of material that made it structurally and economically efficient. But as documented in the catalogues of the first iron foundries in the United States, this mass-produced, standardized product was seen to have unique aesthetic properties appropriate for commercial and industrial buildings. First manufactured as individual structural components in the 1840s, slender cast iron columns, strong in compression and cast with a variety of ornamental motifs, first replaced wood and masonry columns.[13] Wood beams were replaced more gradually, first with cast iron, and then with wrought iron, the latter having a higher tensile strength and greater span capacity. The notion of using cast iron as a complete system of interconnected columns and beams was first used to produce a building façade, and then eventually the entire load-bearing building frame. Entrepreneurs and iron founders like James Bogardus[14]and Daniel Badger in New York promoted the prefabricated building intensely from the late 1840s onwards, erecting examples in major cities throughout the country. In building catalogues and even architectural journals, cast iron was promoted as being cheap and efficient with a greater capacity in its structural and fireproofing capacities and providing an array of ornamental options that could respond to changing styles. Commercial establishments were the among the first structures to benefit from the increasing use of cast iron that made possible a more open and flexible floor plan and a distinctive and dynamic building shell.[15] The popularity of the mass-produced cast iron storefront relied on its successful promotion as a structurally practical and yet aesthetically adaptable means to "modernize" the face of urban commerce.[16]

But despite the enthusiastic claims of its promoters, the dematerialization of the street wall into a glittering surface of iron and glass was more an image than a reality. The opening up of the storefronts on major commercial streets took place only gradually and often in a piecemeal fashion. The availability

and cost of plate glass of a size large enough to fit into newly expanded openings would also have an impact on the wholesale "modernization" of street architecture.[17] Storefronts were very often more composite structures in their construction and design—as window frames, doors, and other subframing elements continued to be built of wood.

In William T. Comstock's *Modern Architectural Designs and Details* of 1881 the ground-floor storefront is grouped along with other store millwork, depicted as a freestanding unit disconnected from the façade (Figure 7.1).[18] The detailed section reveals how store windows were typically raised off the ground to provide better visibility for displays and had a dropped ceiling to conceal lighting fixtures. The window interior was thus framed inside as a contained enclosure—the bulkhead panels below and transom ones above rendered in the illustration like decorative counter fronts.[19] The show window was treated not just as a flat façade but as a three-dimensional volume that extended back into the store. As entrances were often recessed from the street, the windows became projecting bays with side windows for more display. The definition of the store window as a self-contained volume was reinforced by the addition of a rear wall as the once essential illumination it provided was supplanted by advances in artificial lighting.[20] This back wall could be

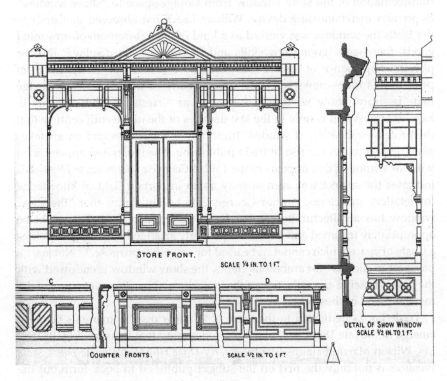

STORE FRONT.
SCALE ¼ IN. TO 1 FT.

COUNTER FRONTS.
SCALE ½ IN. TO 1 FT.

DETAIL OF SHOW WINDOW
SCALE ½ IN. TO 1 FT.

7.1 Storefront Design, William T. Comstock, 1881

temporary or permanent, either full height or a lower screen that allowed light and air to circulate.[21] Concerns about security and cleanliness brought about more complete enclosure as the front window became the store's most visible exhibit, a lockable, dustproof display case that could attract potential clients in the street.

Show Window

In the 1880s what had been seemingly ignored as leftover space became not just the "face of the store," but its "eyes and soul," and a subject of intense study by the retail industry.[22] Early trade journals dedicated to the dry goods trade like *Dry Goods Chronicle and Fancy Goods Review* and the *Dry Goods Economist* began to include a regular feature devoted to window dressing that was separate from articles on other "store attractions." In 1893 Harry Harmon began publishing a trade journal dedicated to window dressing and store decoration, followed by L. Frank Baum's more well-known *Merchants Record and Show Window* which began in 1897.[23] Providing both practical tips and artistic inspiration for aspiring trimmers these trade journals heralded the transformation of the store window from storage space to "show window" as premier merchandising device. William Leach has observed that prior to the 1880s the window was viewed as a kind of back storeroom of unwanted goods, merchants having few skills and little interest in display.[24] But the physical appearance of a store was certainly a concern of merchants even prior to this time—newspaper accounts as early as the 1860s acknowledge that "beautiful show windows" can serve as "irresistible inducements to look."[25] However it is only in the last decades of the nineteenth century that the professionalization of window trimming as a business and an art takes place, evidenced in the rise in trade publishing. The illustrated appendix on window trimming that appears in the 1892 *A Complete Dictionary of Dry Goods* indicates the subject was seen already as an important field of knowledge for retailers and clerks. Author George Cole boldly claims that "the show window has architecturally created for the sole purpose that it might be appropriately trimmed and if it be not properly arranged, it is simply useless, a waste of space which cannot … be used for any other purpose."[26] Not just "a passport to success" for ambitious clerks, the show window is endowed with the power to serve as a reflection of the integrity and progressive nature of the merchant and his business.[27]

Trade books dedicated to the topic of window display manuals begin to emerge in the late 1880s, and at a scale and quality that is surprising. In 1889 J.H. Wilson Marriott claims that his *Nearly Three Hundred Ways to Dress Show Windows* is not only the first on the subject published in book form but the most comprehensive in its coverage.[28] At over 200 pages, Marriott's book sets

the model for those that would soon follow in acting as both instructional manual and artistic treatise. Refuting the notion that window trimming requires special intellectual or artistic ability, Marriot promotes his manual as a means to train the ambitious clerk, even if female, "who has wit enough to sell goods."[29] The author includes practical advice like how to wash store windows and keep them from frosting in cold weather, alongside detailed sections on color harmony and lighting.[30] Generously illustrated with line drawings, the book provides a catalogue of window arrangements, organized by lines of goods including dry goods and clothing, furnishing goods like hosiery, shirts and so on, and "fancy" goods like sewing notions, ribbon, and thread.[31] Marriott also offers a set of guiding principles for the novice trimmer, the first being that the window must truthfully represent the class of goods sold in the store.[32] This "stocky" approach that uses "an immense amount of the same article" is illustrated in a shoe display where open shoe boxes are stacked up against the glass, allowing for close inspection of their variety and quality. But the author observes the dressed window must go beyond simply announcing goods for sale in order to attract the attention of people to the store. He calls on the trimmer to "call into use all the artistic feeling and ingenious faculties," demonstrated by set-piece designs that simulate windmills, lighthouses, cradles, ladders, stars, and crescents. The final aim takes this artistic approach even further in in order to not just capture attention but excite in people "the desire of possession." Using means most "extraneous to the goods kept in stock," this novelty approach makes use of side-show effects like "mechanical toys, [and] all exhibitions of curious animals." For Marriott, then, the window can serve as both a three-dimensional catalogue of the store's inventory and an animated attraction, aspiring to the role of a "silent salesman appealing for trade."

The book's illustrated examples often given a humorous title reflecting their carnival roots, showing how these strategies can easily overlap, often dependent on the type and scale of product.[33] Small-scale notions are often used in a kind of modified stock approach, assembled to create novel objects like the Button Castle built of cards of buttons and the House of Books.[34] Men's apparel items like pants, jackets, and shirts were often displayed with "dummies" to create narrative scenes like the "Poor Man's Dream" where a sleeping figure lies in a bedroom, his worn suit on a chair in the foreground while the new articles of apparel hang above as "tangible ghosts with outstretched arms."[35] Dry goods, the first and largest category of products in the book, had a particularly distinctive approach—dress fabrics and white goods like blankets and handkerchiefs that were more amorphous in shape could be displayed either as rolled bolts, twisted into shapes, or unfurled for decorative display.

In the "Opening of the Season" window, dress materials are woven into a wood lattice framework, creating a patterned background from which shawls

are hung (Figure 7.2). In the bottom of the window, blankets, domestic on one side and imported on the other, are stacked, with new styles of underwear placed along the bottom. Noted to "make a show pleasing to the eye" that will "draw large numbers of ladies to inspect," the arrangement is less concerned with a functional combination of goods than with their artistic composition. The drawing seeks to convey in three dimensions, albeit unsuccessfully, the projecting window bay and the interior volume occupied by the goods. In this effort to paint "pretty pictures ... for the sidewalk crowd"[36] in a convincing manner, Marriott seeks to convey the idea that the store window exists in the real space of the street and of the store.

The fervor with which retailers embraced this task of providing a distinctive public identity for their stock and their store is further demonstrated by Frank L Carr in his impressive tome, *A Wide-Awake Window Dresser*, published in 1894.[37] This large format book of over 400 pages consists largely of full-page illustrations of window displays, many now high-quality black-and-white photographs. Carr begins with a detailed study of the window as storefront, examining different sizes and configurations that consider it as exterior façade and interior space. The layout and finish of interior surfaces from fabric and

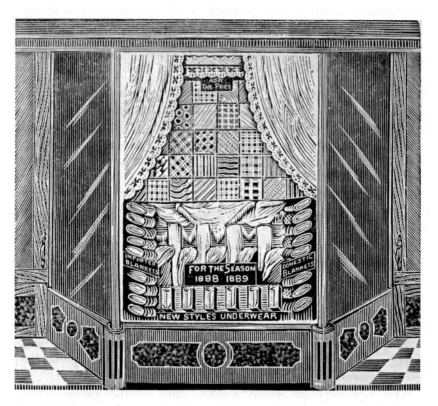

7.2 "Opening of the Season" Display, J.H. Wilson Marriott, 1889

painted covered surfaces and mirrors and lighting define the effort to make use of the full volume of the window interior. After considering the character and dimensions of the window as an empty space, Carr turns to the task of how to fill it with the ever-growing variety of mass-produced consumer goods. The range of examples now include clothing for men, women and children, seasonal costumes, corsets, cloaks, millinery, furs, handkerchiefs, rugs, blankets, pictures, shoes, hats, furniture, spool cotton, buttons, and other notions— as well as a large section on store interiors. Dress goods are again the first and the largest category—now even more specifically identified by type, season, and intended use, from French sateens to "silk-warp henriettas," and from mourning goods to tennis suitings.

The latter display again portrays the window from the street, placed within its architectural setting and identified now by the name of the designer and author (Figure 7.3). In a hybrid "stocky" and "artistic" approach, an appropriately dressed female figure stands within a voluminous space constructed entirely from "masonry" formed by bolts of dress goods. The depth of the window is fully used to create a dense and compact interior—the foreground fabric bolts stand vertically as single pedestal blocks but in the background are laid horizontally to form stacks, columns, and walls—and even draped as a stage curtain. The middle ground parts slightly to provide

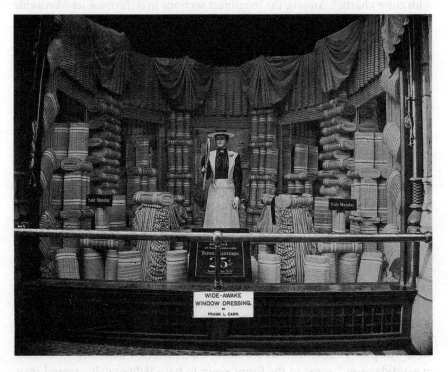

7.3 "Tennis Suitings" Display, Frank L. Carr, 1894

an opening for the female tennis player who provides the visual focus in the composition, serving as a kind of living version of the sign that identifies "tennis suitings" on sale at 25 cents per yard. This human figure is completely encased within the fortified interior of the selling space created by the massive assembly of fabric goods that act simultaneously as commodity, prop and architectural setting.

The task of window trimmers was thus seen as to both attract and "distract," to find a balance between drawing the viewer's attention to the impressive range of the store's stock, and attracting and luring them inside for a sale. While early manuals relied heavily on illustrated examples of finished arrangements, they increasingly sought to reveal the increasingly complex systems behind the scenes. Backgrounds were considered a sufficiently important topic that entire books are published after 1900, dedicated to its treatment as both architectural wall and picture frame. More upscale establishments might have more permanent solid backs of paneled wood, mirrors, and glass, while others employed temporary screens that allowed for greater flexibility and more opportunities for decorating.[38] The first in a four-volume series on window trimming produced by the International Correspondence Schools of 1903 is dedicated solely to backgrounds, with detailed instructions on painting, stenciling, frescoing, wallpaper, lattice and crepe paper ornaments, complete with color charts.[39] Among the lengthiest sections in *A Textbook on Mercantile Decoration* dealt with the covering of the wooden frame in fabric—that could be stretched flat or gathered into various kinds of folds. Despite the elaborate options shown, trimmers were warned that the primary purpose of the background was to "provide relief" while keeping attention focused on the objects in front of it.[40] The treatment of the foreground objects had also became a major topic of discussion, as goods were shaped into discrete display "units" that were arranged to form orderly compositions. A new industry emerged, dedicated to display fixtures as the wood storage box evolved into a complex variety of specialty pedestals and stands, painted or covered in cloth—taking the form of cubes, pillars, columns, and arches that stood on the floor as well as wall brackets and ceiling pendants.[41] These devices provided the invisible framework to help order random piles of goods into an organized system within the architectural confines of the window. Dress goods and clothing items could be draped, gathered, and arranged over these forms to produce a diverse and often abstract collection of "sculptures" in cloth.

As seen in a display for ladies evening wear of 1903 (Figure 7.4), the display fixtures allowed for the creation of forms that ranged from the architectonic— as in the theater box built of columns and walls of "onyx paper, fresco, plush and silk festoonings"—to the organic as seen in the foreground accessories of hats, fans, and other unidentifiable frilly items. While this "Ladies Evening Wear" display is described as featuring merchandise "naturally associated in everyday use," some of the forms seem to have deliberately crossed over

7.4 "Ladies Evening Wear" Display, 1903

from dress accessory to purely decorative feature. The pyramidal draped element in the right foreground, for example, serves as a potential skirt form, completing the hidden body of the female theatergoer, and a column base that completes the architectural setting.

Supported by the frame of the store window, the display of dry goods seems to be thus freed to take on a distinctly artistic approach. The "Art of Draping" becomes the subject of numerous publications, emerging as a distinct specialization with the field of window trimming.[42] The artful draper was endowed with even higher status as an artist by giving an attractive form to the abundant and diverse range of consumer goods available at the end of the century. As women's clothing had yet to be fully taken over by the ready-made clothing market, dress fabrics were unlike other consumer goods in being a kind of raw material for direct sale to the public.[43] These material

goods were also distinct from other fancy good items for dressmaking like laces, ribbons, trims, and thread in their greater scale and wider variety in material, texture, color and pattern. As seen in "Tennis Suitings" display, textile goods were weighty and bulky in their stored state on a roll, but highly malleable and fluid when unfurled for inspection. The technique of draping was originally intended to help the consumer to inspect the texture and color more closely, and even its weight and fall in the final dress. But George Cole observes that dress materials were of interest not only to the female buyer who is in need of a particular article but also who "has nothing to do," who is certain to be "attracted by goods prettily or tastily displayed."[44] Even white goods, like sheets, blankets, handkerchiefs, and other household items that served a specific identifiable purpose provided decorative raw material for the creative trimmer.

In an "Artistic Linen Decoration" by James M. Walters (Figure 7.5), table and fancy linens are displayed in what is identified as a seasonal display for the Thanksgiving holiday of 1904. The window contains what appears to be a giraffe in an elaborate canopied cage, set within a landscape of column "trees" and foliage that are arranged in ascending tiers that lead the eye back in now deep space. Lacking a written description, the display appears to be constructed totally of linens, embroideries, laces, handkerchiefs, and trim that have cut, hung, folded, wound, and twisted, providing a visually complex scene in which goods for sale and decorative elements merge into an elaborate

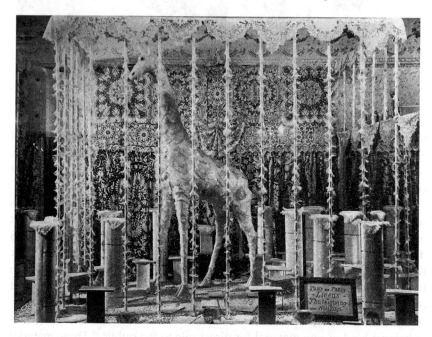

7.5 "Artistic Linen Decoration" Display, James M. Walters, 1904

but still believable space. While certain linen items appear to be displayed in deliberate ways like the table napkins atop the pedestals, they serve more as foliage than as household goods for Thanksgiving dinner. The visual appeal of the scene is more important than the associative value of the products back to their use, or even to the holiday in question. This fantastical zoo of lace and linen is clearly intended to "attract" through its spectacular visual effect and the novelty of its exotic subject. Despite its inexplicable presence in this Thanksgiving scene, the "curious creature" sculpted in fringed fabric rests solidly within this architectural space defined by a light and frilly web of embroidery and lace.

The move away from the associative power of goods to the spectacle of the "unfamiliar" and exotic in window display has often been identified with the work of L. Frank Baum who has been seen as the leading figure in the transformation of the window trimmer to showman. But earlier window manual writers had identified the aim of transforming mere attraction into the kind of "distraction" that could induce desire. The idea of showing goods not in their intended use but as decorative building blocks produced unusual creations like the Brooklyn Bridge made of spool thread. Exotic creatures roaming in theatrical settings was nothing new as evidenced in J.H. Wilson Marriott's "Have you Seen the Elephant" display where a row of "wax" boys sat on a great pachyderm composed of coats and other articles of attire.[45] However, the means to achieve these special effects became more sophisticated with advances in electricity and mechanical devices that not only illuminated displays but set them into motion. Revolving stands first intended to facilitate 360 degree inspection evolved into moving attractions like spinning windmills, ships riding waves, and astronomical scenes with a revolving earth. Displays sometimes incorporated goods, as in the Mechanical Butterfly that opened and closed to reveal the bust of a woman wearing a hat.[46] But the show was paramount, evident in increasingly theatrical displays like the Vanishing Woman where a now live woman modeled hats, "disappearing" between costume changes. The featuring of the woman's body as the primary display form reflected both advances in ready-made clothing and in fixture design and construction. The increasing naturalism of the display form that would come to be known as the mannequin facilitated the move towards narrative scenes more strongly associated with the use of the displayed goods.

With the acceptance of the profession and the increasing specialization in the field, manuals dedicated to window display seem to become less ambitious after 1910, the subject either absorbed into advertising texts or reduced to promotional pamphlets for various manufacturers of storefronts, display fixtures and other merchandising devices.[47] But *Display Window Lighting and the City Beautiful* of 1912 is still an impressive publication in which F. Laurent Godinez takes retail lighting as a subject as much related to urban design as to electrical engineering. Atmospheric photographs of city

streets outweigh technical diagrams as the author passionately argues that the properly illuminated display window is essential to the attraction of a business thoroughfare and to the creation of the modern "city beautiful."

The figure entitled "The Effect Beautiful" (Figure 7.6) illustrates a featured example of how such an effective and well-engineered attraction can be created by the skillful combination of artistic draping and artistic lighting.[48] A now flat black background accentuates the profile of luminous, pastel-colored "fountains," the illusion created by draped silk fabrics supported by invisible wires and illuminated by lights within.[49] As the space of the window seems to have dissolved, so too has the identity of the goods, transformed here into a purely abstract landscape that promotes only "the hypnotic power of light" and the idea that it is "the thing which is *different* that *attracts*." Acting as a kind of a large-scale illuminated commodity and a "theatrical stage in miniature,"

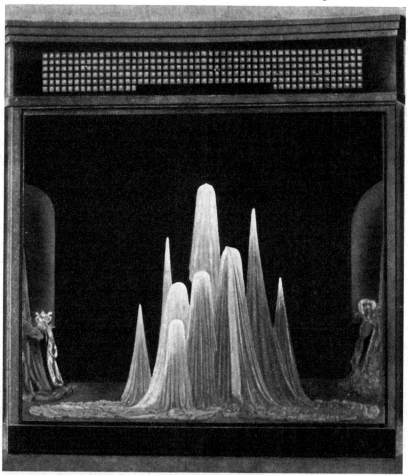

7.6 "The Effect Beautiful" Display, L. Frank Godinez, c.1914

the display window is thus seen again as spanning the spatial continuum between sign, street, and city.

For Godinez and other aspiring window trimmers, the design of windows would continue to offer an appeal across disciplines as diverse as building engineering and city planning, retail advertising and building design. Even with much more spectacular entertainments available, the shop window still survives in present-day cities as a magical lure for the urban crowd and a potent tool for the professional display man. In 1896 an anonymous writer in the *Dry Goods Chronicle* provides a vivid description of a famous business thoroughfare that serves as a testament to the power of window advertising:

> The Storefronts glitter with plate glass, behind which the art of the dresser evolves scenic displays equal to those of fairyland. The sheen of silks, the luster of satins, mingle their hues with variegated and brilliant dyes of fine wool fabrics. Thin wool dress goods, almost as delicate in texture as a spider's web, and of spotless white, vie with tintings and shadings of purples, pinks and blue, all blending in a harmony of color as complete in rhythm as the notes in music. Arches of ribbon as brilliant as rainbows span wide spaces of plate glass, while fluted columns and pyramids of laces and jets spring from the base, and sparkle and gleam in rare beauty.[50]

In this poetic description of the windows of Broadway in New York, iron and glass, and silks and satins intertwine as solid architectural surfaces dissolve into ephemeral effects of color and light. The structural matrix of the street front provides the framework for the creation of a fantastical landscape composed of fabrics and trimmings for sale. In its construction as street architecture and in its "dressing" as display fixture, the show window embodies the rise of the spectacle of consumption and the codifying of merchandising strategies in the turn-of-the-century city. For no matter how magical the scene, fantasy is never far from reality as rainbows are made of ribbons and fountains of laces in these windows that never stop selling.[51]

Notes

1 Walter Benjamin, *The Arcades Project*, trans. Howard Eiland and Kevin McLauchlin, Cambridge, Mass. and London: Belknap Press of Harvard University, 1999 and Sean Nixon, "Technologies of Looking: Retailing and the Visual," in Stuart Hall, ed., *Representations: Cultural Representations and Signifying Practices*, London: Sage, 2007, pp. 333–4.

2 See for example Anne Friedberg, *Window Shopping: Cinema and the Invention of Modern Life*, Berkeley: University of California Press, 1994, pp. 47–90; Janet Ward, *Weimar Surfaces: Visual Culture in 1920s Weimar Germany*, Berkeley: University of California Press, 2001, pp. 191–240 and Jean-Paul Bouillon, "The Shop Window," in *The 1920s. Age of the Metropolis*, ed., Jean Clair, Montreal: Montreal Museum of Fine Arts, 1991, pp. 162–81.

3 Much of the attention came from historic preservationists in the 1970s and 1980s and is focused on small town main streets. See for example: H. Ward Jandl, "Rehabilitating Historic Storefronts," Washington, DC: Technical Preservation Services, US Dept of the Interior, (September 1982): pp. 1–11.

4 Walter Knight Sturgis, "Introduction," *The Origins of Cast Iron in America*, New York: Da Capo, 1970, p. viii.

5 Mike Jackson, "Storefronts on Main Street: An Architectural History," *Illinois Preservation Series* 19, Springfield, Illinois: Illinois Historic Preservation Agency, 1998, pp. 1–19.

6 Rueben Skye Rose-Redwood, "Rationalizing the Landscape; Superimposing the Grid on the Island of Manhattan," Ph.D. diss., Penn State, 2002, p. 120.

7 M. Field, *City Architecture; or Designs for Dwellings, Stores, Hotels, etc.*, Putnam: New York, 1853.

8 "The Development of American Architecture," *The Continental Monthly: Devoted to Literature and to National Policy* 5, 4 (April 1864), p. 466.

9 "Strength in Buildings and its Appearance," *Scientific American* XIX, 16, (Oct 14, 1868) p. 249.

10 The inner bays of doors and windows were then subdivided again into multiple panes, reinforcing the street grid, now in elevation. Jackson, "Storefronts on Main Street: An Architectural History," pp. 3–6.

11 "Improved Shutter," *Scientific American* XII, 18 (Oct. 28, 1865), p. 271.

12 Fields, p. 40.

13 Wm. J. Fryer, Jr, "Iron Storefronts," *The Architectural Review and American Builder's Journal* (April 1869): pp. 619, 621.

14 James Bogardus, *Cast Iron Buildings: Their Construction and Advantages*, 1865; reprint in *The Origins of Cast Iron Architecture in America*, New York; De Capo Press, 1970.

15 Doors would often have provided access not only to the store at ground floor but leasable spaces above.

16 Robert Childs, *The Thoughtful Thinker on Window Dressing*, Syracuse, NY: US Window Trimmer's Bureau, 1896, p. 45.

17 Jackson, pp. 8–9. I thank Mike Jackson for providing additional insights on the development of storefront design in the nineteenth-century. He notes that while large panes of plate glass were being produced in France in the early nineteenth century, smaller sizes continued to be prevalent in store windows for some time. Plate glass was only being produced profitably and extensively in the US late in the century. See *Glass: History, Manufacture and Its Universal Application*, Pittsburgh, Pittsburgh Plate Glass Co., 1923, pp. 31–2.

18 William T. Comstock, *Modern Architectural Designs and Details*, New York: William T. Comstock Co., 1881.

19 Jackson observes that the decorative pattern of this millwork reflected woodworking advances and changing styles in residential architecture and even of furniture. Bulkhead and transom panels would also be made of cast iron, and eventually sheet metal. Jackson, p. 5–8.

20 I am grateful to Ernest Frithiof Freeberg for sharing his research on electric lighting in this period. He observes that this was a period of transition between gas and electric. While available to downtown shopkeepers by the 1890s, electric lighting was expensive—and there was no central supply.

21 Concerns about security and about the control of light and dust influenced the debate as to whether the window should be fully enclosed. See *Dry Goods Chronicle* 2, 16 (Oct 16, 1886), p. 5.

22 "The Art of Window Dressing," *New York Times Magazine Supplement* (8 Sept. 1901): p. SM5.

23 Leigh Eric Schmidt points out that Harry Harmon published some of the earliest pamphlets on window dressing such as *Window and Store Decorating for the Christmas Holiday*, Louisville: H. Harmon, [1890]. Schmidt, "The Commercialization of the Calendar: American Holidays and the Culture of Consumption, 1870–1930," *Journal of American History* 78, 3 (December 1991), pp. 894–5. Baum compiled excerpts from his journal into the book, *The Art of Decorating Dry Goods Windows and Interiors*, Chicago: Show Window Publishing, 1900.

24 William Leach, *Land of Desire: Merchants, Power and the Rise of a New American Culture*, New York: Pantheon Books, 1993, p. 55.

25 "The New Store of C.C. Holbrook & Co.," *Boston Daily Atlas*, (26 Feb. 1856), p. 2. See also "Lyons and Co.'s Mammoth Clothing House," *New Orleans Times* (31 Dec. 1865), p. 2.

26 George S. Cole, *A Complete Dictionary of Dry Goods*, Chicago: W.B. Conkey & Co., [1892], p. 470.

27 Cole, p. 470. *Dry Goods Chronicle* 2, 15 (Oct 9 1886), p. 5.

28 J.H. Wilson Marriott, *Nearly Three Hundred Ways to Dress Show Windows: Also Suggestions and Ideas for Store Decoration*, Baltimore: Show Window Publishing, 1889.

29 Cole, p. 470.

30 Marriot, p. 42.

31 Also included are special seasonal and holiday arrangements as well as window displays for groceries, furniture, hardware, druggists, paint, and stationary stores.

32 Marriott, pp. 5–8, 116.

33 Leonard Marcus, *The American Store Window*, New York and London: Architectural Press, 1978, p. 16–17.

34 Marriott, pp. 81, 143.

35 Marriott, p. 57.

36 Marriott, p. 10.

37 Frank L. Carr, *The Wide-Awake Window Dresser*, New York: Frank L. Carr, Dry Goods Economist, 1894.

38 *A Textbook on Mercantile Decoration*, Scranton: International Correspondence Schools, [1903–1906]) consisted of four volumes; Vol. 1 on Backgrounds, Vol. 2 on Dress Goods, White Goods and Clothing, Vol. 3 on Men's and Women's Furnishings and House Furnishings and Vol. 4 on Miscellaneous Decorations and Light and Motion.

39 *The Art of Decorating Show Windows and Interiors*, Chicago: Merchants Record Co., 1904, pp. 35–8. Window backgrounds are characterized by holiday season and period style in George J. Cowan, *Window Backgrounds*, Chicago: Dry Goods Reporter, 1912.

40 Cole, p. 485.

41 *The Art of Decorating Show Windows and Interiors*, 1904, pp. 11–18.

42 Albert A. Koester, *The Koester System of Draping*, Chicago: Merchants Record [1906].

43 See Rob Schorman, *Selling Style: Clothing and Social Change at the Turn of the Century*, Philadelphia: University of Pennsylvania Press, 2003.

44 Cole, p. 485.

45 Marriott, p. 193.

46 Variations on this theme included the Mechanical Fan and the Mechanical Egg, as well as the Straw Hat Machine. *The Art of Decorating Show Windows and Interiors*, pp. 7–99, 117–23.

47 There are exceptions, of course, as in International Correspondence Schools, *The Window Trimmers Handbook*, Philadelphia; John C. Winston, 1921 and Albert T. Fischer's *Window and Store Display: A Handbook for Advertisers*, Garden City, NY: Doubleday, Page & Co., 1922.

48 F. Laurent Godinez, *Display Window Lighting and the City Beautiful*, New York: Wm. T. Comstock: c.1914, p. 36.

49 The author offers this display as an alternative to the "light-in-the-stocking" exhibit. Godinez, p. 188.

50 *Dry Goods Chronicle*, 1, 25 (June 19, 1886), p. 5.

51 "A shop window is both magical and frustrating- the strategy of advertising in epitome." Jean Baudrillard, *The System of Objects*, London: Verso, 2005, p. 42.

PART III

Place

Selling Automobility: Architecture as Sales Strategy in US Car Dealerships before 1920

Robert Buerglener

New York, 1917.[1] A lofty space with a coffered ceiling. Walls adorned with elegant wood paneling, tastefully divided by fluted pilasters. Above a dentiled cornice, light shimmered on travertine. Tall marble columns framed a dramatic staircase, which was flanked by bronze balusters. Potted palms, oriental rugs, and richly upholstered chairs enhanced the lavish setting for all who came to view the objects on display. A "veritable model of dignified simplicity," noted one observer approvingly.[2] What great cultural institution, what elite private club elicited this praise? None, for the building was actually the Ford Motor Company showroom on Broadway at 54th Street, designed by architect Albert Kahn (Figure 8.1).

Today's driver might find this an overly formal setting to buy a car. However, those who built and designed dealerships in the early twentieth century saw the elaborate decoration and spaces of their sales buildings not as incidental, but rather as serving crucial dramaturgic and educational functions. Successful automobile dealership buildings had to address many different needs. For individual buyers, dealerships provided a setting for decisions about what cars to buy. For dealers and manufacturers, these buildings represented an effort to create brand identities and establish respectability for the automobile industry, whose early years were marred by unreliable cars and short-lived companies. And beyond the level of individual consumers or dealers, the physical form of dealership buildings played a vital role in the overall burgeoning popularity of automobile-based transportation: as spaces of consumption, maintenance, and education, dealerships became nodes for the distribution of knowledge about cars and the creation of entire systems centered on their use. Dealers' sales and service buildings thus offer an excellent site to understand more fully the complex interaction between retailing and social power enacted through visual and material culture.

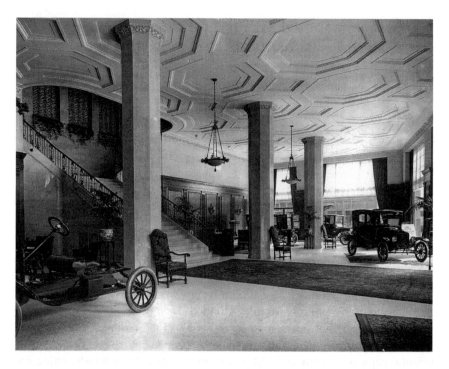

8.1 Main showroom, Ford Motor Company, New York, Albert Kahn, architect, 1917

In spite of the obvious importance of automobiles in American culture, the design and uses of automobile dealership buildings have been surprisingly understudied as a key element in this story. The automobile industry in general has received considerable scholarly attention centered on individual companies or the economic development of the industry as a whole.[3] Few scholars, however, have connected their analysis of business systems with the physical spaces and functions of distribution, especially in terms of the built environment. Although a complete history of marketing is beyond the limits of this chapter, what is significant is that automobile makers, like many other companies at this time, were attempting to create brand awareness through print advertising and trademarks.[4] As part of these larger efforts, manufacturers and individual dealers actively integrated the form and decoration of their buildings with larger marketing goals. In this quest, automobile dealers faced a number of challenges specific to the product they were marketing and the reputation of the automobile industry; they turned to design and décor to help solve these problems.

Within the history of commercial architecture, automobile dealerships came about in the same era that witnessed the construction of great department stores, banks, and skyscrapers.[5] Unlike those building types, though, dealership buildings were associated with a new product that from the very

beginning led to modification and innovation of established architectural forms. Historian Chester Liebs has provided perhaps the only overview of the topic. In a brief yet evocative summation, he has portrayed dealership buildings as an indispensible element of roadside architecture. According to Liebs, in the first decades of the twentieth century, automobile manufacturers built "'object-lesson' salesrooms in highly visible locations near business districts of large cities."[6] Such buildings were often clustered together in automobile or motor rows, districts devoted to the sale of cars. Among other cities, Chicago, Boston, and San Francisco all boasted motor rows.[7] Liebs characterized the more opulent dealerships as "model showrooms ... crafted to resemble the most impressive office buildings, banks, and railroad depots so they would instantly be perceived as civic assets."[8] He maintained that these substantial buildings were part of an overall strategy to win acceptance of individual brands of cars, and cars in general as a new kind of technology: "Producing good cars and convincing advertisements was one way to inspire public confidence. Building impressive and attractive showrooms was another."[9]

Despite Liebs's thought-provoking treatment, scholars have for the most part not pursued the topic during the intervening quarter century. While Liebs provided an excellent introduction to built forms, his work also raises a series of unanswered questions about the larger web of agency and systems. To understand their full importance, dealership buildings must be analyzed for their physical form and also for the complex interplay between consumers, manufacturers, and dealers that took place within them.

I would like here to suggest one framework based on the work of several key theorists from the history of technology. Although not generally applied in the context of visual culture or architectural history, these theories provide, first of all, methods to analyze the social interactions that took place in dealerships, and, secondly, ways to connect discrete buildings with larger commercial and social systems. The first of these is the concept of the consumption junction, introduced by historian Ruth Schwartz Cowan. She defined this as the "place and the time at which the consumer makes choices between competing technologies" and decides "which paths seemed wise to pursue and which too dangerous to contemplate."[10]

Dealerships, especially the flagship showrooms in large cities, represented the physical embodiment of Cowan's concept of the consumption junction, where individual customers bargained with dealer representatives over expensive products. The dangers inherent in the consumption junction involved not just money and products that might not work. Would-be automobile drivers before 1920 were buying an expensive and unknown commodity, a purchase with significant financial and social status implications. To succeed in this context, people who wanted to own a car had to renegotiate

their customary roles as consumers while simultaneously learning about intricate, unfamiliar machines.

Beyond the level of personal choice, automobile dealerships represented the mediation between individual consumers and larger systems. Historians Ruth Oldenziel, Adri Albert de la Bruhèze, and Onno de Wit have taken Cowan's concept of a consumption junction a step further to develop the idea of a mediation junction, in which "[n]ew actors and institutions made systematic attempts at coordinating between mass production and mass consumption in novel ways."[11] Oldenziel, de la Bruhèze, and de Wit formulated this idea especially in reference to consumer groups and others users of consumer goods. However, here I would add a chronological and situational aspect to their theory in terms of early automobile dealers. While the system of automobility was still in the process of formation, the boundaries between consumers, producers, and sellers were much less well defined than they would later become. Although of course profit was a factor, some early dealers entered the business precisely because of their enthusiasm for cars. They, too, were consumers. They took part in the activities of local motor clubs, and some even manufactured or assembled cars. So despite their commercial motivation, dealership personnel played an educational role by making new technology available and explaining its use, often in spectacular form. Like the early advertising agents Roland Marchand described as "mediators of modernity as well as its apostles," the creators and personnel of early automobile dealership buildings embodied Oldenziel's mediation junction by directly connecting individual consumers to larger systems of production and distribution.[12]

Finally, dealerships played a crucial role in creating what sociologists Mimi Sheller and John Urry have called the system of automobility, an inextricable part of present-day consumer society.[13] According to Sheller and Urry, this system consists of "a complex amalgam of interlocking machines, social practices and ways of dwelling, not in a stationary home, but in a mobile, semi-privatized and hugely dangerous capsule."[14] In sales rooms and repair stations dealers and customers enacted the social practices necessary to buying and keeping a car. In the case of automobile dealerships, the architects and designers—sometimes well-known, sometimes anonymous—created sales buildings to function on multiple levels, advertising the desirability of the entire system of automobility as well as the merits of individual brands.

In actual practice, the size, form, and decoration of automobile dealerships varied immensely. Small-town dealerships, for instance, were much less grand in form. Even smaller dealers, however, adapted similar strategies regarding the decoration and separation of spaces.[15] Though only part of a complex whole, large urban dealerships nevertheless can serve to illustrate the growing importance of visual meaning and spatial separation in early automobile marketing. After looking at this situation in general terms, I will

emphasize Chicago's automobile row as a case study, with a focus on one building in particular, the Locomobile dealership building completed in 1910. As a major retail center for automobile sales in the Middle West during the period leading up to 1920, Chicago offers an excellent example of how the consumption and mediation junctions were embodied in the buildings necessary to selling and maintaining the system of automobility.

The Automobile Market in the Early Twentieth Century: Actors and Interests

The topic of automobile dealers and dealership buildings encompasses both the history of the firms behind the buildings, and also the history of retail architecture generally. The automobile industry was changing with amazing speed in the early twentieth century. Many details of distribution and sales had not yet been settled. Speaking in very general terms, automobile retailing in the first decades of the industry developed from a nearly chaotic situation to a much more organized, bureaucratic corporate structure by the early 1920s.[16] Part of this evolution involved where buyers could purchase cars: early on, companies pursued a variety of strategies, including direct sales from the factory to customers through so-called branch houses.[17] Over time, consumers who wanted to purchase a car increasingly went directly to a franchised dealer. By 1920, for instance, some 96 percent of General Motors' sales were through a dealer, not through branch houses, although branch houses continued to exist for certain brands.[18]

Under the emerging system of franchised dealerships, the owners of dealerships as well as sales personnel faced many different pressures. The dealer-manufacturer relationship was often contentious. Typical franchise contracts required dealers to buy a certain number of automobiles per season or per year. Dealers were obligated to pay between 2 to 10 percent of the purchase price at the time of the order, with the remainder due when the cars were delivered.[19] Particularly in the first years of the industry, from about 1898 to 1910, dealers operated under uncertain conditions due to the general fiscal instability of many automobile makers and the rapid changes taking place within the industry. Because manufacturers had not yet worked out the production process, dealers might not receive cars they had ordered, or might receive them only after great delay. For dealers, this meant they had tied up capital in cars they did not have, and they had to placate disappointed or angry customers.[20] Those who sold automobiles doubtless faced their own challenges in this context. Pressures from the manufacturers on dealers and agents to sell automobiles may at least in part have led to the stereotype of the aggressive automobile sales agent.[21]

Of course, customers represented another interested group on the floor of the grand new showrooms. As more people bought cars, they expressed greater doubts about being misled by the appearance of the product. In 1910, Robert Sloss, an author who wrote extensively in the popular press about various matters relating to cars, warned consumers about the dangers of trusting their visual impressions in picking a car. "The day has gone when superiority can be *seen*," according to Sloss.[22] In a similar vein, the author of a 1912 *Harper's Weekly* piece confirmed this assessment when he wrote that the "man who decides to purchase a motor-car" has "a perplexing problem to solve" because to the novice, all automobiles looked more or less the same.[23] He continued, "To the first purchaser any automobile is an automobile. He sees all makes and kinds and sizes ... So far as he can see, they all run all right."[24] After a period of use, however, the journalist claimed that drivers would begin to experience a plethora of difficulties not visible at the time of purchase. [25] In picking out a car, seeing was not believing, as these contemporary sources made clear.

Hearing was not believing either, at least when it came to salesmen, who were an integral part of a visit to an automobile showroom. A number of those who wrote about buying a car suggested constant skepticism about all salesmen. Two examples can stand here as representative. In 1910, journalist Howard Coffin warned against listening to the "many false and foolish statements" from salesmen attempting to convince buyers.[26] A 1914 guidebook by Thomas Fay, *How to Buy an Automobile*, took this attitude even further. Throughout his book, Fay pitted the purchaser against the dishonest salesmen, who was aided with the science of psychology to break down sales resistance. The "skilled salesman" was, according to Fay, "in a position to take undue advantage of the guileless."[27] Purchasers could only protect themselves through insisting on proof for every statement the sales agent made and also by having a thorough knowledge of the many tricks salesmen used. In Fay's estimation, drivers should thoroughly educate themselves before even entering the showroom, and maintain a continually skeptical attitude toward sales promises.[28]

The Art and Practice of Merchandising Automobiles

All of these preconditions to the sales floor represented challenges for dealers and salesmen. In addition to overcoming customers' potential doubt about the reliability of cars, and then confronting buyers' mistrust of salesmen, the nature of the merchandise and also the question of gender complicated the sales process. To begin with, dealers faced the conundrum of displaying cars themselves. Cars were meant to be used in motion, yet at least the initial sales pitch took place indoors, where the product was not moving. In an era when

cars often were unreliable, dealers needed to offer service and maintenance without frightening potential buyers by overemphasizing the difficulties and expense of owning a car. Finally, according to many early sources, women were important factors in the buying decision, yet dealers felt that women required an especially clean and inviting atmosphere, something not necessarily compatible with the world of machinery.

Particularly in large dealerships, dealers attempted to overcome these problems by creating dramatic spaces and displays that simultaneously emphasized luxury while hiding the potential problems of automobile maintenance. Large front windows typically provided light for sales rooms. For flagship stores, two-story sales rooms, with a descending staircase, were often favored to create an atmosphere of opulence. Trade journals advocated dramatic window displays to catch the attention of pedestrians—not drivers— and convey a seasonal or pro-automobile message. One example is a 1914 show window in Baton Rouge, Louisiana, praised by the journal *Motor World* for its "timeliness and attractiveness" in advocating good roads (Figure 8.2).

The window contained not only the car that was for sale, but a sample of the gravel that was to be used to create new roads in the county. The window thus promoted not just that brand, but also advocated the infrastructure necessary to automobility by evoking the open road and carefree driving.[29]

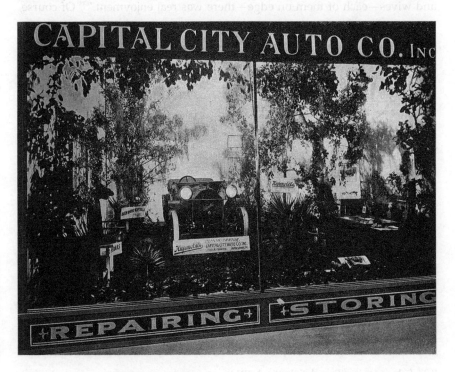

8.2 "Good Roads Window" ad, 1914

Trade publications advocated the use of potted plants, flowers, and tastefully chosen furniture, and so on, to put customers at ease and, not coincidentally, to appeal to women as potential buyers.[30] As one example of creating a proper merchandising atmosphere, a 1914 article, "Stimulating Trade When It is 'Sagging'," recommended elaborate displays that would connote luxury and what the dealer referred to as "class."[31] (Figure 8.3).

Through its appeal to domesticity and opulence, this aura was intended to appeal to women as part of the buying process, though nothing was said about women as buyers or drivers themselves. According to the dealer interviewed, a gendered approach to selling would bring the best results. If a husband and wife came in to buy a car, this dealer directed his salesmen to split them up: one salesman led the husband in one direction and discussed the mechanical attributes of the car, while another salesman entertained the wife by discussing the display and the aesthetic qualities of the car (in this case, a Hudson). This display involved the use of "Turkish rugs," "true Jacobean Period" chairs, and the skins of a bear, a lion, and a tiger.[32] In boasting of his success, the dealer said that although the display was complicated, "in every sense it has been a practical and profitable investment." In particular, he thought he had succeeded, in breaking down sales resistance: "Instead of the uncomfortable 'shopping spirit' that seems to be common to most husbands and wives—each of them on edge—there was real enjoyment."[33] Of course,

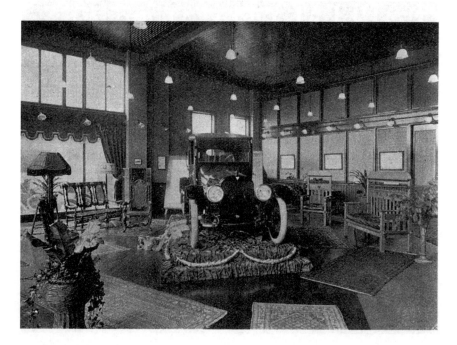

8.3 Salesroom as "French Salon" ad, 1914

the results were most important: he and his sales team sold 23 cars in two weeks at a time of year when business was usually slow. [34]

Beyond the artistry involved in creating individual displays, the architectural layout of dealership buildings also revealed considerable attention to creating the proper selling atmosphere by strictly separating spaces by function. The interior spaces devoted to the care and maintenance of cars were not seen from the showroom floor itself, since they would have served as a reminder of the possibly expensive repairs and maintenance awaiting the prospective buyer. Some sources even advocated entirely separate buildings for sales and service. In a 1918 book titled *How to Run a Retail Automobile Business at a Profit*, the authors recommended a separate building as a "service station." This arrangement allowed dealers to use high-rent retail space on main streets, and locate larger, much less ornamental buildings on lower-rent side streets. Also, according to the anonymous authors, this arrangement encouraged more women customers, who were allegedly more sensitive to what they called the "continual noise, unpleasant odors, and other disagreeable features" of a combined sales and service building.[35] Throughout this time period, trade journals and advice manuals to dealers portrayed potential buyers generally as being middle class and above. The issue of ethnicity was typically not discussed. Rather, cleanliness and order were melded into a selling space that would appeal to an ideal of a white, gendered, normative middle class.

Chicago's Motor Row: Monuments to Sales

The development in larger cities of automobile or motor rows devoted to merchandising cars and accessories reflected the belief in the importance of using buildings to create a selling mood. As with much commercial architecture during the early twentieth century, the builders of these motor rows used historicist styles that emphasized respectability and permanence. Indeed, in a way similar to retail spaces like the late nineteenth-century department stores studied by Neil Harris and others, flagship automobile dealerships in this era took on a monumental quality that allowed the pursuit of modern commerce within a vocabulary of historicist architectural styles.[36] Writing about Chicago skyscrapers, Daniel Bluestone has argued that the rich ornament used in early office buildings allowed business leaders to "ennoble commerce with monumental forms, using rich materials, traditional architectural motives, and expressions of white-collar cultivation."[37] Nor was the technique of building elaborate commercial structures to give credence to new or sometimes dubious ventures confined to department stores or office buildings. Cinema historian Douglas Gomery has found that by the late 1910s and into the 1920s, studios built elaborate movie palaces to increase the respectability of their product. Luxurious appointments and the latest

in modern ventilation and lighting systems were combined with a fanciful use of historicist architectural styles to reassure middle-class audiences of the probity of the industry.[38] Certainly, the design of showrooms suggests that many automobile dealers wanted to convey stability, decorum, and, depending on the brand, out and out luxury.

The monumental form of many of the buildings in Chicago's Motor Row and the extensive use of decorative terra cotta in historical motifs implied permanence and prestige in what was still an unstable industry. Moreover, as architectural historian Robert Bruegmann has pointed out, the form and materials of these buildings provided "the visual stimulation that dealers felt was necessary to convey the excitement of the rapidly changing new technology."[39] The buildings were stylistically impressive, despite the fact that they had to be "fireproof and thoroughly ventilated" in order to combat the dangers of gasoline and exhaust fumes.[40] Architects played down the industrial character of the poured concrete structures by adding elaborate brickwork and terra cotta façades, and they used a stylistic vocabulary that ranged from English, to Italianate, to French Beaux Arts, to Gothic.[41] Motor Row structures shared this stylistic mixing with other prestigious Chicago banks, clubs, and office buildings. Indeed, many of the Motor Row buildings were designed by the same well-known architects of other prominent Chicago commercial buildings, including Alfred Alschuler and the prolific Chicago firm of Holabird & Roche.[42]

Chicago's Motor Row, one of the country's most extensive from 1905 onwards, evolved into a highly developed buying environment for urban automobile purchasers. Running south of the downtown Loop district along Michigan Avenue between roughly 12th and 24th Streets, Motor Row consisted of dealerships and retail outlets for tires and related accessories. At this time, Michigan Avenue was a major north-south route through the city and therefore especially desirable for the automobile trade. According to one author in 1905, the buildings on Automobile Row were "of permanent construction, and combine beauty, convenience, and utility to a pronounced degree."[43] A 1910 article in *The Architectural Record* outlined the "Transmutation of a Residence Street," explaining how Michigan Avenue property owners sold their formerly desirable houses to developers who promptly tore them down to build stores and commercial buildings that catered to the automobile trade. This transformation is markedly apparent in contemporary photographs: an 1891 illustration of Michigan Avenue looking north from 24th Street shows the residential character of the area, with only a single vehicle—horse drawn—in view. By 1908, a view of Michigan Avenue looking north from 15th Street shows an almost solid wall of commercial buildings on both sides of the street, with many cars parked along the curb.[44] Unlike many automobile dealerships built in the post-World War II period, the dealership buildings on Chicago's Motor Row were

not surrounded by parking lots. Rather, these buildings still maintained a mostly unbroken street wall and emphasized street-level displays aimed at pedestrians, not drivers.[45] (Figure 8.4).

Although Michigan Avenue rapidly became commercialized in the early twentieth century, neighboring residential streets remained fashionable, and the continuing presence of churches and clubs on Michigan Avenue meant that there most likely would have been ample foot traffic to look at window displays. Once inside the buildings, consumers encountered a space strictly separated by use, with different interior functions emphasized by a hierarchy of applied decoration. These spaces were filled with light from the large windows, although not yet the advanced level of theatrical spot-lighting that would enhance merchandising efforts in later decades.[46] The focal points in these spaces were, of course, the automobiles: their aesthetic qualities were further enhanced by polished, decorative surfaces surrounding them and by potted plants and tastefully chosen furniture.[47] The buildings along Chicago's Automobile Row conformed with the suggestions of trade literature in their layout: the interior spaces devoted to the care and maintenance of the goods on sale were not seen from the showroom floor itself. Using the alley layout of Chicago's street plan, automobiles in need of repair or maintenance were typically brought in to most dealerships through a back entrance.[48] Servicing and in some cases even final assembly took place at the back of the building and on the upper floors.[49] Taken together, the architecture of the buildings, along with the clustering of automobile-related businesses, must have contributed to the symbolic importance of making a major purchase for early drivers. And the scope and scale of Motor Row indicates that for at least a

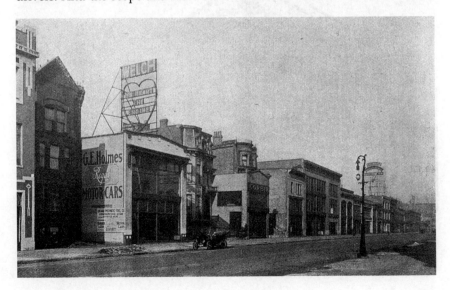

8.4 Automobile Row, Chicago, *Architectural Record*, 1910

period of about 20 to 25 years, those who built the buildings believed in their efficacy as selling tools.

The Locomobile Building: "An Architectural Gem"

Photographs from 1910 of Chicago's Automobile Row branch of the Locomobile Company illustrate the interplay of architecture and marketing found all along Chicago's automobile row (Figure 8.5). The building was designed by the well-established commercial firm of Jenney, Mundie, and Jensen and built at a cost of $250,000 in 1909. Described by the Locomobile Company as "an architectural gem," the four-story building was prominently located on a corner, with large show windows on two sides in the front half of the building and an entrance on the Michigan Avenue façade.[50] The building was built of red brick with cream-yellow terra cotta trim. Rather than extensive signage, contemporary photographs show a restrained "Locomobile" molded into the terra cotta on the Michigan Avenue side and a lighted sign on the side entrance away from the main façade. Stylistically, the building was an eclectic mix: historicist details like a cornice were combined with an overall window pattern that recalled factories and certain Chicago-style buildings. The strong horizontal piers emphasize the framing of the building, as was common in

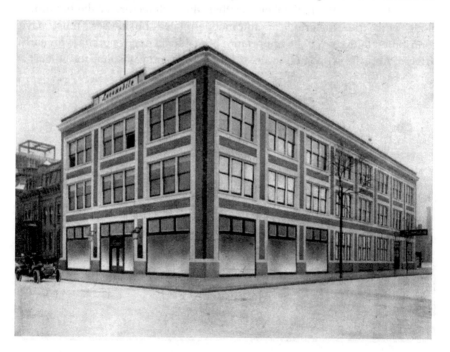

8.5 Locomobile Building, Chicago, Jenney, Mundie and Jensen, Architects, 1909

industrial buildings. However, the overall form of the building follows the base-shaft-capital organization of Chicago School skyscrapers, although in truncated form. The building also shared in common with downtown office structures the hierarchical use of building materials: on the Michigan Avenue façade and one bay west on the cross street, the base of the building was faced in stone, a more expensive material than either terra cotta or brick.

The Locomobile Company produced expensive cars, and they clearly utilized architecture to enhance their overall image. In a 1910 ad specifically aimed at a Chicago audience, the Locomobile Company referred to the "size and dignity" of its new sales building as a reflection of the company's success.[51] Another example, an advertisement from the Chicago *Tribune* in 1911, did not specifically mention architecture in the written copy (Figure 8.6). However, visually it directly equated the staid lines of the Landaulet in the foreground with the dignity of the Beaux-Arts building in the background— in this case the New Theatre, designed by the New York architectural firm of Carrère & Hastings in 1909.[52] Although automobiles as moving objects might seem antithetical to architecture, these examples imply that the Locomobile Company, along with others at the time, understood the importance of architecture as the space of consumption and mediation, and wanted to associate their products with approved architectural styles and forms.

The series of photographs of the Locomobile Building published in 1910 illustrated how the arrangement of spaces in a large dealership choreographed the experience of buying a car.[53] Pedestrians had an unobstructed view into the showroom, yet the cars were placed far enough back to tempt possible buyers in for a closer look. Customers entering the first-floor showroom were channeled through a single double-door entrance from the front, possibly along the strip of carpet leading to four desks for sales staff. The room itself had a high, elaborately painted ceiling and decorative light fixtures on sculpted columns, and wood paneling around the exterior wall. A glass-enclosed office, where deals would be closed, contained domestic-scale furniture and what looks like an opulent Oriental rug.

Other photographs show the continuation of this hierarchy of interior decoration beyond the first-floor showroom. The second floor also seems to have been a sales area. Although it had a decorative tile floor, the ceiling and wall surfaces were much less elaborately treated than on the first floor. The concrete structure was plainly visible: no paneling was apparent, neither were columns or ceiling decorated. The least-decorative area of all was the service or storage area at the rear of the ground floor. Unadorned concrete and functional lighting characterized this space as one for storage and maintenance, rather than sales. In all these regards, the Locomobile Building brought together many aspects of the advice literature in creating spaces appropriate to function and, at the same time, separating the selling and maintenance functions of buying and owning a car. Whether the average buyer would have consciously

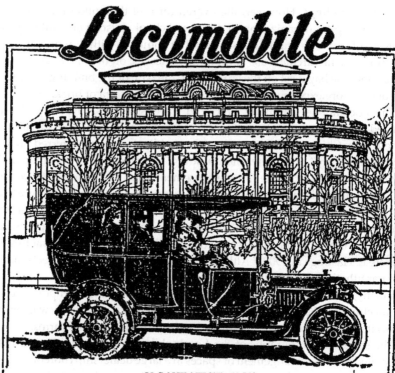

Figure 8.6 Locomobile ad, *Chicago Daily Tribune,* 1911

noticed these differences is a matter of speculation, but clearly those at the Locomobile Company who were responsible for showroom design carefully orchestrated the physical surroundings so as to impress the potential buyers by appealing to their desire for status through affiliation with a highly regarded automobile company.

Conclusion

Dealership buildings fulfilled many different functions, but their architecture, along with more ephemeral decoration like signs and displays, may be seen as a combination of devices intended to promote sales and a larger aura of respectability for the industry and for the idea of automobility. In this quest, both drivers and automobile dealers understood the crucial importance of display and representation. Successful manipulation of visual culture meant increased prestige for drivers and higher profits for dealers. It also led to increased prestige for their brands and industry. As the skepticism about salesmen indicates, it is important to note that automobile dealerships did not represent a one-way message successfully forced upon unsuspecting prospective buyers. Trade literature repeatedly emphasized the need for skillful selling, based on face-to-face interactions and establishing personal relationships with prospective clients.

Nevertheless, commercial architecture and display like that found in automobile showrooms played an important role in mediating between many different levels of the emerging system of automobility. Such spaces helped form the boundaries of imagination. The architecture of dealerships offers the chance to understand more fully what happened when fantasies about mobility and personal power confronted larger commercial systems and the economic realities of owning a car. As mentioned at the outset, much work remains to be done on this subject, beginning with the form and decoration of buildings themselves, especially vernacular buildings. Further research is also needed on those who sold automobiles and the interactions between buyers, sellers, and manufacturers. Even at this preliminary stage, however, it is clear that this topic allows for greater understanding of the social organization and cultural ideals of the United States in the twentieth century. Not just a mere sidelight to the history of commercial architecture or automobility, dealerships thus provide insight into the larger history of material and visual culture in the late nineteenth and early twentieth centuries as a rich field for understanding social power and values.

172 VISUAL MERCHANDISING

Notes

1 For their generous assistance and suggestions, I would like to thank Louisa Iarocci for organizing and editing this collection; members of the audience at the 62nd Annual Meeting of the Society of Architectural Historians, April, 2009, where an early version was presented; Carol Duncan and Andrew Hemingway for helpful discussions about the history of retailing; and Robert Bruegmann for very generously reading a draft and making excellent suggestions on many key points. And as always, I am grateful to Paul Jaskot for talking about the larger context of Chicago architecture in this period and reading multiple drafts of this paper.

2 "The Ford Motor Company's Building, New York City," *Architecture and Building* 51, 6 (June, 1919): text on 18; building illustrated in Plates 100 through 102.

3 For an overview of literature about the automobile, see Michael L. Berger, *The Automobile in American History and Culture: A Reference Guide*, Westport, Connecticut: Greenwood Press, 2001.

4 On the early advertising industry in the United States, see Pamela Walker Laird, *Advertising Progress: American Business and the Rise of Consumer Marketing*, Baltimore: The Johns Hopkins University Press, 1998.

5 For a recent consideration of commercial architecture, see the articles in *Winterthur Portfolio* 44, no. 2/3 (Summer/Autumn, 2010), including A. K. Sandoval-Strausz, "Spaces of Commerce: A Historiographic Introduction to Certain Architectures of Capitalism," *Winterthur Portfolio* 44, 2/3 (Summer/Autumn, 2010), pp. 143–58.

6 Chester Liebs, *Main Street to Miracle Mile*, Baltimore: Johns Hopkins University Press, 1985, reprint 1995, p. 79. See Liebs generally for illustrations of dealerships through the 1980s, pp. 75–86.

7 Liebs, pp. 83–6. Nor were these the only cities with automobile or motor rows: among others, Atlanta, St. Louis, Omaha among others developed some variant on the motor row. On New York City's automobile row, see David W. Dunlap, "Street of Automotive Dreams," *New York Times*, 7 July 2000, p. 35.

8 Liebs, p. 79.

9 Liebs, p. 79.

10 Ruth Schwartz Cowan, "The Consumption Junction: A Proposal for Research Strategies in the Sociology of Technology," in *The Social Construction of Technological Systems: New Directions in the Sociology and History of Technology*, eds, Wiebe E. Bijker, Thomas P. Hughes and Trevor J. Pinch, Cambridge, Mass: M.I.T. Press, 1987, p. 263.

11 Ruth Oldenziel, Adri Albert de la Bruhèze, and Onno de Wit, "Europe's Mediation Junction: Technology and Consumer Society in the Twentieth Century," *History and Technology* 21, 1 (March 2005), pp. 112–3. Also on the subject of mediation through specific artifacts, see H. Otto Siburn in "AHR Conversation: Historians and the Study of Material Culture," *American Historical Review* 114, no. 5 (December, 2009), pp. 1374–5.

12 Roland Marchand, *Advertising the American Dream: Making Way for Modernity, 1920–1940*, Berkeley, Calif.: University of California Press, 1985, p. 51, for this use of the term, though this concept is discussed at various points throughout.

13 See Mimi Sheller and John Urry, "The City and the Car." *International Journal of Urban and Regional Research* 24, 4 (Dec, 2000), pp. 737–57; and John Urry, "The 'System' of Automobility," *Theory, Culture & Society* 21, 4–5 (2004), pp. 25–39.

14 Sheller and Urry, p. 739.

15 For illustrations of more vernacular dealerships, see Henry L. Dominguez, *The Ford Agency: A Pictorial History*, Osceola, Wisc: Motorbooks International, 1981; Robert Genat, *The American Car Dealership*, Osceola, Wisc: MBI Publishing Company, 1999; and Jay Ketelle, *The American Automobile Dealership: A Picture Postcard History*, Amarillo, Texas: Jay Ketelle Collectables, Inc., s.d.

16 Again, the literature here is extensive. For an overview, see Berger, pp. 3–34.

17 George S. May, "Marketing," in *The Automobile Industry, 1896–1920*, ed., George S. May, New York: Facts on File, 1990, p. 317.

18 May, p. 316.

19 Ralph C. Epstein, *The Automobile Industry: Its Economic and Commercial Development*, Chicago: A.W. Shaw & Company, 1928, pp. 137, 139. On the same point, see Lawrence H. Seltzer, *A Financial History of the American Automobile Industry*, Boston: Houghton Mifflin Company, 1928, p. 21.

20 On Ford's early production problems see Dicke, p. 60. Also see Robert Casey, *The Model T: A Centennial History*, Baltimore: Johns Hopkins University Press, 2008, pp. 78–9.

21 Reflecting economic structures and gender norms of the time, most sales personnel were men. The few mentions of saleswomen treat them as an oddity. The best narrative overview of the history of dealerships as franchise businesses for this time period remains Ch. 1, "The Experimental Years, 1900–1910" and Ch. 2, "Growth and Maturity, 1920–1930," in Charles M. Hewitt, *The Development of Automobile Franchises*, Bloomington: University of Illinois Press, 1960. For general essays on the franchising of automobile sales, see Bloomfield and also Akio Okochi and Koichi Shimokawa, *Development of Mass Marketing: The Automobile and Retailing Industries: Proceedings of the Fuji Conference, International Conference on Business History, No. 7*, Toyko: University of Tokyo Press, 1981.

22 Robert Sloss, *The Automobile: Its Selection, Care, and Use*, New York: Outing Publishing Company, 1910, p. 27.

23 K.P. Drysdale, "Novie and His First Automobile," *Harper's Weekly*, (January 6, 1912), p. 26.

24 Drysdale, p. 26.

25 Drysdale, p. 26.

26 Howard E. Coffin, "Selection of a Motor-Car," *Suburban Life* 11 (1910), p. 100

27 Thomas J. Fay, *How to Buy an Automobile*, Cleveland, Ohio: The Motor Press Syndicate, 1914, p. v.

28 See Fay throughout, but especially, "Meeting the Demonstrator on His Own Terms," pp. 1–10.

29 "Cashing in with 'Current Events' Window: Good Roads Movement in a Louisiana County Made the Keynote of an Attractive Window Display—Dealer Even Produced a Bona Find Sample of the Roads to Be Built and Had a Real Car on It," *Motor World for Dealers, Jobbers and Garagemen* 38, 10 (February 26, 1914), p. 15.

30 See illustrations of the 1908 interior of the Ford showroom and the 1910 interior of the Locomobile showroom, both on Chicago's motor row, in Commission on Chicago Landmarks, *Landmark Designation Report: Motor Row District, Michigan Avenue, Primarily between Cermak Road and the Stevenson Expressway, Designated a Chicago Landmark on December 13, 2000*, Illust. 24 and 19, respectively.

31 "Stimulating Trade When It Is 'Sagging,'" *Motor World for Dealers, Jobbers and Garagemen* 38, 8 (February 12, 1914), p. 19.

32 "Stimulating Trade When It Is 'Sagging,'" p. 19.

33 "Stimulating Trade When It Is 'Sagging,'" p. 19.

34 "Stimulating Trade When It Is 'Sagging,'" p. 19.

35 *How to Run a Retail Automobile Business at a Profit*, Chicago: A.W. Shaw and Company, 1918, p. 77.

36 Neil Harris, "Museums, Merchandising, and Popular Taste: The Struggle for Influence," in *Cultural Excursions: Marketing Appetites and Cultural tastes in Modern America*, ed., Neil Harris, Chicago: University of Chicago Press, 1990, pp. 63–66.

37 Daniel M. Bluestone, *Constructing Chicago*, New Haven: Yale University Press, 1991, p. 150.

38 Douglas Gomery, Chapter 3: "The Rise of National Theatre Chains," in *Shared Pleasures: A History of Movie Presentation in the United States*, Madison, Wisc: University of Wisconsin Press, 1992, pp. 29–33. See also Douglas Gomery, "The Movie Palace Comes to America's Cities," in *For Fun and Profit: The Transformation of Leisure into Consumption*, ed., Richard Butsch, Philadelphia: Temple University Press, 1980, pp. 138–9.

39 Robert Bruegmann, *The Architects and the City: Holabird & Roche of Chicago, 1880–1918*, Chicago: University of Chicago Press, 1997, p. 378.

40 Peter B. Wight, "The Transmutation of a Residence Street, Resulting in Another Solution of a Utilitarian Problem by Architects." *Architectural Record* 27, 4 (1910), p. 288.

41 See the illustrations in Wight, throughout.

42 On Holabird & Roche, see Robert Bruegmann, Ch. 18, "Terra Cotta on South Michigan Avenue: Automobile Row," pp. 367–88. For other architects, see Wight, throughout, and Chicago Landmarks, *Landmarks Designation Report*, throughout.

43 "Who's Who is Chicago," p. 105.

44 Photographs available in Bruegmann, pp. 369, 376.

45 For analysis of many of the important buildings of Chicago's Automobile Row, see Bruegmann, pp. 367–88. Also see Chicago's Automobile or Motor Row in Commission on Chicago Landmarks, *Landmark Designation Report*, throughout. Illustration of Locomobile dealership interior from Chicago City Council, *A Half Century of Chicago Building: A Practical Reference Guide/All Building Laws and Ordinances Brought to Date. Historical, Technical and Statistical Review of the Construction and Material Development of America's Inland Metropolis*, Chicago: Chicago City Council, 1910, p. 206B.

46 On lighting in retailing, see Ch. 2, "Facades of Color, Glass, and Light," in William Leach. *Land of Desire: Merchants, Power, and the Rise of a New American Culture*, New York: Pantheon Books, 1993, pp. 39–70.

47 See illustrations of the 1908 interior of the Ford showroom and the 1910 interior of the Locomobile showroom, both on Chicago's motor row, in Commission on Chicago Landmarks, *Landmark Designation Report*, 24 and 19, respectively.

48 "Who's Who in Chicago," *Automobile Review* XII, 5 (1905), p. 105.

49 Commission on Chicago Landmarks, *Landmark Designation Report*, pp. 21, 23.

50 "Locomobile: Chicago Branch," *Chicago Daily Tribune*, 8 February 1910, p. 2. Cost of building from "No Motor Row Like Chicago's," *Chicago Tribune*, 6 February 1910, p. 12.

51 "Locomobile: Chicago Branch," p. 2.

52 "Locomobile: Fashionable Limousines and Laundaulets Correctly Adapted for Town, Touring, and Suburban Service," *Chicago Daily Tribune*, 8 January 8, 1911, p. 3. On the New Theatre, see "The New Theatre, Central Park West, New York/Messrs. Carrere & Hastings, Architects," *The American Architect and Building News* XCVI, 1772 (December 8, 1909): eight separate plates following p. 252.

53 Chicago City Council, 206B.

Mansions as Marketing: The Residential Funeral Home and American Consumer Culture, 1915–1965

Dean Lampros

Anyone who has ever paid for a funeral understands that funeral homes are sites where money changes hands—often large sums of it. Jessica Mitford knew it and said so in such a humorous and caustic way that her 1963 exposé, *The American Way of Death*, became an instant best-seller. Other critics, both before her and since, have said much the same. Reformers have addressed what they regard as exorbitant burial costs, and historians have discussed the commodification of death; both have viewed the funeral home more as an institution than a physical space. As a retail space within an expanding consumer culture, the funeral home has had a complicated and little understood history. Although the idea of space within the modern residential funeral home for selling burial goods was embraced early on by the general public, precisely how much space and what form it should take were questions that divided funeral directors, among whom there was no small amount of ambivalence towards merchandising and salesmanship.

This division is reflected in funeral home layouts from the 1910s through the 1960s, as several generations of funeral directors experimented with different spatial solutions to achieve the proper balance between sales and ceremony. On one side were the funeral directors who perceived a direct connection between their success as businessmen and the physical space of the funeral home, its overall luxuriousness, and the arrangement of their casket display rooms. Others felt that too prominent a space for merchandising undermined the professional status they had long coveted. The majority of funeral directors were torn between these two factions, so that even as the residential funeral home established itself as a recognizable feature of America's cultural landscape, its interior space became the battleground in the debate over merchandising and whether or not the funeral director could be both a professional and a merchant.

From the very moment that the earliest funeral homes began to appear in the older residential neighborhoods of American cities and towns around the time of World War I—either in converted mansions or as purpose-built mortuaries that looked like mansions—many housed the retail functions once contained within the undertaking establishments that had appeared in business districts throughout the United States following the Civil War (Figure 9.1). A typical turn-of-the-century downtown undertaking "parlor" possessed a front office, a ceremonial space—a chapel of sorts—for holding funeral services, and a showroom for caskets. A 1906 newspaper article from Portsmouth, New Hampshire, provides a glimpse into a typical downtown showroom from around the turn of the century: The caskets, the article explained:

> might be contained in cabinets, or they might be secured, in vertical position, to the backs of panels running continuously along the side of the room, and forming, to the eye, a continuous high panelling [sic]. Each of these panels, with a casket attached to it, is so pivoted and balanced that without effort it can be pulled down into a horizontal position for the display of the casket at a convenient height from the floor.[1]

If the family was not satisfied with the stock on hand, the undertaker might show them an illustrated catalogue or accompany them to the showroom of a casket manufacturer. Whatever the case, shopping for a casket prior to World War I meant going downtown, which remained the center of the undertaker's trade.

Downtown parlors were used relatively infrequently for actual funeral services.[2] As late as 1928 when David Webb of Hamilton, Ohio, remodeled his downtown parlor, nearly three quarters of the town's funerals were still being held at home, despite the availability of other options. These included a few residential funeral homes which had begun to compete with older downtown establishments. Webb's "exceptionally attractive" display room, on the other hand, was quite popular, "where those articles so necessary to the conduct of the business are artistically arranged and can be judged upon their merits and by comparison. This feature of the Webb establishment is one that will be much appreciated."[3] In promoting his establishment Webb went so far as to hype the fact that his display room carried an exact duplicate of the silver bronze casket "in which Rudolph Valentino, the movie star, was buried."[4] Three years later, barely a quarter of Hamilton's funerals were being held in the town's undertaking parlors and residential funeral homes, of which there were now several. Nonetheless, Webb saw that change was coming and by November 1931 had relocated his business to the remodeled Sohngen mansion, long "known as one of the fine old homes of Hamilton."[5]

It is widely accepted within the historiography of deathcare that the majority of funerals in the United States were held at home until roughly mid-century,[6] by which time downtown funeral parlors were decidedly out

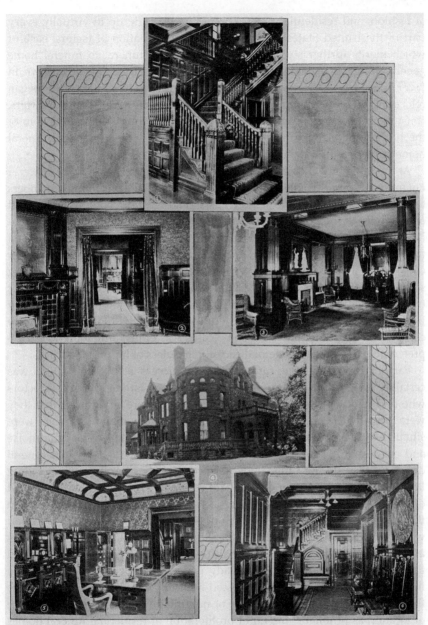

A MAGNIFICENT FUNERAL HOME
No. 1—Beautiful Davies Mortuary of Minneapolis. No. 2—View Through Several of the Parlors. No. 3—One of the Parlors. No. 4—Exterior View of Mortuary. No. 5—The Office. No. 6—The Hall.

9.1 Davies Mortuary, Minneapolis, February 1921

of fashion, and residential funeral homes had sprung up in virtually every part of the United States. Resulting from a combination of factors, each of which merits further study, the shift from home funeral to funeral home generally lagged behind the industry's abandonment of the downtown in favor of residential neighborhoods. In other words, as funeral directors began relocating their operations from the business districts to residential quarters, consumers were initially reluctant to follow, preferring the older custom of the home funeral. Like its downtown predecessor, the residential funeral home struggled for acceptance as a ceremonial space.

At the same time, however, it quickly established itself as a retail space. A not unusual scenario of the 1920s and 1930s was for bereaved family members to visit the funeral home to select a casket and have the body of their loved one brought to the funeral home for embalming, but afterwards request that it be returned home for the funeral service. Some might argue that reliance on the residential funeral home's retail function was less a matter of consumer choice than a simple function of where the majority of caskets were being sold. However, in many cities and towns a downtown establishment or two persisted for those who preferred that option, although by World War II they had become increasingly outnumbered. What is more likely to have constrained consumer choice in some cases was ethnic affiliation, race, or a preference for a specific funeral director, regardless of his or her address.

Part of the residential funeral home's success as a retail space was certainly its location. Beginning in the 1920s, for example, funeral directors who had relocated to residential neighborhoods were advertising that they were proximate enough to the downtown—where many churches were situated—to be convenient, yet distant enough away to be free from noise and congestion. While it might be an overstatement to claim that funeral directors were the first merchants to recognize that the future of retailing lay away from the downtown, they did see an advantage within the context of a burgeoning car-oriented culture to establishments situated "away from the hurry and noise and dust of the downtown district."[7] During a period when parking and traffic problems were intensifying in city and town centers as automobile usage rose, residential funeral homes confidently advertised their ample parking facilities. Already in 1928, the Bender Funeral Home in Gettysburg, Pennsylvania, possessed a lot that could accommodate more than 30 cars.[8] Regardless of whether or not funeral directors saw their choice of location as prophetic, the rapid proliferation of residential funeral homes during the interwar years foreshadowed the postwar period's widespread decentralization of retail business, a key element of twentieth-century consumer culture.[9]

Savvy funeral directors certainly envisioned themselves within the context of a broadening culture of consumption. They consistently maintained that the demand for better quality funeral goods was "in keeping with the trend

of the American consumer's demand in other lines."[10] Often this argument was made in response to criticism that the general public spent too much on funerals. The industry repeatedly pointed to rising consumer demand not just for high-end burial goods, but for luxury goods of all kinds. "More than one-third of the total national income of the people of the United States is spent for luxuries," wrote one funeral director in 1931, "for jewelry, perfumery and cosmetics, candy, entertainment, joy rides, sporting goods, tobacco and the rest. But life would be a dull affair stript [sic] of its luxuries."[11] A quarter century later in *The History of American Funeral Directing*, industry insiders Robert Habenstein and William Lamers posited that the "general upgrading of consumer demands—for furniture, automobiles, housing, dress, and the like—has carried with it to some degree a demand for more expensive funerals."[12]

Such observations helped funeral directors rationalize "merchandising upward"—in other words, the deliberate phasing out of cheaper, lower end funeral goods in favor of new, more expensive ones. Corralling consumers toward more expensive purchases by narrowing their options was reasonable, they claimed, because "standards of burial equipment and service should keep pace with the standard of living."[13] Even the funeral reformers were forced to acknowledge that the public's tendency towards extravagant funerals stemmed from a demand for luxury goods in general.[14] Thus, when the Metropolitan Life Insurance Company completed their groundbreaking 1928 report on rising burial costs, *Funeral Costs: What They Average; Are They Too High? Can They Be Reduced?*, they concluded that "the demand for more elaborate and expensive caskets and funeral services has accompanied the general demand for more expensive goods of all kinds."[15]

If a key article of faith within the world of merchandising was that consumer demand for luxury items rose in direct proportion to a society's standard of living, then an important corollary was that merchants could stimulate demand if it was not increasing quickly enough. "It is possible for every man to gradually lead his people to use better things," declared one industry leader in 1928, "and as they become more and more prosperous they should buy better funeral furnishings just as they buy better merchandise for the home."[16] One way to do this was through print media and advertising. "Booklets are also distributed; a description of the establishment or funeral home ... serving to educate the lay mind with reference to the highly specialized service offered, and to particularly foster a local demand for a higher and more satisfactory type of funeral goods,"[17] explained former funeral director Charles Berg in his 1920 work, *The Confessions of an Undertaker*. Another tool used to awaken desire was the physical space of the funeral home itself.

Space, after all, was persuasive. The new retail spaces that had emerged during the first decade of the twentieth century were understood to play a major role in the creation of desire. As grand department stores replaced the

disorganized and dowdy dry goods emporia of the nineteenth century, faith in the power of these retail palaces to sell goods rose sharply. Opulent, well-lit interiors in particular were seen as a powerful stimulus to spending. Historians like Gary Cross and William Leach have described how "department stores imparted an aura of luxury to shopping,"[18] democratized desire, encouraged a taste for luxury, and employed elegant and colorful displays to tempt consumers to buy finer goods.[19] Funeral directors repeatedly demonstrated how well versed they were in this aspect of retail culture and argued that public demand for better goods and more elaborate and luxurious establishments went hand-in-hand.[20]

It was not unusual, moreover, for funeral directors to compare their establishments to department stores while drawing comparisons between themselves and other purveyors of luxury items, such as "the automobile dealer, the furrier, [and] the clothing merchant."[21] Speaking to his colleagues about their showrooms, one funeral director pointed out that "the funeral director's display room is very similar to the window and counter displays in the up-to-date retail store—the department store, for example."[22] Many funeral directors argued that caskets should display price tags showing the entire cost of the service, so that the buyer would know "at a glance exactly what everything will cost him—the same as if he were buying in a retail store."[23] Not only were casket display rooms believed to be similar to other types of display rooms, but customer behavior was also thought to be more or less the same. "The *public* is the *public*—that *buyers* are *buyers*—whether they are purchasing dresses, automobiles or funeral merchandise; that the same buying psychology holds good in any case,"[24] argued Albert Kates, editor of *The American Funeral Director*, who went on to credit merchandising giants Marshall Field and John Wannamaker with the "one-price system," with price haggling and bargaining surviving in only "the cheapest of stores." "Why," he asked, "shouldn't the funeral industry borrow from the book of other lines of business?"[25] A basic principle of "buying psychology," whether in the context of the department store or the funeral home, was that it could be influenced by the spatial setting in which purchases were made (Figure 9.2).

Consequently, in the vehicles they used, the goods they sold, and the spaces in which those goods were sold, funeral directors, like department store owners, consciously cultivated an image of comfort, beauty, and luxury. For example, in 1926 when the Ford & Douglas Funeral Home set up shop in the substantial dwelling of a former doctor in Gastonia, North Carolina, the article that ran in *The American Funeral Director* referred to the structure with "its luxuriously furnished interior [as] one of the showplaces of Gastonia."[26] Similarly, the local press described the "elegantly appointed" display rooms containing merchandise that was "most luxurious."[27] In general, neither funeral directors nor the popular press were shy about drawing attention to the opulence of the new residential funeral homes.

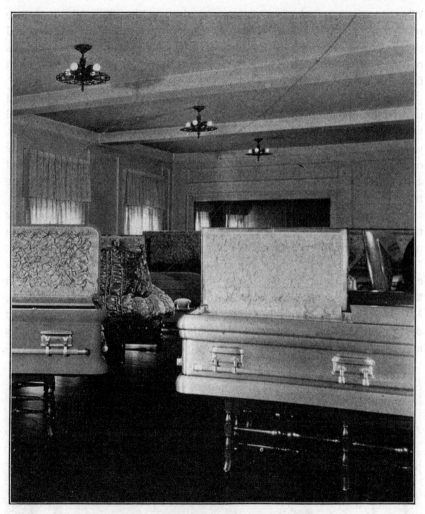

"The client can best be satisfied through a combination of compelling sales appeal and a good showroom arrangement."

9.2 Casket Display Room, August 1931

Luxuriousness in the funeral home consisted of a combination of integral features and imported furnishings and finishes. Establishments possessed oak-paneled walls, coffered ceilings, and ornate staircases along with tapestries, paintings, silk carpets, velvet drapes, carved tables and chests, and damask-covered chairs. For those in converted dwellings, moreover, luxuriousness transcended style. The houses chosen by funeral directors consisted of a variety of styles ranging from Federal, Greek Revival, Gothic, and Italianate to Queen Anne, Colonial Revival, Craftsman, and Neoclassical.

What mattered was the association with the wealthy elites who had once resided there. Klute & Son's Funeral Home in Richmond, Indiana, boasted shortly after its opening in 1929 that the "spacious mansion" that housed its new establishment had been built "by one of the oldest and most prominent families of the community."[28] (Figure 9.3).

Moreover, those who had opted for remodeled mansions could point to opulent interiors rich in period detail, such as stained glass and original woodwork, which in the case of Klute & Son's consisted of "cherry and oak, with oak floors. Especially notable," they reminded their patrons, "is the open stairway in the reception hall, hand carved out of solid cherry wood and widely known as the most beautiful piece of woodwork of the kind in the region."[29] (Figure 9.4).

Similar descriptions of residential funeral homes appeared in industry trade journals and in newspaper articles accompanying the opening of a new establishment. Phrases like "luxuriously" or "lavishly" furnished, "elegantly appointed," and "showplace" were frequently employed. Some establishments, such as the Ralph James Balbirnie Funeral Mansion in Muskegon, Michigan, and the William Cook Funeral Mansion in Baltimore, Maryland, boldly advertised with their very names the type of extravagant dwelling that housed them, while the majority simply let imposing exteriors and elaborate interiors speak for themselves. This was true of purpose-

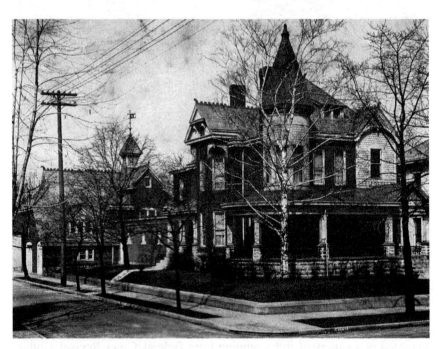

9.3 Klute & Son's Funeral Home, Richmond, Indiana, September 1930

9.4 Klute & Son's Funeral Home, Richmond, Indiana, September 1930

built, residential-style mortuaries as well. Following the construction of the Wichmann Funeral Home in Appleton, Wisconsin in 1931, the press reported that the "large service room ... resembles a room one might expect to find in an English mansion. The room is luxuriously furnished with old English furniture, and at the extreme right is a large fireplace constructed of white Bedord [sic] stone."[30] It was no accident that an explosion of lavish funeral establishments occurred during an era in which the persuasive power of a sumptuous retail space was taken for granted by merchants of all kinds.

In addition to offering luxuriousness, retail spaces of the interwar period also strove to create a homelike atmosphere akin to that of a "finely appointed private residence of the better class."[31] Funeral homes were by no means unique in their attempt to furnish homelike comforts to shoppers. First-generation department stores, posits historian Susan Benson, modeled their stores "along two complimentary lines: as a home and as a downtown club." She quotes a female executive from the 1930s who believed that the department store should whenever possible reflect "those standards of comfort and grace which are apparent in a lovely home."[32] An important component of a truly homelike environment was privacy, one of the most assiduously advertised attributes of the residential funeral home. "Not infrequently," argued one funeral director, "a church is out of the question, not contributing to the privacy the immediate family desires in the last tribute. Likewise, there is a want of privacy and homelike atmosphere in an undertaker's parlor in the congested business district."[33]

Privacy mattered, especially in the display room. Through advertisements, funeral directors sought to assure prospective patrons that they would be able to select the casket of their choice, within their means, "without any embarrassment"[34] and "at their own leisure, with none but the members of their own family as observers."[35] This was a well-known concept within the world of retail, in which the more elite department stores also sought to protect customers from the gaze of strangers.[36] Privacy was invoked to symbolize the myth of personal freedom and autonomy within the marketplace, even though families were clearly choosing from a limited range of high-grade merchandise. When funeral directors argued that the family should enter the display room and make their selection unaccompanied by any funeral home staff, the display room became an idealized shopping space in which a highly romanticized version of the consumer was imagined to exercise his or her own will, free from the salesman's influence.

Many funeral directors believed that their space was their most effective sales tool. Frank Stewart of Leon, Iowa, was not alone when he declared in 1931: "I find that an attractive showroom promotes the sale of better caskets."[37] As a result, many funeral directors sought to emulate the department store by experimenting with new and innovative lighting designs, display cases, and layouts. "Proper display of funeral merchandise," it was believed, could

create sales "in just the same way that the display of any other articles does."[38] By 1960 casket manufacturers such as the F.H. Hill Company, the Boyerton Burial Casket Company, and Elgin Associates had begun offering free consulting services to funeral directors to assist with the creation of attractive and effective showroom layouts. Especially important were modern lighting effects, considered "a vital factor in making possible the proper display of merchandise,"[39] and many funeral directors installed indirect lighting systems (Figure 9.5). Still others tried new types of racks for displaying merchandise or special glass cases for burial garments, not unlike the glass showcases used by department stores.[40]

The enthusiasm shown by some funeral directors for the merchandising strategies employed by department stores might have arisen from the perception that women were far more likely than men to shop for burial goods. While many funeral directors spoke of selling in connection with bereaved families and naturally had experience dealing with widowers looking to choose caskets and burial garments for their deceased wives, it was not uncommon for funeral directors to argue that a disproportionate number of visitors to their showrooms were women. Harry Allen of Peru, Indiana, claimed: "Women select 75 percent of the caskets we sell. Women appreciate good designing and are becoming expert judges of material."[41] Others drew broader inferences:

> The statistics of every line of business tell us that the women folks do most of the buying of the world. The interiors of caskets, silks and satins, are things with which the women folks are more familiar than the men folks. It has seemed to us, therefore, advisable to carefully select such things as appeal to the women folks and about which we can talk understandingly to them.[42]

It is difficult to assess the exact degree to which retail space within the funeral home was shaped by considerations of gender. Whatever the case, many funeral directors took pains to transform their sector of the retail world and looked to department stores and other merchants for inspiration. "After all," asked one funeral director, "is funeral merchandise so vastly different from other merchandise that the same principles of selling do not apply? Absolutely not."[43]

Not everyone within the industry agreed. Some tried to temper the emphasis on luxury, while others were uncomfortable with the whole idea of merchandising and salesmanship. For starters, even those who created luxurious spaces for their customers were cognizant of the ongoing calls for simplicity from the funeral reformers, who condemned what they deemed "the foolish extravagance of the ordinary funeral."[44] This critique predated the appearance of residential funeral homes, and it continued well into the twentieth century. By the early twentieth century, moreover, a rejection of ornamentation in favor of a more rustic simplicity came to dominate a new

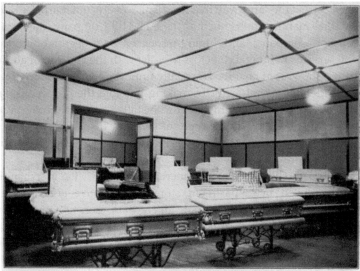

Modern Funeral Home Display Room. Notice How the Folds of Silk Stand Out in the Casket Interiors Due to Well Diffused Light

9.5 Casket Display Room, May 1931

aesthetics that touched everything from flatware to houses.[45] Historically, simplicity required that an object or space be understated, modest, and restrained. In the lexicon of the American funeral reform movement, dignity and simplicity went hand in hand. Their spartan vision of simplicity, which left no room for compromise, required committing the body of the deceased in "a simple winding sheet to mother earth, without coffin or casket or any such thing." If something more substantial was needed, a simple pine box or "a light coffin of soft wood or wicker work, or wood pulp or other perishable material"[46] would suffice.

Funeral reformers were not alone in their rejection of luxury. Calls for a return to simplicity sometimes came from within the funeral industry itself. When the modest Aubuchon Funeral Home was completed in Fitchburg, Massachusetts, in 1927, the accompanying publicity explained: "No effort was made to establish a pretentious, lavishly furnished establishment, but rather one, while beautiful, is practical and moderate in cost."[47] Most funeral directors sought a more nuanced approach by redefining simplicity itself. Simple, contrary to what the funeral reformers counseled, did not have to mean plain or cheap. By no means, they argued, should simplicity be confused with bare necessities or burials that consisted of "a corpse and a hole in the ground."[48] Funeral directors maintained that sumptuous funeral homes and expensive burial goods could possess simplicity and "quiet dignity."[49] It was for this reason perhaps that many owners of purpose-built mortuaries opted for the "stately Colonial," whose "classic simplicity of design," they argued,

"gives just that atmosphere of dignity and calm which should hang about every mortuary."[50]

However, those whose establishments were housed in ornate and elaborate Victorian dwellings did not shy away from advertising the simplicity of their quarters, and the results were often strange and incongruous. When Gettysburg's Bender Funeral Home opened in 1928, its publicity claimed that it combined "features of the elaborate, tempered by quiet, stately dignity; strictly modern without being flashy or gaudy."[51] The advertisements of the Emrick Funeral Home in Portsmouth, Ohio, moreover, were positively schizophrenic. Housed in a substantial brick mansion, the firm declared in May 1933: "Our chapel is the last word in pretentious appearance and appointments. Our rolling equipment is luxurious."[52] By October they had switched to an entirely different message, claiming instead that "true grief never seeks a showy display. Rather does it demand beauty and simplicity."[53] Likewise, the large Second Empire dwelling that housed the McKenna Funeral Home in Lowell, Massachusetts, was described in one newspaper article as being "elaborate," while James McKenna himself insisted in the same piece that he had created "an atmosphere of reverence and simplicity."[54] Simple and elaborate had not always gone together with such apparent ease.

The paradox at play within the funeral home mirrored tensions within the complex consumer culture that flourished beyond its four walls. As historian Sarah Elvins explains: "On one hand, advertisers and manufacturers encouraged Americans to give in to the hedonism of luxury goods and conspicuous consumption; on the other, a simultaneous emphasis on control and personal efficiency underscored their messages."[55] Alongside the trappings of democratized luxury ran a deep countercurrent that cherished frugality and restraint and considered fashion and luxury to be corrupting influences.[56] One solution was to blend decadent luxury with virtuous simplicity. That simplicity and luxuriousness could be made to coexist was a concept that had already taken root in the broad aesthetic revolution that defined early Modernism.[57] The resulting marriage would eventually become a key element of American consumer culture as well and by mid-century was being evoked in advertising campaigns to sell everything from clothing to cars. It proved to be a winning combination that gradually released inhibitions and eased anxiety over luxury consumption.

If some funeral directors felt a certain amount of ambivalence toward their luxurious appointments, many also had serious misgivings about the impact of merchandising itself on the funeral home. Too large or prominent a showroom, they feared, would result in an overly commercial atmosphere, and this was one of the reasons funeral directors had begun to abandon their downtown locations in the first place. In addition, too great an emphasis on salesmanship not only threatened the homelike quality of the funeral home, but it compromised the professional status of the funeral director. "For years,"

explained Albert Kates in 1931, "the funeral director has been handicapped by the belief that it was 'unprofessional' to 'sell' merchandise. He felt that merchandising was not for men of his calling—that it was demeaning."[58] This attitude lingered for decades, with one funeral director arguing in 1947 that "service in our field is far more important than merchandise, and accounts for from 70 to 80 percent of what the public pays for... merchandise only comprises a small portion of what the funeral director sells."[59]

While some tried to downplay their role as salesmen and claimed instead that they were professionals in the same class as doctors, lawyers, or ministers, others argued that "there exists a definite danger, rather than any hope of gain, in this effort to garb ourselves in the raiment of other professions."[60] Some charged that any funeral director who was "often inclined to think more in terms of his profession than his *business*" was less likely "to give the proper amount of attention to the arrangement of the show room."[61] In some funeral homes, complained one funeral director, the "show rooms (if they have any) are carelessly laid out,"[62] clearly a jab at those who eschewed merchandising completely and relied on casket manufacturers' showrooms. These were common enough during the 1930s, so much so that funeral directors who had their own showrooms advertised this "additional convenience for the patrons," which "saves relatives from making an extra trip to a public display room."[63] By the 1950s they had all but disappeared.[64]

During the interwar years, the often controversial debate over the identity of the funeral director left its mark on the physical landscape of the American funeral industry, as practitioners struggled to decide how the funeral home could—or if it even should—successfully accommodate both sales and service. One solution was simply to relegate the showroom to a less visible spot within the funeral home. Even those who embraced the merchandising side of their work generally believed that display rooms should be "out of the way so that visitors and others will not come into contact with them unless the occasion requires."[65] Attractive and well-lit display rooms were in fact frequently situated in basements and upper stories. For example, in the grand Federal-era mansion that housed the Lanoue Mortuary in Warren, Rhode Island, caskets of various styles covering a wide price range were arranged in a series of spacious second-floor rooms reached by means of the structure's elegant, hand-carved central staircase.[66] Lowell's James McKenna noted that his dual role as "not merely a business man but... a professional one as well [was] considered in the equipment of the new home," which possessed "an excellent display room where a large variety and style of caskets may be seen." At the same time, he hinted at what he believed the heart of the funeral home to be. On the main floor, he explained, "is the real funeral home which is made up of large adequate rooms tastefully furnished and in keeping with the needs which they serve."[67]

Most funeral directors were very deliberate about maintaining a strict separation between the sales and service functions of the funeral home, even while attempting to keep them both on equal footing. Chapel rooms and showrooms were kept "distinct and separate from each other by ideal arrangements ... yet they are convenient to each other and in their appointments they reflect that quiet elegance so desirable to the atmosphere of the modern mortuary."[68] For example, when it was completed in 1928, Los Angeles' Ruppe Mortuary was "designed with the idea in mind of separating those sections of the mortuary meant for service to the public and the other activities incidental to the work of establishment. This plan is carried out by setting aside the ground floor for chapel purposes." However, the second floor contained "a large show room, 77 feet long by 22 feet wide," with a "section partitioned off for the bronzes."[69] Of course, the owners of purpose-built funeral homes offered even greater flexibility in planning their arrangements, and not every funeral director deemed it necessary to shift the showroom to the second floor. The Hudson Funeral Home in Durham, North Carolina, achieved "an even balance between the funeral service and business department" by dividing the funeral home down the middle, with "the left half ... used exclusively for service, while the right half ... is devoted to business functions." There were two separate entrances, as well.[70] Similarly, architect Harvey Clarkson's designs for a modernist mortuary in 1947 provided "a complete separation of funeral services from the other elements in the business."[71] Separate but equal became the rule.

Naturally, funeral directors were also careful to separate the public spaces of the funeral home from the private spaces, such as the preparation room and the family's living quarters. That distinction mattered then and still does.[72] However, the public space of the funeral home was shaped and subdivided in part by the tension between the non-commercial atmosphere demanded by the professional man and the spatial needs of a successful merchant, for whom an opulent setting and a large, attractive, and well-lit display room constituted a powerful and persuasive selling tool. While some funeral directors rejected retailing altogether, far more attempted to work out a compromise between their desire for professional status, on one hand, and the importance of good merchandising practices, on the other. After all, concluded one astute practitioner in 1930, "the funeral director is in one respect different from many retailers in other types of business. He is neither wholly a professional man nor wholly a merchant. He is, or should be, something of both."[73] Ultimately, the residential funeral home found ways to make room for both, reflecting the uneasy balance between retail and ritual and earning its place as an iconic feature of twentieth-century America's rapidly expanding landscape of mass consumption.

Notes

1 "Late Undertaking," *Portsmouth Daily Herald*, 16 April 1906, p. 3.

2 The exception was California. For example, by 1910 roughly half of the funerals in greater Los Angeles were being held at professional funeral establishments. This may have had something to do with the overall composition of the population, many of which were new arrivals with fewer roots and family connections, but there were likely reasons rooted in domestic space as well. Either way, California's early trend away from home funerals warrants further study.

3 "Webb Funeral Home To Be Open To Inspection On Saturday," *Hamilton Evening Journal*, 27 April 1928, p. 16.

4 "David Webb and Sons Complete Remodeling of Modern Funeral Home," *The Hamilton Daily News*, 27 April 1928, p. 13.

5 "Webb Funeral Home Finished," *Hamilton Daily News*, 13 November 1931, p. 3.

6 Historians generally place the period of transition from home funeral to funeral home within the second quarter of the twentieth century and agree that by mid-century, the transition from home funeral to funeral home was complete. For more see LeRoy Bowman, *The American Funeral: A Study in Guilt, Extravagance, and Sublimity*, Westport, Conn: Greenwood, 1959, p. 17; James Farrell, *Inventing the American Way of Death, 1830–1920*, Philadelphia: Temple University Press, 1980, pp. 172, 209–11; Robert Habenstein and William Lamers, *The History of American Funeral Directing*, Milwaukee: Bulfin Printers, 1955, p. 570; Gary Laderman, *Rest in Peace: A Cultural History of Death and the Funeral Home in Twentieth-Century America*, Oxford and New York: Oxford University Press, 2005, p. 24; Vanderlyn Pine, *Caretaker of the Dead: The American Funeral Director*, New York: Irvington, 1975, pp. 17–18; Robert Wells, *Facing the 'King of Terrors': Death and Society in an American Community, 1750–1990*, Cambridge, UK and New York: Cambridge University Press, 1999, pp. 261–2, 273.

7 "Quietness and Solitude," *The Daily Northwestern*, 22 January 1923, p. 7.

8 "Invite Public to New Funeral Home Saturday," *The Gettysburg Times*, 6 September 1928, p. 1.

9 See Richard Longstreth, *City Center to Regional Mall: Architecture, the Automobile, and Retailing in Los Angeles, 1920–1950*, Cambridge, Mass: MIT Press, 1998.

10 C.H. Logan, "Let the Public Have the Opportunity to Choose Quality," *The American Funeral Director* 51/10 (1928), p. 65.

11 George Burlingame, "Selling an Appropriate Service," *The American Funeral Director* 54/8 (1931), p. 43.

12 Habenstein and Lamers, p. 549.

13 "Special Advertising for Funeral Directors," *The American Funeral Director* 51/1 (1928), p. 61.

14 Both critics and apologists of the funeral industry had been making this argument since the late nineteenth century. In 1882 one funeral director wrote that "the growing wealth and prosperity of our country has caused people to demand something more in accordance with their surroundings." See Charles Benjamin, "Essay," *The Casket* 7/2 (1882), p. 2.

15 John Gebhart, *Funeral Costs: What They Average; Are They Too High? Can They Be Reduced?*, New York: G.P. Putnam's Sons, 1928, p. 222.

16 Curtis Frederick Callaway, *The Art of Funeral Directing; a Practical Manual on Modern Funeral Directing Methods*, Chicago: Undertakers' Supply Co, 1928, p. 193.

17 Charles Berg, *The Confessions of an Undertaker*, Wichita, KS: McCormick-Armstrong Press, 1920, p. 88.

18 Gary Cross, *An All Consuming Century: Why Commercialism Won in Modern America*, New York: Columbia University Press, 2000, p. 32

19 William Leach, *Land of Desire: Merchants, Power, and the Rise of a New American Culture*, New York: Vintage, 1993, p. 29. See also Susan Benson, *Counter Cultures: Saleswomen, Managers, and Customers in American Department Stores, 1890–1940*, Chicago and Urbana: University of Illinois Press, 1987, p. 83.

20 Callaway, p. 218.

21 George Algoe et al., "Let's Do a Better Selling Job," *The American Funeral Director* 54/8 (1931), pp. 35–6.

22 "Your Display Room and the Merchandising Problems Revolving Around It," *The American Funeral Director* 49/12 (1926), p. 31.

23 "Price Tags in the Showroom," *The American Funeral Director* 54/2 (1931), p. 39.

24 Albert Kates, "Buying Habits and Price Marking," *The American Funeral Director* 54/2 (1931), p. 37.

25 Kates, p. 38.

26 "Ford & Douglas Open New Mortuary," *The American Funeral Director* 49/7 (1926), p. 44.

27 "Opening of Ford & Douglas New Funeral Home This Week," *The Gastonia (N.C.) Daily Gazette*, 26 May 1926, p. 7.

28 "From Mansion to Mortuary," *The American Funeral Director* 53/9 (1930), p. 43.

29 "From Mansion to Mortuary," p. 43.

30 "Hoeppner Company Built Wichmann's New Funeral Home," *Appleton Post-Crescent*, 19 March 1931, p. 18.

31 "One Will Find," *The Lowell Sun*, 12 September 1925, p. 3.

32 Benson, p. 83.

33 "Hisey & Titus Establish 'Funeral Home' as a New Institution for Indianapolis," *The Indianapolis Star*, 17 May 1916, p. 6.

34 "Griesmer-Grim Co. Offers Fitting Appointments At The Time of Sorrow," *The Hamilton Daily News*, 17 September 1927, p. 12.

35 "Heitger Funeral Home Has Served Massillon 73 Years," *The Evening Independent*, 20 July 1942, p. 9.

36 Jan Whitaker, *Service and Style: How the American Department Store Fashioned the Middle Class*, New York: St. Martin's Press, 2006, p. 36.

37 Algoe, p. 37.

38 "Your Display Room," p. 31.

39 G.W. Fergason, "Effective Funeral Home Lighting," *The American Funeral Director* 54/5 (1931), p. 37.

40 Leach, p. 74.

41 "Funeral Directors See Increasing Demand for Quality Interiors," *The American Funeral Director* 51/4 (1928), p. 54.

42 "Allowing the Public a Selection of Interiors," *The American Funeral Director* 51/12 (1928), p. 55.

43 "Your Display Room," p. 31.

44 "Burial Reform," *The Lowell Sun*, 15 August 1891, p. 1.

45 Leach, pp. 34–5.

46 "About Burials," *North Adams Transcript*, 4 February 1897, p. 4.

47 "New Aubuchon Funeral Home Will Be Open for Inspection on Sunday and Memorial Day," *Fitchburg Sentinel*, 25 May 1927, p. 1.

48 "The Press Fires Another Editorial Barrage," *The American Funeral Director* 59/12 (1936), p. 32.

49 "Quiet Dignity," *The Morning Herald*, 4 October 1930, p. 6. During the first quarter of the twentieth century, it was used to sell everything from shoes and flatware to furniture and houses. Whether or not funeral directors borrowed this phrase from the world of marketing is unclear.

50 "Colonial Architecture Featured in Kentucky Funeral Home," *The American Funeral Director* 51/5 (1928), p. 51.

51 "Invite Public to New Funeral Home Saturday," *The Gettysburg Times*, 6 September 1928, p. 1.

52 "Magnificent Equipment! Modern Management!" *The Portsmouth Times*, 20 May 1933, p. 2.

53 "Beautiful in Its Simplicity," *The Portsmouth Times*, 21 October 1933, p. 2.

54 "In New Funeral Home," *The Lowell Sun*, 10 January 1933, p. 2.

55 Sarah Elvins, *Sales & Celebrations: Retailing & Regional Identity in Western New York State, 1920–1940*, Athens, OH: Ohio University Press, 2004, p. 111.

56 Leach, pp. 34–5; 202–10.

57 David Raizman, *History of Modern Design*, 2nd ed., Upper Saddle River, NJ: Pearson Prentice Hall, 2011, pp. 103–110.

58 Albert Kates, "Sell Satisfaction, Not Just Merchandise," *The American Funeral Director* 54/6 (1931), p. 33.

59 "Chain Operation in the Funeral Field," *The American Funeral Director* 69/3 (1947), p. 51.

60 Mark Pierce, "Why We Advertise Price," *The American Funeral Director* 53/9 (1930), p. 35.

61 "Your Display Room," p. 31.

62 "Your Show Room," *The American Funeral Director* 49/11 (1926), p. 34.

63 "Heitger Funeral Home," p. 9.

64 Habenstein and Lamers, p. 568.

65 "Your Display Room," p. 32.

66 "A Funeral Home With a Pleasingly Rural Atmosphere," *The American Funeral Director* 53/8 (1930), p. 43.

67 "In New Funeral Home," p. 2.

68 "Prominent in Lancaster's Business and Professional Life," *The Lancaster Daily Eagle*, 19 January 1927, p. 6; "Frank J. McAllister 'Funeral Director'," *McKean County Miner*, 11 April 1929, p. 11; "Hohenschuh Mortuary," *The Oxford Leader*, 6 March 1930, p. 7.

69 "Efficiency and Comfort of Patrons Well Provided for in New Los Angeles Mortuary," *The American Funeral Director* 51/6 (1928), p. 35.

70 "A Well Balanced Funeral Home," *The American Funeral Director* 69/12 (1947), p. 52.

71 "Design for a De Luxe Funeral Home," *The American Funeral Director* 69/6 (1947), p. 52.

72 Kyro Selket, "Bring Home the Dead: Purity and Filth in Contemporary Funeral Homes," in Ben Campin and Rosie Cox, eds, *Dirt: New Geographies of Cleanliness and Contamination*, London and New York: I.B. Tauris & Co Ltd, 2007.

73 "Advertising Merchandise," *The American Funeral Director* 53/9 (1930), p. 54.

The Common Place of the Common Carrier: The American Truck Stop

Ethel Goodstein-Murphree

> What gave the new industrialized landscape style was the presence—in parking lots, lined up at loading docks, barreling along the new white highways—of trucks: enormous and sleek and shiny ... Watching the evolution of the drive-ins, driving through the highway-dominated landscape with its new spaces, its brightly colored signs and structures, seemed a good way of observing our progress toward a new social order.[1]

In his seminal essay "Truck City," J.B. Jackson reflects on the role of trucks and truckers in the creation of "an American vernacular way of life," rooted in decentralized commerce and the spatial order of the road.[2] In contrast to its enduring love affair with the automobile, American popular culture is, at best, ambivalent to the semi-trailer truck.[3] As Jackson notes, American "affinity with burgeoning truck culture" of the mid-century long ago waned, replaced with antipathy toward the truck's noise, pollution, and command of the highway. Few shoppers stop to think, as they saunter down the aisles of a big-box grocery or an intimate boutique, that if a product is on the shelf, it is because a truck delivered the goods. Perhaps they should, for it is the big rig that carries watermelons from the fields of Georgia to the supermarkets in New Jersey, and ferries chicken wings from coolers in Arkansas to distribution centers on the edges of Los Angeles. Somewhere between the garden of America and the neighborhood store, the truck and its driver will need fuel, food, and facilities with plumbing. Truck stops, the common places of the common carrier, provide them (Figure 10.1).[4]

At the end of almost every interstate highway off-ramp, fast food places, gas stations, cheap motels, and outlet malls greet the curious tourist and the weary traveler alike. They weave an architectural welcome mat stitched of flimsy "dryvit" walls and familiar corporate logos. The scenographic clutter marks the oft-times maligned places where the everyday rituals of the road are practiced. The truck stop is an integral part of this American scene, so deeply embedded into the commercial fabric of the roadside that, according to *Learning from Las Vegas* co-author Steven Izenour, it has no architectural tradition of its own; "they've been amorphous boxes strewn across the tarmac."[5] In parallel, Dolores Hayden bemoans how "the massive truck terminal" and the "modest truck stop" alike make spaces to fit the truck and "destroy the historic scale of the built environment."[6]

Although branded in the visual syntax of roadside commerce, the truck stop's identity is as distinct from that of other vernaculars of roadside architecture as the eighteen-wheel constituency it serves differs from a fleet of

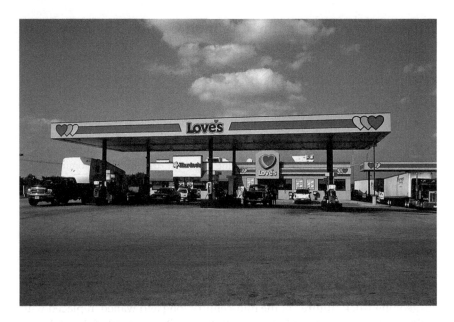

10.1 Love's Truck Stop, Joplin, Missouri

soccer-mom piloted SUVs. Despite corporate graphics and familiar franchises that seek to blend them seamlessly with other ordinary off-ramp sites, today's truck stops convey long-established associations with drug trafficking, illicit prostitution, and petty larceny. [7] Together, its banal commercial façade and tawdry popular identity belie the truck stop's intricacy as an agora of the highway, both a self-contained community and a dynamic conduit along the open space of the road.

From Roadhouse to Roadside Oasis

> Sure they stop, but it ain't to eat. They ain't hardly ever hungry. They're just goddam sick goin ... Joints is the only place you can pull up, an when you stop you got to buy somepin so you can sling the bull with the broad behind the counter. So you get a cup of coffee and a piece of pie. Kind of gives a guy a little rest ... the road gets into a guy. [8]

As evoked by John Steinbeck in the *Grapes of Wrath*, during the years that followed World War I, the truck emerged with a central role in American commerce. [9] The nationalization of the railroads during World War I had forced manufacturers to turn to trucks, which provided an inherent flexibility of movement and economy of operation that railroads could not match, for long-haul shipping. It was the truck that brought automobiles, washing machines, and Coca-Cola to voracious postwar consumers, and transported tons of

brick and miles of lumber as prosperity fostered building that catalyzed the growth of American cities. With a seemingly boundless consumer revolution, little government regulation, and vehicles available for purchase for less than $5,000, "trucks held out an elusive brass ring to the common man."[10]

By the early 1920s, dedicated truck routes were established and, in the tradition of the stagecoach stop relay station where horses and drivers were changed and passengers refreshed, the truck stop was born. It was, however, a typology that grew up haphazardly, albeit out of necessity, when service stations, initially devoted to the needs of long-distance automobile and bus travelers, realized the revenue potential of filling the big truck's big tank. Long before truck manufacturers introduced sleeper berths in their semis, savvy station owners added lodging, lounges, and showers to their emporiums; houses, gas stations, and garages were adapted handily to serve the burgeoning business of providing food and mechanical services to truckers. An "oasis of respectability" among early twentieth-century roadside accommodations,[11] the truck stop was a haven where drivers, seeking relief from hard leather seats and "muscle-wrenching double-shifts," could share benevolent companionship or practical information.[12]

The Dixie Trucker's Home, once a Route 66 landmark, offers a formative example (Figure 10.2). Opened in 1928 in McLean, Illinois, a midway stop on the busy route between St. Louis and Chicago, it grew from unassuming beginnings when its founders, John Geske and J.P. Walters, rented half of their

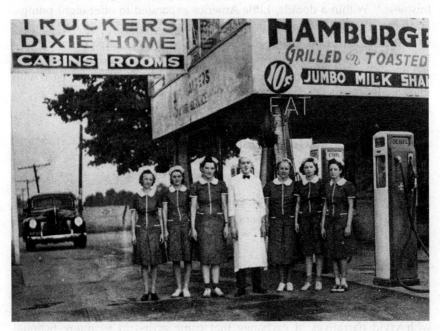

10.2 Dixie Trucker's Home, McLean, Illinois

mechanics garage to sell sandwiches to truckers. Within a decade, the Dixie added a counter fitted with six stools where grilled burgers and ten-cent milk shakes could be purchased at any hour of the day. Behind the restaurant stood cabins for road-worn drivers and a cattle pen for the livestock they hauled; free movies played in the parking lot. From the windshield view, the Dixie Trucker's Home differed little from ordinary filling stations of the period: a box of a building that greeted the highway with a four-pump fuel island and an overhanging canopy marked with stark graphics that listed menu items and advertised rooms. The austere surroundings notwithstanding, its name, chosen according to local history to evoke the warm associations of "Southern hospitality," set the Dixie Trucker's Home apart from the unpolished roadhouses of the era.[13]

The prosaic Dixie Trucker's Home provided a model for the emerging building genre, but the formula adapted easily to a myriad of variations. Covey's Little America on Highway 30, west of Green River, Wyoming, opened in 1934 with two pumps, 12 cabins, and a 23-seat counter. The sleek and white streamlined forms that dignified both the café and the pumps at its threshold suggested that affinities with the fashionable Art Moderne style could transform the truck stop from a utilitarian way station to a marketable commodity. A marquee-inspired sign, shaped in the aerodynamic lines of a big rig and spanning between the café and the pump station, spelled out the truck stop's name, but a unique logo, featuring two penguins, branded the business.[14] Within a decade, Little America expanded to offer eight pumps, and both a lodge and a hotel; its new Palm Room, a dining and dancing club, featured Art Deco banquettes and an allée of artificial palm trees. From Route 66 to the Lincoln Highway, the truck stop's utilitarian architectural conventions and spatial practices endured for decades, if often enlivened with idiosyncratic elements conceived to catch the consumer's eye.

A Red Hot Truck Stop for the Postwar Highway

> At a red hot truck stop with a dirt floor parking lot
> A waitress named Shirley
> Poured him some coffee and she said
> Hello stranger where're you going?
> I see the dust of where you've been
> Seems like the fire of trouble
> Claims you like the next kin[15]

Like many postwar truck stops, the real Red Hot Truck Stop in Meridian, Mississippi, provided a setting for the juxtaposition of mundane functionality with vivid narratives of exchange that come across in so many fictional representations of this roadside site. Architecturally, it echoed the modest

program and small-town scale of examples from the interwar years. But designed in 1955 by local architect Chris Risher, Sr.,[16] this truck stop also resonated with the freshness of 1950s car culture and a trucking industry that was modernizing incrementally with the progress of the interstate highway system (Figure 10.3).

The building reflects the oil industry's desire to make its invisible (liquid) products appear modern by giving a new look to the facilities that dispensed them.[17] Compact and concrete framed, the Red Hot translated International Style modernism for the American roadside. A state-of-the-art curtain wall, capped with a broad, overhanging flat roof, wrapped around its restaurant. Signage that rivaled early Las Vegas super-graphics announced "Red Hot Truck Stop Good Food" to drivers who approached from a new four-lane section of Route 80. Fuel flowed from six pumps that stood on an island in front while mechanical services were relegated to an attached garage at the rear of the remarkably unified structure. Inside, a sinuously curved counter created two discrete dining rooms. Although drivers reminisced about rubbing shoulders with "Fats Domino and Percy Sledge's valet," others speculated that the bi-partite plan was a tacit tool of segregation.[18]

Glimpsed from the roadside, the Red Hot resembled the typical postwar gas station, an oblong white box with generous yet utilitarian display windows pioneered in Water Dorwin Teague's prototype designs for Texaco (1937–48).[19] In its merging of International Style principles with new icons of American industrial design however, the Red Hot reflects the imagery and ideology of Raymond Loewy's dealerships for the International Harvester

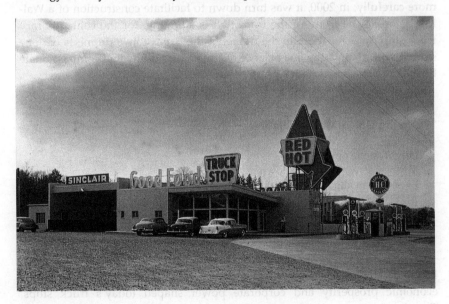

10.3 Red Hot Truck Stop, Meridian, Mississippi, (demolished)

Company, launched in 1945.[20] Nearly one decade earlier, International Harvester had contracted Loewy, already known for employing trendsetting aesthetics to serve contemporary market interests, to revamp its entire farm equipment line, including the dealer service stations in which its tractors and trucks were sold. The dealership was meant to stand alone "on the trucker's broad highway,"[21] presenting the curtain-walled face of its showroom to the roadside with service facilities placed behind it, contained by concrete block walls painted white. A flat roof swept broadly beyond the building line, practically shielding the outdoor sales area, but, symbolically, reaching out to the highway.[22] A bright red pylon bearing the Loewy-designed International Harvester logo branded the box. Just as the truck stop and the truck dealership shared an emerging commercial vernacular, so too each pragmatically accommodated multi-functional programs, while promoting efficient merchandising and establishing memorable product identity. Sited on the roadside as purposefully as any item for sale, each building inside contained an eye-catching display, a convenient package for selling products and services.

Period photographs of the Dixie Truckers Home and the Red Hot Truck Stop arouse nostalgia for a lost highway landscape of White Castles, Howard Johnson's, and drive-in movie screens. Architecturally, they are as closely connected to these symbols of the American highway as they are to truck stop myths about comely waitresses and flawless cups of coffee. The original Dixie Truckers Home burned in 1967, to be replaced by a barren box with false parapets and mansard awnings. The demise of the Red Hot was calculated more carefully; in 2000, it was torn down to facilitate construction of a Wal-Mart store.[23] The irony of the transition is stunning, for the contemporary truck stop owes far more to the model of the superstore's promises of "one shop fits all" than to the fine balance of "machinic" utility and compassionate hospitality associated with its earliest exemplars.

"Pumping Up" A Marketable Image

> Drivin' alone on 71
> My eyelids weighing me down
> I've been up all night
> And I had to be up all day
> I began to think I wouldn't make it
> But I did.
> Thank God for that little truck stop in LaGrange.[24]

Familiar and deeply engrained meta-narratives of postwar America's economic prosperity and corporate power shaped today's truck stops. Together, bigger trucks, an expanding trucking industry, and the Federal-Aid

Highway Act (1956) conspired to make the traditional truck stop obsolete. By the end of the 1950s, truck stops had grown to two-to-six acre properties, often owned and operated by major oil companies. The Pure Oil Company, for example, controlled more than ten percent of American truck stops in 1960. It appealed to drivers on more intimate terms than corporate commerce connoted, luring drivers with promises of "Pure's blue ribbon cup of coffee" and air-conditioned "roomettes," in other words, the comforts of home. But the image of the Pure Oil truck stop, white, planar and unornamented, matched the increasingly sterile stuff of the suburban strip. The Detroiter in Woodhaven, Michigan, the "crown jewel of the Pure system," easily could have been mistaken for an early Holiday Inn. Beyond its façade, however, the truck stop ensemble included restaurant accommodations for 112 drivers, scales, two lube bays, tire service, a store, and ten paved acres of parking. The transformation of the truck stop from the scale of the gas station to the proportions of the shopping center was well underway.

The Detroiter remains a feature of the I-75 corridor but the original building is substantially renovated and enlarged, reconceived in 1988 as "a mall within a truck stop." Nowadays, situated on the outskirts of an urban center stereotyped with a history of civil unrest and a delicate postindustrial economy, it markets "secure and guarded" parking in lieu of blue-ribbon coffee. With comfortable sleeper berths in most big trucks, its carpeted roomettes have become outdated, but private showers, washing machines, shoeshine stands, a barber shop, and a massage room enhance the Detroiter's aura of domesticity. Similarly, "steel biscuits," yellow humps in the asphalt that provide parking space hookups for cable TV, landline phones and the internet bring the accouterments of the late-modern home to acres of blacktop. As John McPhee observes, in a culture where a truck without a television is about as common as a house without a television: "After dark, the big parking lots appear to be full of blue fireflies, as drivers lying in their sleepers watch TV."[25] Lounges, movie theaters, and video-game rooms offer public entertainment, associated with pleasure palaces traditionally found in the center of the city. Fax machines, FedEx drops, free Wi-Fi, and ATM machines constitute an information age marketplace of commercial services drawn from the downtown office. A 24-hour deli and an International House of Pancakes, the stuff of the suburban strip, complement the time-tried full-service restaurant.

The amenities available at the renovated Detroiter are hardly extraordinary. They are standard spatial and functional fare at countless Petros, Pilots, and Travel Centers of America, yet they pale in comparison to those of the Iowa 80 in Walcott, Iowa. Originally constructed for Standard Oil in 1964, the truck stop was a modest facility, comprised of a store, one lube bay, and a restaurant. Thirty years later, a $4,000,000 expansion project transformed the Iowa 80, by then a Travel Centers of America franchise, into the "world's largest truck

stop."[26] Here, on 225 acres, the requisite fuel and service center, fast-food restaurant and hot showers coexist with a 30,000-square-foot showroom of truck ornaments and equipment, the Trucker's Warehouse Store, noteworthy for its selection of chrome items that afford opportunities to dress up the big rig. Its Trucking Museum, housed in a separate structure, caters to a different market, "dedicated to the restoration and preservation of antique trucks and trucking artifacts so that the history of trucking may be shared with the general public."[27]

Eager to expand its reach to a four-wheel driving clientele, a marketing strategy analogous to Las Vegas' self-referential reinvention of itself as a family destination, the truck stop industry changed its popular image. The Lodi Travel Center near Cleveland features a Starbucks café while hundreds of slot machines energize the Alamo Truck Stop at Sparks, Nevada, and Wyoming's Little America now boasts a swimming pool and fitness center. With a critical mass of news articles, television documentaries, and the publication of an *All American Truck Stop Cookbook*, the image of trucks stops as "greasy spoons catering to rough clientele" has quickly disappeared from the popular imagination, replaced with a far more marketable roadside identity.[28] The addition of chiropractor offices, clinics for sex workers, and permanent ministries housed in abandoned trailers, however, transcends the culture of late-capitalism and underscores the degree to which the truck stop has become an expansive ex-urban community. Consequently, neither the gas station, the fast food restaurant, the family-friendly motel nor the shopping mall—where Sears long ago conquered the dilemma of harmoniously intermingling tire sales, oil changes, and ladies' lingerie—offer satisfying models for making cultural or architectural sense of the truck stop.

At Home, At Work, and At Prayer at the Truck Stop

> 45,000 pounds of russets, three inches of snow, and two days to Ontario, California. It's New Year's Eve at the Wright Brothers Travel Center. The restaurant offers neither foie gras nor champagne, but 21 varieties of homemade pie beckon. Situated like a triumphal arch in a roadside colony, the bakery counter leads to the dining room–large, cathedral ceilinged, and awash with the glare of fluorescent lights that cast an icy glare on the already frozen parking lot. The hum of 60 engines idling notwithstanding, midnight comes and goes with a chilly silence.[29]

Like the paradigmatic shopping mall, the expansive domain of the truck stop has become a hybrid place that straddles the borders between a private precinct and a public domain. As a self-contained community, however, it embodies layers of transience and permanence, and strata of social organization that mirror the complexities of more ancient models of community life. The

truck stop's merger of the ordinary practices of trade and respite recall the caravansaries of the Silk Road, populated similarly by traders, whores, and moneylenders. Its spatial negotiation among the realms of labor, leisure, community, and solitude begs comparison to the socialization and discourse of the Roman bath, the hierarchical ordering of labor, prayer and dwelling of the monastery, and the power to practice one's trade of the Familistère. Equally compelling are the contradictory interfaces of the truck stop's dominant mythologies: the spheres of domesticity, labor, and faith, all accessible tropes in American marketing and merchandising.

With its clientele of long-haul drivers, who may be away from home for weeks at a time, the institutionalization of the truck stop is unavoidable. An architectural rhetoric of gabled entrance bays, dormer windows, and enormous front porches masks many contemporary truck stops. At the small scale of the parking lot, the simple gables that indicate entrances to Flying J stores and green corrugated awnings that denote Petro's Iron Skillet Restaurant convey stereotypical imagery of the most ordinary American home. More elaborate, architect-designed truck stops include the "chalet-influenced" Iowa 80 (Figure 10.4), the Trails Travel Center in Albert Lea, Minnesota, and the Gateway Gravel Center in Breezeway, Pennsylvania.[30]

These buildings with their pastiche elements recall both the materiality of the log cabin and the luxury of the national park lodge, exploiting imagery drawn from a popular historic collective of places to dwell at home and on the road. Although built in the first decade of the twenty-first century they

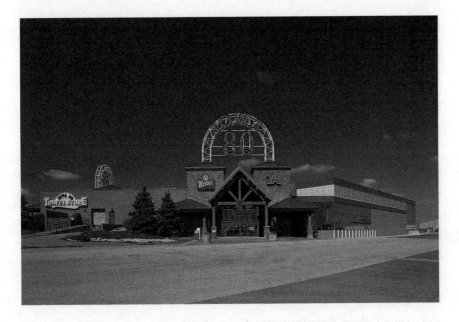

10.4 Iowa 80 Truck Stop, Walcott, Iowa

evoke skin-deep references to the past of Disney's Main Street and 1980s postmodern historicism, but here the references are calculated to brand the roadside genre.

The façade of domestic order is deceptive, for, psychically, the big truck's sleeper cab is the driver's dwelling, and domesticity is hardly authentic in a placeless sea of asphalt with as many as 100 other rigs constituting a very extended family. Parked at the truck stop, with the sounds of diesel engines idling and refrigerator units humming, the machine enters the domestic garden—or more correctly, the back yard, for, typically, truck parking is situated at the rear of the truck stop (Figure 10.5). Outside and inside form a "dialectic of division" analogous to that of the suburban house on its front yard, creating a sense of place that is both isolated and penetrable.[31] Only within the confines of the truck stop interior, where drivers pass through the same spaces, performing the same rituals of dwelling—dining, grooming, laundering, shopping—does a phantasm of domesticity become possible. In other words, the truck stop is a space of sociality that alludes to, but barely engages domestic relations.

The illusion of domesticity, however, is not sufficiently palpable to erase the residue of work and its traditionally masculine *telos* from the truck stop.[32] As an institution and practice, trucking involves physical labor, which scholarship in masculine studies suggests is necessarily connected to the semiotic construction of working-man's bodies as their primary economic asset.[33] In this connection, pumping fuel, checking tire pressure, and attending

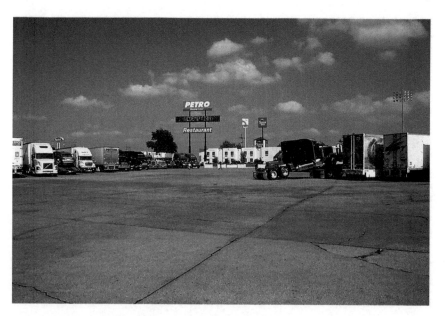

10.5 Truck Parking, Petro Truck Stop, Joplin, Missouri

to the cyclic maintenance and repair of equipment at the truck stop are self-evident extensions of the active labor of driving. Documenting logbooks, scheduling deliveries, and emailing load confirmations are equally critical to the business of trucking, yet they embody a more modern construction of work that organizes and rationalizes masculinity around "technical knowledge." As a domain of work, consequently, the truck stop blurs the clear economic circumstances, institutional structures, and spatial domains of the blue collared laborer on the factory floor and the white collared middle manager in the office cubicle.

Embodying both the disorder of the urban world of work and the diaspora of the suburb's domesticity, the truck stop manifests the profane qualities of ordinary places. Truck stop chapels, an increasingly visible part of the truck stop's cultural landscape, negotiate this territory to create an illusion of sacred space in the midst of the labor and capitalism that comprise the ordinary practices of the road (Figure 10.6). Even in late twentieth-century America, where chapels have been placed in such secular territories as shopping malls, resort hotels, and casinos, the truck stop chapel is unique. It alone offers an immediate and direct sense of involvement with the sacred that confirms the shared world view of its transient community, the experience of the road as only a truck driver might know it.

More than 30 truck stops in the United States and Canada feature permanent chapels under the auspices of Transport for Christ International, Truck Stop Ministries, Inc. operates chapels in 28 states, and Truckers Christian Chapel

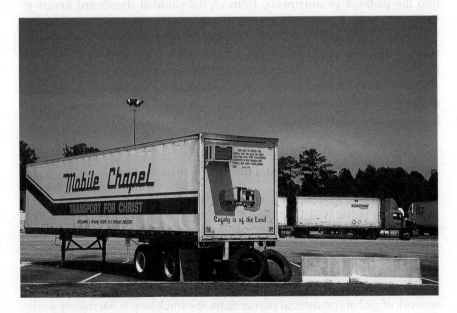

10.6 Truck Stop Chapel, off I-95, near Brunswick, Georgia

Ministries support an additional 116 congregations.[34] These organizations propound a non-denominational, evangelical Christianity, devoted to mitigating the rigors of trucking with fast-food-like deliveries of faith served in manufactured buildings and standard trailers adapted, sometimes with makeshift side-lights and steeples, into preaching boxes. Their aniconic spaces link the chapels to both traditional Protestant congregations that forgo splendor in space to make the sermon and reading of scripture preeminent in worship and contemporary "post-denominational" churches that use theatrical settings to intermingle faith, fellowship, and mass-marketing. A plethora of devotional objects firmly situate the truck stop chapel in a marketplace that reveals changing meanings of traditional symbols in late-capitalist America where material culture and the culture of commodities are increasingly inseparable.

Ethnographic studies of contemporary Christian practice conclude that: "Evangelicals turn out stuff."[35] In particular for truckers—isolated from the traditional sacred centers of both home and church—material expressions nurture a sense of belonging and provide a direct and tactile connection with the sacred that mitigates the worldly concerns of the road. During the 1960s and 1970s, black velvet paintings of the Christ figure, with arms outstretched, embracing a semi driving into the night, were truck stop staples. Nowadays, the evangelical mission of the truck stop chapel is augmented by the commercial imperatives of its shops. Traditional devotional objects reconceived in chrome-colored plastic and neon blend with surprising ease into the plethora of ornaments, from crystal-studded dashboard knobs to flame-patterned chrome rearview mirror trim, that drivers covet to customize their trucks. Chrome "Jesus" signs appear on exhaust grills and decorative lights in the sign of the cross embellish refrigerated trailers, rendering the big rig itself a site of sacred practice and religious significance. Like the truck stop itself, its chapel and its consumable religious goods create an allusion of stability in an atmosphere charged with high-speed movement and equally high-speed market transactions.

The Trucker, the Truck Stop, and the Mystique of the Road

In a liminal wedge between I-15 and Las Vegas Boulevard, we turn left off Tropicana to the Wild Wild West Truck Stop. The glare of the Rio's laser marquee and the Luxor's sky-turned spotlight mere blocks away dwarf its dated neon sign. After nine, the door to its glass-box of a convenience store yields only to the push of a security buzzer, but its casino is open all night.[36]

For the trucker, at once isolated in the driver's seat yet fully connected to a network of global commercial transactions, the truck stop is not merely a self-contained community; it is equally a dynamic conduit along the open space

of the highway, the intersection at which the rigors of the trucking industry and the mystique of the road meet. The unions of opposites of the highway are as potent as those made manifest in the negotiation of domesticity and labor, of the sacred and the profane, and of production and consumption at the ordinary Petro or the extraordinary Iowa 80.

Popular portrayal of the American highway contrasts the perceived freedom of the open road with the complacency of American life in the age of corporate capitalism. Typical road stories begin with a virtual departure from the duties of everyday life, liberating their characters from the spatial and temporary boundaries of their ordinary practices, and offering an escape route from care and conventionality.[37] Jack Keroac's canonical *On the Road* espoused the belief that on the road, one could be anything one wanted to be–"a sordid hipster or a maker of a new beat generation."[38] He constructed an American myth, yet, as feminist critiques of the road genre point out, the highway is hardly the "easy riding adventurous and liberating playground" that dominant narratives suggest.[39] As described by the female hitchhiker Brenda Bradshaw in Sharlene Baker's *Finding Signs*:

> On the road you belong to the world. You depend on the weather not to be too cruel to your highly vulnerable self, you depend on your own body not to betray you with sickness or depression.[40]

Such decentering from the liberating mystique of the road resonates with the lot of the trucker, and the function of the truck stop.

If the road is perilous territory, more benignly, it is also a banal path of endless white lines and anonymous real estate. The early work of Ed Ruscha adds another dimension to reading the American roadside. Inspired by the Beat poets, Ruscha represents the once mythic West in photographs and paintings of the static billboard advertisements, anonymous gas stations, and miles of asphalt that comprised its cultural landscape by the mid-century. His *Twentysix Gasoline Stations* chronicles numerous journeys along Route 66 from Ruscha's native Oklahoma to Los Angeles with closely studied portraits of the roadside's commercial vernacular framed to evoke the momentary glance from the vehicle's eye view.[41] The sweeping cantilevered roofs, battered pump stations and mundane branding graphics that characterize his *Flying A in Kingman, Arizona*, or a *Standard Oil Station in Amarillo, Texas* resonate with the architectural situation of the truck stop. However as isolated portraits of place with no tangible measurement of space, time, or place, the photographs are repetitive, yet purposefully unconnected, discrete and episodic, much in the way in which a long-haul driver might see the truck stop. Like the truck driver, however, Ruscha understood the road as a continuum of "moving mindless miles" where "attention to common-place matters of life unfold against a limitless sky and setting sun."[42]

Space, Place, and Commerce as Only the Road can Know Them

In its emulation of domesticity, the truck stop advertises a hegemonous model of domestic bliss that enforces precise orders of sleeping, eating, and bathing that are requisite for conducting a life in common. Along its restaurant counters, in carpeted lounges that lead to shower halls, and on the blacktop of its parking lots, quasi-public places of encounter, discourse, and, occasionally, sexual concourse locate a sociality that is bound, concomitantly by the rigors of the trucking industry, the multiple mystiques of the road, and contemporary corporate commerce. For all the designer coffee, home-style fried chicken, and chrome ladies that can be bought at the Pilot or Petro on "Any Interstate Interchange, USA," the truck stop cannot be dismissed as just another anonymous constituent of the road. Like the liminal edges and decentered slums of late-capitalist cities, truck stops are heterotopias, which are, according to Michel Foucault's formative discourse, "those singular spaces to be found in some given social spaces whose functions are different, or even the opposite of others."[43] Understanding the truck stop as a heterotopia thus recognizes how it juxtaposes in one real place several different spaces, incorporating several sites that are in themselves incompatible with or foreign to one another.[44]

As represented in art and literature, or experienced from the rearview mirror of the big truck, the dichotomies of the road create a nearly constant state of transition, between public and private, sacred and profane, and center and margin. In this "floating world," the truck stop attains meaning as part of, what Reyner Banham has called, "the language of movement not monuments."[45] As repetitive points on the map, characterized by sameness and sequence, truck stops weave together the vast spaces of the road, replacing the traditional townscapes they emulate and marking time, space, and society through the trucker's journey.

The twenty-first century truck stop is nothing like its antecedents of the 1920s or the 1950s; neither are the cities linked to the interstates they serve. After a half-century of the suburbanizing and malling of America, the long-haul driver is hardly alone when (s)he plots a route that patently avoids the historic city center. Perhaps the contemporary truck stop can appeal to this expanded audience of consumers because it is painfully akin to the new setting for urban life—"superburbias, suburban activity centers, and pepperoni pizza cities"[46]—in which, increasingly, they dwell. For a night or two at a time, the truck stop serves all the functions of these new edge cities, and, just like them, brings together space and place and commerce in a form that only the road can recognize:

> Twenty miles west of Casa Grande, California, carrying Mexican lemons from a freezer in Yuma, Arizona. Department of Transportation, stop ... US border

patrol, stop again. No wonder my driver tried to sleep in the desert last night, on a stretch called Freeman's Road, among cactuses, long-tailed gerbils, and a moth that fails to appear in the *Audubon Book of North American Insects*. Ours was the only reefer running and the sky provided the only order of things. But, there's no coffee, and the truck needs a wash; so does he. In the end, it will be just another night at the Flying J.[47]

Notes

1 John Brinckerhoff Jackson, "Truck City," in his *A Sense of Place, a Sense of Time*, New Haven: Yale University Press, 1996, p. 182.

2 Jackson, p. 177.

3 A transport of large proportions dedicated to moving masses of goods for a fee, semi-trucks are known colloquially as 18-wheelers, big rigs, or, simply, semis. Most are built to the specifications of the Department of Transportation that stipulate limits of 102 inches in width, 13.5 feet in height and a gross weight of 80,000. The standard single trailer unit can be 48 or 53 inches.

4 Large franchises dominate the truck stop industry. Among the most prominent corporations in the United States are Petro Truck Stops, Pilot Travel Centers, including Flying J with which it merged in 2010, Love's Travel Stops, and Travel Centers of America.

5 Steven Izenour cited in Patricia Leigh Brown, "Truck Stop's Image Takes Turn Toward Glitz," *New York Times*, 5 July 1999, Technology, p. 1.

6 Dolores Hayden, *A Field Guide to Sprawl*, New York, W.W. Norton & Co., 2004, p. 117.

7 See for example, Robert A. Hamilton, "The View From Wilmington: After 15 Years, Plan for I-84 Truck Stop Still Angers Residents," *New York Times*, March 18, 1990; Scott Goldstein, "Dallas police fight truck stop prostitution with rehabilitation," *Dallas Morning Star*, 8 November 2007; Ann Morse, "Coming to a Truck Stop Near You (Porn-Fueled Sex Slavery and Child Prostitutes in the USA)," *National Review*, 15 January 2008; and John McPhee, "A Fleet of One," in his *Uncommon Carriers*, New York: Farrar, Straus and Giroux, 2006, p. 21.

8 John Steinbeck, *Grapes of Wrath*, New York: Viking, 1939, revised ed., New York and London: Penguin, 2006, p. 10.

9 Jackson, p. 172.

10 Stephen B. Goddard, *Getting There: The Early Struggle Between Road and Rail in the American Century*, Chicago: University of Chicago Press, 1996, p. 85.

11 Ruth Tobias, "Road Houses," in *Oxford Encyclopedia of Food and Drink in America*, Andrew F. Smith, ed., New York: Oxford University Press, 2004, p. 367.

12 Goddard, p. 85.

13 See Robert Kirks, *Come and Get It! McDonaldization and the Disappearance of Local Food from Central Illinois Communities*, Bloomington, IL, McLean Country Museum of History, 2011, pp. 321–3.

14 The penguins were meant to connect the truck stop to its namesake, Admiral Byrd's Little America station in Antarctica. The chain still uses the logo.

15 Marty Stuart, *Truck Stop*, from the album *The Pilgrim*, MCA Records, 1999.

16 Although little known outside of the region, Risher was one of the South's most accomplished Modernists, and his Red Hot Truck Stop has been recognized as an "architectural gem." See Willie Morris, *My Mississippi*, Jackson: University Press of Mississippi, 2000, p. 92.

17 For a parallel argument see John A. Jakle, "The American Gasoline Station, 1920–1970," *Journal of American Culture* 1/3 (1978), pp. 529–31.

18 Marty Stuart, "Truck Stop Heaven," *Oxford American*, March/April 2001. Meridian architect Ed Welles argued that the arrangement was simply the product of Risher's exploration of modern

space relative to the functional requirements of the truck stop, (telephone interview with the author, September 14, 2003).

19 See Chester Liebs, *From Main Street to Miracle Mile*, Boston, Little Brown, 1985, pp. 104–5 and "Standardized Service Stations Designed by Walter Dorwin Teague," *Architectural Record* 82 (September 1937), pp. 69–72.

20 For Loewy's relationship with International Harvester, see Christine O'Malley, "Modernization Through Comprehensive Design: Raymond Loewy Associates and International Harvester, "A Case Study," in her "'The 'Design Decade' and Beyond: American Industrial Designers and the Evolution of the Consumer Landscape from the 1930s to the 1950s," Ph.D. diss., University of Virginia, 2002. See also Raymond Loewy, *Industrial Design*, Woodstock, NY: Overlook Press, 1979; Angela Schonberger, ed., *Raymond Loewy: Pioneer of American Industrial Design*, Munich: Prestel, 1990; and Gary Kulik, "Raymond Loewy: Designs for a Consumer Culture At the Hagley Museum and Library," *Technology and Culture* 44/3 (2003), pp. 566–73.

21 See O'Malley, pp. 191–3.

22 See "International Harvester launches prototype designs for a 'base of operations' for its 8,000 retail dealers," *Architectural Forum* 84 (January 1946), p. 114.

23 Ultimately, a different site was selected for the Wal-Mart. Soon after the demolition of the Red Hot Truck Stop, paleontologists from the Carnegie Museum of Natural History, the University of Michigan, and the University of California at Berkeley studied the site, recovering early Eocene plant and mammal remains. See Melissa Hendricks, "Tales from the Crust," *Johns Hopkins Magazine*, Web.

24 Dale Watson, *Truckstop in LaGrange*, from the album *Blessed or Damned*, Hightone Records, 1996.

25 McPhee, p. 30.

26 See Phil Roberts, *The Perfect Spot: Iowa 80's Journey from Iowa Cornfield to the World's Largest Truck Stop, 40th Anniversary, Iowa 80 Truck Stop, 1964–2004*, Walcott, Iowa: Iowa 80 Group, 2004.

27 "Mission Statement," Iowa 80 Trucking Museum, Web.

28 Kate Harries and Jim Ross, "The Truck Stops Here—'travel plazas' raise the bar," *Toronto Star*, March 3, 2002, News section, p. 11; see also Kitty Bean Yancey, "Truck stops pump up image. Today's 'travel centers' are cleaner, friendlier and courting 4-wheel traffic," *USA Today*, August 31, 2001, D8; Michael Long and Cory Wolinsky, "Down Home at the Truck Stop," *National Geographic*, 199/5 (2001), p. 124; *Extreme Truck Stops*, Travel Channel, 2008; and Ken Beck, Jim Clark and Les Kerr, *The All American Truck Stop Cookbook*, Nashville: Routledge Hill Press, 2002.

29 Ethel Goodstein-Murphree, Journal Entry, Pocatello, Idaho, January 1, 2003. From 2002–05, the author was an investor in a long-haul trucking business, and, as her academic schedule allowed, accompanied her husband, artist and partner David Murphree, on many commercial turns across the country.

30 All three truck stops are the work of Renner Architects.

31 See Gaston, Bachelard, *The Poetics of Space*, New York: Orion Press, 1964.

32 This is not intended to suggest that trucking is, in practice, a uniquely masculine domain. According to *The Trucker*, the industry's principle news outlet, it is difficult to determine the number of women employed in the trucking industry or in what capacity they work. In 2008, the Department of Labor documented 1,319,000 (15 percent of the industry) women employed in "transportation and material moving occupations." US Census Bureau data for the same year for the category "drivers/sales workers and truck drivers," notes only 4.9 percent of the category, or approximately 166,000 workers, are women. See Ellen Vote, "Finding data about women in the trucking industry," *TheTrucker.com*, August 2010. Web.

33 R.W. Connell, *Masculinities*, Berkeley: University of California Press, 1995, pp. 36, 55.

34 See Betty MacDowell, "Religion on the Road: Highway Evangelism and Worship Environments for the Traveler in America," *Journal of American Culture* 5/4 (1982), pp. 63–73; and Dana Byrd, "Way Finding: Work, Space and Evangelism at a Truck Stop Chapel," Third Annual Material Culture Symposium for Emerging Scholars, April 23, 2005, Center for Material Cultural Studies, University of Delaware, Newark, Delaware.

35 Barbara Wheeler, "We who were far off," paper presented to the Religious Research Association, St. Louis, Missouri, November 1994 cited in Steven M. Hoover, "The Cross at Willow Creek" in

Religion and Popular Culture in America, Bruce David Forbes and Jeffrey H. Mahan, eds, Berkeley and Los Angeles: University of California Press, 2005, p. 145.

36 Goodstein-Murphree, Journal Entry, December 19, 2002, Las Vegas, Nevada.

37 See especially Ronald Primeau, *Romance of the Road: The Literature of the American Highway*, Bowling Green: Bowling Green State University Popular Press, 1996, p. 6.

38 Brian Ireland, "American Highways: Recurring Images and Themes of the Road Genre," *Journal of America Culture* 26/4 (2003), p. 476. See also Jack Kerouac, *On the Road*, New York: Viking, 1957.

39 Alexandra Ganser, "On the Asphalt Frontier: American Women's Road Narratives, Spatiality and Transgression," *Journal of International Women's Studies* 7/4 (2006), p. 158.

40 Sharlene Baker, *Finding Signs*, New York: Warner, 1990, p. 4.

41 Edward Ruscha, *Twentysix Gasoline Stations*, Los Angeles: Edward Ruscha, 1963. See also Eleanor Antin, "Reading Ruscha," *Art in America* 61/6 (1973), pp. 64–71, and Jaleh Mansoor, "Ed Ruscha's One-Way Street," *October 111* (Winter 2005), pp. 127–42.

42 Ed Ruscha quoted in Kerry Brougher, "Words As Landscape," in Neal Benezra and Kerry Brougher, eds, *Ed Ruscha*, Washington, DC and Oxford: Scalo, 2000, pp. 157–77.

43 Michel Foucault, "Des espaces autres," *Architecture/Mouvement/Continuité* 5 (October 1984), pp. 46–9, based on a lecture delivered in 1967; see also his "Space, Knowledge and Power," in Paul Rabinow, ed., *The Foucault Reader*, New York: Pantheon, 1984, p. 252.

44 See Edward Soja, *Postmodern Geographies: the Reassertion of Space in Critical Social Theory*, London and New York: Verso, 1989.

45 Reyner Banham, *Los Angeles: the Architecture of Four Ecologies*, New York: Harper and Row, 1971, p. 159.

46 See Joel Garreau, *Edge City, Life on the New Frontier*, New York: Doubleday, 1988, pp. 1–17.

47 Goodstein-Murphree, Journal Entry, September 14, 2003, Fayetteville, Arkansas.

A Tale of Two Cities: Image, Space and the Balancing Act of Luxury Merchandising

John Potvin

In an early interview with Daniela Morera in 1977, Armani summarized what would become his retail and distribution philosophy years before he would became one of the most famous, successful and recognizable designers on the American retail landscape:

> We have a small, very exclusive production for the moment. Even in Italy, Germany and England, where we are very famous, we sell to just one boutique in each town. So, who is able to buy an Armani suit is a privilege. We have so many demands, we are going bananas.[1]

In those early years, the company's fledgling manufacturing and distribution capabilities meant not only a small and exclusive retail and merchandising network in key cities in Europe, Asia and North America, but it also, importantly, helped to increase the designer's and his label's cultural cachet and aura of exclusivity. Unlike today, in those early years, and well into the 1990s, locating and purchasing his clothes was only made accessible to those in know; so much so that even his own boutiques in Europe were not listed in local telephone directories. Armani's material success was initially tempered by the company's apparent lack of industrial know-how, yet his and his partner and co-founder Sergio Galeotti's now infamous controlled approach to retail management and merchandise distribution would quickly solidify the long-term financial growth and mythologize the image of the man, label and company. In the first years, and even decades, of Giorgio Armani SpA (Milan), Galeotti and Armani were quick to harness over-distribution of their products, fearing too rapid growth, poor quality control, oversaturation in key markets, and loss of control over the company's image. Galeotti's zealous management of the retail distribution of the top-end, exclusive Giorgio Armani line began

in earnest in the North American market and importantly paralleled the opening of the company's first North American wholly owned free-standing boutique in New York in spring 1984, less than one year after the inauguration of the first flagship boutique in Milan. The Italian designer's foray into the American retail market, as with most designers, marked a decisive move into the largest market in the world, claiming the house's importance on a global scale. Within a global context, the marketing and even identity of luxury is at once duplicitous and schizophrenic; it must remain exclusive and elusive and out of reach, while at the same time appeal to the masses to ensure an ever-increasing market share and potential for future growth. This chapter narrates the precarious balancing act Armani has performed, tracing the shifting tense, yet mutually beneficial, relationship between exclusivity on the one hand and mass appeal on the other within the visual, material, and cultural landscape of American retailing. By exploring the idiosyncratic and particularized cases of New York and Beverly Hills, I wish to suggest that Armani's relationship to these two cities has been decisive in the house's history, symptomatic of his controlled retail strategies deployed in the development of his expansive global empire.

By the time Armani opened his boutique at 815 Madison Avenue, near 68th Street, in February 1984, compatriots Gianni Versace and Missoni had already located nearby (Figure 11.1). The area between 60th and 80th Street along Madison Avenue has been an upscale shopping retail district for decades. However, by the mid-1980s the street's identity was shifting from one filled with antique and speciality shops to a street littered with high-end European designer boutiques. "We located here because we wanted to keep a European flavour, and Madison is the most European street in New York," said Pierfilippo Pieri, a spokesman for Armani. "Physically the buildings are lower, there aren't any skyscrapers." Unlike Fifth Avenue, the pace and tempo of Madison Avenue was slower, more conducive to gazing, window shopping, and, in effect, lifestyle shopping.[2] By 1986 the overwhelming European, and in particular Italian, presence on the prestigious avenue marked an initial yet decisive moment in the history of the continued success of the Italian fashion industry as fashion houses collectively claimed their space in key outposts around the globe. For many of these Italian fashion houses, and more importantly for Armani, America marked a decisive turning point in plans for expansion, retail growth, and global recognition through the country's myriad media outlets, namely the movie industry.

Many industry insiders and an even more cynical American press viewed Italian incursion into Madison Avenue as simply an exercise in image building. The *New York Times* reported that "[i]t is popularly believed that many European merchants are on Madison Avenue to create a prestige presence for themselves and to build business for their wholesale divisions rather than to make profits on their retail operations there."[3] Given that the rent for the five-

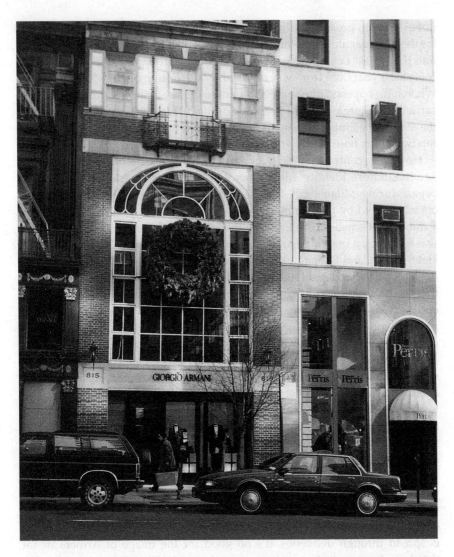

11.1 Façade, Giorgio Armani boutique, Madison Avenue, New York, opened in 1984

story, 10,000-square-foot Georgian brownstone Armani leased had doubled in the span of five years from $150 to a then staggering $300 per square foot, a spokesperson for the designer was quick to stress that the venture was "not a public relations venture, it's a business."[4] Gabriella Forte, then executive vice-president and head of American operations and touted as Armani's right hand and first line of defence, also adamantly dismissed the idea of the promotion-rather-than-profits idea. "The Europeans are like Americans," she claims. "They don't do anything unless they make money. Would you move into a space just for the fun of it? Who is saying this? American retailers? They are

nuts."[5] In fact, projected sales for the new store were estimated at $3,500,000 for the first year alone, one of only two stores on the street boasting profit well into the 1990s.[6] Leased by antiques dealer Ginsburg and Levy to Armani for $660,000 a year,[7] the store was inspired by the design of the Milan boutique. When it first opened, the spare and minimally merchandised first three floors carried the Giorgio Armani primary so-called "black label" couture line and the secondary Emporio Armani line as well as his children's lines, while the top two floors housed showrooms and offices.

However, controversy surrounding the house's desire to enhance the new boutique's identity and presence within New York's retail landscape began during Milan's fall 1984 season. Armani's women's collection was overshadowed by the company's contentious move to pull its top line from a number of smaller retailers in both Canada and the US. The controversy was fueled by a brewing feud between *International Herald Tribune* columnist Hebe Dorsey and Beppe Modenese, then president of the Camera Nazionale della Moda Italiana and founder of Milan Fashion Week, the former claiming that the Italians were only interested in money. Dorsey immediately singled out the house of Armani for its closure of an account with a retailer that had not sold enough Armani for two continuous seasons.[8] In a dismissive swipe of her pen, Dorsey simply wrote of Armani's significant collection: "Their attitude has to change."[9] The situation was exacerbated at the following spring/summer presentations, when retailers and buyers were talking less about what was in the collection as much as whether they would be allowed to continue to sell the Armani line in their stores. Rumors heavily circulated amongst North American buyers that Armani had designs on limiting access to his line to only two of his New York retailers. While buyers' suspicions did not materialize, Galeotti did in fact cancel all stores with consistently low budgets for the primary GA label, which in real terms meant $20,000 or less per season. In the end, seven doors in both Canada and the US were closed to the designer's collection. "As a company, we do not impose minimum dollar amounts on our clients," explained Galeotti. "But if a small amount is spread through deliveries, it's no good for the image of Armani or for the store, because it doesn't keep enough merchandise in stock to develop an Armani customer."[10] Armani's move in New York and beyond was not unusual nor was it a one-time initiative. In Germany, for example, when the company opened Giorgio Armani and Emporio Armani boutiques, it pulled the secondary line from 150 clients while the GA line was taken away from ten clients. The move was meant to guarantee and enhance the labels' cachet of exclusivity while other designers, like his largest Italian rival Versace, were signing contracts with increasing numbers of retailers.

The house's image, that is the perception of limited access to its products and designer, was endemic to its retail and merchandising strategies from the outset. Armani has always maintained that his boutiques and those outlets

carrying his GA couture line need to clearly articulate the correct, consistent image he wants to project to his customers whom he believes he designs for directly. Even in its early years, the house recognized the need for clarity and a consistency of vision that would enable the education of both its retailing partners and customers. Armani himself later claimed that, "[i]t's fundamental to know retailing because you know your customer. You can control and improve the product and also educate the public—the maximum way to function as a designer."[11] In the company's seemingly ruthless manoeuvres we can clearly identify the embryo of lifestyle branding before the concept was thrown around by global corporate retailing giants who vied to take over the fashion industry in the late 1990s. Image was so fiercely maintained by Galeotti who even threatened to discontinue the line from those stores which displayed the clothes poorly, antithetical to the blueprint established by the in-house merchandising group headed and directed by the designer himself. Surely, at least in part, the cancellations of smaller retailers would offset the increased demand on Armani's runway theatre which was reduced from its usual 600-guest capacity to 400; a move which only further enhanced the house's strategy to limit access and attenuate its mystique as exclusive and elusive.

While some retailers were being downsized out of existence, other department stores were increasing and accelerating their relationship with the designer. Department stores have always been a crucial facet of the designer business in the US. Barney's in New York was the first to carry the Armani couture collection for both men and women, which it began to sell in 1976, almost immediately after the designer began showing under his own label. What is unique is how early on Armani assured a department store's commitment to the image and ideal of his label by negotiating large floor space and exclusive environments which mimicked his own boutiques, a by-now common merchandising practice that ensures a brand's visual and material continuity as a way to spatially demarcate and extend a fashion house's DNA. These unique and specially designed spaces, constructed at the expense of the department stores, soon became crucial assets to the stores themselves in their quest to create, educate and facilitate customer loyalty by hosting, for example, twice annual trunk shows in the correct, separate and exclusive spaces of the in-store boutiques. Trunk events, held before the season has begun as a means to ensure timely production and delivery, present a designer's entire collection, whether the entire collection ever hits the sales floor. According to one Armani representative: "Many of the special pieces shown on the runway never even hit the [store's] floor. They're all reserved for the trunk shows. We might have 20 of the hot style in various sizes, but there'll be a waiting list of 65 for them."[12] Those who later stroll into the boutiques throughout the season are often left without access to the key or more iconic pieces of the season they saw in pictures from the runway

presentations, having already been sold out or exclusively produced and sold on demand through trunk shows.

In October 1985 New York retailer Bergdorf Goodman opened a new, expanded Giorgio Armani boutique which for the first time coupled women's with men's wear in one single space. "[B]y combining the two, we will have a stronger Armani business," the department store's president Dawn Mello remarked of the unorthodox decision to merge the sexes within a single department store space. "We believe men and women shop together for certain kinds of clothes," she concluded. "For men's and women's, the point of view is quite similar."[13] Within this rather unique retail configuration, Armani's notoriety for gender blending and textiles that crossed across the sexes is made spatially tangible and compelling. By combining the two previously separate spaces devoted to Armani's men's and women's fashions and accessories, Bergdorf established itself early as a retailer committed to maintaining and advancing a cohesive image for the GA couture line, as well as a unified gendered ideal endemic to the designer's design ethos. Although today the men's and women's collections are housed in separate spaces— separate buildings in fact—the upmarket New York retailer has consistently maintained its steadfast relationship with the designer, more often than not seeing continuous sales growth and expanded floor space. Bergdorf was certainly not alone in its success with the Giorgio Armani line, and by fall 1989, Armani was Bloomingdale's highest-volume European designer which also resulted in a move to place the designer in a larger space.[14]

Insuring his success in North America's most important retail and advertising mecca was not the only project the designer had underway by the end of the 1980s as part of the designer's attempt to consolidate and control his image. In 1988, after seven successful years of collaboration with Hollywood through various films, most notably *American Gigolo* (1980) and *The Untouchables* (1987), the house opened a sprawling 13,000-square-foot boutique on the famed Rodeo Drive in Beverly Hills, a street Armani had always maintained he would never open a store on (Figure 11.2). With this spectacular boutique, whose design was luxurious and markedly unlike any of his other stores, Armani set out to establish his presence not simply within the city, but in the mass media market beyond. Through the immense and expansive public relations system Hollywood offered, he single-handedly invited the world to join him by taking the red carpet upmarket and into the image-saturated realm of mass media. Given the location of the boutique and the designer's increasing global reputation as designer to the stars, the move meant that Armani was attracting a new clientele. According to Don Tronstein, the owner of the building that both Armani and Ralph Lauren occupy, between 40 and 60 percent of sales come from tourists.[15]

However, the move to open a boutique in the epicentre of the "more is better" style ethos initially proved counterintuitive to Armani's pared down,

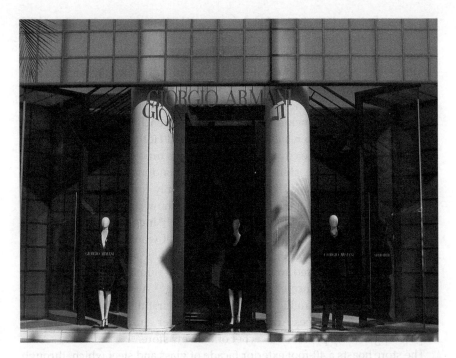

11.2 Façade, Giorgio Armani boutique, Rodeo Drive, Beverly Hills, opened in 1988

rigorous minimalism. Marketing the Armani aesthetic meant creating a buzz and presence for the boutique itself. In anticipation of the opening of the Beverly Hills boutique, Armani hosted one of the most eagerly anticipated and coveted black tie events on the LA social calendar on 27 January 1988 at the Museum of Contemporary Art (MOCA), to which he had made a substantial donation. With the art taken down as a protective measure rather than simply and exclusively an aesthetic manoeuvre, the first room was devoted to the recreation of his Milan Via Borgonuovo basement bunker-like theatre to showcase his spring and summer men's and women's collections, a shrewd move given the city's warm climate. Referring to the fashion show, Forte stated the day after: "Personally, I look at the clothes and I look at the audience, and I see no relation ... These things take time and education; little by little they evolve."[16] What was required was an act of translation on the part of Armani staffers in the US and in particular in Beverly Hills, a city notorious for its over-the-top aesthetic and style sense.

A second space swathed in draped white fabric was devoted to the three-course (Italian) dinner, prepared by famed LA restauranteur Wolfgang Puck and to a dance reception for the 250 specially invited guests. Leading up to the event, New York-based Armani ambassador and social coordinator Lee Radziwill who co-hosted the event was heavily criticized by the dismayed

Los Angeles based press for her purported lack of knowledge about the city's A-list celebrities. As one columnist reported, the event was "sending tremors along our city's fashionable fault line. It will probably be a very lovely evening—but it becomes much more important to be there when it's clear that you can't buy an invite."[17] The list, however, was not simply made up of guests from the neighborhood, but friends of Armani from across the US and around the world, and included, among others, French socialite and Armani attaché Dreda Mele. As a result, many disgruntled Hollywood celebrities and socialites were left off the coveted list, with tickets unavailable for sale.

For the Rodeo Drive store, Armani hired London based restauranteur Michael Chow who claimed responsibility not only for designing the store, but also for "staffing it and setting it all up." Chow described the store as "classic modern," where "[n]othing will be cheap."[18] Indeed it was not, costing Armani $4 million as an initial investment in what would become one of his most important and successful boutiques. First day's sales for the first four hours alone were reported to be $70,000, equal in number to the invitations sent out weeks in advance of the store's opening.[19] According to Forte, the store generated over $7 million in its first year.[20] First through the door were celebrity Armani-devotees Arnold Schwarzenegger and wife Maria Shriver, heightening the star power and cachet of the new store.

The store boasts a 40-foot exterior façade of glass and steel which, through a grid of opaque glass square panels, allows light to pour into the ground and first floors. The 5,000-square-foot selling space on the ground level is devoted to women's wear, along with a small mezzanine level located at the far back. Ascending the dual staircase of painted steel, which acts as the store's focal point, one initially arrives at a second mezzanine level which showcases accessories for both men and women and from which one has a perfect panoptic view of the whole of the ground level. From there, the final stop is the 5,000-square-foot first floor devoted to men's wear (Figure 11.3). As with the women's floor, suits hang off steel pegs equidistant along the periphery, each row surmounted by two upper shelves over top to display shirts or pullovers purposefully coordinated with the suits hanging below. As with every free-standing and in-shop boutique, Armani stipulates the exact distance between each hanger; an Armani regulation stringently imposed and intensely scrutinized by the New York office. The shelves and pegs which display the garments are attached (though movable) to specially designed gold-leafed panels set against the wall. These opulent panels are further enhanced by way of the luminescent white marble floors and sumptuous beige carpets. Each carpeted area also contains a dark Macassar and ebony wood display case, a black leather and wood club chair, and a gold-leaf upright shelving unit. These specially designated, intimate shop-within-shop areas are each devoted to a special facet of the Armani collection: a tuxedo shop, cashmere shop, and business suitings, for example. In addition to these

JOHN POTVIN 219

selling spaces, 3,000 square feet on the first floor are used for executive offices, a full kitchen, warehouse facilities, and lockers for staff.

With at most two of each garment displayed on any given shelving unit, only 70 percent of the collection is displayed at any one time, with the staff of approximately 30 required to constantly replenish and re-merchandise the floor. The garments are located in a back storage space, accessed only by way of one security-coded, unobtrusive door flush with the adjoining wall. For the store, Armani "wanted a boutique like his runway, and his runway is based on changing light. ... Los Angeles' natural environment is sunshine all the time, and we wanted to imitate the light outside and inside."[21] In Armani-owned boutiques, staff are usually given two complete regulation Armani navy blue suits, usually of wool crepe, and an equally small number of shirts/blouses which are specially designed to represent a season's significant suit and unique shirt style, usually worn by the men without a tie. Managers are often identified by their more formal grey suits. At the end of the season staff are given the option of purchasing the garments at a significantly discounted rate. The usually attractive staff, sporting the latest silhouette, walking in a soft, smooth and controlled manner, coupled with the space itself, mimic the designer's unique and controlled runway presentations in Milan; the spaces of the boutique extend and attenuate the harmonious (and controlled) lifestyle image Armani conjures through his Milan headquarters and flagship.

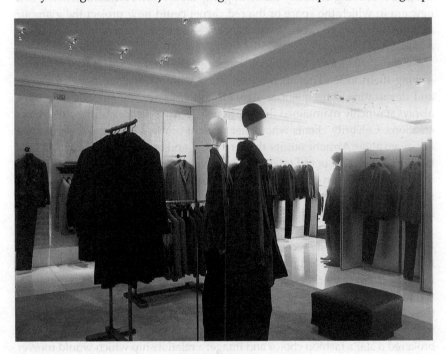

11.3 View of men's wear, first floor, Rodeo Drive, Beverly Hills

The designer has stated that the "purpose of the Giorgio Armani stores is to put my spirit on display in a concentrated and well-expressed way."[22]

At the time of the inauguration of the new boutique, at the suggestion of Forte, Armani was also quick to hire Wanda McDaniel as a special liaison to his increasing Hollywood clientele, who had previously been a social columnist and was well connected to Hollywood's elite through her director husband. One year later, both the new store and McDaniel proved to be a brilliant combination to be reckoned with in the movie industry. When Billy Crystal hosted the 31st Oscar Awards, for example, he not only wore a Giorgio Armani tuxedo, but changed into four different ones throughout the evening's event. Three of the tuxedoes fresh from the new boutique required fittings, while the fourth came from his own closet. Service, beyond simply offering clothing, is a premium for A-list clientele and when Crystal was reportedly having troubles with his bow tie Armani had McDaniel send along a representative from the Beverly Hills boutique to assist him backstage on the night of the awards.[23] McDaniel's and Armani's much-documented personal touches and close relationships with stars not only guaranteed the success of the designer's store in that city, but also led industry insider newspaper *Women's Wear Daily* to christen the Oscars the "Armani Awards" in 1991, to describe the legions of A-list stars who wore the label to one of the most televised events around the globe. Turning celebrity marketing into an art form, Armani ushered in a new era in which the space of the red carpet could now project the glamour and media coverage necessary to increase sales in the spaces of boutiques at a global level.

By the 1970s movie studios no longer gave or lent clothes to their stars, leaving them to fend for themselves, often with extravagantly awful results and devastating consequences. Armani and his past and present staff have always staunchly maintained that the house does not pay celebrities to wear his creations. Celebrity clients who either present or are nominated for an award are given their Armani outfits that are fitted and altered in the Rodeo Drive boutique. A second tier of celebrities are given clothing on loan, to be returned in pristine condition after the event. According to McDaniel, originally "[i]t starts out as, 'Oh my God, Armani is going to let me wear something!' It was like a privilege coming into the inner sanctum, it has a mystique."[24] In 1997, with the mania of the red carpet already reaching dizzying new heights, actress Lauren Holly famously received 56 free dresses from 13 different designers for the Oscars. Actresses as unpaid models embody a precarious and duplicitous function for designers, as they at once operate as agents of mass publicity through their ubiquitous visibility, yet at the same time their star status lends the clothes an exclusivity and hence increased desirability. Holly's move signaled a new phenomenon, the emergence of the celebrity stylist who now brokered a star's fashion choice and image; a relationship which would forever alter the once direct rapport some designers had with their celebrity clientele.

The Armani boutique at 815 Madison Avenue in New York flourished, enhanced by a consolidated and controlled network of a highly successful department store with specially fitted in-store boutiques. But Barney's move in 1993 to open a second luxury emporium a mere eight blocks away posed a significant problem for the designer and his controlled retail and merchandising vision. The equilibrium, between access and restraint, within the retail landscape Armani had devoted years to contrive was threatened by Barney's desire to sell the Giorgio Armani black label men's and women's collections in its new store. What this meant in actual retailing terms was that the exclusive and expensive men's black label collection would be made available in three different doors while the women's sold in five stores within a rather limited and small retail district, each blocks away from the other. The ensuing feud between Armani and Barney's reached an arbitration tribunal in Geneva which ruled in favour of Barney's. In a statement following the tribunal's decision, the designer claimed that while he would adhere to the ruling, he wished to make clear that he had signed the contract with the New York retailer in 1979, under entirely different conditions and circumstances. In addition, the tribunal also ruled that he did not have to permit Barney's to sell his label in their other city locations. In a retaliatory move, Armani discontinued selling his line to the retailer's Houston and Dallas stores. Armani's legal action against Barney's notably coincided with American designer Ralph Lauren's decision to pull his lines from both Barney's uptown Madison Avenue as well as its legendary 17th Street downtown stores.[25]

In an attempt to keep up with the ever-expanding retail architectural boom, in 1996 Armani commissioned architect and interior designer Peter Marino to design a new and significantly larger boutique at 760 Madison Avenue (Figure 11.4), a few blocks south of where the original store had stood since 1984 and slighter closer to Barney's new luxury emporium. Marino had gained a reputation as a retail architect, acquiring an impressive roster of clients within and beyond the fashion industry. The architect was also, and significantly, responsible for the 1988 renovation of the designer's Milan seventeenth-century palazzo in Via Borgonuovo where his home, design headquarters, and runway are located. The designer's choice of architect for his new store is significant, not only because Marino's spare aesthetic is in keeping with Armani's own pared down rigor, but also because the designer wanted the boutique to hold "a familiar atmosphere similar to that of a friend's home," underlining his desire for aesthetic and spatial continuity even along the ostensible private/public divide.[26] Despite Armani's best efforts to conjure a homey space, the reception of the new boutique by local authorities would prove to be less than friendly.

The proposed building designs were presented to Manhattan's local government agency representing the Upper East Side Community Board 8 for approval, which in turn voted 14 to 12 to send the proposal back for changes.

11.4 Façade, Giorgio Armani boutique, Madison Avenue, New York, opened in 1996

The Board's members who voted against the project felt it was ill-suited for its Upper East Side historical surroundings. However, Shelley S. Friedman, a lawyer for Armani, stated that the "minimalist building reflects the artistic values of Giorgio Armani."[27] Although minor adjustments were suggested and concessions were made, the final plan kept within Marino's and Armani's minimalist vision. In the end, Marino deferred to the strict codes established by the New York City Landmarks Preservation Commission by keeping the boutique's height at 61 feet, flush with those of its neighboring brownstones. To add some architectural detail or slight decorative flourish, the architect also incorporated a recessed bay and centrally placed terrace on the second level of the three-story building. Architectural critic Ned Cramer claimed that Marino attempted to "echo the Italian designer's sophisticated clothes through a minimalist wrapper for his new store. But other than adhering to Adolf Loos's axiom that ornament is crime, his rectilinear architecture turns its back on Modernism's basic tenents." He continues: "To mask the building's awkwardness, and to relieve his clear discomfort with unadorned surfaces, Marino employs an extravagant material palette on the interior."[28] Although Cramer spares enough ink to criticize the boutique's interior as well as its furnishings, like many detractors he saves his hostility for the outside, that is, the façade. This sort of superficial physiognomic reading of architecture ignores the spatial dimension within and beyond the space created by the

designer and what it might suggest about the development of minimalist architecture and its relationship to consumption and display. As a method of ascertaining meaning through surfaces, a physiognomic reading, I suggest, is not dissimilar to the minimalist *geist* itself. Minimalist space and architecture allow for the brand's identity to be clearly articulated, ensuring the consumer-viewer is neither distracted nor dissuaded from the goal, that is, the purchase of a lifestyle. In the Madison Avenue boutique, boundaries are created, both perceived and material—between the store interior and the street outside as well as between the store itself and its historical surroundings. In his exploration of the multi-faceted notion of heterotopias, Michael Foucault states that they "always presuppose a system of opening and closing that both isolates them and makes them penetrable. In general, the heterotopic site is not freely accessible like a public place To get in one must have a certain permission and make certain gestures."[29] The solidity of the cream-colored repetitive panels of French limestone used for the store façade is counterposed with the purported transparency of the glass panels featured in the central portion of the building as well as the red brick of its surrounding neighbors. Thick white-colored scrims and paneled walls divide the outside from the inside, allowing some light to pour in, while generally obstructing the view from the street. The only visibility given to the pedestrian is through the central glass doors and the central portion of the first level. The walls blocking the view into the boutique on the ground level function as surfaces providing standardized and uncompromising spatial backdrops to the minimalist displays of mannequins featured in the windows. By way of the seemingly unintrusive minimalist architecture as well as the scrims and panels, the Armani boutique clearly sets itself apart from the neighborhood and outside world and is beholden only to its own rules, rituals and regulations. Shop minimalism, with its spare display of objects, is not unlike the minimalism of a modern art gallery; it stands to represent importance through the creation of an aura of the works inside as both original and exclusive, authentic and rare.

Within a minimalist landscape, as a sort of immediate experience, the embodied subject enters the rarefied realm of fashion and is impelled to create its own narrative, its own sensorial perceptions of the spaces of fashion. The minimalist "aesthetic of emptiness initially attracts the gaze of passers-by and, as the naked walls offer no further distraction, attracts them magnetically to the strategically placed goods."[30] Armani himself wrote of the importance of the space of the boutique and how it should be at once alluring and accessible for his customer:

> Furnishings must reflect the soul of the product, the brand, as well as create what I call a thousand and one complicities—the subtle temptations which lure a consumer into the store for a quick look. If he or she is then captivated by a friendly space, by easy-to-look-at displays and pleasant lighting, the store will be successful. It will be even more successful if the second element of atmosphere is there. I'm talking about the salespeople.[31]

Once inside the boutique, luxury, while restrained, is subtly perceived in the ebonized French wood floors which are partially covered with thick and soft custom-made gray or espresso woven linen carpets that help to mark out unique spaces of consumption, each suggesting its own narrative. The individual sales rooms, which flank either side of each floor's central sales areas, have walls of either French limestone, bleached cerused curly hickory or bleached anigre wood surfaces on which complete outfits are hung equidistant from each other. Not unlike the manner in which the critics viewed the design of the building, Armani invites his visitors to participate in a form of surface reading by way of the garments' tactile and irregular textiles set in relief against the neutral backdrop.

To celebrate the opening of this and a new Emporio Armani boutique a few blocks away also located on Madison Avenue, Armani planned a one-week trip to the American city. With numerous special events planned, the week was filled with interviews and parties, including a concert for 900 that featured musical entertainment by the Fugees, D'Angela, Eric Clapton, and the Wallflowers who were all received by an unusually glowing, happy, and dancing Armani. To acknowledge and thank Armani for his continued success and high sales, the top four department stores (Barney's, Bergdorf Goodman, Bloomingdales, Saks Fifth Avenue) featured specially merchandised Armani window displays when the designer was in town, "in what amounts to a rare simultaneous window dressing effort." When asked if the new mega-store on Madison would put a crimp in department store sales, one spokesperson from Saks believed there were enough Armani customers in or visiting the city to warrant more space devoted to the designer, claiming simply: "We all buy Armani differently."[32] The glowing accolades, however, quickly lead to controversy and confusion. In a now infamous interview with *New York Magazine*,[33] Armani declared "Fashion is finished for me, the diktat is finished." The declaration was taken up by the press around the world which reported that Armani had proclaimed the death of fashion; a declaration seemingly so controversial that it could only be rivalled by Friedrich Nietzsche's death of God and Roland Barthes's death of the author. In a follow-up interview with *The Sunday Telegraph*, Armani attempted damage control by asserting that "[t]his did not mean that I would stop designing. What it did mean," said the designer, "was an end to the changing fads of every season, which no longer made sense."[34] In part the confusion was a result of the media's insatiable desire to make headlines. However, it also suggested a new era for Armani, one in which his former right-hand Gabriella Forte was no longer there to speak on his behalf, having taken a position at his American rival Calvin Klein. As the *New York Times* made clear:

No one will ever speak for Mr. Armani again. Or insulate him. The GA who came last week and conquered New York was no a man in a tower. He was a man who wanted to meet Glenn Close, dance with Mira Sorvino and hug Winona Ryder. After years of reclusive power, Mr Armani wants to interact in the world he has worked so hard to create.[35]

While the two store openings were meant to clearly demonstrate Armani's staying power and retail prowess, the publicity and social events initiated by younger Armani aids was meant "to help overcome the perception that the house was out of touch."[36] The results were positive, showing a lighter, happier side of the designer and removing once and for all the definitive Forte stamp that all forms of communication, special events, and merchandising strategies possessed particularly in the US. "In the past," Armani said of her power, "when Gabriella was around, there was a filter. Gabriella would filter information or adopt ideas that came from people in the company as her own."[37] While Armani's own voice was becoming clearer it was also becoming more ferocious toward his competing compatriots. When on tour of the, by then three-year-old, Madison Avenue Barney's luxury emporium, Armani was less than pleased to find that his men's wear boutique shared the space of the complete first floor with Prada. Recognizing that he had fallen from the headlines and spotlight of late, a very annoyed Armani lashed out by attacking the press: "In the newspapers we read I'm not in fashion. No? Well, I'm very happy to be unfashionable when my clothes fly out the store. Fashion that people don't wear but gets exalted in the press doesn't interest me."[38] Armani was not alone in this sentiment, as Gene Pressman of Barney's pointed out: "There hasn't been a change since GA"; Armani has continued to dominate men's wear sales at this and other major retailers.[39]

Over a decade later, as a means to prove his dedication to the American market as well as his staying power and vision toward the future, Armani opened a new mega-store at the corner of Fifth Avenue at 56th Street in fall 2008 amid the worst recession since the 1930s (Figure 11.5). Dubbed the second Guggenheim by New York Mayor Bloomberg, entirely due to its overwhelming spiralling central staircase (Figure 11.6), the store designed by Maximillian and Doriana Fuskas offers all of Armani's lifestyle labels under one roof. Occupying the former Hugo Boss boutique, the 47,000-square-foot store was offered as a present to the designer himself as well as to the city of New York on the 25th anniversary of the creation of his subsidiary, American-based Giorgio Armani Corporation. The store is the crowning jewel of the company's three-year $100 million investment in expanding its US wholesale and retail operations. This risky move dispels the current conventional notion that established brands can no longer experience any substantial retail growth. The mammoth multi-brand boutique features the various Armani lifestyle fashion labels (Giorgio Armani, Emporio Armani, Armani Jeans, Junior and Armani/Casa) as well as a restaurant, sweet shop and beauty boutique. Dubbed "Armani World" by

11.5 Façade, Giorgio Armani boutique, Fifth Avenue, New York, opened in 2008

W magazine, according to the designer, the store is meant to be "flexible, open and eclectic."[40] Unique to this strategy of bringing together the various family members of the Armani brand under one roof is the creation of a harmonious integrated whole, rather than selling each label as a unique and separated entity as the house did throughout the 1980s and 1990s. "In 2000 with the opening of Armani/Via Manzoni in Milan," Armani stated, "we pioneered a new type of multi-faceted retail destination catering to the growing desire that I noticed among fashion and lifestyle consumers to be able to enjoy an all round experience when they go shopping."[41] This vertical diversification has allowed Armani to recreate his own department store, or conceptual epicentre. With its democratizing ethos, the store showcases the designer's prowess for designing lifestyle products for multi-segmented constituencies; the various Armani labels within a single brand is, in the twenty-first century, meant to suggest and market his diversity and mainstream appeal, spatially providing the incentive for customers to gradually upmarket over time. Part of this multi-brand experience is to engender greater access to fashion for a greater number of people. According to Armani:

> One of my guiding principles has always been a sense of democracy through my various collections. Armani/Fifth Avenue will be the retail essence of that sense of Armani democracy, as it will be a space in which customers at every

level will be welcomed and where they will feel at home. In many ways the spirit of this new store will reflect the way we increasingly see the world today: international, cosmopolitan, multi-cultural and above all contemporary.[42]

Against the backdrop of the urban stage and with a feeling of domestic comfort, the store allows the customer to consume all aspects of Armani's complex and layered lifestyle brand, while also providing new clients entry into this world by placing lower-priced goods alongside more exclusive items. The strategy seems financially astute, contemporary, and in keeping with the new fashion ethos of mixing high street and designer goods with low-priced, fast-fashion items. Armani's creation of a luxury object, now marketed to the masses, would never have been made possible had it not been for the co-founders' astute and controlled merchandising techniques in the early years of their house's history.

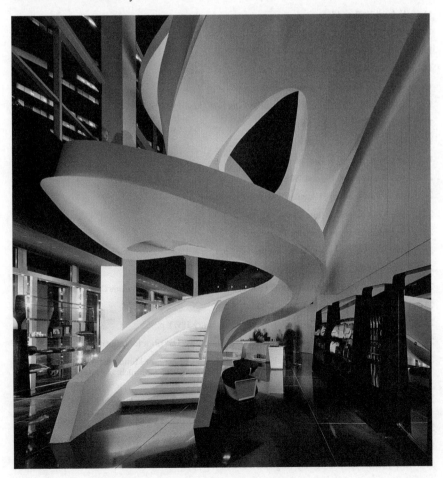

11.6 Interior view of the Giorgio Armani boutique, Fifth Avenue, New York

Notes

1 Daniela Morera, "Giorgio Armani," *Interview*, 7, 6, June 1977, pp. 26–7.

2 *New York Times*, 26 June 1986, p. A1.

3 *New York Times*, 11 December 1983, p. R1.

4 *Women's Wear Daily*, 23 September 1983, p. 4.

5 *New York Times*, 11 December 1983, p. R1.

6 By 1988 the New York boutique was generating $10 million in sales annually (*Women's Wear Daily*, 31 August 1988).

7 *New York Times*, 26 June 1986, p. A1.

8 The Armani camp only added fuel to the fire when the bouncers at Armani's Erreuno presentation roughed up her photographer son. *Women's Wear Daily*, 15 March 1984, p. 27.

9 *Women's Wear Daily*, 15 March 1984, p. 27.

10 *Women's Wear Daily*, 8 October 1984, p. 2.

11 *W*, April 1987, p. 18.

12 *Los Angeles Times*, 12 June 1997, p. 2.

13 *Women's Wear Daily*, 27 September 1985, p. 2.

14 *Women's Wear Daily*, 30 June 1989, p. 2.

15 *Los Angeles Times*, 30 November 1990, p. 1.

16 Ben Brantley, "The Armani Mystique," *Vanity Fair*, (June 1988), p. 130.

17 *Los Angeles Times*, 25 January 1988, p. 1.

18 *New York Times*, 24 December 1987, p. C1.

19 *Daily News Record*, 31 August 1988, p. 2.

20 *Daily News Record*, 19 June 1989, p. 42.

21 *Women's Wear Daily*, 31 August 1988, p. 1.

22 *Daily News Record*, 19 June 1989, p. 42.

23 *Los Angeles Times*, 17 February 1989, p. 9.

24 *Wall Street Journal Europe*, 15 September 1999, p. 1.

25 *Daily News Record*, 15 April 1993, p. 2.

26 Translation author's, "Boutiques de Luxe et de Mode," *Architecture Interieure Crée*, 275 (1997), p. 107.

27 *New York Times*, 19 March 1995, p. CY6.

28 Ned Cramer, "Fashion Victim," *Architecture*, (February 1997), p. 45.

29 Michel Foucault, "Of Other Spaces," with Jay Miskowiec, *Diacritics* 16, 1 (Spring 1986), p. 26.

30 Ilka and Andreas Ruby, "Essential, Meta-, Trans-, The Chimeras of Minimalist Architecture," in Ilka Ruby, Andreas Ruby and Angeli Sachs, *Minimal Architecture*, Munich, New York, Berlin and London: Prestel, 2003, pp. 21–2.

31 Giorgio Armani, "Foreword," in Grant Camden Kirkpatrick, *Shops and Boutique*, New York: Pbc Intl., 1994, p. 9.

32 *Daily News Record*, 20 August 1996, p. 2.

33 *New York Magazine*, 16 September 1996, p. 32.

34 Hilary Alexander, *The Sunday Telegraph*, 9 March 1997, p. 5

35 *New York Times*, 17 September 1996, p. B7.

36 *New York Times*, 17 September 1996, p. B7.

37 *New York Times*, 17 September 1996, p. B7.

38 *W*, November 1996, p. 280.

39 *New York Times*, 19 November 1996, p. B7.

40 *W*, August 2007, p. 74.

41 Armani Press Release, 31 May 2007.

42 Armani Press Release, 31 May 2007.

Bibliography

Abler, Ronald, *The Social Impact of the Telephone*, Cambridge, Mass: MIT Press, 1977.

Abler, Ronald, "What Makes Cities Important," *Bell Telephone Magazine* 49, 2 (March–April 1970): pp. 10–15.

Adburgham, Alison, *Liberty's: A Biography of a Shop*, London: Allen, 1975.

_____, *Shops and Shopping*, London: Allen, 1964.

Ades, Dawn, ed. *The Twentieth-Century Poster: Design of the Avant-Garde*, New York: Abbeville Press, 1996.

Adorno, Theodor W., *Aesthetic Theory*, trans. Robert Hullot-Kentor, New York and London: Continuum, 2004.

_____, and Max Horkheimer, "Das Schema der Massenkultur," 1942, in Theodor Adorno, *Gesammelte Schriften* III, 332–5, Frankfurt am Main: Suhrkamp, 1981.

Armi, C. Edson, *The Art of American Car Design: The Profession and Personalities: "Not Simple Like Simon,"* University Park: The Pennsylvania State University Press, 1988.

Ashmore, Sonia, "Liberty's Orient: Taste and Trade in the Decorative Arts in Late Victorian and Edwardian Britain: 1875–1914," Ph.D. diss., Open University, 2001.

Attfield, Judith, *Wild Things: The Material Culture of Everyday Life*, Oxford: Berg, 2000.

Auerbach, Jeffrey, *The Great Exhibition of 1851: A Nation on Display*, Yale University Press: New Haven and London, 1999.

Bachelard, Gaston, *The Poetics of Space*, New York: Orion Press, 1964.

Banham, Reyner, *Los Angeles: the Architecture of Four Ecologies*, New York: Harper & Row, 1971.

Banner, Lois, *American Beauty*, New York: Alfred A. Knopf, 1983.

Barthes, Roland, *Mythologies*, trans. Annette Lavers, New York: Farrar, Starus and Giroux, 1972.

Baudelaire, Charles, "The Painter of Modern Life," in Jonathan Mayne, ed., *The Painter of Modern Life and Other Essays*, London: Phaidon, 1995.

Baudrillard, Jean, *The Consumer Society: Myths and Structures*, trans. Chris Turner, London, Thousand Oaks, New Delhi: Sage Publications, 1998.

Beck, Ken, Jim Clark and Les Kerr, *The All American Truck Stop Cookbook*, Nashville: Routledge Hill Press, 2002.

Behne, Adolf, "Alte und neue Plakate," in *Das Politische Plakat*, Charlottenburg: Verlag "Das Plakat," 1919.

Benezra, Neal and Kerry Brougher, eds, *Ed Ruscha*, Washington, DC: Hirshhorn Museum and Sculpture Garden and Oxford: Museum of Art, 2000.

Benjamin, Walter, *The Arcades Project*, trans. Howard Eiland and Kevin McLauchlin, Cambridge, Mass. & London: Belknap Press of Harvard University, 1999.

Bennett, Tony, "The Exhibitionary Complex," *New Formations* 4 (1988): pp. 73–102.

Benson, Lee, "Historical Background of Turner's Frontier Essay," in *Turner and Beard: American Historical Writing Reconsidered*, Glencoe, Ill.: Free Press, 1960, pp. 41–91.

Benson, Susan, *Counter Cultures: Saleswomen, Managers, and Customers in American Department Stores, 1890–1940*, Chicago and Urbana: University of Illinois Press, 1987.

Berger, Michael L., *The Automobile in American History and Culture: A Reference Guide*, Westport, Connecticut: Greenwood Press, 2001.

Bernstein, Alison R., *American Indians and World War II: Toward a New Era in Indian Affairs*, Norman: University of Oklahoma Press, 1991.

Bertoni, Franco, *Claudio Silvestrin*, Basel, Boston, and Berlin: Birkhausen. 1999.

Betsky, Aaron, "Minimalism: Design's Disappearing Act," *Architecture* 86, 2 (February 1997): pp. 47–51.

Betts, Paul, *The Authority of Everyday Objects: A Cultural History of German Industrial Design*, Berkeley and Los Angeles: University of California Press, 2004.

Bingham, Neil, *The New Boutique: Fashion and Design*, London and New York: Merrell, 2005.

Bluestone, Daniel, M., *Constructing Chicago*, New Haven, Conn.: Yale University Press, 1991.

Bogart, Michele H., *Artists, Advertising, and the Borders of Art*, Chicago and London: University of Chicago Press, 1995.

Bongie, Chris, *Exotic Memories: Literature, Colonialism, and the Fin de Siècle*, Stanford: Stanford University Press, 1991.

Bourdieu, Pierre, *Distinction: A Social Critique of the Judgment of Taste*, trans. R. Nice, London: Routledge, 1984.

Bowman, LeRoy, *The American Funeral: A Study in Guilt, Extravagance, and Sublimity*, Westport, CT: Greenwood, 1959.

Bowlby, Rachel, *Just Looking: Consumer Culture in Dreiser, Gissing and Zola*, New York and London: Methuen, 1985.

Brantley, Ben, "The Armani Mystique," *Vanity Fair* (June 1988): pp. 126–30, 170–3.

Bronner, Simon, *Consuming Visions: Accumulations and Display of Goods in America 1880–1920*, New York: Norton, 1989.

Brooks, John, *Telephone: The First Hundred Years*, New York: Harper and Row, 1976.

Brown, Bill, *A Sense of Things: The Object Matter of American Literature*, Chicago: University of Chicago Press, 2004.

Bruegmann, Robert, *The Architects and the City: Holabird & Roche of Chicago, 1880–1918*, Chicago: University of Chicago Press, 1997.

Buckley, James David, *The Drama of Display: Visual Merchandising and its Techniques*, New York: Pelligrini & Cudahy, 1953.

Burke, Gene and Edgar Kober, *Modern Store Design*, Los Angeles: Institute of Product Research, 1945.

Campbell, Joan, *The German Werkbund: The Politics of Reform in the Applied Arts*, Princeton, NJ: Princeton University Press, 1978.

Carey, James W., *Communication as Culture: Essays on Media and Society*, Boston: Unwin Hyman, 1989.

Casey, Robert, *The Model T: A Centennial History*, Baltimore: Johns Hopkins University Press, 2008.

Celant, Germano and Harold Koda, *Giorgio Armani: A Retrospective*, New York: The Solomon Guggenheim Museum Foundation, 2000.

Cheang, Sarah, "Dragons in the Drawing Room: Chinese Embroideries in British Homes, 1860–1949," *Textile History* 39, 2 (November 2008): pp. 223–49.

_____, "Chinese Robes in Western Interiors: Transitionality and Transformation," in Alla Myzelev and John Potvin, eds, *Fashion, Interior Design and the Contours of Modern Identity*, Surrey, UK: Ashgate, 2010: pp. 125–46.

Clarke, David B., Marcus A. Doel and Kate M.L. Housiaux, *The Consumption Reader*, London and New York: Routledge, 2003.

Cliff, Stafford, *50 Trade Secrets of Great Design Retail Spaces*, Gloucester, Mass: Rockport Publishers, 1999.

Clifford, James, *The Predicament of Culture: Twentieth-Century Ethnography, Literature, and Art*, Cambridge, Mass.: Harvard University Press, 1988.

Cohen, Jeffrey E., "The Telephone Problem and the Road to Telephone Regulation in the United States, 1876–1917," *Journal of Policy History* 3, 1 (1991): pp. 42–69.

Cohen, Lizabeth, "Is there an Urban History of Consumption?" *Journal of Urban History* 29 (2003): pp. 87–106.

Connell, R.W., *Masculinities*, Berkeley: University of California Press, 1995.

Connelly, Frances. *The Sleep of Reason: Primitivism in Modern European Art and Aesthetics, 1725–1907*, University Park: The University of Pennsylvania Press, 1995.

Cooke, Lynne and Peter Wollen, *Visual Display, Culture Beyond Appearances*, New York: Dia Center for the Arts, 1995.

Cowan, Ruth Schwartz, "The Consumption Junction: A Proposal for Research Strategies in the Sociology of Technology," in Wiebe E. Bijker, Thomas P. Hughes and Trevor J. Pinch, eds, *The Social Construction of Technological Systems: New Directions in the Sociology and History of Technology*, Cambridge, Mass: MIT Press, 1987, 261–80.

Cowee, Howard M. et al., *The Pilot Study of Display*, New York: National Association of Display Industries, Prentice Hall, 1949.

Cox, Nancy, *The Complete Tradesman: A Study of Retailing, 1550–1820*, Aldershot, UK and Burlington: Ashgate, 2000.

Cramer, Ned, "Fashion Victim," *Architecture* (February 1997): p. 45.

Cross, Gary, *An All-Consuming Century: Why Commercialism Won in Modern America*, New York: Columbia University Press, 2000.

Crossick, Gregory and Serge Jaumain, eds, *Cathedrals of Consumption: The European Department Story, 1850–1939*, Aldershot, UK: Ashgate, 1999.

Culver, Stuart, "What Manikins Want: The Wonderful Wizard of Oz and the Art of Decorating Dr Goods Windows," *Representations* 21 (Winter 1988): pp. 97–116.

Czitrom, Daniel J., *Media and the American Mind: From Morse to McLuhan*, Chapel Hill: University of North Carolina Press, 1983.

Dahlgren, Anna, "The Art of Display," *Konsthistorisk tidskrift/ Journal of Art History* 79: 3, (2010): pp. 160–73.

Davis, Kingsley, "The Urbanization of the Human Population," *Scientific American* 213, 3 (September 1965): pp. 40–53.

d'Aulaire, Emily and Per Ola d'Aulaire, "Mannequins: Our Fantasy Figures of High Fashion," *Smithsonian Magazine* 22, 1, (April 1991): pp. 66–77.

Deloria, Ella, *Speaking of Indians*, New York: Friendship Press, Inc., 1944.

Deloria, Philip J., *Playing Indian*, New Haven: Yale University Press, 1998.

de Wit, Leontine and David Vernet, eds, *Boutiques and Other Retail Spaces: The Architecture of Seduction*, London: Routledge, 2007.

Domash, Mona, "Shaping the Commercial City: Retail Districts in Nineteenth-Century New York," *Annals of the Association of American Geographers*, 80, 2 (June 1990): pp. 268–84.

Dominguez, Henry L., *The Ford Agency: A Pictorial History*, Osceola, Wisc: Motorbooks International, 1981.

Duncan, Hugh Dalziel, *Culture and Democracy: The Struggle for From in Society and Architecture in Chicago and the Middle West during the Life and Times of Louis H. Sullivan*, Totowa, NJ: Bedminster Press, 1965.

Dunlap, David W., "Street of Automotive Dreams," *New York Times*, (July 7, 2000): p. 35.

Eco, Umberto, "The Structure of Bad Taste," *The Open Work*, trans. Anna Cancogni, Cambridge, Mass.: Harvard University Press, 1989.

Elvins, Sarah, *Sales & Celebrations: Retailing & Regional Identity in Western New York State, 1920–1940*, Athens: Ohio University Press, 2004.

Epstein, Ralph C., *The Automobile Industry: Its Economic and Commercial Development*, Chicago: A.W. Shaw & Company, 1928.

Eskilson, Stephan, *Graphic Design: A New History*, New Haven and London: Yale University Press, 2007.

Farrell, James, *Inventing the American Way of Death, 1830–1920*, Philadelphia: Temple University Press, 1980.

Faultisch, Werner, *Medienwandel in Industrie- und Massenzeitalter (1830–1900)*, Göttingen: Vandenhoeck & Ruprecht, 2004.

Feigenbaum, Eric, "The 1940s: Guadalcanal to Levittown," *VMSD*, 11 July 2001, Web.
_____, "The 1930s: Fashion, Art and Hollywood," *VMSD*, 3 May 2001, Web.

Fischer, Claude S., *America Calling: A Social History of the Telephone to 1940*, Berkeley: University of California Press, 1992.

Forbes, Bruce David and Jeffrey H. Mahan, eds, *Religion and Popular Culture in America*, Berkeley and Los Angeles: University of California Press, 2005.

Foucault, Michel, "Of Other Spaces," with Jay Miskowiec, *Diacritics* 16, 1 (Spring 1986): pp. 22–7.
_____, "Space, Knowledge, and Power," in Paul Rabinow, ed., *The Foucault Reader*, New York: Pantheon, 1984.

Fowler, Elizabeth M., "Mannequins Limn Mores; Mannequins a Reflection of Mores," *New York Times* (22 Feb 1970): p. 11

Fox, Richard Wightman and T.J. Jackson Lears, eds, *The Culture of Consumption: Critical Essays in American History, 1880–1980*, New York: Pantheon, 1983.

Frank, Hilmar, "Arabesque, Cipher, Hieroglyph: Between Unending Interpretation and Loss of Meaning," trans. David Britt in *The Romantic Spirit in German Art, 1790–1990*, eds, Keith Hartley, Henry Meyric Hughes, Peter-Klaus Schuster, and William Vaughan, Stuttgart: Oktagon Verlag, 1994: pp. 146–54.

Frankl, Paul, *New Dimensions: the Decorative Arts of Today in Words & Pictures*, New York: Brewer & Warren, 1928.

Friedberg, Anne, *Window Shopping: Cinema and the Invention of Modern Life*, Berkeley: University of California Press, 1994.

Gaba, Lester, *The Art of Window Display*, New York: Studio Publications, 1952.

Gagel, Hannah, "Studien zur Motivgeschichte des deutschen Plakats, 1900–14," Ph.D. diss., Freie Universität: Berlin, 1971.

Ganser, Alexandra, "On the Asphalt Frontier: American Women's Road Narratives, Spatiality and Transgression," *Journal of International Women's Studies* 7 (2006): pp. 153–67.

Garreau, Joel, *Edge City, Life on the New Frontier*, NY: Doubleday, 1988.

Gartman, David, *Auto Opium, A Social History of American Automotive Design*, New York: Routledge, 1994.
_____, "Three Ages of the Automobile: The Cultural Logics of the Car," *Theory Culture Society* 21, 4/5 (2004): pp. 169–95.

Genat, Robert, *The American Car Dealership*, Osceola, Wisc.: MBI Publishing Company, 1999.

Giedion, Sigfried, *Space, Time and Architecture: The Growth of a New Tradition*, Cambridge: Harvard University Press, 1941.

Goddard, Stephen B., *Getting There: The Early Struggle Between Road and Rail in the American Century*, Chicago: University of Chicago Press, 1996.

Goffman, Irving, *The Presentation of Self in Everyday Life*, Garden City, NY: Doubleday Anchor Books, 1959.

Gomery, Douglas, *Shared Pleasures: A History of Movie Presentation in the United States*, Madison, Wisc.: University of Wisconsin Press, 1992.

_____, "The Movie Palace Comes to America's Cities," in Richard Butsch, ed., *For Fun and Profit: The Transformation of Leisure into Consumption*, Philadelphia: Temple University Press, 1990: pp. 136–51.

Goodman, Michael K., David Goodman and Michael Redclift, eds, *Consuming Space: Placing Consumption in Perspective*, Aldershot, UK and Burlington: Ashgate, 2010.

Goulet, Anne Laure, "Boutiques de Luxe et de Mode," *Architecture Intérieure Crée*, 275 (1997): pp. 106–23.

Griese, Noel L., "AT&T: 1908 Origins of the Nation's Oldest Continuous Institutional Advertising Campaign," *Journal of Advertising* 6 (Summer 1977): pp. 18–24.

Growald, Ernst, *Der Plakat-Spiegel. Erfahrungssätze für Plakat-Künstler und Besteller*, Berlin: Kampffmeyer'scher Zeitungs-Verlag Salomon, 1904.

Gruenberg, Christoph and Max Hollein, eds, *Shopping, A Century of Art and Consumer Culture*, Ostfildern-Ruit: Hatje Canz, 2003.

Habenstein, Robert and William Lamers, *The History of American Funeral Directing*, Milwaukee: Bulfin Printers, 1955.

Hall Stuart, ed., *Representations: Cultural Representations and Signifying Practices*, London: Sage, 2007.

Hale, Marsha Bentley, "From Plaster to Fiberglass, Body Attitudes of Mannequins Part VIII," *Fashionwindows.com*, 8 August 1999. Web.

Hansen, Miriam, "Mass Culture as Hieroglyphic Writing: Adorno, Kracauer, Derrida," *New German Critique* 56 (Spring-Summer, 1992): pp. 43–73.

_____, *Babel & Babylon: Spectatorship in American Silent Film*, Cambridge, Mass: Harvard University Press, 1991.

Harris, Neil, *Cultural Excursions: Marketing Appetites and Cultural Tastes in Modern America*, Chicago: University of Chicago, Press, 1990.

Harris, Stefanie, *Mediating Modernity: German Literature and the "New" Media, 1895–1930*, University Park, PA: Pennsylvania State University Press, 2009.

Harris, Walter W., *Pontiac Mascots, Hood Ornaments, Trademarks*, Toledo, Ohio: Walter R. Harris, 2000, 2nd ed. 2005.

Hayden Dolores, *A Field Guide to Sprawl*, New York: W.W. Norton & Company, 2004.

Hebdige Dick, *Subculture and the Meaning of Style*, London: Routledge, 1979.

Hellwag, Fritz, "Bernhard," *Das Plakat* 7, 1 (1916): pp. 2–15.

Herdeg, Walter, *International Window Display*, New York: Pellegrini and Cudahy, 1951.

Hevia, James, *English Lessons: The Pedagogy of Imperialism in Nineteenth-Century China*, Durham NC: Duke University Press, 2003.

_____, "Loot's Fate: The Economy of Plunder and the Moral Life of Objects 'From the Summer Palace of the Emperor of China,'" *History and Anthropology* 6, 4 (1994): pp. 319–45.

Hewitt, Charles M., *The Development of Automobile Franchises*, Bloomington: University of Illinois Press, 1960.

Hewitt, John, "*The Poster* and the Poster in England in the 1890s," *Victorian Periodicals Review* 35, 1 (Spring 2002): pp. 37–62.

Hine, Thomas, *Populuxe*, New York: Alfred A. Knopf, 1986.

Hower, Ralph, M., "Urban Retailing 100 Years Ago," *Bulletin of the Business Historical Society* 12, 6 (Dec. 1938): pp. 91–101.

Ireland, Brian, "American Highways: Recurring Images and Themes of the Road Genre," *Journal of America Culture* 26 (2003): pp. 474–84.

Jackson, John Brinckerhoff, *A Sense of Place, a Sense of Time*, New Haven: Yale University Press, 1996.

Jackson, Peter, *John Tallis's London Street Views, 1838–1840*, London: Nattali & Maurice, 1969.

_____, Michelle Lowe, Daniel Miller and Frank Mort, eds, *Commercial Cultures: Economics, Practices, Spaces*, Oxford: Berg, 2000.

Jakle, John A., "The American Gasoline Station, 1920–1970," *Journal of American Culture* 1 (Spring 1978): pp. 520–42.

James, Pearl, ed., *Picture This: World War I Posters and Visual Culture*, Lincoln and London: University of Nebraska Press, 2009.

Jay, Robert, *The Trade Card in Nineteenth-Century America*, Columbia, Missouri: University of Missouri Press, 1987.

Kaspar, Karl, *Shops and Showrooms: An International Survey*, New York: Frederick A. Praeger, 1967.

Keats, John, *The Insolent Chariot*, Philadelphia: Lippincott, 1958.

Kellerman, Aharon, *Telecommunications and Geography*, London: Belhaven Press, 1993.

Kerfoot, Shona, Barry Davies and Philippa Ward, "Visual Merchandising and the Creation of Discernible Retail Brands, *International Journal of Retail and Distribution Management* 31, 3 (2003): pp. 143–52.

Kerouac, Jack, *On the Road*, New York: Viking, 1957.

Ketelle, Jay, *The American Automobile Dealership: A Picture Postcard History*, Amarillo, Texas: Jay Ketelle Collectables, Inc., [1980].

Kiesler, Frederick, *Contemporary Art Applied to the Store and its Display*, New York: Brentanos, 1930.

Kinchin, Juliet, "Interiors: Nineteenth-Century Essays on the 'Masculine' and the 'Feminine' Room," in Pat Kirkham, ed., *The Gendered Object*, Manchester: Manchester University Press, 1996: pp. 12–29.

King, C. Richard and Charles Fruehling Springwood, *Team Spirits: the Native American Mascots Controversy*, Lincoln: University of Nebraska Press, 2003.

Kirkpatrick, Grant Camden, *Shops and Boutique*, (Forward by Giorgio Armani), New York: Rizzoli International Relations, 1994.

Kittler, Friedrich, *Discourse Networks 1800/1900*, trans. Michael Metteer, with Chris Cullens, Stanford, CA: Stanford University Press, 1990.

Klinger, Julius, "Plakate und Inserate," *Jahrbuch des Deutschen Werkbundes. Die Kunst in Industrie und Handel* (1913): pp. 110–12.

Kouwenhoven, John A., *The Columbia Historical Portrait of New York*, New York: Harper & Row, 1972.

Kunstler, James H., *The Geography of Nowhere*, New York: Simon & Schuster, 1993.

Kriegel, Lara, "Narrating the Subcontinent in 1851: India at the Crystal Palace," in Louise Purbrick, ed., *The Great Exhibition of 1851: New Interdisciplinary Essays*, Manchester: Manchester University Press, 2001: pp. 146–78.

Laderman, Gary, *Rest in Peace: A Cultural History of Death and the Funeral Home in Twentieth-Century America*, Oxford and New York: Oxford University Press, 2005.

Laird, Pamela Walker, *Advertising Progress: American Business and the Rise of Consumer Marketing*, Baltimore, Md.: Johns Hopkins University Press, 1998.

Lalvani, Suren, "Consuming the Exotic Other," *Critical Studies in Mass Communications* 12, 3 (1995): pp. 263–86.

Lambert, Richard, *The Universal Provider: A Study of William Whiteley and the Rise of the London Department Store*, London: G.G. Harrap & Co., 1938.

Lamm, Michael, "The Beginning of Modern Auto Design," *The Journal of Decorative and Propaganda Arts* 15 (Winter–Spring, 1990): pp. 60–77.

Lancaster, Bill, *The Department Store: A Social History*, Leicester: Leicester University Press, 1995.

Leach, William, *Land of Desire: Merchants, Power, and the Rise of a New American Culture*, New York: Vintage, 1993.

Lerner, Paul, "An All-Consuming History: Recent Works on Consumer Culture in Modern Germany," *Central European History* 42 (2009): pp. 509–43.

Lewis, Reina, *Gendering Orientalism: Race, Femininity and Representation*, London: Routledge, 1996.

Liebs, Chester, *From Main Street to Miracle Mile*, Boston: Little Brown, 1985, reprint 1995.

Loewy, Raymond, *Industrial Design*, Woodstock, NY: Overlook Press, 1979.

Longstreth, Richard, *City Center to Regional Mall: Architecture, the Automobile, and Retailing in Los Angeles, 1920–1950*, Cambridge, Mass: MIT Press, 1998.

_____, *The American Department Store Transformed 1920–1960*, New Haven: Yale University Press, 2009.

MacDowell, Betty, "Religion on the Road: Highway Evangelism and Worship Environments for the Traveler in America," *Journal of American Culture* 5 (1982): pp. 63–73.

Manvelli, Sara, *Design for Shopping: New Retail Interiors*, London: Lawrence King Publishing, 2006.

Marchand, Roland, *Advertising and the American Dream: Making Way for Modernity, 1920–1940*, Berkeley: University of California Press, 1985.

Marcus, Leonard A., *The American Store Window*, New York and London: Architectural Press, 1978.

May, George S., "Marketing," in *The Automobile Industry, 1896–1920*, ed. George S. May, New York: Facts on File, 1990: pp. 315–8.

Mitford, Jessica, *The American Way of Death*, New York: Simon and Schuster, 1963.

Marling, Karal Ann, *As Seen on TV: The Visual Culture of Everyday Life in the 1950s*, Cambridge, Mass: Harvard University Press, 1994.

Marvin, Carolyn, *When Old Technologies Were New: Thinking About Communication Technologies in the Late Nineteenth Century*, New York: Oxford University Press, 1988.

McCall, Walter, *American Funeral Vehicles 1880–2003: An Illustrated History*, Hudson, WI: Iconografix, 2003.

McClintock, Anne, *Imperial Leather: Race, Gender and Sexuality in the Colonial Conquest*, London: Routledge, 1995.

McCracken, Grant, *Culture and Consumption: New Approaches to the Symbolic Character of Consumer Goods and Activities*, Bloomington: Indiana University Press, 1988.

_____, *Culture and Consumption II: Markets, Meaning, and Brand Management*, Bloomington: Indiana University Press, 2005.

McPhee, John, *Uncommon Carriers*, New York: Farrar, Straus and Giroux, 2006.

Meyer, James, ed. *Minimalism*, London: Phaidon, 2000.

Miller, Daniel, ed. *Acknowledging Consumption: A Review of New Studies*, London: Routledge, 1995.

Monkkonen, Eric H., *America Becomes Urban: The Development of US Cities and Towns, 1780–1980*, Berkeley: University of California Press, 1988.

Mostadi, Arian, *Hotshops*, Barcelona: Carlos Broto and Joseph M. Minguet, 2003.

Tony Morgan, *Visual Merchandising: Windows and In-Store Displays for Retail*, London: Laurence King, 2008.

Mueller, Milton L., *Universal Service: Competition, Interconnection, and Monopoly in the Making of the American Telephone System*, Cambridge, Mass: MIT Press, 1997.

Mullikin, Thomas S., *Truck Stop Politics: Understanding the Emerging Force of Working Class America*, Charlotte, NC: Vox Populi Publishers, 2006.

National Dry Goods Retail Association, *Display Manual*, New York: National Dry Goods Retail Association, 1951.

Nava, Mica, *Visceral Cosmopolitanism: Gender, Culture and Normalisation of Difference*, Oxford: Berg, 2007.

_____, "Modernity's Disavowal: Women, the City and the Department Store," in Pasi Falk & Colin Campbell, eds, *The Shopping Experience*, Sage: London, 1977, pp. 56–91.

Nicholson, Emrich, *Contemporary Shops in the United States*, New York: Architectural Book Publishing Co., 1948.

Norberg-Shulz, Christian, *Intentions in Architecture*, Cambridge, Mass: The MIT Press, 1965.

O'Brien, Anne and Warner Olivier, "The Lady in the Window," *Saturday Evening Post*, (20 July 1946): pp. 26–7, 85–6.

Okochi, Akio and Koichi Shimokawa, *Development of Mass Marketing: The Automobile and Retailing Industries: Proceedings of the Fuji Conference, International Conference on Business History*, 7, Tokyo: University of Toyko Press, 1981.

Olalquiaga, Celeste, *Megalopolus, Contemporary Cultural Sensibilities*, Minneapolis: University of Minnesota Press, 1992.

Oldenziel, Ruth, Adri Albert de la Bruhèze, and Onno de Wit, "Europe's Mediation Junction: Technology and Consumer Society in the 20th Century," *History and Technology* 21, 1 (March 2005): pp. 107–39.

O'Malley, Christine, "The 'Design Decade' and Beyond: American Industrial Designers and the Evolution of the Consumer Landscape from the 1930s to the 1950s," Ph.D. diss., University of Virginia, 2002.

Oswald, Laura, "The Space and Place of Consumption in a Material World," *Design Issues* 12, 1 (Spring 1996): pp. 48–62.

Packard, Vance, *The Hidden Persuaders*, New York: Ig Publishing, 1957, reprint 2007.

Panofsky Edwin, "The Ideological Antecedents for the Rolls-Royce Radiator," 1937, in *Three Essays on Style*, ed. Irving Lavin, Cambridge, Mass: MIT Press, 1997, pp. 127–64.

Parezo, Nancy J., "The Indian Fashion Show," in Ruth B. Philips and Christopher B Steiner (eds), *Unpacking Culture, Art and Commodity in Colonial and Postcolonial Worlds*, Berkeley: University of California Press, 1999: pp. 243–63.

Parker, Ken W., "Sign Consumption in the 19th-Century Department Store: An Examination of Visual Merchandising in the Grand Emporiums (1846–1900)," *Journal of Sociology* 39 (2003): pp. 353–71.

Parnes, Louis, *Planning Stores That Pay*, New York: F.W. Dodge, 1948.

Parrot, Nicole, *Mannequins*, New York: St. Martin's Press, 1982.

Patti, Charles H. and Edwina Luck, "Marketplace Forces and the History of Retailing: The Cycle of Control," in *The European Institute of Retailing and Services Studies (EIRASS) Conference on Recent Advances in Retailing and Services Science Conference*, July 2004, Prague. (Unpublished): pp. 1–16. Web.

Pavitt, Jane, ed. *Brand New*, London: V&A Publications, 2000.

Pegler, Martin, *Visual Merchandising and Display: The Business of Presentation*, New York: Fairchild Publications, 1983, 6th ed. 2011.

Peirce, Charles Sanders, "Of Reasoning in General," 1894, in The Peirce Edition
 Project, ed., *The Essential Peirce: Selected Philosophical Writings, 1893–1913*, vol. 2,
 Bloomington: University of Indiana Press, 1998: pp. 13–28.
Pine, Vanderlyn, *Caretaker of the Dead: The American Funeral Director*, New York:
 Irvington, 1975.
Pool, Ithelia de Sola, ed. *The Social Impact of the Telephone*, Cambridge, Mass: MIT
 Press, 1977.
Potvin, John, *Giorgio Armani: Empire of the Senses*, Aldershot, UK and Burlington:
 Ashgate, 2012.
_____, ed. *The Places and Spaces of Fashion, 1800–2007*, New York and London:
 Routledge, 2009.
_____, and Alla Myzelev, eds, *Fashion, Interior Design and the Contours of Modern
 Identity*, Aldershot, UK and Burlington: Ashgate, 2010.
Pred, Allan R., *Urban Growth and the Circulation of Information; The United States System
 of Cities, 1790–1840*, Cambridge, MA: Harvard University Press, 1974.
Primeau, Ronald, *Romance of the Road: The Literature of the American Highway*, Bowling
 Green: Bowling Green State University Popular Press, 1996.
Quinn, Bradley, *The Fashion of Architecture*, Oxford and New York: Berg, 2003.
Raizman, David, *History of Modern Design*, Upper Saddle River, NJ: Pearson Prentice
 Hall, 2011.
Rappaport, Erica, *Shopping for Pleasure: Women in the Making of London's West End*,
 New Haven and London: Princeton University Press, 2000.
Reinhart, Dirk, *Von der Reklame zum Marketing. Geschichte der Wirtschaftswerbung in
 Deutschland*, Berlin: Akademie Verlag, 1993.
Reuveni, Gideon, *Reading Germany: Literature and Consumer Culture in Germany before
 1933*, trans. Ruth Morris, Oxford, U.K., and New York: Berghahn Books, 2006.
Richert, G. Henry, *Retailing: Principles and Practices of Retail Buying, Advertising, Selling
 and Management*, New York: Gregg Publishing, 1938.
Rickards, Maurice, *Posters of the First World War*, New York: Walker and Company, 1968.
Riedel, Hubert, ed. *Lucian Bernhard. Werbung und Design im Aufbruch des 20.
 Jahrhunderts*, Berlin: Institut für Auslandsbeziehungen, 1999.
Riewoldt, Otto, *Retail Design*, London: Laurence King Publishing, 2000.
Roberts, Phil, *The perfect spot: Iowa 80's journey from Iowa cornfield to the world's largest
 truck stop, 40th Anniversary, Iowa 80 truck stop, 1964–2004*, Walcott, Iowa: Iowa 80
 Group, 2004.
Ruby, Ilka, Andreas Ruby and Angeli Sachs, *Minimal Architecture*, Munich, New York,
 Berlin and London: Prestel, 2003.
Ruscha, Edward, *Twentysix Gasoline Stations*, Los Angeles: Edward Ruscha, 1963.
Rushing, W. Jackson, *Native American Art and the New York Avant-Garde, A History of
 Cultural Primitivism*, Austin: University of Texas Press, 1995.
Said, Edward, *Orientalism: Western Conceptions of the Orient*, London: Vintage, 1978.
Sandoval-Strausz, A.K., "Spaces of Commerce: A Historiographic Introduction
 to Certain Architectures of Capitalism," *Winterthur Portfolio* 44, 2/3 (Summer/
 Autumn, 2010): pp. 143–58.
Schmidt, Leigh Eric, "The Commercialization of the Calendar: American Holidays
 and the Culture of Consumption, 1870–1930," *Journal of American History* 78, 3
 (December 1991): pp. 887–916.
Schneider, Sara K., *Vital Mummies: Performance Design for the Show-Window Mannequin*,
 New Haven and London: Yale University Press, 1995.
Schwartz, Frederic J., *The Werkbund: Design Theory and Mass Culture before the First
 World War*, New Haven and London: Yale University Press, 1996.

Schumacher, Fritz, "Form Follows Fetish: Adolf Behne and the Problem of *Sachlichkeit*," *Oxford Art Journal* 21, 2 (1998): pp. 47–77.

Seelig, Thomas, Urs Stahel and Martin Jaeggi, eds, *Trade: Commodities, Communication and Consciousness*, Zurich: Scalo, 2001.

Selket, Kyro, "Bring Home the Dead: Purity and Filth in Contemporary Funeral Homes," in Ben Campin and Rosie Cox, eds, *Dirt: New Geographies of Cleanliness and Contamination*, London and New York: I.B. Tauris & Co Ltd, 2007.

Serrats, Marta, *New Shops and Boutiques*, New York: Harper Design, 2004.

Sharp, Homer, *Visual Merchandising and Store Design* 125, 4 (1994): pp. 16–21.

Sheller, Mimi and John Urry, "The City and the Car," *International Journal of Urban and Regional Research* 24, 4 (Dec, 2000): pp. 737–57.

Shi, David, *The Simple Life: Plain Living and High Thinking in American Culture*, Oxford, UK and New York: Oxford University Press, 1985.

Shields, Rob, ed. *Lifestyle Shopping: The Subject of Consumption*, London and New York: Routledge, 1992.

Simmel, Georg, "Die Großstädte und das Geistesleben", *Jahrbuch der Gehe-Stiftung zu Dresden 9. Die Großstadt. Vorträge und Aufsätze zur Städteausstellun, Winter 1902–1903* (1903): pp. 187–206.

Simmons, Sherwin, "Advertising Seizes Control of Life: Berlin Dada and the Power of Advertising," *Oxford Art Journal* 22, 1 (1999): pp. 121–46.

Siry, Joseph, *Carson Pirie Scott: Louis Sullivan and the Chicago Department Store*, Chicago: University of Chicago Press, 1988.

Sloan, Alfred P., Jr, *My Years with General Motors*, Garden City, New York: Doubleday and Company, Inc., 1964.

Smith, Roland B., "The Genesis of the Business Press in the United States," *Journal of Marketing* 19, 2 (Oct. 1954): pp. 146–51.

Sneeringer, Julia, "The Shopper as Voter: Women, Advertising, and Politics in Post-Inflation Germany," *German Studies Review* 27, 3 (Oct. 2004): pp. 476–501.

Soja, Edward W., *Postmodern Geographies: the Reassertion of Space in Critical Social Theory*, London and New York: Verso, 1989.

Stannard, David, ed. *Death in America*, Philadelphia: University of Pennsylvania Press, 1975.

Stewart, Susan, *On Longing: Narratives of the Miniature, the Gigantic, the Souvenir, the Collection*, Durham NC: Duke University Press, 1993.

Storper, Michael and Richard Walker, *The Capitalist Imperative: Territory, Technology, and Industrial Growth*, New York: Basil Blackwell, 1989.

Strege, Gayle, "Influences of Two Midwestern American Department Stores on Retailing Practices, 1883–1941," *Business and Economic History Online* 7, (2009): pp. 1–10.

Swett, Pamela E., S. Jonathan Wiesen, and Jonathan R. Zatlin, *Selling Modernity: Advertising in Twentieth-Century Germany*, Durham and London: Duke University Press, 2007.

Tanenbaum, Morris, "The Historical Evolution of US Telecommunications," *Technology in Society* 15 (1993): pp. 264–65.

Tobey, Ronald C., *Technology as Freedom: The New Deal and the Electrical Modernization of the American Home*, Berkeley: University of California Press, 1996.

Townsend, Kenneth William, *World War II and the American Indian*, Albuquerque: University of New Mexico Press, 2000.

Trachtenberg, Alan, *The Incorporation of America: Culture and Society in the Gilded Age*, New York: Hill and Wang, 1982.

Tucker, Johnny, *Retail Desire: Design, Display and Visual Merchandising*, Rotovision: East Sussex, UK, 2003.

Urry, John, "The 'System' of Automobility," *Theory, Culture & Society* 21, 4–5 (2004): pp. 25–39.

Varnedoe Kirk and Adam Gopnik, *High and Low: Modern Art and Popular Culture*, New York: The Museum of Modern Art, 1990.

Virilio, Paul, *Speed and Politics: An Essay on Dromology*, trans. Mark Polizzotti, New York: Semiotext(e), 1986.

Visual Merchandising 4, Cincinnati, OH: Media Group International, 2005.

Wainwright, Nicholas B., *Philadelphia in the Romantic Age of Lithography*, Philadelphia: Historical Society of Pennsylvania, 1958.

Walker, Lynn, "Vistas of Pleasure: Women Consumers and Urban Space in the West End of London, 1850–1900," in Clarissa Campbell Orr, ed. *Women in the Victorian Art World*, Manchester: Manchester University Press, 1995: pp. 119–45.

Walsh, Claire, "Shop Design and the Display of Goods in Eighteenth-Century London," *Journal of Design History* 8, 3, (1995): pp. 157–76.

Ward, Janet, *Weimar Surfaces: Visual Culture in 1920s Weimar Germany*, Berkeley: University of California Press, 2001.

Weber, Adna Ferrin, *The Growth of Cities in the Nineteenth Century: A Study in Statistics*, Ithaca: Cornell University Press, 1962.

Wells, Robert, *Facing the "King of Terrors": Death and Society in an American Community, 1750–1990*, Cambridge, UK and New York: Cambridge University Press, 1999.

Whitaker, Jan, *Service and Style: How the American Department Store Fashioned the Middle Class*, New York: St. Martin's Press, 2006.

Wigley, Mark, *White Walls, Designer Dresses: The Fashioning of Modern Architecture*, Cambridge, Mass. and London: MIT Press, 1995.

Williams, Raymond, "Advertising the Magical System," in Simon During, ed., *The Cultural Studies Reader*, New York: Routledge, 1993: pp. 320–35.

Wilson, Verity, "Studio and Soirée: Chinese Textiles in Europe and America, 1850 to the Present," in Ruth Phillips and Christopher Steiner, eds, *Unpacking Culture: Art and Commodity in Colonial and Postcolonial Worlds*, Berkeley: University of California Press, 1999: pp. 229–42.

Wise, Marc F. and Bryan Di Salvatore, *Truck Stop*, Jackson: University Press of Mississippi, 1995.

Index

Bold page numbers indicate figures.

For Product Safety Concerns and Information please contact our
EU representative GPSR@taylorandfrancis.com Taylor & Francis
Verlag GmbH, Kaufingerstraße 24, 80331 München, Germany